SMITHSONIAN ASIAN PACIFIC AMERICAN

HISTORY, ART, AND CULTURE IN

101 OBJECTS

CONTRIBUTING SMITHSONIAN MUSEUMS AND UNITS

National Museum of American History · Archives of American Art · Anacostia Community Museum · Center for Folklife and Cultural Heritage · Cooper Hewitt, Smithsonian Design Museum · Hirshhorn Museum and Sculpture Garden · National Air and Space Museum National Museum of Asian Art · National Museum of African American History and Culture · National Museum of Natural History · National Portrait Gallery · National Postal Museum · Smithsonian American Art Museum · Smithsonian Libraries and Archives

SMITHSONIAN ASIAN PACIFIC AMERICAN HISTORY, ART, AND CULTURE IN 101 OBJECTS

Edited by Theodore S. Gonzalves
Foreword by Erika Lee

CONTRIBUTIONS BY

Joshua A. Bell · Kālewa Correa · Chelsea R. Cozad · Lawrence-Minh Bùi Davis
Saisha Grayson · Diana Jocelyn Greenwold · Jon Grinspan · Melissa Ho · Nafisa Isa
John P. Jacob · Sojin Kim · Thanh Lieu · Adriel Luis · Andrea Kim Neighbors
Sarah Newman · Sam Vong · Grace Yasumura · Cedric Yeh · Claudia E. Zapata

SMITHSONIAN BOOKS
WASHINGTON, DC

In Association with the Smithsonian Asian Pacific American Center

Dedicated to Franklin S. Odo
1939–2022

Edited by Theodore S. Gonzalves
Foreword by Erika Lee

Curatorial assistant: Thanh Lieu

Published by Smithsonian Books
Director: Carolyn Gleason
Senior Editor: Jaime Schwender
Editor: Julie Huggins

Edited by Jean Vengua
Designed by Christina Newhard

Special thank you to photographers and image specialists Erin Beasley, Marisa Bourgoin, James Di Loreto, Janice Hussain, Jaclyn Nash, Daisy Njoku, Kay Peterson, Riche Sorensen, Richard Strauss, and Benjamin Sullivan.

This book may be purchased for educational, business, or sales promotional use. For information, please write: Special Markets Department, Smithsonian Books, P.O. Box 37012, MRC 513, Washington, DC 20013

Friends of the Smithsonian Edition ISBN: 978-1-58834-763-3

Library of Congress Cataloging-in-Publication Data

Names: Gonzalves, Theodore S., editor. | Smithsonian Institution. Asian Pacific American Center.
Title: Smithsonian Asian Pacific American history, art, and culture in 101 objects / edited by Theodore S. Gonzalves; in association with The Smithsonian's Asian Pacific American Center.
Description: Washington, DC : Smithsonian Books, [2023] | Includes bibliographical references and index.
Identifiers: LCCN 2023013353 | ISBN 9781588347510 (hardcover)
Subjects: LCSH: Asian Americans--Antiquities. | Asian Americans--Material culture. | Pacific Islander Americans--Antiquities. | Pacific Islander Americans--Material culture. | Smithsonian Institution--Catalogs. | United States--Relations--Pacific Area. | Pacific Area--Relations--United States. | United States--Ethnic relations.
Classification: LCC E184.A75 S58 2023 | DDC 973/.0495--dc23/eng/20230418
LC record available at https://lccn.loc.gov/2023013353

Printed in Malaysia, not at government expense
27 26 25 24 23 1 2 3 4 5

Contents

Foreword

Objects hold our memories of the past. They can share our dreams for the future. We collect and display them, hide them away, or give them as gifts. Yet, such objects also raise questions. Do we know the whole story? How and to whom do we tell our histories? These are some of the issues that *Smithsonian Asian Pacific American History, Art, and Culture in 101 Objects* seeks to address.

Asian Americans, Native Hawaiians, and Pacific Islanders are diverse communities with unique histories and experiences. It is essential to recognize that there is not one uniform Asian American Native Hawaiian and Pacific Islander history. There are many. But there are significant connections between them as well. Theodore S. Gonzalves helps us understand their relationships, differences, and similarities through themes that evoke the globe-spanning experiences of these histories: navigation, intersection, labor, innovation, belonging, tragedy, resistance and solidarity, community, service, memory, and joy.

As a historian, teacher, and writer, I recognize so many of the personal, family, and community histories in the objects featured in the following pages. I think of the ones that we value in our own homes, community spaces, and memories. Sitting on my own bookshelf is the 1956 copy of *Betty Crocker's Picture Cook Book* that my Chinese immigrant grandmother used to learn to cook American food after she arrived in the United States. I can tell from the worn cover and dog-eared pages that she also used the book to navigate through American culture. Her recipe for dan taat was legendary and brought much joy to her children and grandchildren. When I asked her for the recipe, I expected her to bring out a yellowed piece of parchment that had traveled with her from Canton to New York. Instead, she turned to Betty Crocker's recipes for "flaky pastry" and "egg custard." She learned about the wonders of this picture cookbook from the Italian immigrant woman next door and navigated racism alongside her African American neighbors. Their worlds intersected with one another and they found community with each other through cooking. But Yen Yen was only able to make dan taat on special occasions. She was too busy raising seven children, running a laundry, and supporting her family through her hard labor.

I think of the two paj ntaub (story cloths) that my Hmong American students gave me many years ago. Like My Yia Vang's story cloth featured on page 200, the first of my paj ntaub (opposite top) tells how the Hmong were forced out of their homeland in Laos during the wars in Southeast Asia, how they braved the rough currents of the Mekong River and traveled to safety in a Thai refugee camp, but were forced to wait years before being resettled in the United States. The hills, military tanks, and people that illustrate this tragedy are painstakingly rendered in bright threaded embroidery that dances across the fabric. A second story cloth (opposite bottom) shows Hmong American students making a different journey. Dressed in graduation caps and gowns, they pass through a little red schoolhouse in Minnesota on their way to achieving American dreams. Taken together, these story cloths continue the tradition of preserving memory, but they also celebrate innovation and claim a new sense of belonging in the United States.

As I write these words, I look up at the "No Muslim Ban Ever" poster that I hung on my office wall after marching alongside my Muslim students and friends in 2017. I picked it up the weekend after former President Donald J. Trump signed an executive order that prohibited travel and refugee resettlement from select predominately Muslim countries and it has hung on my wall ever since. It joins a "No on Prop. 187" button that I have from the 1994 protests I participated in when California voters passed a ballot initiative that barred undocumented immigrants from state public services including public education and healthcare. For me, they are reminders that resistance and solidarity, plus service to our communities, has defined my own work.

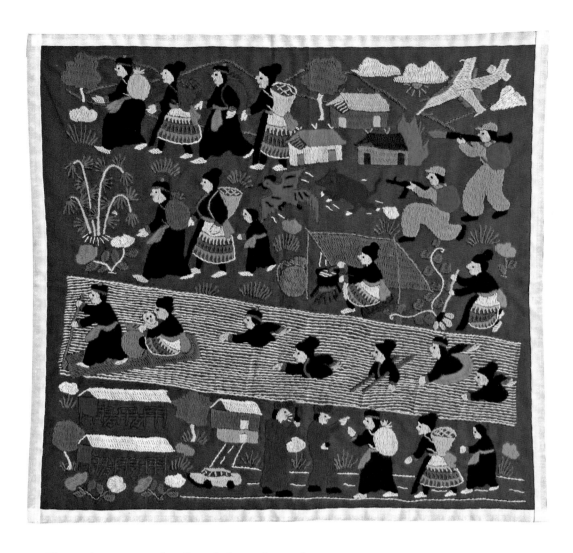

Paj ntaub. Unknown artists, c. 2000.

Those themes are also found throughout the Smithsonian's vast collections representing a variety of experiences and traditions. As you read the following pages and view the images, I hope that the featured objects will inspire you to think about the things that tell your own story, the stories of your family, and your community.

Like my poster, my students' story cloths, and my grandmother's cookbook, *Smithsonian Asian Pacific American History, Art, and Culture in 101 Objects* begins to tell our diverse stories. From Queen Kapiolani's waʻa gifted to the Smithsonian in 1888 to a 2014 comic book featuring Kamala Khan, a Pakistani American girl from New Jersey who is superheroine Ms. Marvel—they are examples of Asian Pacific American contributions and achievements. They reveal resilience and resistance. And most importantly, they are proof of how Asian Americans, Native Hawaiians, and Pacific Islanders have experienced, recorded, and preserved our histories on our own terms and how, together, we have transformed America.

—Erika Lee

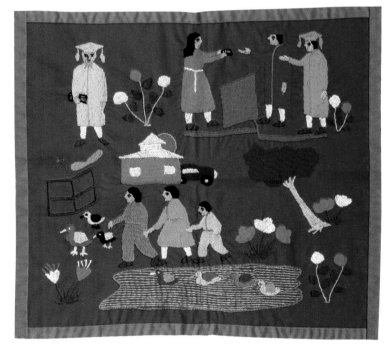

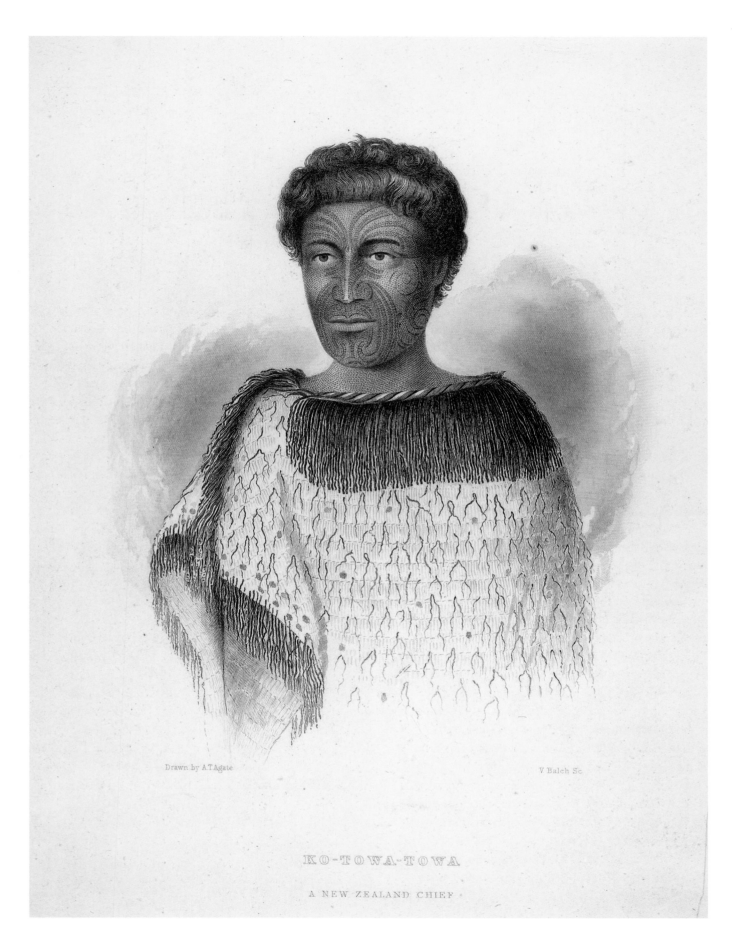

Drawn by A.T.Agate

V.Balch Sc.

KO-TOWA-TOWA

A NEW ZEALAND CHIEF.

Secretary's Note

This project is a feat of curation: through the careful examination of 101 objects across 14 Smithsonian units, we get a true sense of the incredible complexity and breadth of Asian, Pacific Islander, and Asian American history. The narrative behind each object recognizes these histories as integral to both American history and the Smithsonian's origin story.

I mean the latter quite literally: the Smithsonian's reputation as the national museum began with an expedition to explore and map the Pacific (including Hawai'i, Fiji, and numerous Southeast Asian islands), Antarctica, and the Northwest coast of the United States. Our collections from Asia and Oceania are not new to the institution, but rather predated and made possible its existence.

In 1838, six US Navy vessels set out to explore uncharted oceans under the command of Lieutenant Charles Wilkes. That four-year endeavor, known colloquially as the Wilkes Expedition, yielded some 4,000 ethnographic objects; it is thought to be the largest ever collection obtained from a single sailing eoxpedition. In addition, the men brought back tens of thousands of specimens of plant species and hundreds of specimens of birds, mammals, fish, and marine wildlife species. These objects—in combination with detailed record keeping and maps of the vast lands and oceans they passed through—enormously increased the intellectual resources of the United States.

The collection prompted the creation of the first national museum in Washington and, in 1858, they became part of the earliest collections of the Smithsonian Institution.

The expedition brought about immense cultural and intellectual capital and helped create the institution I am so proud of leading today. It was also an endeavor marred by open racism toward—and violent encounters with—the native people the voyagers encountered and stole from. Lt. Wilkes painstakingly detailed the expedition in his *Narrative of the United States Exploring Expedition,* in which he catalogued native people alongside objects and animals.

Across the institution, we are committed to telling the full stories of the communities we seek to represent. Since 1997, the Asian Pacific American Center has deeply engaged with reparative work that directly addresses some of the harms of our past. Their staff is part of a larger group of curators, collections managers, and educators committed to that work across the institution. It is our responsibility to build relationships with communities of origin, exchange knowledge, and create agreements for shared stewardship or repatriation of items when appropriate. The Smithsonian's ethical returns policy might well be invoked in some of the objects included in this collection, and this work unambiguously confronts that possibility.

This book is a testament to the richness of Asian, Pacific Islander, and Asian American history and culture; it is a collection of painful and joyous memories that offers hope for a more equitable future. Above all, it is a reminder of the way our histories are inextricably bound together, and the weighty responsibility museums have to tell the complete story.

—Lonnie G. Bunch III

Portrait of Chief Ko-Towa-Towa by Alfred T. Agate, from Narrative of the United States Exploring Expedition.

Introduction

*We sweat and cry salt water, so we know
that the ocean is really in our blood.*

—Teresia Teaiwa

*You can't hide the fish heads / in your
pockets / the smell is too strong.*

— Al Robles

When the global pandemic of 2020 revealed how broken our systems were, from supply chain disruptions to the inability to protect the most vulnerable frontline workers, aunties swung into action. A group of Asian American women and their loved ones—anchored in California and connected online throughout the United States—did what had to be done. They assembled materials; they connected strangers across the country; they coordinated the assembly, pickup, and drop-offs of hundreds of thousands of masks. They objected to characterizing their efforts as charity and preferred to see this work as "mutual aid" and "radical care." We can link the actions of a few, connected to a network of many, with Asian American and Pacific Islander traditions of the past. The Auntie Sewing Squad, as they referred to themselves, teach all of us about one of the enduring truths of Asian and Oceanic traditions: aunties get things done.

In *Smithsonian Asian Pacific American History, Art, and Culture in 101 Objects*, we explore the fullness of Asian American and Pacific Islander (AAPI) experiences. Included are stories of individuals and groups who cannot be reduced to or defined by racist stereotyping. This book anchors itself in the traditions of mutuality and care that are at the core of Asian American and Pacific Islander hidden histories, unlikely affinities, and fantastic transformations.

In exploring the Smithsonian's national collection, we can link objects to contexts, biographies to histories, and memories of the past to dreams of more just futures. According to the Pew Research Center, Asian Americans are the fastest growing group in the United States. Numbering 24 million, they hail from the globe's largest continent next to the largest ocean. Since 1997, the US Census Bureau has understood the need to identify the distinct experiences between Asian Americans ("person[s] having origins in any of the original

peoples of the Far East, Southeast Asia, or the Indian subcontinent") and Native Hawaiians or other Pacific Islanders (or "person[s] having origins in any of the original peoples of Hawai'i, Guam, Samoa, or other Pacific Islands"). Their histories in the Americas have been centuries in the making, and this book offers a window into the expanse of those stories.

In every aspect of American culture—from labor, to law, the arts, sports, education, and service—Asian Americans and Pacific Islanders have contributed, achieved, and adapted. However, in 2022, a survey of American attitudes toward Asian Americans found that 58 percent of respondents could not name a "prominent Asian American." How is that possible? Sanjay Gupta gives medical advice almost nightly. Sandra Oh and Mindy Kaling have played beloved characters on big and small screens. Tiger Woods, Naomi Osaka, Kristi Yamaguchi, and Apolo Ohno have been inspiring athletes for years. There is no shortage of musicians cutting across all genres from Yo-Yo Ma to Steve Aoki, Bruno Mars, Anderson .Paak, MILCK, Mitski, Karen O, H.E.R., and Olivia Rodrigo. Journalists like Lisa Ling, Richard Lui, Jose Antonio Vargas, and Alex Wagner have told thousands of stories and talked to as many Americans for decades. Andrew Yang ran a national campaign for the nation's highest office and in 2020 Kamala Harris made history in becoming the first Black and South Asian American woman to serve as vice president of the United States. This is, of course, just a tiny portion of what is an incredibly long list. Yet, the best that a large majority of Americans could come up with is: "Don't know."

We need to change that reality, but first we need to reframe what we think we know about this problem. According to the report's authors, not being able to name prominent AAPIs contributes to the group's so-called "invisibility." The metaphor of invisibility is helpful to get a conversation started, but ultimately, it's inadequate. We must

acknowledge the painful truth that Asian Americans and Pacific Islanders have been seen for centuries in the Americas in distorted ways, with the fullness of their humanity narrowed into stereotypes, insults, and half-truths. They have rarely been seen on their own terms.

In Hawai'i, Asian settler plantation workers were given numbers to pick up their paychecks. Their names were irrelevant in a ledger. I could list hundreds of racist slurs and casual euphemisms that have been used to name Asian and Oceanic persons in newspaper stories, films, billboards, popular lyrics, political cartoons, and advertisements. In the nineteenth century, it did not matter to recruiters that workers from disparate and vast places throughout China, Japan, the Philippines, Korea, and India migrated to the Americas. The Spanish crown indiscriminately referred to them as "Chinos," a term that has lasting power to this day.

Reach even further back. An entire part of the globe was given a name that was nothing more than a direction—the "Orient"—a placeholder that has become synonymous with the "Other." Notice how Europeans, the givers of the name,

are not known as Occidentals. Names matter. They carry the burden of what it means to see and be seen. Asian Americans and Pacific Islanders are not invisible. We have been here—with our given, adopted, and invented names.

That is why it is important to pay attention to the birth of the Asian American movement of the 1960s. Activists, artists, and scholars created a new, albeit imperfect, name. That is the nature of what it means to be in a coalition: interests and memberships shift, and not everyone identifies with the label. If we are all works in progress, so are movements for social change. The important thing is to recognize that the fastest growing group in the country is not simply a census category. They are the authors of stories that have overlapped and intersected for centuries.

From 1565 to 1812, persons from Asia and Oceania crewed galleons with precious metals, porcelain, human labor, and more in their holds. For centuries, these massive ships sailed sea routes stretching from Shanghai to Manila, Acapulco, and Seville. When the global trade of enslaved Africans formally ended in the early 1800s, replacement workers from

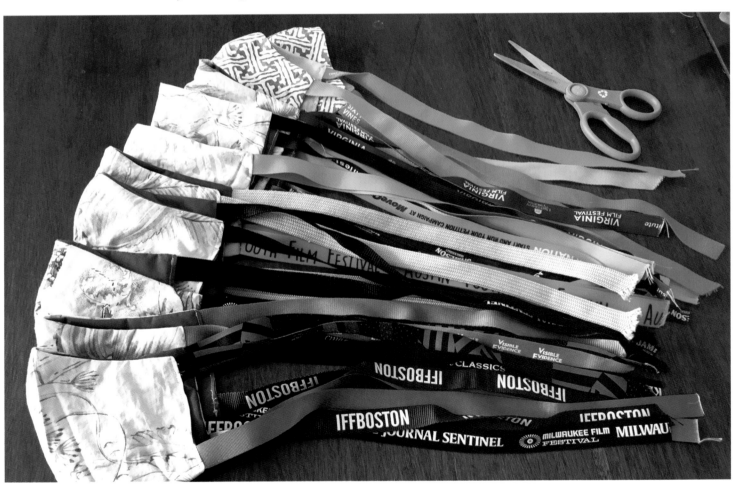

Masks created by the Auntie Sewing Squad in April 2020.

China and India were sent as bonded labor to the Americas and the Pacific—to Hawai'i, Peru, Cuba, the West Indies, Panama, and Ecuador among other locations.

For at least 3,000 years, the native peoples of what we know as Samoa, Hawai'i, Guam, and the Marshall Islands developed complex self-sustaining societies and traversed a massive sea of islands. In the wake of Europeans arriving beginning in the sixteenth century, Oceanic life was drastically transformed: kingdoms overthrown, lands appropriated, and locals and natives began voyaging to and through Western colonies, territories, and continents. While Pacific Islander bodies were thrown into the chaos of global labor migration, their formerly sovereign lands became colonial dependencies, conditions which continue to be challenged.

As European and American empires planted flags across the Pacific, economic interests demanded robust defenses. This has resulted in the creation of the world's largest military command, connecting the west coast of North America to Antarctica, Australia, the Pacific Islands, mainland Asia, and the South Asian subcontinent—a region of 3,000 languages heard on the busiest sea lanes and throughout ports. In every decade of the twentieth century, generations of Asians, Pacific Islanders, and Asian Americans witnessed constant war, leaving indelible traumas and memories of acts of patriotism, wars of national liberation, nuclear devastation, environmental hazard, and the exodus of refugees.

The oldest permanent settlements of AAPIs in the 1800s on the North American continent were varied and far-flung—from the shrimp-harvesting Filipino villages in Louisiana's Barataria Bay to the densely populated streets of San Francisco's Chinatown. For at least a century, communities and extended families transformed rural and urban spaces into places. In locales that had been segregated or were in the process of gentrifying, they built businesses, cared for elders, watched their US-born children adopt and adapt, and connected the newest arrivals from their homelands with jobs, housing, and food. The Chinatowns, Manilatowns, Koreatowns, and Japantowns of the past century are now echoed in the suburban developments of Falls Church, Virginia, and Westminster, California (Little Saigons), the South Asian American community of Flushing, New York, and the Hmong communities of Minneapolis, Minnesota; Milwaukee, Wisconsin; or Hickory, North Carolina.

These histories have spanned the globe and have been centuries in the making. Dizzying, to be sure, but these experiences are anchored by the dreams that journalist Helen Zia wrote about: "for freedom and family and the next generations."

A book like this would not have been possible without many who gave so much to the Asian American movement and to the development of Asian American studies. It is impossible to pay back what is owed to people like Nobuko JoAnne Miyamoto, a performer and songwriter whose work on the album, *A Grain of Sand*, is featured in this book. We can only pay forward what we have learned from them. Echoing the ethic of mutuality and care, Miyamoto's involvement in the movement is a great place to start.

In the 1960s, Miyamoto made her way from California to New York where she appeared in films and on Broadway as a dancer and singer. She earned a living performing works composed and choreographed by others. Savvy community organizers like Yuri Kochiyama introduced Miyamoto to activists Kazu Iijima and Minn Matsuda, both of whom helped to create a group called Asian Americans for Action in 1969.

Miyamoto writes in her memoir about what it was like to meet these women activists who gave themselves a new name: "The label 'Asian American' was new. 'Oriental' was what the world called us when they lumped us together. . . . We were all seeking answers, seeking solutions, seeking justice. We were like severed neurons suddenly awakened, excited in a moment of recognition, leaping to re-connect."

That meeting set Miyamoto on a new course. She started her organizing work by handing out leaflets to oppose what was then the latest US war in Asia. And instead of performing the works of others, she began to share her own lyrics. She described the song she cowrote, "Something About Me Today," as "an awakening to our love of community, and for me, awakening to myself as an Asian woman."

> I looked in the mirror
> And I saw me
> And I didn't want to be
> Any other way
> Then I looked around
> And I saw you
> And it was the first time I knew
> Who we really are

The crest of the Asian American movement coincides with changes to the nation's population in the years following the 1965 Immigration and Nationality Act. The largely working-class populations of the nation's Chinatowns, Japantowns, and Manilatowns would continue to age while

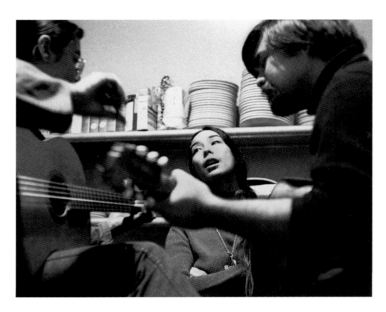

Chris Kando Iijima, Nobuko JoAnne Miyamoto, and William "Charlie" Chin rehearsing before a New York City show in 1971, photographed by Bob Hsiang.

welcoming the latest waves of immigration. Outside the major urban centers where Asians had lived for years, newer communities took hold in suburbs and exurbs—to Daly City, California; Monterey Park, California; Dearborn, Michigan; and Annandale, Virginia. Members of refugee communities from Southeast Asia relocated and transformed Westminster, California; Las Vegas, Nevada; and San Jose, California. Today, nearly every American metropolitan area is transformed and enriched by Asian American and Pacific Islander life—Little Rock, Arkansas, or Minnesota's Twin Cities, for example. When talking about AAPI communities, you can measure its growth not just by one city block after another, but over whole counties: in Harris County, Texas; Clark County, Georgia; Philadelphia County, Pennsylvania; or Cook County, Illinois.

As the nation's population has changed, so too have practices at the Smithsonian regarding these communities. This book departs from the Smithsonian's earlier curatorial practices with respect to representations related to Asian Americans and Pacific Islanders. Except for the Asian Pacific American Center (APAC, founded in 1996), much of the Smithsonian's work can be characterized as ad hoc: researching, collecting, exhibiting, or programming *about* Asia and the Pacific Islands rather than *with* members of actual communities. Just as we cannot now imagine curatorial work at the Smithsonian taking place without African American, Latinx, and Native American voices—involving sincere and substantive community engagement coupled with rigorous academic scholarship—the same needs to be true for Asian

American and Pacific Islander histories. APAC has embraced community-informed projects in its Culture Labs, which echo the spirit of participatory research and presentation pioneered by organizers of the Smithsonian Folklife Festival since 1967 and staff at the Wing Luke Museum of the Asian Pacific American Experience in Seattle.

Today, stories about and by AAPI are told throughout the Smithsonian Institution. This book enlisted curators and others who know the collection inside and out. Even before the Smithsonian was created in 1846, the US government had commissioned exploring expeditions that netted thousands of items from Asia and the Pacific. Those early holdings became part of the Smithsonian's founding collections. Curators and educators not only continue to reinterpret what is under our care but also to develop underrepresented areas and topics.

Our team of writers collaborated on objects and documents held in more than a dozen museums and archives. As the list of objects for this book was narrowed from an initial 1,200 to the final list of 101, many themes emerged. Rather than fixing the objects into a strict chronology, we grouped them into themes that can also represent shared experiences. You will soon see that these themes easily blend into one another, or that an object identified in one category could easily fit into another. The themes are navigation, intersections, labor, innovation, belonging, tragedy, resistance and solidarity, community, service, memory, and joy.

With an eye toward mutuality and care, this book can serve as your standing invitation at the Smithsonian to learn about many stories spanning Asia, Oceania, and Asian Pacific America that have yet to be told. That invitation would be incomplete without the spirit of Carlos Bulosan, whose poem "If You Want to Know What We Are" offers a vision of what to look for in this book.

We are multitudes, the world over, millions everywhere;
in violent factories, sordid tenements, crowded cities,
in skies and seas and rivers, in lands everywhere;
our numbers increase as the wide world revolves
and increases arrogance, hunger, disease and death.

We are the men and women reading books, searching
in the pages of history for the lost word, the key
to the mystery of living peace, imperishable joy;
we are factory hands field hands mill hands everywhere,
molding creating building structures, forging ahead.

— Theodore S. Gonzalves

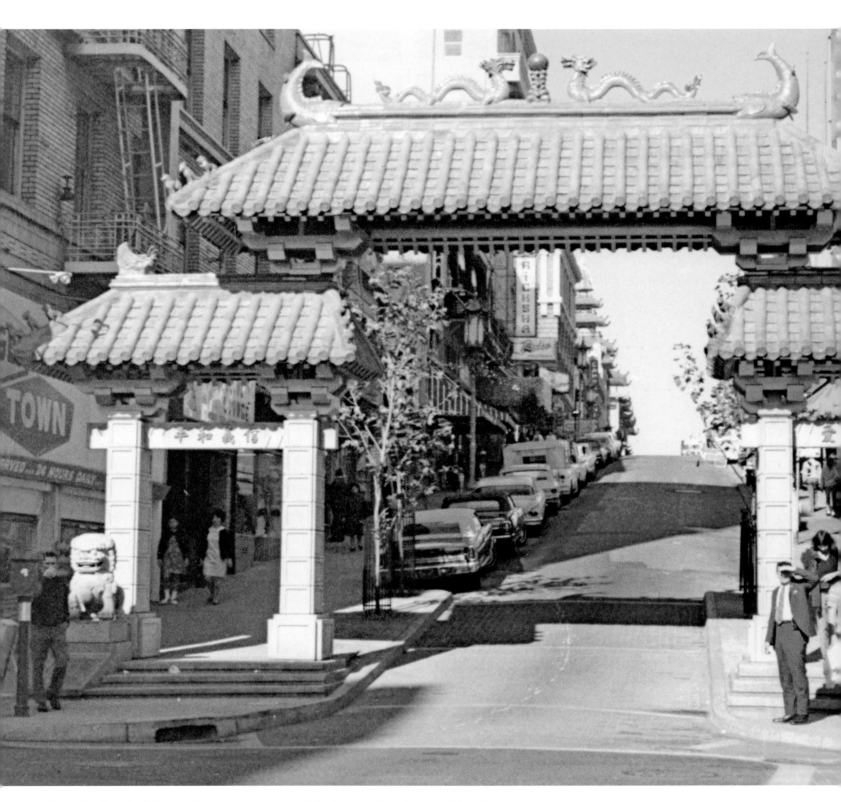

Above: San Francisco's Dragon Gate, ca. 1970 (pg. 22). Right: Lacquered trunk, ca. 1906 (pg. 18).

Navigation

The ancestors of Asian Americans and Pacific Islanders are some of the world's greatest navigators. For thousands of years, their forebears sailed out from the globe's largest land mass and populated islands across the Pacific. The peopling of that vast sea of islands was not the result of accidental drift but instead the upshot of curiosity, necessity, and technical skill. Ancestors' knowledge of wave patterns, sea swells, and stellar constellations had been studied and passed down for generations. Over time, navigation has often involved negotiation—with laws, prejudices, and shifting borders. In this section, consider the tools of wayfinding that assisted AAPI journeys.

Boundless Space

Some of the world's most sophisticated mariners, whose ancestors pushed eastward from mainland Asia across the globe's largest ocean, made their homes on twenty-nine atolls and five islands, located about 2,400 miles west of Honolulu and about 1,700 miles north of Fiji. Those ancestors called their home of 2,000 years "Aelon Kein Ad" ("our atolls"), and they referred to themselves as "Armij Aelon Kein" ("people of these islands"). In folklore, the archipelago is also known as "jolet jen Anij" ("gifts from God"). The Europeans who arrived in the late 1780s named the archipelago after one of their own, British naval captain John C. Marshall, and they are now known as the Marshall Islands.

For the most part, the Marshall Islands consist of parallel island chains—the western Ralik and the eastern Ratak—covering a staggering area of 750,000 square miles. Foreigners accustomed to life on large continents must have been puzzled by or even dismissive of these "tiny" island societies separated by so much water. But it's all a matter of perspective. Consider the point of view from the Tongan-Fijian scholar and writer, Epeli Hau'ofa: "The world of Oceania is not small; it is huge and growing bigger every day," he wrote in 1994. "[O]ur ancestors . . . viewed their world as 'a sea of islands,' rather than as 'islands in the sea.'" Hau'ofa envisioned Oceania as a place where diverse kingdoms and peoples traded, explored, settled, and warred.

The Marshallese, too, navigated this boundless space. To teach their young, experienced navigators used stick charts fashioned from palm fronds bound by coconut fiber. They attached shells to denote atolls. However, these were not maps as we know them today; these charts were not meant to be taken aboard, but rather committed to memory while on land.

Trade winds, which move east to west near the equator, drive swells in the region, with the easterly being the strongest. The swells are broken by various low-lying atolls, creating reflections and refractions that navigators can observe while at sea. Marshallese navigators created the teaching aids to convey the complex relationships of swells, waves, and land.

Voyaging as a way of life in the Marshall Islands ceased in the years after World War II. From 1946 to 1958, the United States conducted weapons testing there—detonating sixty-seven nuclear bombs, producing radioactive fallout and endangering lives, lands, and seas. A half-century after the US military developed its war fighting technology in the region, Captain Korent Joel—working with University of Hawai'i anthropologists and oceanographers—played a key role in revitalizing local knowledge systems around wayfinding. Captain Korent gathered information from surviving elders and started on a path to train a new generation of Marshallese navigators.

—Theodore S. Gonzalves

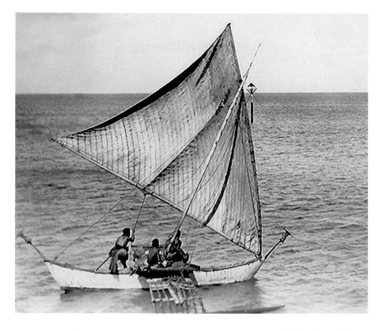

Above: Marshallese men sailing in an outrigger canoe. Right: Marshall Islands stick chart used to learn wave and swell patterns in the Pacific, ca. 1899.

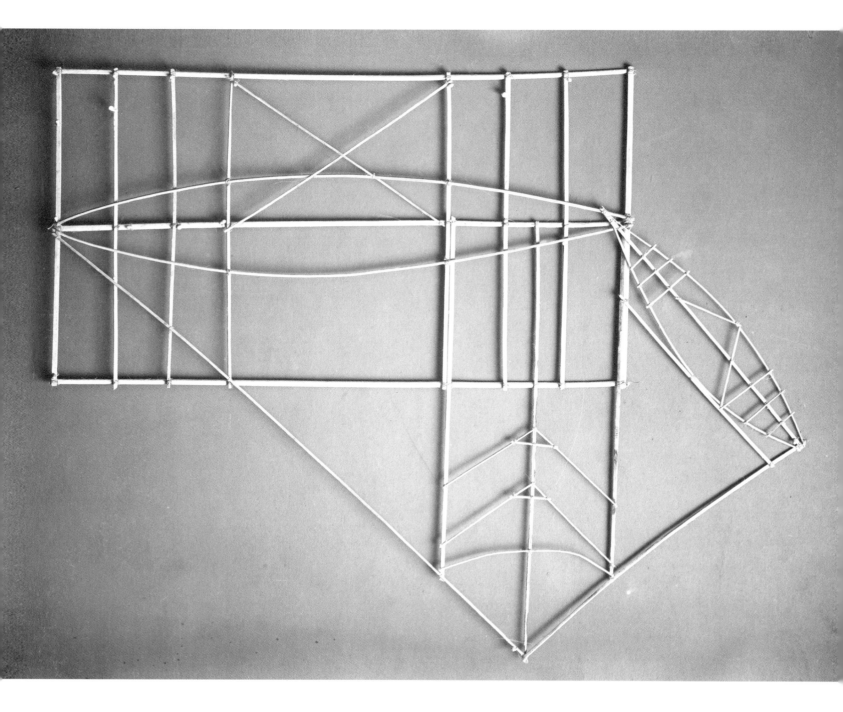

Emissary of Culture and Knowledge

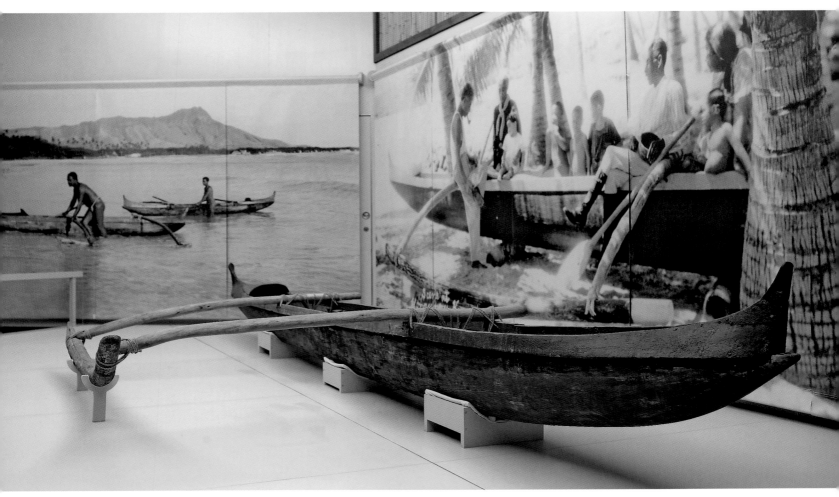

Queen Kapiʻolani's waʻa (outrigger canoe), accessioned by the Smithsonian in 1888.

On January 25, 1888, the Smithsonian National Museum (now the National Museum of Natural History) accessioned a nineteen-foot waʻa—a single hull outrigger canoe with a sail—from the Kingdom of Hawaiʻi. Queen Kapiʻolani (1834–99) promised the waʻa to the Smithsonian following her visit with Princess Liliʻuokalani to Washington, DC,

in May 1887, as they traveled to attend Queen Victoria's Golden Jubilee celebrations in London. The waʻa was later sent by steamer to San Francisco and arrived in Washington through the Alaskan Commercial Company. When the waʻa was given to the Smithsonian it was said to be a hundred years old, making it the oldest documented Hawaiian outrigger canoe in a museum. Since its arrival in

1888, the waʻa has been a powerful emissary of Hawaiian knowledge, skill, and culture.

Carved with adzes (a tool similar to an axe), the hull of the waʻa is made from koa (*Acacia koa*) while the outrigger is made from hau (*Hibiscus tiliaceus*). While an axe's blade is parallel to the handle, an adze's is perpendicular to the same, allowing the woodcutter to make precise carvings. The sail is made from woven hala (*Pandanus tectorius*) leaves. The waʻa had undergone extensive Indigenous repairs along various sections of the hull held together by coconut sennit rope. The exterior of the hull is covered in black paint that appears to be part of the local repair. Once at the Smithsonian, the interior of the waʻa was painted with gray ship paint, presumably to prevent insect damage. Eight paper labels with terminology in Hawaiian were attached to the waʻa by Smithsonian staff. Recent examination of the waʻa by Hawaiian canoe carvers has suggested that the sail was an addition to the canoe before it was sent to the Smithsonian, and that the waʻa was not used for fishing but for recreation.

The waʻa was displayed in Boat Hall of the Smithsonian's Arts and Industry Building for several decades (ca. 1889 to ca. 1950) before being moved into storage facilities in Suitland, Maryland. In 2004, the waʻa became the centerpiece of the National Museum of Natural History's exhibit *Nā Mea Makamae o Hawaiʻi— Hawaiian Treasures* curated by Adrienne Kaeppler. Prior to this exhibit, the waʻa underwent extensive conservation work to stabilize the canoe. In 2018 the Recovering Voices Program initiated a collaborative project around the waʻa, which brought together master Hawaiian and Māori canoe carvers to work with Smithsonian staff to re-rigg the waʻa, understand the canoe's form and construction, and help promote the revitalization of Oceanic canoe carving.

This collaboration has led to a series of events in Hawaiʻi and Aotearoa New Zealand focused on the waʻa. In 2019, a full-sized replica was carved by female students working

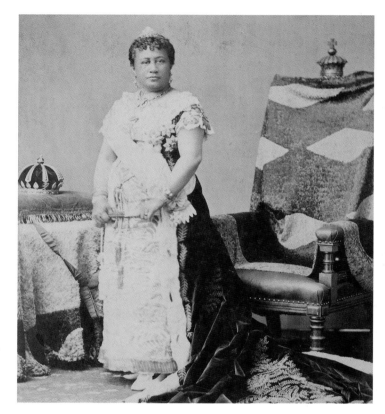

Portrait of Dowager Queen Kapiʻolani.

with master canoe carvers Raymond and Alika Bumatay in Hilo, and a full-sized 3D print inspired by a digital scan of the waʻa was printed by University of Victoria of Wellington professor Derek Kawiti as a proof of concept for an intercultural canoe symposium at the Hihiaua Cultural Centre in Whangārei. Inspired by this waʻa, these projects honor the Queen's gift and through different forms of engagement seek to inspire the intergenerational transmission of canoe carving and its wider revitalization.

— Joshua A. Bell

汝妻舅乜名字 今幾多歲 現在做乜

汝妻舅生有仔女否

汝舅仔女乜名今幾多歲

汝妻姨許配嫁人否

汝妻姨丈乜名字 現幾歲多

汝 姨生有仔女否

汝 姨

▲父親

汝父姓乜名 今年幾多歲 做大幾

汝父乜年乜月乜生日 在乃出世

汝父親有兄弟乜名字 否生死

汝父親之兄弟乜名字 否生死

汝伯之子女乜名 乜出世期

汝伯有子女否

汝有伯母否伯乜脚

汝有伯否

汝叔乜名字 娶妻否

汝叔母乜名氏乃村人女 乜脚

汝有叔否

汝叔有仔女否乜名乜名 乜年月 乜日出世

汝大三四姑

汝叔有仔女否乜名 今年幾多歲

汝姪世出之時有做剃頭酒否

A Chinese Immigrant's Coaching Book

Chinese exclusion acts made it difficult for Chinese laborers and their families to immigrate to the United States and to become naturalized citizens. The Chinese Exclusion Act of 1882 suspended the immigration of Chinese laborers to the United States, limited the immigration of wives and children of Chinese laborers already in the US, and prevented Chinese immigrants from becoming naturalized citizens for a ten-year term. Upon expiration in 1892, this act was extended through the Geary Act and made permanent in 1902. These exclusion acts placed new requirements on the reentry of Chinese into the United States—if they left, they then had to obtain certifications to reenter. Additional restrictions also required each Chinese resident to register and obtain a certificate of residence, without which they faced deportation.

In 1906, a major earthquake struck San Francisco, resulting in a fire that destroyed many public records. This allowed many Chinese men to indisputably claim that they had been born in San Francisco. With their new citizenship status, these men could regularly return to China to claim citizenship for their children (mostly boys), who could then immigrate to the US. Some "paper son" certificates were even sold to strangers in China, allowing them to gain entry to the US.

As US officials became more aware of these practices, they carried out extensive interviews attempting to reveal these "paper sons." Elaborate "coaching books" were given to any would-be Chinese immigrant to study for these interviews, helping to corroborate stories put forth by the alleged US citizen waiting for his "paper son." Questions one had to answer included minute details of the immigrant's home and village as well as specific knowledge of their ancestors. This practice continued until the Chinese exclusion acts were repealed in 1943.

From 1910 to 1940, approximately 175,000 Chinese immigrants came through and were detained and interrogated at the US Immigration Station on Angel Island located off the coast of San Francisco. Officials detained immigrants for weeks, months, and sometimes years before admitting or rejecting them. Those who did not pass the scrutiny of the interrogations were deported back to China.

—Thanh Lieu

Coaching book used to prepare Chinese family members for stringent interviews by immigration officials upon arrival in the United States, ca. 1938.

Family History in a Lacquered Trunk

While the United States initially welcomed Asians and Pacific Islanders to drive down labor costs, nativists and racists used their growing political power to create federal bans on migration for decades, notably in 1875, 1882, 1917, 1924, and 1934. According to historian Sucheng Chan, despite restrictive immigration laws enacted between the 1870s and the 1940s, nearly a million people from Asia emigrated to the United States and to Hawai'i: 370,000 from China, 400,000 from Japan, 7,000 from Korea, 7,000 from India, and 180,000 from the Philippines.

Ng Shee Lee traveled from China to the United States in 1906, arriving in San Francisco sick and tired. In this trunk donated to the Smithsonian by family member Virginia Lee, Ng Shee had packed family belongings and clothes such as trousers, blouses, and slippers. Ng Shee continued her journey by rail across Canada before finally arriving in New York City, where she joined her husband, Lee B. Lok. While US laws prevented the Lees from becoming American citizens, they would eventually raise seven children who would later attend college and became educators, doctors, and business leaders.

Lee had arrived earlier in San Francisco, in 1881, from China's Guangdong Province. Lee made his way east to New York City where he founded the Quong Yuen Shing and Co. store in 1891, supplying the community with medicinal herbs, groceries, and clothing. Over the years, the store would become both hub and haven for Chinese Americans living in a formally segregated country. The 1882 Exclusion Act prevented the migration of Chinese laborers to the United States but granted exceptions to merchants like Lee. He returned to China and married Ng Shee sometime around 1900.

They made a home for themselves above the store, located at 32 Mott Street in the heart of New York City's Chinatown. Despite the store's long history, the economic downturn in the wake of the 9/11 attacks were too much for Quong Yuen Shing and Co. to survive. After 112 years of operation, the longest tenure of any store in NYC's Chinatown, it closed in 2003. Speaking to the *New York Times* about the historical significance of the shuttered business, John Kuo Wei Tchen, scholar and cofounder of the Museum of the Chinese in America, said, "The interior is one of the most important surviving historical sites as far as I am concerned in the whole city from the 19th century."

—Theodore S. Gonzalves

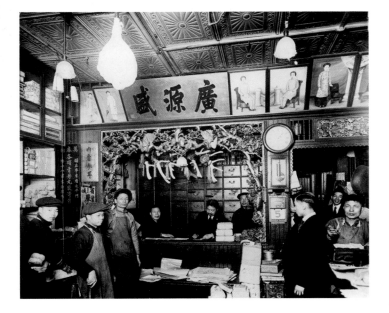

Left: Lee B. Lok at his store, Quong Yuen Shing and Co., ca. 1917. Right: Lacquered trunk used by Ng Shee Lee to pack family belongings for the journey from China to the United States, ca. 1906.

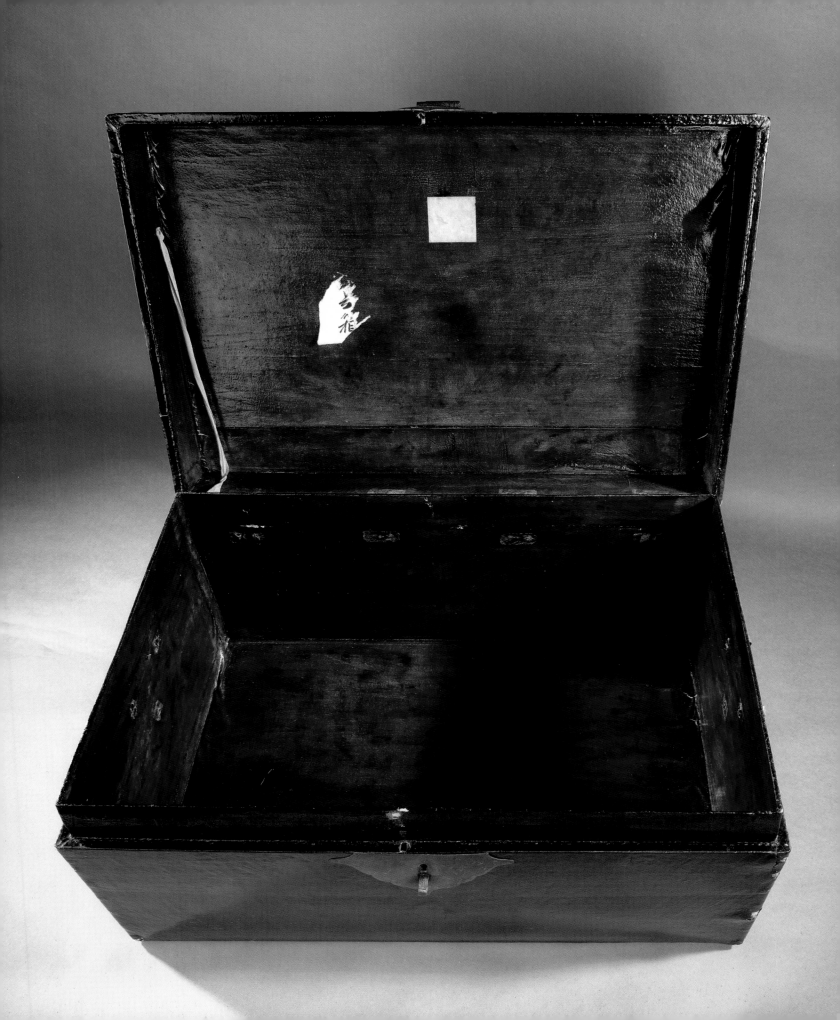

Filipino American Arts Exposition
and **Center for the Arts**
Yerba Buena Gardens

present

Teatro ng Tanan's

production of

peregriNasyon

A play about the enduring spirit of Filipinos
and their struggle for a place to call home.

Written and Directed by Chris B. Millado
Producer, Delia Batle
Associate Producer, Glades Perreras

Is America in the Heart?

Center for the Arts Forum
701 Mission Street at Third
San Francisco

August 18, 19 & 20 7:30 pm performance
August 25, 26 & 27 7:30 pm performance
August 21 & 28 2:00 pm Sunday Matinee performance
August 19, Gala 7:30 pm performance
with reception

Tickets
General admission $15
Students, seniors & disabled $12
Group rates (for 15 or more) $11
Gala Night $50, August 19

For Tickets and 24/hour Information call
Center for the Arts Box Office
(415) 978-ARTS

For Gala Tickets call

Sponsored by Nestlé Beverage Company with Leadership support for the Center for the Arts Education & Community Resource Program from Columbia Foundation, Gap Foundation, Richard & Rhoda Goldman Fund, Miriam & Peter Haas Fund, Walter & Elise Haas Fund, The Hearst Foundation, Inc. and additional inaugural support from AT&T, Fleishhacker Foundation, and Wells Fargo Bank.

Searching for the Heart of the Nation

In the early 1990s, Lucille Tenazas (b. 1953) was selected from a roster of Bay Area designers to create the logo for San Francisco's new Yerba Buena Center for the Arts (YBCA). YBCA opened to the public in 1993 and became the cultural anchor of the South of Market (SOMA) district, honoring the area's diverse cultural heritage. One of the projects to emerge from this design engagement was her poster design for Chris B. Millado's play, *peregriNasyon*, an adaptation of Carlos Bulosan's 1943 influential social history memoir, *America Is in the Heart*. The poster is in the collection of the Cooper Hewitt, Smithsonian Design Museum, which awarded Lucille Tenazas the National Design Award in Communication Design in 2002.

One of the top graphic designers in the United States, Tenazas was born in the Philippines and came to the US in 1979 to study at Cranbook Academy of Art, known for decades as an incubator of midcentury modernism and devoted exclusively to graduate education in art, architecture, craft, and design.

As an educator at the California College of Arts from 1985–2005, and as the Henry Wolf Professor of Communication Design at Parsons School of Design in New York since 2008, Tenazas's pedagogical approach reflects her interest in design work that explores the intersection of typography and linguistics. Text is not just "read" but "seen," building on her attention to form, and evolving into design work that simultaneously reflects poetic means of visual expression.

The earliest uses of the term, "peregrination," in the English language are chiefly theological: "The course of a person's life viewed originally as a temporary sojourn on earth and hence as a spiritual journey, especially to heaven."

Tenazas's design for the *peregriNasyon* poster incorporates a vintage photo, taken in the early twentieth century, of three Filipino men wearing stylish Western suits. Across the center is the play's title. The designer has intentionally split the word, "peregrination," combining it with the Tagalog rendering of "Nation," creating a hybrid and multilingual word. In an interview, Tenazas commented that the lettering used for the capital "N" was intentional, "not typeset, so that it reflected the gesture of the hand."

Other forms of coding and wordplay are evident in her choice to highlight the initial letters of the theater troupe that mounted the production, **T**eatro **ng T**anan (Theater for Everyone, a troupe founded in 1989 by Millado). "TNT" is a code word for undocumented persons in the Filipino American and overseas communities.

Tenazas grew up in Manila and learned English within a strict formal context. Like many who grew up in a household speaking Tagalog while learning a foreign language at school, she also spoke the many provincial dialects that her parents understood. From this multilingual experience, Tenazas developed a sensitivity to the role of language. By questioning the authority of language and the relativity of meaning, she adopted the widespread practice of challenging the colonizing influence of the English language and made it her own.

Tenazas's highlighting of a non-English word draws our attention to the multiple ways that Asian Americans have navigated from the periphery to the core of the American empire, precisely at a time when Filipinos were neither alien nor citizen but in the liminal legal space of "US National."

—Theodore S. Gonzalves

Poster for peregriNasyon: Is America in the Heart? *designed by Lucille Tenazas, 1994.*

This Way to Chinatown

Historic drawings and photographs allow us to see what an immigrant community looked like at various points in its history. The built environment depicted in a photograph can give us clues about cultural inheritance, innovation, and invention. San Francisco's Chinatown—the oldest Chinatown in North America—was devastated by an earthquake in 1906. Just before the earthquake, white city leaders had realized that the segregated neighborhood commanded some of the best views of the city and San Francisco Bay. After the earthquake they proposed relocating the Chinatown residents to the mudflats near the periphery of the city. But, according to historian Judy Yung, this was not acceptable to the Chinese Family Association or Chinese Counsel General who intended to rebuild the Chinese consulate in the heart of Chinatown. Ultimately their arguments prevailed.

Many of the new buildings were purposely designed to reflect an orientalized vision of Chinese culture, typical of what had been presented in various world's fairs. This innovation helped to draw in tourists and boost the neighborhood economy. Nevertheless, during the period of rebuilding, Chinatown continued to be a city within a city, where people moved in and through segregated places.

By the mid- to late-twentieth century, segregated Asian American communities in the United States witnessed the repeal of the exclusion laws in 1943, the rise of Mao in the late 1940s, and the return of Chinese Americans from service after World War II. During the 1950s, San Francisco's city leaders reshaped whole neighborhoods under the guise of urban renewal—most notoriously, displacing Black families and pushing Black businesses out of the Fillmore District, setting a template for contemporary gentrification. In response to this disturbing trend, Chinese American civic organizations advocated on behalf of local businesses to bolster the tourist trade, including projects to better highlight and enhance Chinatown's presence in the city.

One such project involved the construction of the Dragon Gate at the corner of Bush Street and Grant Avenue, the arch prominent in marking a southern entrance to San Francisco's Chinatown. Modeled on the pailou (ornamental gates) found in China, the concept of the dragon gate as a cultural marker for the built environment came into the American consciousness through presentations at various world's fairs, including the construction of the Chinese Theater at the 1893 World's Fair held in Chicago and similar structures in San Francisco's 1915 Panama-Pacific International Exposition.

The gateway to Chinatown was designed by the San Mateo-based architect Clayton Lee, with the assistance of landscapers Melvin H. Lee and Joseph Yee. Lee's design won out over nineteen other entries. Jurors who selected the proposal noted Lee's "fine sense of scale," which implied an "entrance into a village rather than into a shrine." The city of San Francisco budgeted the project at $70,000, and the Republic of China donated 120 ceramic tiles. The gate was dedicated in the fall of 1970. Premier Yen Chia-kan of the Republic of China attended the ribbon cutting, along with three thousand onlookers and about fifty who challenged the city's priorities with chants of "Housing for the People, not Moon Gates for Tourists."

Atop the center of the gate is a plaque with a quote from Sun Yat-sen, a founder of modern China: "All Under Heaven Is for the Good of the People." The lions on either side of the gate are placed to counter evil spirits.

—Theodore S. Gonzalves

Above: San Francisco's Dragon Gate when first erected, ca. 1970.
Below: The Dragon Gate in 2019.

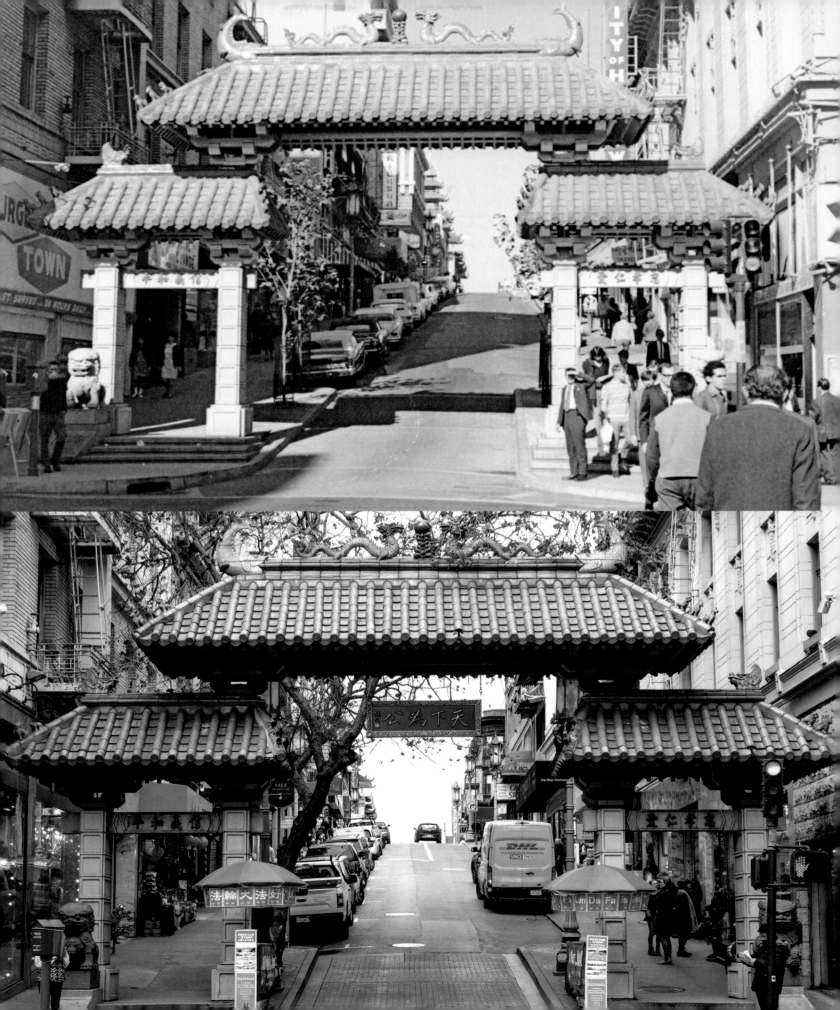

All One Family

Spare name tag for Ellison S. Onizuka, the first Asian American to be selected into the astronaut corps, ca. 1985.

Astronauts wear name tags attached to their clothing. A spare name tag belonging to astronaut Ellison Shoji Onizuka (1946–86) displayed his nickname, "El," identifying him as one of a very special group of people—Onizuka was a space shuttle astronaut.

Seeing the earth from space, Onizuka described a view that few of us get a chance to see. "It's a beautiful planet," he said. "It is the most beautiful sight you'll ever see, something that film just can't capture." From his seat on the *Discovery*, he could spot the Big Island, Hawai'i, the most easterly and youngest in the archipelago. As the first Asian American to navigate to the stars, perhaps he thought about his ancestors who made his own journey possible one hundred years earlier.

Onizuka's grandparents Kichihei and Wakano Onizuka left their village in Minou, Japan, in the late 1890s. They boarded a steamship bound for Hawai'i, eventually settling on the Big Island, where they harvested coffee on the windward side. His father, Masamitsu, worked in the coffee fields and drove a taxi; his mother, Mitsue, managed a store. Brought up in Keopu, Ellison was a devout Honpa Hongwanji Buddhist.

Graduating from Konawaena High School in 1964, Ellison relocated to the continent for college and graduate school, earning a bachelor's and master's degrees in aerospace engineering at the University of Colorado at Boulder by 1969. He married his college sweetheart, Lorna Leiko Yoshida, also a local Japanese American from the Big Island.

Onizuka put his academic training to work as a flight test engineer and test pilot for the US Air Force with postings at Sacramento's McClellan AFB and then Edwards in the Mojave Desert. The backdrop for his adventures in the skies involved a global race to even higher heights. The Soviet Union launched the first artificial satellite to earth's orbit in 1957.

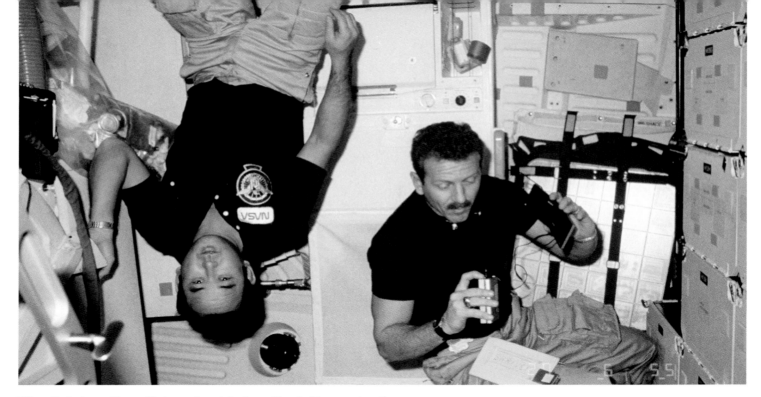

Ellison Onizuka and Loren Shriver onboard the Space Shuttle Discovery in 1985.

The Americans followed a year later with their Explorer 1. The Soviets made another leap by putting the first human into orbit in April of 1961. Again, the Americans followed with Alan Shepard's suborbital flight in *Freedom 7* a few months later.

Ellison's mother, Mitsue, said: "Ellison always had it in his mind to become an astronaut. But he was too embarrassed to tell anyone. When he was growing up, there were no Asian astronauts, no Black astronauts, just white ones. His dream seemed too big.'"

Nevertheless, in 1977 Onizuka applied to be an astronaut along with 8,100 candidates. He rose to the top as a finalist, eventually making it to the historic Class of 1978 known as NASA's "Thirty-Five New Guys," which included six women, three African Americans, and an Asian American for the first time.

For his first flight to space on January 24, 1985, Onizuka brought with him mementos from home: macadamia nuts, Kona coffee, patches from the 442nd Regimental Combat Team and the 100th Battalion (highly decorated Japanese American units from World War II that inspired him), and a Buddhist medallion given to him by his father. He and the crew logged seventy-four hours in space and completed forty-eight orbits before returning to Earth.

"I looked down as we passed over Hawai'i and thought about all the sacrifices of all the people who helped me along the way. My grandparents, who were contract laborers; my parents, who did without to send me to college; my schoolteachers, coaches, and ministers—all the past generations who pulled together to create the present. Different people,

different races, different religions—all working toward a common goal, all one family."

A year later, Ellison and the rest of the *Challenger* crew lost their lives in a tragic explosion on January 28, 1986, just seventy-three seconds after launch.

—Theodore S. Gonzalves

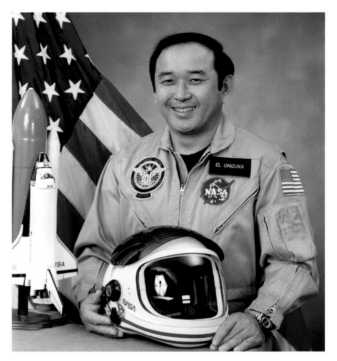

Ellison Onizuka's official NASA portrait.

WALKING TOUR OF SOUTH PHILLY REFUGEE COMMUNITIES

-WITH- CATZIE VILAYPHONH

(ILLUSTRATIONS BY ASHLEY KHAKEO)

BOK

FORMALLY A VOCATIONAL HIGH SCHOOL THAT SAT DORMANT UNTIL 2015. THE BUILDING CURRENTLY HOUSES ARTISTS, MAKERS, AND SMALL BUSINESS OWNERS AND A ROOFTOP BAR IN THE SUMMER. IN ADDITION TO STUDIOS AND OFFICES, BOK PROVIDES EVENT SPACES. YOU CAN FIND SOUTHEAST ASIAN SENIORS MEETING ON TUESDAY MORNINGS (HOSTED BY SEAMAAC). BOK IS ALSO THE HOME SPACE FOR MY ORGANIZATION LAOS IN THE HOUSE AND CAMBODIAN AMERICAN GIRLS EMPOWERING

SNYDER AVE.

IN THE SUMMER THERE'S A KHMER WOMAN WHO IS SAID TO HAVE THE BEST KROUENG MARINATED BEEF STICKS. SHE TAKES CASH ONLY & COOKS WHEN SHE FEELS LIKE IT. TO FIND HER YOU'LL HAVE TO FOLLOW THE SMELL OF SWEET BBQ (OR LOOK FOR SMOKE) AND A GATHERING OF PEOPLE WAITING WITH DOLLAR BILLS IN HAND.

BEEF STICK LADY

SOUTHEAST BY SOUTHEAST

A PROGRAM OF PHILLY'S MURAL ARTS PROGRAM AND THEREFORE RESPONSIBLE FOR THE WALLS AROUND HERE LOOKING SO VIBRANT. OKAY, MAYBE A LOT OF THAT IS THE WORK OF SHIRA WALINSKY, WHOM I'VE WORKED WITH WHEN I WAS AN ARTIST-IN-RESIDENT HERE. A NEIGHBORHOOD COMMUNITY SPACE THAT'S ALSO A CREATIVE FOR NEW IMMIGRANT AND REFUGEE FAMILIES (BURMESE, SHAN, CHIIN, KAREN, & CONGOLESE). IT SEEMS SMALL, BUT CITIZENSHIP CLASSES, SEWING SESSIONS, HOMEWORK HELP, AND ARTS WORKSHOPS ALL TAKE PLACE HERE AND THERE'S EVEN A GARDEN IN THE BACK!

LAO FAMILY COMMUNITY ORGANIZATION OF PHILADELPHIA

ONCE A THRIVING CENTER KNOWN SIMPLY AS "SUMMAKOHM", MEMBERS HELD NEIGHBORHOOD MEETINGS HERE, HOSTED HEALTH FAIRS FOR FLU SHOTS, AND KIDS LEARNED THE LAO ALPHABET. SADLY, THE DOORS TO LFCOP HAVEN'T BEEN OPENED IN A LONG TIME AND COMMUNITY EVENTS ARE HELD AT EITHER OF TWO WAT LAO BUDDHIST TEMPLES.

HENG SENG RESTAURANT

WHEN THEY FIRST OPENED IN THE 90's HENG SENG DIDN'T HAVE MENUS. AS NEIGHBORS BECAME FAMILIAR WITH SIMILARITIES IN LANGUAGE AND CUISINE, IT WAS EASY TO PICK UP THE LAO/KHMER/VIET WORDS FOR NOODLE SOUP, RICE SOUP, AND STIR-FRIED NOODLES AND THAT WAS ALL YOU NEED TO KNOW.

↓ EAK MENG GROCERY

SEAMAAC

LOS GALLOS

CHAI HONG MARKET

S 9TH

I ♥ CAMBODIA

THIS PARK WAS A NATURAL ATTRACTION FOR SOUTHEAST ASIAN IMMIGRANTS WHO COME FROM TROPICAL CLIMATES WITH PLANTS EVERYWHERE. AT ONE POINT, THE PARK WAS WELL KNOWN AS AN OPEN MARKET SELLING GRILLED BBQ, PAPAYA SALADS, AND PRODUCE. THE OPEN FIELDS OF GRASS PROVIDED A PERFECT SPACE TO PLAY VOLLEYBALL AND KATAW- SO MUCH THAT SOME OF THE GOAL NETS ARE PERMANENTLY INSTALLED IN THE GROUND.

FRANCIS SCOTT KEY SCHOOL

SAM'S DISCOUNT

No. 1 SUPER MARKET

KOH KONG GROCERY

★ FRUIT STAR

KHAMLA

ONE OF THE REMAINING LAOTIAN GROCERY STORES STILL STANDING SINCE THE 80's RUN BY HUSBAND AND WIFE KHAMLA AND KAY. SELLING READY-TO-EAT DISHES LIKE LAAP, MUM, MOK AND KHAOPOON, IN THE SUMMER KAY CAN BE SEEN OUT FRONT GRILLING MEAT STICKS AND MAKING FRESH PAPAYA SALAD. MORE THAN A PLACE FOR GROCERIES, KHAMLA HAS REMAINED A DESTINATION FOR OLDER GENERATION LAO LIKE MY PARENTS - IT'S NOT UNFAMILIAR TO WITNESS LONG-TIME FRIENDS REUNITED AT THE REGISTER. THE OWNERS HAVE BEEN CONTEMPLATING RETIREMENT SO AS OF THIS PUBLICATION MIGHT BE LIVING IN LAOS.

NEW PHNOM PENH RESTAURANT?

HANG OUT SPOT

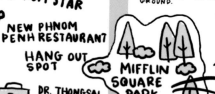

DR. THONGSAI VORASINGHA'S OLD OFFICE

MIFFLIN SQUARE PARK

S 6TH

APSARA LAUNDRY MAT

ONE OF THE FIRST BUSINESSES OWNED BY A SOUTHEAST ASIAN WOMAN ON THIS STRIP. SENGTHONG STILL CUTS HAIR BUT ONLY IN SPRING & SUMMER (SHE RETIRES TO FLORIDA EVERY WINTER). HER SHOP IS RUN BY HER DAUGHTER AND GRANDSON, BUT LOYAL CUSTOMERS STILL WAIT FOR SENG'S RETURN TO SCHEDULE THEIR HAIR APPOINTMENTS.

PREAH BUDDHA RANGSEY TEMPLE

THIS CAMBODIAN TEMPLE IS FAIRLY NEW. THE BUILDING ACROSS THE STREET WAS ACTUALLY THE OLD TEMPLE, BUT THIS LOCATION HAS THE COURTYARD AND OF COURSE THE GUILDED WALLS WHICH I LOVE LOOKING AT WHENEVER I TURN THIS CORNER. I REMEMBER OVER THE COURSE OF IT GETTING FIXED UP, WATCHING THE MONKS DO ALL THE WORK HAND-PAINTING ALL THE DETAILS. THERE WAS NEVER A GUY IN WORK UNIFORM OR A HARD HAT, JUST A COUPLE OF MONKS WITH PAINT BRUSHES.

TAGGART JOHN H SCHOOL

MAY TAG LAUNDRY

Connecting Communities

To date there is no institution devoted to refugee poetry anywhere in the world. The pop-up Center for Refugee Poetics (CfRP) imagines one into being, a single day at a time. Launched by the Smithsonian Asian Pacific American Center in May 2018, hosted again in 2020 and 2024, CfRP is a mobile literary arts and education project that nurtures refugee artmaking and memory through performances, workshops, mentoring, and reading groups. It is a center with no permanent home, a mock institution that critiques institutions and their roles in perennially recreating the global refugee condition. CfRP's inaugural program: a morning walking tour of South Philadelphia refugee neighborhoods.

Led by local poet Catzie Vilayphonh, the tour intended to anchor the center in the area's Southeast Asian refugee communities, predominantly Laotian, Khmer, Vietnamese, and Hmong, as well as more recently arrived refugee and immigrant Karen, Bhutanese, and Rohingya populations. A mix of resettlement histories and poetry, the tour meant to embody the dynamic interworkings of community and artmaking—how poetry comes out of, documents, responds to, and grows communities.

An intimate venture, cocreated with neighborhood organizations and small businesses, it operated not for a general gaze but a small cohort of visiting refugee poets and scholars—Ocean Vuong, Cathy Linh Che, Cathy J. Schlund-Vials, Lan Duong, and Monica Sok—giving the group the chance to learn about local refugee histories and forge new cross-diaspora and cross-community connections. It was an incubator for the futures of refugee artmaking, scholarship, and organizing.

This map, created by Catzie Vilayphonh and artist Ashley Khakeo in consultation with South Philly refugee communities, was first published in *Verge: Studies in Global Asias 6*, no. 1 (Spring 2020) and is a lasting record of the walking tour. It is a version of the tour that welcomes visitors into South Philly refugee neighborhoods on the neighborhoods' own terms: a story in map form told by refugee communities, rather than imposed upon them. As such it is also a fitting index of CfRP's larger project, a sustained, community-generated exploration of what refugee artmaking can make visible and possible.

—Lawrence-Minh Bùi Davis

Walking map of South Philadelphia refugee communities created for a small group of refugee poets and scholars by Catzie Vilayphonh and Ashley Khakeo, 2020.

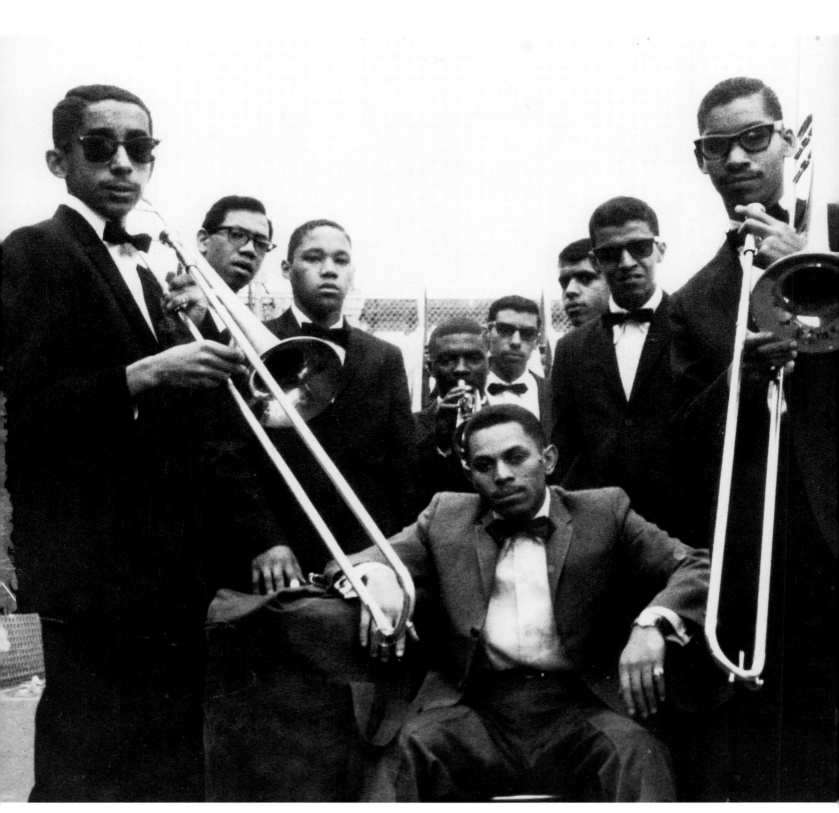

Above: Photograph of Joe Bataan (seated) with his band (pg. 40). Right: China poblana (pg. 34).

CHAPTER TWO
Intersections

For centuries, persons from Asia and Oceania have been part of massive flows to the Americas as laborers, merchants, and students. Think of workers—18,000 from China and 500,000 from India—sent to Latin America and the Caribbean in the years after the trade of enslaved persons from Africa was made illegal, or sailors based in Manila who served on ships' crews during a galleon trade that spanned the globe from the sixteenth to the nineteenth centuries. These were just preludes to travels that brought Asian Americans and Pacific Islanders into crowded global intersections, allowing many to take root along complicated routes.

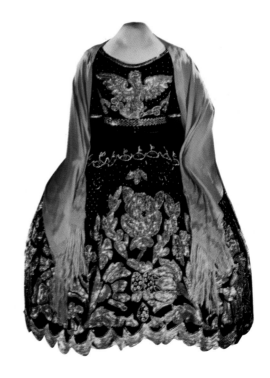

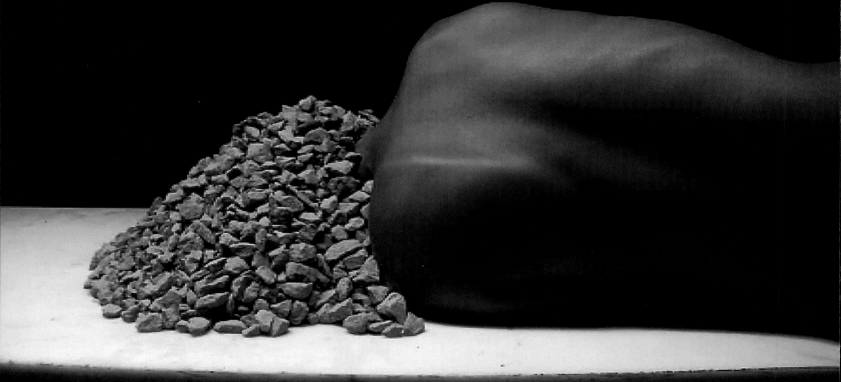

A Lesson in Stillness

We invented film to capture movement. Before the late nineteenth century, motion had to be witnessed in-person: a photo could only depict a single instant. Yet the film *My Dreams, My Works Must Wait Till After Hell* (2011) is a reminder that stillness, too, is an action.

The film begins with the view of a nude, dark-skinned woman from the torso up; she is lying on her side with her back turned toward us, atop a white marble slab. But where we would expect a head, we instead encounter a heap of coarse gray pebbles piled over her head. She lies so quietly, she could be mistaken for a photograph, if it weren't for the subtle expanding and contracting of her ribs and the sound of her steady breathing alongside music from a Japanese wind instrument soundtracked by Kaoru Watanabe. The scene described is the entirety of what continues for all seven minutes and fourteen seconds of the artwork. It ends exactly where it begins. When viewed in a gallery, *My Dreams* plays in a seamless and continuous loop.

The work's title comes from a poem by Gwendolyn Brooks, which contains the line, "No man can give me any word but Wait." Like Brooks, the works of Simone Leigh (b. 1967) and Chitra Ganesh (b. 1975) who came together as the duo Girl to create *My Dreams*, reveal how women of color are often underrecognized and misunderstood against the weight of assumptions. By taking on the name "Girl," Leigh and Ganesh show that what may seem like a simple notion of identity in fact possesses deep complexities. *My Dreams* holds such complexities—the hardness of stone against the tenderness of human flesh. Stillness is both death and recovery.

Writing about bringing *My Dreams* to the Smithsonian American Art Museum, curator Saisha Grayson recalls how the artists chose to be identified in the label text as "queer women of color," as a response to the historical art tradition "that had allowed no space for artists, subjects, or viewers like them." Yet in possession of this space, Girl remains defiant. Through moving images, they depict complete stillness. As a piece of time-based media, *My Dreams* takes its sweet time. The artwork, like its artists, transcends categories.

—Adriel Luis

Still from My Dreams, My Works Must Wait Till After Hell, *Girl (Simone Leigh and Chitra Ganesh), 2011.*

A Dancer's Stance

Choreographers write with the body. For Dana Tai Soon Burgess (b. 1968), that has involved a lifetime of exploring the freedoms and limits of Asian American personhood. Burgess grew up in Santa Fe, New Mexico, with ever-present Latino and Indigenous cultural references. It was an upbringing that involved puzzling through what it meant to be an Other: a Korean American kid in the Southwest during the 1970s and early 1980s.

Burgess trained in martial arts for a decade, starting at the age of seven. At sixteen, he began to train in dance, tasking his body with a related discipline. Burgess studied dance and Asian history at the University of New Mexico and danced for Tim Wengerd, the former soloist of the Martha Graham Company. Burgess headed east to dance professionally in Washington, DC, where he trained with notable dancers, and established his own company in 1992. He is one of the few individuals who studied the technique and works of Michio Itō—known as the first Asian American choreographer (1892–1961)—directly from former Itō dancers and protégés.

Burgess's parents were visual artists, giving him an early foundation for how to think about the confluence of art and dance. Future professional collaborations with lighting designer Jennifer Tipton, the Kennedy Center, and multiple museums brought more opportunities to hone and showcase his craft.

For more than twenty-five years, Burgess's company has toured the globe under the auspices of the US State Department. In 2016, Burgess became the inaugural choreographer in residence at the Smithsonian National Portrait Gallery. As with other choreographers, Burgess expresses the development of his work in ways similar to other writers/artists: "I go into the studio and I start working on phrases with the dancers. The phrases become sentences and then chapters in a book." Burgess' work as a cultural figure also includes hosting the *Slant Podcast,* which focuses on conversations with AAPI artists.

Burgess' portrait was taken by Korean American Miami-based artist CYJO, for her project, *KYOPO* (2004–09). As an American of Korean ancestry who grew up in the DC metropolitan area and lived in New York City, Florence, and Beijing, CYJO pushes viewers to think through the concept of life in the diaspora—being a member of a larger group, whether that's a community, nation, ethnicity, or a people. While individuals in the diaspora relate or interact with that larger body in any number of ways, others reject parts of it altogether. *KYOPO* is a "story about the evolution of identity and culture," featuring more than two hundred photographic profiles of persons of Korean ethnicity.

CYJO describes the project in the following way: "The individuals are posed frontally, their eyes returning the camera's and the viewer's gaze, against the static backdrop of my studio with a deliberate falsification of scale. Thus, each person connects with and mirrors the others compositionally. This uniformity of composition along with their shared narratives bring forth the inevitable—a uniqueness of each individual as well as their connections to communities that go beyond the borders of assumed categorizations."

Each of CYJO's participants in the project, like Burgess, stands out. They are unique, self-contained, complete, and sovereign. The sum also has its own character: not simply uniform, but a complex and diverse whole.

—Theodore S. Gonzalves

Photograph of choreographer Dana Tai Soon Burgess by CYJO, for the KYOPO project, 2004–09.

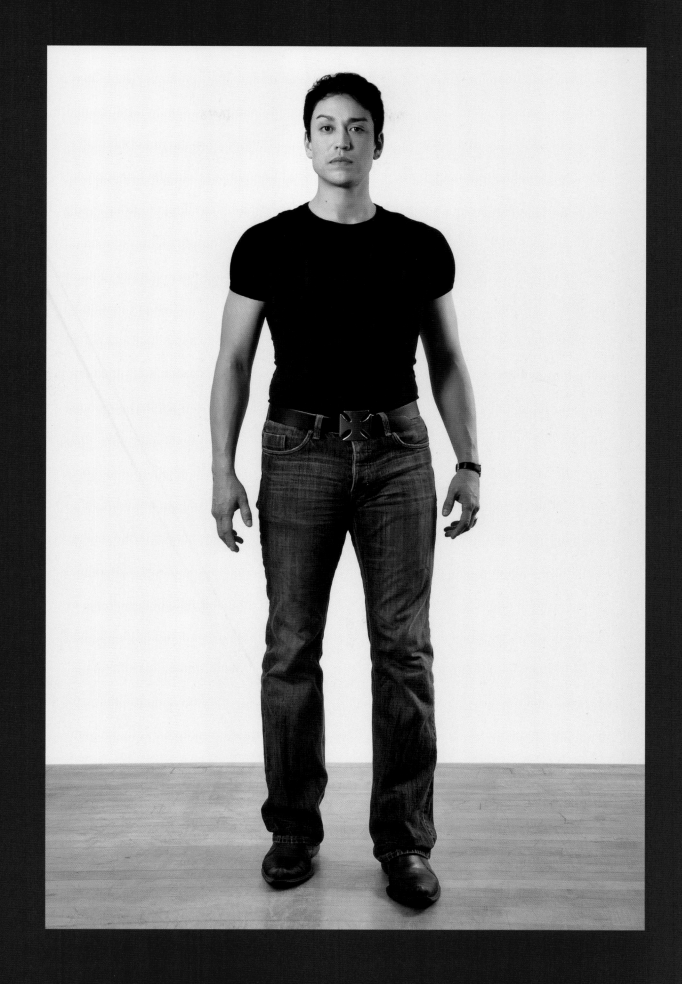

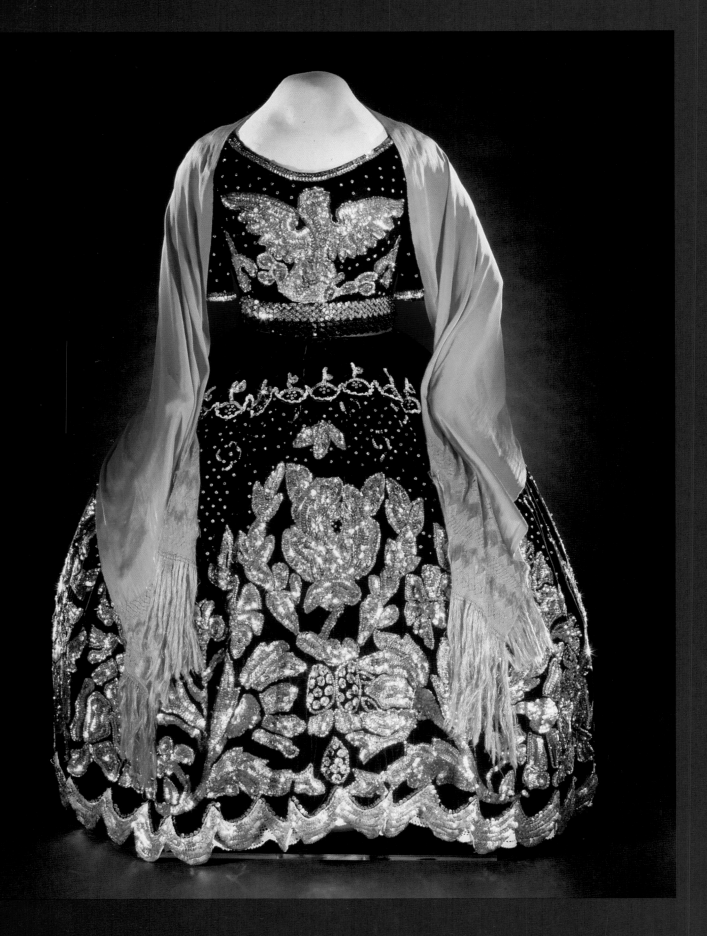

A Journeyed Costume

The china poblana is a style of traditional Mexican dress for women that has become synonymous with not only the region's musical and dance culture, but also a symbol of the nation. This dress was worn by Rosita Fernandez (1918–2006), known popularly as "San Antonio's First Lady of Song." With a career that spanned nearly six decades, Fernandez pioneered the recording of Tejano corridos and ballads.

While Fernandez often wore the style in performance, the dress also has its own unique history that goes back centuries and intersects with the journeys of Asian women traveling to the Americas as early as the 1600s. One such person was Catarina de San Juan.

From 1565 to 1812, the world was formally connected through a massive enterprise known as the Manila galleon trade, linking Asia, the Americas, and Europe. Historian David Irving looks to the Manila of 1571, when the city became an open port, as globalization's birthdate: "We might view it as a kind of buckle on a belt whose fastening presaged an unprecedented acceleration in global flows and exchanges of commodities and cultural practices."

Among commodities such as sugar, silver, copra, and ceramics, we can also consider the troubling histories of trafficked women and girls as part of this globalization. A handful of seventeenth-century biographies tell the story of a young girl named Mirra, likely born in Mughal India's Agra to a wealthy Muslim family. Perhaps as early as nine years old, Mirra moved with her family to the coastal city of Surat where she was captured by Portuguese slavers. From there, the girl was taken to Cochin (now Kochi) where Jesuit missionaries baptized her as Catarina de San Juan. Her journey continued to the slave markets of Manila, where she would eventually board a nao de China (a Manila galleon) bound for Acapulco. Iberian slavers and merchants loosely gathered several peoples under the category of "chino." They could be slaves from India, anyone from Asia, or simply passengers on the nao de China. The girl eventually known as Catarina de San Juan traveled to Mexico City and then finally to Pueblo to work as a domestic.

It was rare for any woman of the seventeenth century to have a biography written about them. But Catarina's conversion to Christianity—understood as a survival tactic for a young woman trafficked across the world—earned her admiration. She worked for not only her own freedom but those of other young women. It is said that Catarina wore native saris that she eventually adapted to the Mexican style of dress. A direct connection between Catarina and the china poblana hasn't been conclusively made. Yet, through this style of clothing, stories of the links between Asia, Europe, and the Americas—and the slave trade that brought Asian women like Catarina de San Juan to Mexico—remain in the collective memory of Mexicans. Historian Tatiana Seijas notes that "residents of Puebla continue to talk about Catarina in relation to the colorful costume."

—Theodore S. Gonzalves

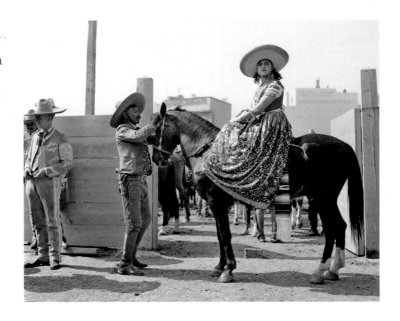

Left: China poblana dress, a style closely identified with Catarina de San Juan, originally an enslaved girl from India who traveled to the Americas, worn by Rosita Fernandez, ca. 1960s. Right: Woman wearing a traditional china poblana, ca. 1930.

Light as Salvation

samu Noguchi's *Lunar Landscape* is part of a small series of sculptures that the internationally celebrated artist created as early as 1943. In a 1972 note to the Hirshhorn Museum, Noguchi (1904–1988) explained that the context for the object was the time he spent in an American concentration camp during World War II: "The memory of Arizona was like that of the moon, a moonscape of the mind. . . . Not given the actual space of freedom, one makes its equivalent—an illusion within the confines of a room or a box—where the imagination may roam to the further limits of possibilities, to the moon and beyond."

Noguchi lived in the Poston camp, situated on the site of the Colorado River Indian Reservation over the objections of council leaders. Of all the stories of life in camp for Japanese and Japanese Americans, ranging from boredom to resistance, Noguchi's story is unique for the fact that he *volunteered* to be interned.

Born in 1904 in Los Angeles to American writer Léonie Gilmour and Japanese poet and critic Yone Noguchi, Isamu lived in Japan between the ages of two and fourteen. Traveling to Paris on a Guggenheim fellowship in 1927, he returned two years later to New York City. The December 7, 1941, military attacks on Pearl Harbor and Manila by the Japanese military amplified anti-Japanese sentiment that had been evident for decades.

Noguchi helped to organize the Nisei Writers and Artists for Democracy with the aim to counter the hatemongering in the press and popular culture. He reflected on his own mixed-race background when he wrote about Japanese Americans and Japanese in the United States: "The racial and cultural intermix is the antithesis of . . . the Axis Powers. For us to fall into the Fascist line of race bigotry is to defeat our unique personality and strength."

The defense that Noguchi and others mounted wasn't enough to stave off political and popular pressure. On February 19, 1942, President Franklin D. Roosevelt signed Executive Order 9066, calling for all persons of Japanese ancestry to be physically removed from the majority of the western states and concentrated into ten camps. Because

Noguchi was a resident of New York, he was exempt from the order.

Noguchi felt compelled to act: "I was not just American, but Nisei" (second generation Japanese American). He made arrangements to use his skills in art and design and was given permission to enter the Poston camp in May of 1942. He created detailed plans for

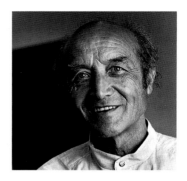

Isamu Noguchi photographed by Mimi Jacobs, 1973.

adobe buildings to be created, including a school with a play area, natatorium, gymnasium, store, hospital, gardens, and more.

Upon arrival, it only took two weeks for Noguchi to realize how difficult it would be to create and sustain community. "This is the weirdest, most unreal situation . . . nothing is of any consequence," he wrote to artist Man Ray.

His relationship to government and military officials soured. To artist George Biddle he wrote: "I came voluntarily, and find myself in as strange a situation as exists, or could exist in a democracy. . . . Maybe [the government thinks] that race hatred is good for the war spirit." His relationship with his fellow Japanese residents also left him alienated. In his late thirties, he was older than the younger Nisei and felt culturally closer to the first-generation Issei.

Lunar Landscape demonstrates the complicated tangle of memory, identity, and imagination during wartime. Noguchi recalled the sculpture later in his life: "While I was living my dark prison-like life at the relocation camp at Poston, I had a never-ending yearning for a brighter world. It was from then that I thought about making a sculpture that had a controllable light. I thought that I wanted to free the dark world with akari [light]. . . . I thought of a luminous object as a source of delight in itself—like fire it attracts and protects us from the beasts of the night."

—Theodore S. Gonzalves

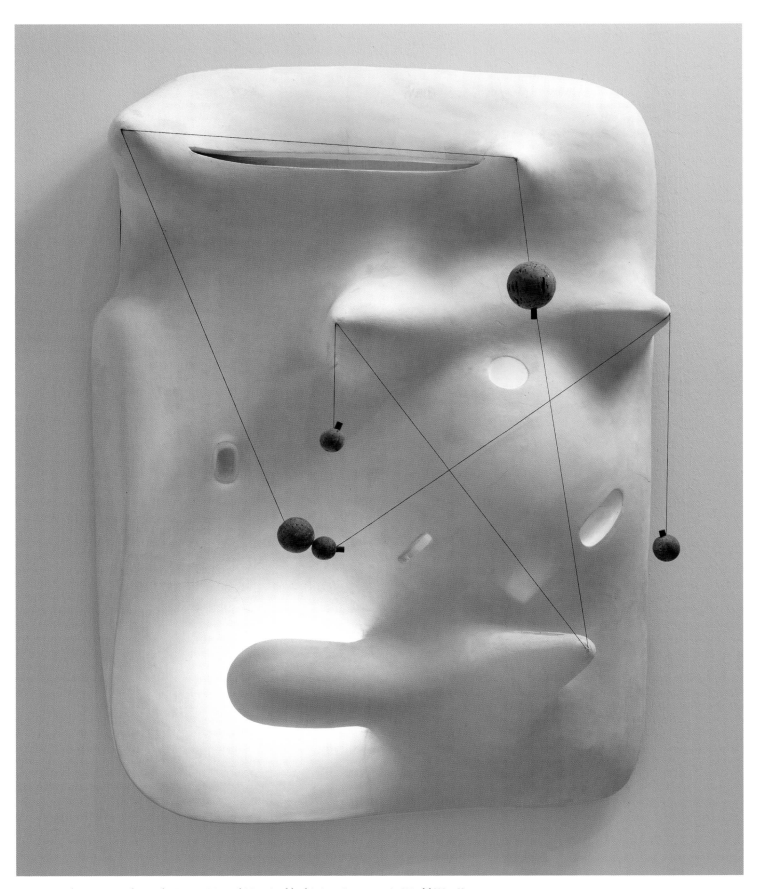

Lunar Landscape, *a sculpture by Isamu Noguchi inspired by his imprisonment in World War II, 1942–43.*

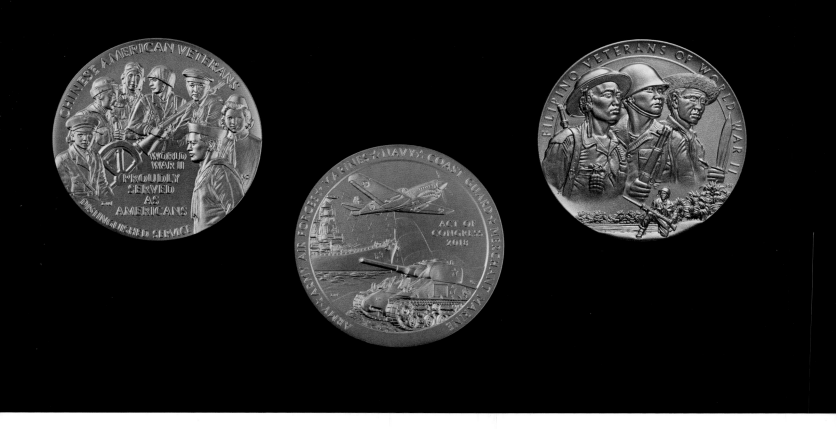

Fighting for the Nation

The Congressional Gold Medal is the highest civilian award given by the US Congress. It is awarded to persons, institutions, or groups who have made a major and long-standing impact on American history and culture. The United States Mint designs each medal that is awarded in cooperation with representatives of the awardees. Therefore, each medal has a unique appearance. Only one medal is struck. Congress directed the Smithsonian Institution to collect and display these three medals.

The Nisei Soldiers of World War II medal, awarded in 2010, recognizes the service of three units—the US Army's 100th Infantry Battalion, the 442nd Regimental Combat Team (RCT), and the Military Intelligence Service (MIS). The front features Nisei soldiers from both European and Pacific Theaters. "Go For Broke" references the 442nd RCT's motto, which eventually became associated with the other units as

well. The reverse of the medal depicts unit insignias—a Torch of Liberty shoulder patch representing the 442nd RCT; a sphinx, a traditional symbol of secrecy, for the MIS; and symbols relating to Hawai'i (a taro leaf and a Native Hawaiian helmet), pointing to the service of Japanese locals from the islands who served alongside those on the continent.

Eighteen thousand Nisei served in the military, cementing their units' reputations as some of the most decorated in United States history, with 3,600 Purple Hearts, 350 Silver Stars, 810 Bronze Stars, 47 Distinguished Crosses, and one Congressional Medal of Honor. Their storied career included the rescue of a Texas battalion pinned down by German forces in France, as well as the liberation of Jewish prisoners at Dachau.

While Nisei soldiers served in the war effort, 315 Japanese Americans challenged the military's ability to draft persons

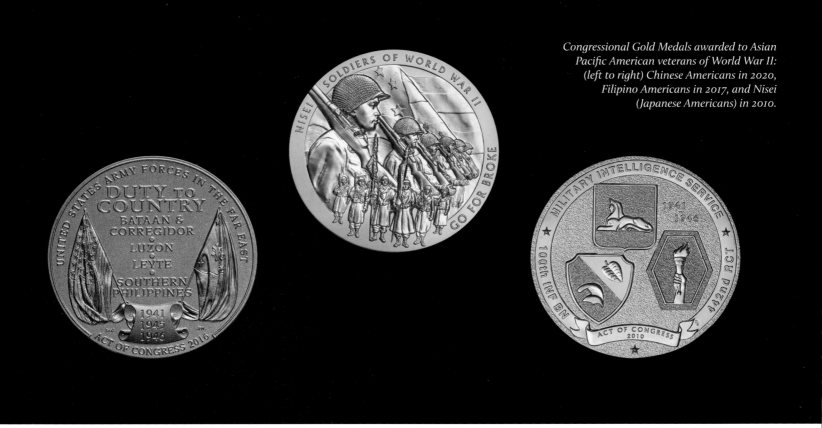

who had been denied due process. The draft resisters of the Heart Mountain Fair Play Committee argued that mass incarceration had violated their civil rights. Pardoned by President Truman in 1947, the story of Nisei draft resisters has continued to win admiration in their own fight for the preservation of democratic ideals during wartime.

The Filipino Veterans of World War II medal, awarded in 2017, recognizes the service of several thousand Filipino and Filipino American veterans serving in a variety of units. The medal depicts a Filipino scout, a Filipino infantry regiment officer, and a guerrilla soldier. In the foreground is an infantryman on guard. All were part of units that comprised major combat forces of the United States Army Forces in the Far East (USAFFE) from July 26, 1941, to December 31, 1946. The reverse of the medal highlights major campaigns of Bataan, Corregidor, Luzon, Leyte, and the Southern Philippines.

The opportunity for Filipino Americans to serve was initially blocked due to a 1934 US law that changed their status from "United States nationals" to aliens. President Franklin D. Roosevelt signed a law to permit their service. In 1942, the 1st Filipino Infantry Regiment and 2nd Filipino Infantry Regiment were formed in California. Sixteen thousand men registered for service, with 7,000 Filipinos filling out the ranks of the two newly formed regiments. Over 200,000 Filipinos in the Philippines participated in the defense of the archipelago against the Japanese military. At the conclusion

of World War II, the United States Congress passed the 1946 Rescission Act, justified by its authors as a cost-saving measure. The bill stripped Philippine soldiers of their military benefits, launching a seventy-five-year fight for veterans to seek their benefits from the United States government.

The Chinese American Veterans of World War II medal, awarded in 2020, recognizes the military service of the 12,000 to 15,000 Chinese Americans who served in every branch of the United States military. The front of the medal depicts servicemen and a nurse. The reverse features an Iowa-class battleship, an M4 Sherman tank, and a P-40 Warhawk from the Flying Tigers showcased in front of a World War II-era American flag.

Japan's invasion of China in 1937 had a profound impact on the public's perception of Chinese in the United States. For a group initially welcomed only for its labor and later targeted by nativists for exclusion—famously resulting in the 1875 Page Law and the 1882 Chinese Exclusion Act—Chinese Americans slowly found more favorable attitudes among the general population. As Americans of all backgrounds recycled anti-Japanese attitudes, many Chinese Americans participated in the national call to military service as an expression of patriotism. As veteran Harold Lui recalled, "All of a sudden we [Chinese Americans] became part of an American Dream."

—Cedric Yeh

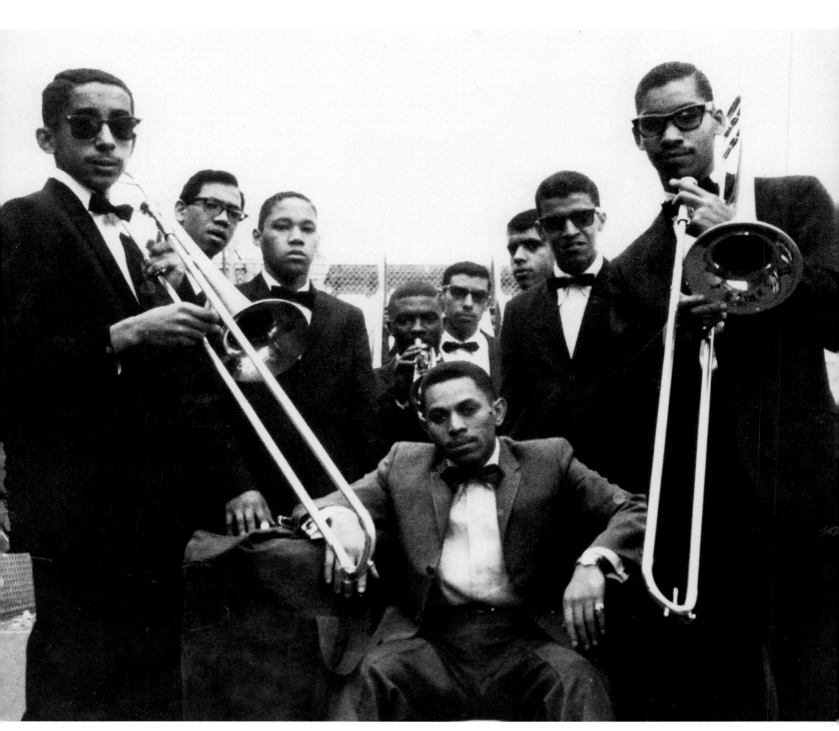

Pioneer of Latin boogaloo Joe Bataan (seated) with his band the Latin Swingers, 1965.

An Ordinary Guy Remaking American Music

The band leader seated in the middle like a general is just twenty-two years old, a gang veteran who had served time. The musicians surrounding him like uniformed and disciplined professionals are still teenagers. This photograph preserves Joe Bataan and the Latin Swingers early in their careers.

Joe Bataan (b. 1942) is considered the originator of Latin soul (Latin-influenced Soul music). He popularized *Latin boogaloo*, taking the danceable rhythms of Cuba and Puerto Rico and combining them with R&B which, throughout the 1960s–70s, expressed growing awareness and pride in Black culture and identity.

Andy González (1951–2020), one of the most revered Latin jazz bass players of the twentieth century, once said, "Joe Bataan sings for real. If you want to know what's going on in the streets of New York, just listen to Joe Bataan's songs." His lyrics reflected the truth of his life—but his name did not. Joe Bataan was born Bataan Nitollano in Spanish Harlem to a Filipino father and an African American mother. Bataan put his origin story in the track "Young, Gifted, and Brown," changing the frequently heard lyrics from Nina Simone's song, "To Be Young, Gifted, and Black," to reflect his mixed-heritage "Afro-Filipino" culture and brown skin.

Having grown up in a working-class immigrant neighborhood, Bataan connected with audiences when he began to write what he was seeing and experiencing in his own life. For example, he focused on details such as holes in the shoes of a young girl in "Unwed Mother," or took on the role of a pleading lover of modest means in "If I Were a King." His songs were about the have nots and their boundless dreams.

People from all walks of life could find themselves in his music. On his 1980 track, "Mestizo," Bataan cast his lyrical net far and wide, honoring the diversity of cultures represented in Spanish Harlem: "Mestizos throughout the earth / Stand proud about your birth / Join hands across the seas / Build a bridge for you and me / Latino, Taino, Chicano, Cubano, Dominicano, Argentino, Colombiano, Moreno, Cubano, Latino, Venezuela, Nicaragua, Porto Rico." It was not just a message for Latinos; mestizos of the Philippine diaspora could easily make sense of the call.

Spurred by fans of the music and the 2015 documentary *We Like It Like That*, Latin boogaloo has enjoyed a revival. Now a revered elder of the Spanish Harlem music scene, Bataan and his bandmembers still tour and perform for enthusiastic audiences. The polyrhythmic energy of his music continues to speak the truth of his experience to the people.

—Theodore S. Gonzalves

Ambassador of Hawaiian Culture

The 'ukulele is globally recognized from Tokyo to Tulsa, from Bellingham to Brisbane. While the instrument is indelibly linked to Hawai'i and Hawaiian culture, the 'ukulele's origins can be traced to an island in the Atlantic, some eight thousand miles away.

The 'ukulele is based on the machete, a popular Portuguese folk music instrument. It is a four-stringed treble guitar that is often played with violin and larger guitars at parties and festivals. Like other members of global diasporas, Portuguese workers who felt the sting of economic hardships at home were recruited for work elsewhere, which in the 1870s included Brazil, Guyana, South Africa, and Hawai'i.

The story of Madeiran labor migration to Hawai'i began in 1878, with the arrival of 123 workers contracted for plantation work. The following year, another 420 arrived via the British ship, *Ravenscrag*. Three of those persons helped to shape the course of music not only for Hawai'i but for the globe: Augusto Dias (1842–1915), Manuel Nunes (1843–1922), and Jose do Espirito Santo (1850–1905). Skilled as cabinetmakers and contracted to perform agricultural work, they all eventually became luthiers based in Honolulu. From their Chinatown-area shops, they advertised a repertoire of guitars of all

'Ukulele made by the C. F. Martin Company of Nazareth, Pennsylvania, ca. 1900–25.

sizes, and the instruments became a hit, quickly adopted by non-Portuguese locals. The ʻukulele's earliest appearance in print was in 1886, when it was referred to as a taro patch fiddle or taro patch. Santo's business card identified the instruments as pila liʻiliʻi (little fiddle). It didn't take long for a proper name to take hold—the term ʻukulele first appeared in print in 1890. Ernest Kaʻai, a musician, presenter, and entrepreneur who helped to popularize the ʻukulele, explained the instrument's name came from the commonly understood term for a jumping flea: "The Hawaiians have a way of playing over all the strings at the same time, strumming and skipping their fingers from one side of the instrument to the other."

The Madeiran luthiers used Hawaiian hardwoods—koa—the same material used for fine furniture, tying the instrument directly to the landscape.

Studio photography and postcards featuring the ʻukulele with dancers anchored idyllic images of the islands with these small instruments. Closely associated with Hawaiʻi and Hawaiians—ʻukulele appeared everywhere from work breaks and family gatherings to special events where royal families were feted by foreign dignitaries. King Kalākaua (reign 1874–91), known for reviving native Hawaiian cultural practices of dance and music—incorporated the use of the ʻukulele in official presentations and repertoires.

By this time, the ʻukulele had crossed over the Pacific back to the United States as images of Hawaiʻi circulated in the years after the American overthrow of the sovereign kingdom and performances of Hawaiian culture were featured on lecture circuits and other events. A year after Queen Liliʻuokalani was imprisoned in Iolani Palace, the ʻukulele made its debut at the 1894 world's fair in San Francisco.

All this activity kept ʻukulele makers busy. By 1915, production ramped up considerably to keep up with demand. In that year, the ʻukulele's appearance at the San Francisco world's fair, where visitors could see and hear the virtuosity of Henry Kailimai and the Hawaiian Quintet, drove demand for the instrument and Hawaiian music.

Despite the instrument's popularity in American culture as a kitschy symbol of island life played for laughs by the likes of Tiny Tim, the ʻukulele has continued to play a role in reasserting Hawaiian cultural values as heard in key recordings by the Sunday Manoa's Guava Jam (1969), Israel Kamakowiwoʻole's versions of "Somewhere Over the Rainbow/What a Wonderful World" (1990) or "Hawaiʻi '78," or any of the soulful singing and songwriting of Paula Fuga.

—Theodore S. Gonzalves

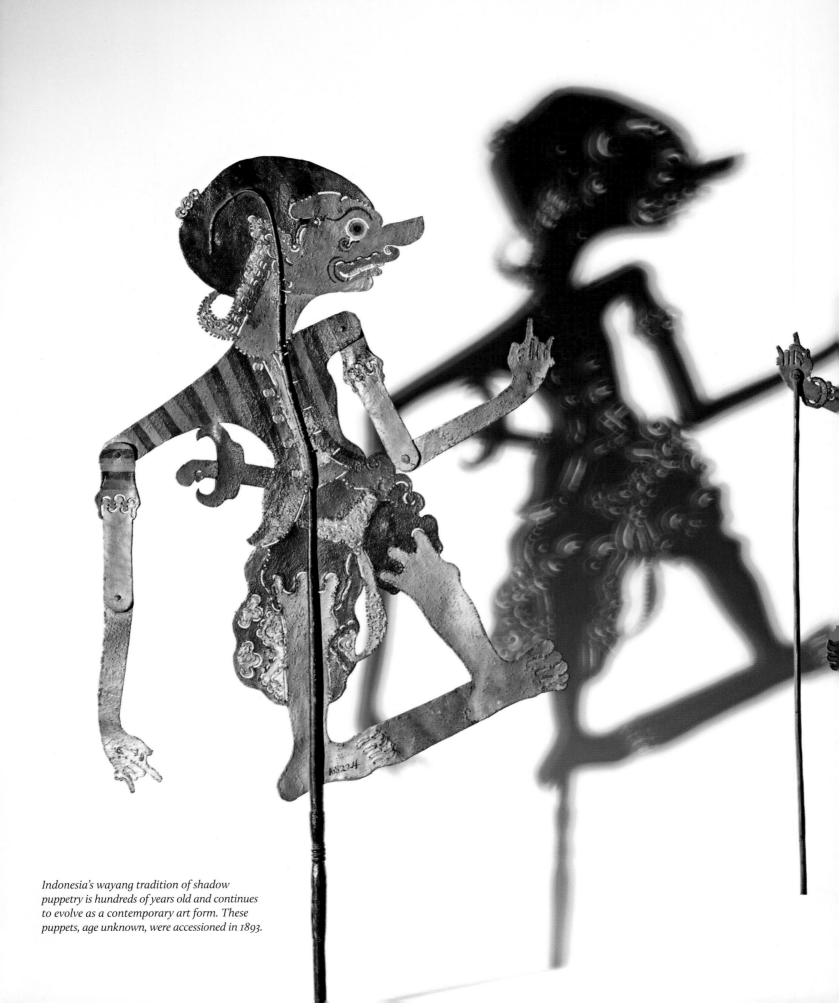

Indonesia's wayang tradition of shadow puppetry is hundreds of years old and continues to evolve as a contemporary art form. These puppets, age unknown, were accessioned in 1893.

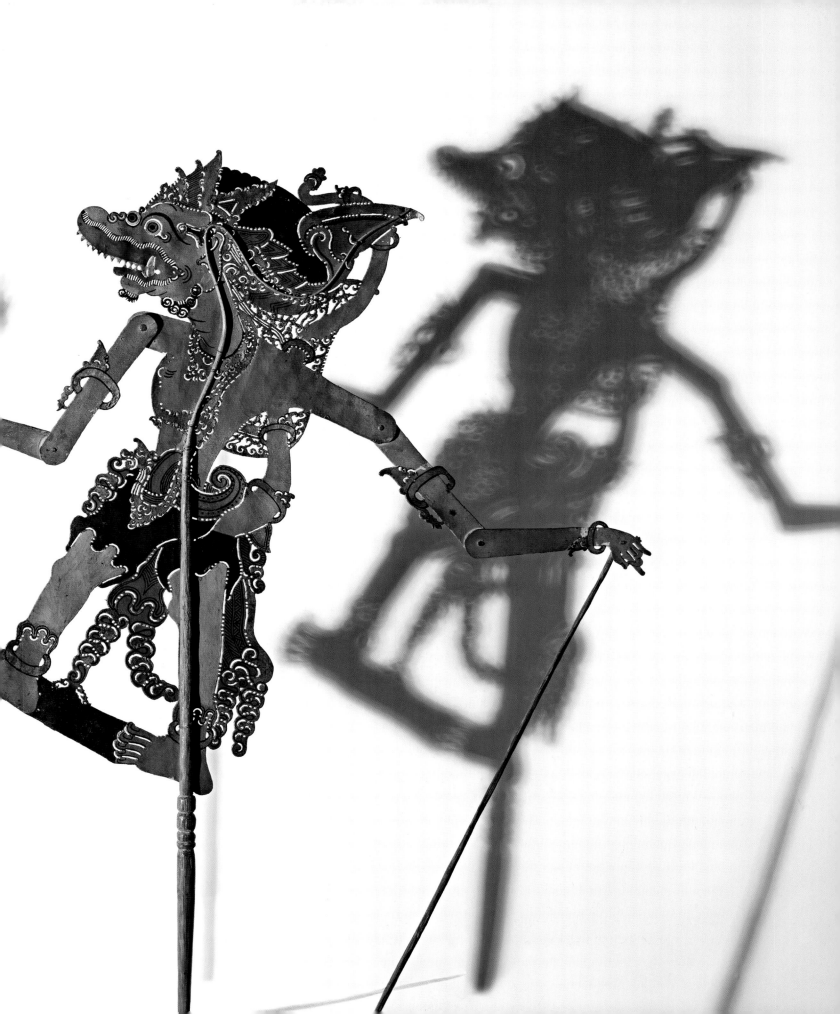

Shadows and Light

The origin story of shadow theater—the use of flat puppets, a light source, and a modest scrim to project the action—is a kind of mystery. Scholar Fan Pen Chen found links and overlapping traditions in figures made of leather (a traditional material for puppets) that date to the first millennium BCE in the graves of Scythians in the region of Mount Altai. Instead of a centralized location for the beginning of this ancient art form, it represents more of a cultural crossroads where North African, Central, South Asian, and Southeast Asian traditions interacted.

By the ninth century, Indonesia's shadow puppet tradition was developing into a sophisticated form involving movement, characterization, ritual, and music. Recognized the world over today as one of the globe's most intricate forms of cultural expression, Indonesia's wayang puppet theater was added in 2008 to UNESCO's (United Nations Educational, Scientific, and Cultural Organization) Representative List of the Intangible Cultural Heritage of Humanity.

The puppets in the Smithsonian's collection were accessioned in 1893, and they pertain to the oldest version of Indonesia's shadow puppet form—the wayang purwa, traced to Hindu epics. With a history stretching more than 1,000 years, this unique form of Asian theater continues to

inspire artists and audiences with both ancient stories and contemporary adaptations. It was not until the early 1970s that interest in wayang began to grow among artists in the United States.

The 1965 Immigration and Nationality Act brought many new Asian immigrants to the United States, including Indonesians fleeing a chaotic transition to a new form of government, Filipino professionals, and refugees from Vietnam, Laos, and Cambodia. Young American artists and students, especially, became interested in the artistic traditions and innovations that these emigrants brought.

The year 1972 was significant for the development of shadow puppetry in the United States. Professor Sumarsam (b. 1944) began teaching courses in Indonesian gamelan at Wesleyan University. As an amateur puppeteer, he also offered workshops on wayang puppetry. In the same year on the west coast, filmmaker, director, and dalang (shadow master) Larry Reed (b. 1944) founded ShadowLight productions, after having trained for several years in the traditional form, both in Bali and with dalang Nyoman Sumandhi and his father Pak Najeg, at the Center for World Music in Berkeley. Reed incorporated modern story-telling techniques in what has been described as a "live animation film" version of shadow theater. Ramon Abad, one of Reed's mentees and collaborators continued to take shadow puppetry even further.

As a student viewing a wayang performance at San Francisco State University, Abad was inspired by the possibility of adapting this traditional Asian cultural form for contemporary American audiences. His parents immigrated to the United States from the Philippines' Visayas region a year before Sumarsam and Reed started their respective work. In a 1999 interview, Abad talked about how he wanted to create theatrical experiences for children by experimenting with his own version of shadow puppetry. Before founding his own puppet theatre, Abad worked as a shadow puppeteer and maker for ShadowLight Productions. Writer Mauro Tumbocon described Abad's Tico Puppet Theater, where the artist reimagined the telling of Philippine folktales as "a major development in contemporary Filipino American theater."

—Theodore S. Gonzalves

Left: Master puppeteer Muhammad Dain Othman performs Wayang Kulit, May 23, 2015. Right: An Indonesian master puppeteer performs Wayang Kulit, February 20, 2012.

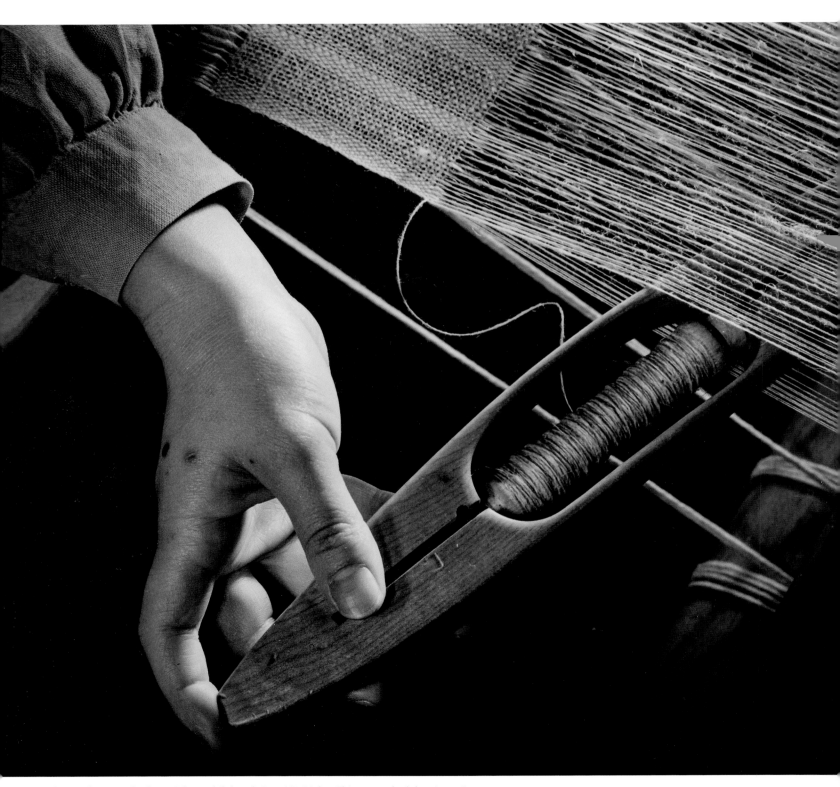

Above: Photograph of Kay Sekimachi's hands (pg. 68). Right: Chinese worker's hat (pg. 56).

CHAPTER THREE
Labor

Most labor is seldom seen or rewarded. The complicated experiences of labor inform so many AAPI life stories. Asian Americans and Pacific Islanders have been alienated from the products of their own making as well as from each other—often having to see others as competition instead of fellow workers. Yet, on dramatic occasions, workers organized to powerful effect, such as the 1920 Hawai'i plantation strike when Japanese and Filipino workers joined forces with laborers of other ethnicities, pressing for better wages and greater measures for workplace dignity. During those rare instances where industries were remade or held accountable, AAPIs allowed us to see that another world is possible. This section highlights objects from a variety of jobs, occupations, and vocations—from caring for the sick to tending to harvests, and crafting costumes and clothing.

Hawaiian Cowboys

Neil Young asked in a 1985 song, "Are There Any More Real Cowboys?" To find the answer, he could have looked west. Perhaps even further out west than he originally expected: to the Hawaiian islands and the history of the paniolo. Hawai'i's monarchs had contacts all over the world. When George Vancouver, a British sea captain, arrived with a gift of Mexican longhorn cattle for King Kamehameha the Great in 1793, it was not a surprise. Kamehameha I (1758–1819) forbade the killing of the animals, allowing them to multiply.

Within a few decades, the wild cattle needed management. The king's second son, Kamehameha III (1825–1854), hired Mexican vaqueros in 1832 to train local Hawaiians how to round up cattle and to begin reshaping the land for ranching. The passing and transformation of those skills gave birth to a new way of life on horseback. Over several decades, both non-Hawaiian residents of the islands and Native Hawaiians who developed and adapted those cowboy skills began to refer to themselves as paniolos. The term derived from the word Españoles, but it didn't refer directly to ethnicity. Paniolos were defined by their labor and the culture of ranching that emerged in the 1830s.

Born in Hawai'i, paniolo Clyde "Kindy" Sproat (1930–2008) was a musician and storyteller who recalled memories of his own ranching life during the "days of yore. Being a cowboy, that was pure love. It was hard work. When they were roping those cattle, it was hard. Those were the days of iron men and wooden ships." In 1988 he became a National Endowment for the Arts National Heritage Fellow.

Author and researcher Billy Bergin noted that the skill sets of Hawai'i's cowboys were varied compared to their counterparts on the continent, pointing out how, in the span of a long day of work, paniolos could wrangle cattle at elevations thousands of feet above sea level and then turn to fishing and hunting.

That hard work was globally connected to international trade, not just with the United States, but all throughout north and south America. International demand grew for Hawai'i's salt beef, hide, tallow, sweet potatoes, goat skins, and wool. By the early twentieth century, Hawai'i's landscape supported 200,000 acres of ranches. Mauna Kea's slopes alone teemed with 10,000 head of cattle.

Some on the continent got a chance to see these skills up close. In 1908, three paniolos traveled to Cheyenne, Wyoming, to compete in the Frontier Days Rodeo, an event dating to 1897 that has become the world's largest outdoor rodeo and western celebration. Imagine the looks on the faces of 12,000 stunned fans when the first, second, and sixth prizes in the World Steer Roping Championship went to three paniolos named Ikua Purdy, Archie Kaaua, and Eben Low. Purdy set a record for roping his steer in fifty-six seconds. Local folk singer and songwriter Gordon Freitas keeps Purdy's exploits alive in his tune, "Cheyenne Waiomina": "From his home rising from the sea / Do you still remember a long time ago / When a Big Island boy won your old rodeo?"

Although their numbers are decreasing, the Hawaiian paniolo still exists today, owning or working for large operations like the Haleakala and Ulupalakua cattle ranches, or for smaller ranches. But in the twenty first century, consumer tastes are changing, and some ranchers are considering sheep as an easier-to-manage alternative. Issues of climate change, sustainability, and preservation of island water resources are also a concern. Despite an uncertain future, the paniolo remains a popular, and nostalgic, figure in Hawai'i.

—Theodore S. Gonzalves

Saddle and hat used by third-generation rancher Masa Kawamoto (1922–2020) on the island of Hawai'i.

Native Pattera vs. Nurse-Midwife

Long before settler colonists landed on Guåhan (Guam) in 1521, Indigenous Chamorros practiced their own healing and wellness rites. Makahna were spiritual leaders and herbalists who tended to the well-being of precolonial life. Pattera served crucial pre- and postnatal care to women. In addition to their knowledge of herbal treatments, pattera provided healing massage therapies. During the Spanish colonial period (1521–1898), missionaries observed the authority that makahna and pattera held in their communities and noted their efficacy in treating ailments and restoring health.

In the 1898 Treaty of Paris, with a humiliated Spain having lost its colonies in the Caribbean and throughout Asia, the United States purchased the Philippine islands and Guam for $20,000,000. The fates of these archipelagos, already tied for centuries, continued under US rule. Admiral Alfred T. Mahan's writings emphasized a nation's economic and strategic needs for naval power. As the adage goes, "Trade follows the flag." Ships traversing the 7,000-mile journey between San Francisco and Manila required coaling stations. The United States' acquisition of Samoa, Hawai'i, and Guam served the critical purpose of refueling its military and commercial fleets.

On January 12, 1899, US President William McKinley communicated to his naval commander in Guam that they arrive as "friends" rather than "invaders or conquerors." Their task, in taking over from the Spanish, was to "win the confidence, respect and affection of the inhabitants of the Island of Guam . . . by proving to them that the mission of the United States is one of benevolent assimilation." This same policy was issued in the Philippines; a bloody war commenced there in a year's time.

Since women's wellness and health care had been the province of the pattera and local healers, the US Navy found its aims in assimilating the population to be in direct conflict with the islands' traditions. The US naval commander in Guam interpreted the president's orders, which involved "aiding the distressed and protecting the honor and virtue of women." US government reports singled out pattera for their cultural practices, questioning pattera's intelligence and competence and expressing a bias toward the training of young women.

In 1905, the US Navy established a Department of Health and Charities, and with a grant from the Russell Sage Foundation in New York, opened the Susana Hospital, Guam's first hospital for women. The Susana Hospital, created as a direct alternative to the work of native pattera, was staffed by volunteer military wives who were originally trained by the wife of one of the navy doctors on the island. Still, local residents continued their use of the pattera. The Susana Hospital was too remote for those coming from faraway villages. The staff was not bilingual and costs were prohibitive.

Two years after the creation of the Susana Hospital, the naval government opened the Native Nurses School of Trained Nursing. As a contrast to the older women who functioned as pattera, applicants to the nursing school had to be unmarried young women. At the completion of their training, they would be certified as "nurse-midwives."

By 1932, approximately one year before this photo of native nurses and a foreign officer was taken, the school had graduated only sixty-six native nurses, even though it had been in existence for twenty-five years. Why the relatively low enrollment? Language barriers persisted. The local community treated enrollment in the foreign government's training program with suspicion, and students described their training to be more janitorial than medical. Many graduated and returned to community life as pattera, melding Western techniques with traditions that persisted under colonial rule.

—Theodore S. Gonzalves

Young women in Guam participating in a program to be trained as nurse-midwives by the US Navy, ca. 1933.

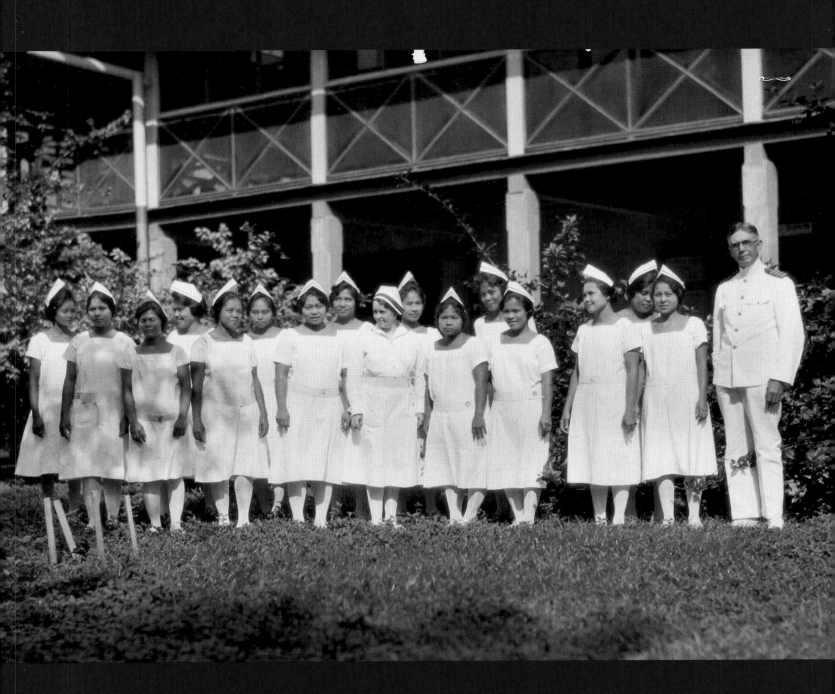

Traditions for Survival

Since 1967, the Smithsonian has held a large festival on the National Mall featuring folk arts and music. The program's many themes over the years have emphasized an understanding of how cultural practices both persist over time and great distances as well as improvise, change, and adapt to new circumstances. The Folklife Festival, as it's known, started out as a weekend affair during the Fourth of July holiday, welcoming 431,000 visitors. It has since widened to two weekends around the same dates with millions of visitors from all over the world.

At the 1979 Folklife Festival, a brief program on Vietnamese communities was followed the next year with a more detailed program on three Southeast Asian groups: the Khmer of Cambodia, Lao and Hmong from Laos, and Vietnamese.

The 1985 Festival's main programs highlighted cultural programs about Louisiana and India and Indian American life. A concurrent program on cultural conservation drew attention to the cultural traditions of the Khmhu, Indigenous communities largely based in northern Laos. Refugees from the end of the Vietnam war, many Khmhu traveled to the United States, including Leck Khoonsirivong (1935–2019).

Khoonsirivong and his family settled in Stockton, California, in 1979, where he worked as a farmer for twenty years. The father of seven children, his family included twenty-six grandchildren, twenty-five great-grandchildren, and six great-great-grandchildren. Beyond the five generations of his family, the larger Khmhu community has a growing national presence. According to the Khmhu National Federation (KNF), the largest concentration is found in California, while others are taking root in Washington, Massachusetts, Arizona, Texas, Oklahoma, North Carolina, Tennessee, and Delaware. The Southeast Asia Resource Action Center (SEARAC), a national civil rights organization working to uplift Cambodian, Laotian, and Vietnamese

communities, advocates for curriculum development, the disaggregation of data among AAPI groups, and the expansion of mental health services and other support for elders.

Researcher Frank Proschan captured the journey of Khoonsirivong and many from northern Laos to the United States in the following way: "In the space of an overnight airplane flight, the Khmhu would travel from a land of subsistence agriculture to one of postindustrial technology, from a land of water buffalo and canoes to one of automobiles and speedboats, from a land of stories and songs to one of television, and from a land of bamboo to one of plastics."

Instead of a lament for what has been lost, refugees like Khoonsirivong reminded festival visitors how repertoires survive and adapt. Khmhu musicians and dancers demonstrated their artistry and others from the community participated in talk-story sessions over the two weekends. Khoonsirivong's extensive knowledge of intricate weaving was displayed to the public at the festival alongside Seneca basketmaking, Mayan weaving from Guatemala, and Puerto Rican mask-making. For the festival, he made not only a bobbin winder but also a flute and fishing/netting gear.

Questioning why the Khmhu diligently continue their age-old practices, made even more difficult due to the scarcity of original materials, Proschan writes, "They will say that they do it for their children or for their new neighbors, so that they will know what it is to be a Khmhu, and what it was like to live in their homeland of Laos. If pressed a little further, they will acknowledge that they also do it for themselves, because they know that the survival of their folk traditions is vital to their survival as human beings."

—Theodore S. Gonzalves

Left: Bobbin winder made and used by Leck and Liang Khoonsirivong at the Smithsonian Folklife Festival, 1985. Right: Khmhu man demonstrates craft traditions, ca. 1985

A Worker's Proper Topper

There are myriad examples of the conical hat over the centuries—from the medieval period to the present, and throughout South Asia, Southeast Asia, and the Pacific Islands. Variants have topped the heads of royalty, performers, scholars, and laborers. The basic design—a flat, curved surface, pointed at the top—has been rendered in many ways. It may be shaped with straight lines and scalloped edges or rounded with a pointed center; and made from every imaginable material such as wood, leaf, straw, and metal.

The hat featured in the Smithsonian collection was acquired from an antique shop in Sausalito, California, and dates to the late 1800s. Made of woven cane over grass fiber, it is typical of the kinds of hats worn by Chinese workers who made their way to the Kingdom of Hawai'i and the US continent during that period.

A labor recruiter could have told the new recruits about the faraway city of San Francisco, known as *Jinshan*, or *Gam Saan*, the "Gold Mountain," which was not far from Sutter's Mill, where the latest gold rush had triggered the flow of prospectors to Northern California in 1848. At first, Chinese workers were welcomed. However, just two years into the historic discovery of gold, California's state legislature passed the Foreign Miner's Tax. The law caused an uproar and had to be rewritten to make sure white foreigners could stake their claims. The message that Chinese were taking jobs from white workers appeared in daily papers, magazines, and political cartoons, even though Chinese miners carried out work that white miners avoided, such as being lowered precariously down cliff faces to detonate explosives. By 1852, the number of Chinese miners swelled to 20,000. According to historian Sucheng Chan, the number of workers coming from China ranged from 2,000 to 9,000 per year for the next decade.

The simple design of the hat could keep rain off your head or protect your eyes from the rays of the sun. Since many Chinese worked in the Sierra Nevada's higher elevations, in mines, or laying track for the railroads, the hats kept snow or dirt out of their faces. As they scaled up and down mountain shafts and tunnels, a sturdy hat repelled falling debris. Invert it and you'd have an impromptu basket. If the hat was light enough, you could even fan yourself during a work break. The Chinese worker's hat was both a cultural connection with China and an essential tool for survival in the United States.

—Theodore S. Gonzalves

A worker's hat used in California made of woven cane over grass fiber, late 1800s.

Wok

Joseph Becker's 1870 illustration of a Chinese railroad work camp offered a glimpse into a quiet moment at the end of a long day of repetitive and dangerous work. The drawing was titled "The Coming Man—A Chinese Camp Scene on the Line of the Central Pacific Railroad," and it appeared in *Frank Leslie's Illustrated Newspaper*. The accompanying text stated:

Their staple article of diet was boiled rice, but they were by no means averse to fish, flesh and fowl, when they could get them. Their cooking was generally performed in broad pans, which they turned one above the other, in case they wished to keep the steam inside. When their meals were ready they squatted on the ground, and performed some very lively work with their chopsticks. For an inexperienced person to eat rice with chopsticks is much like taking soup with a fork; but a Chinese finds no difficulty in getting a large quantity down his throat, and at a very rapid rate.

Chinese railroad laborers worked in gangs of about a dozen; each unit had a cook and a leader. Many toiled and lived in isolated settings, never too far from where the tracks were being laid. Out west, Chinese workers were hired as railroad laborers as early as 1858. Six years later, they were hired by the Central Pacific Railroad and would be indispensable in the creation of the 1,911-mile transcontinental railroad. Historians estimate that 10,000 to 15,000 Chinese workers joined the effort—clearing land, moving snow, and boring tunnels. Some of the most dangerous tasks involved

Wok made in China and brought to California by Chinese immigrants in the 1800s.

setting dynamite charges to create mountain passages for the iron road. While capital welcomed their Chinese labor, nativists increasingly pushed for segregation and eventually legal exclusion.

In the background of Becker's image, two tents are set up with a person setting up a third. The cook is in the foreground, tending to two large woks, both set directly on the ground with fires beneath. One is covered, most likely to steam vegetables. The other appears to be filled with fish perhaps caught in a nearby lake, arranged in a single layer. He's keeping an eye on his shallow frying, with a spatula in his left hand.

Archivists point to evidence that Chinese workers had a varied diet, even as they lived thousands of miles from home. Customs invoices report items such as dried fruits, dried oysters, shrimps, cuttle fish, mushrooms, dry bean curd, bamboo shoots, sausage, and ginger being imported to sell to the Chinese workers. Other receipts list tools such as knives, chopsticks, and ladles. For all these ingredients and staples, storage containers and cookware were needed, including the all-important wok.

The skills that the cooks developed out on those remote camps became essential for the thousands of others who would continue their journeys across the Pacific. Decades later, many of those experiences were distilled into guidebooks published in Chinese American communities like Cui Tongyue's *Hua Ying Chu Shu Da Quan* (*Chinese English Comprehensive Cookbook*). As historian Yong Chen explains, this was more than a travel guide for the casual visitor. A book like this functioned like an atlas for newcomers, including tips for how to travel by rail or steamship, recipes for American dishes, a glossary of food words, and simulated dialogues for how to negotiate a higher wage. For example, here's an exchange from Tongyue's "cookbook."

Q: "What were you paid per month?"

A: "Twenty-five dollars. That is not enough for me."

Q: "How much do you want?"

A: "Forty-five dollars."

The cookbook, like the humble wok and the workers, are part of complex labor histories.

—Theodore S. Gonzalves

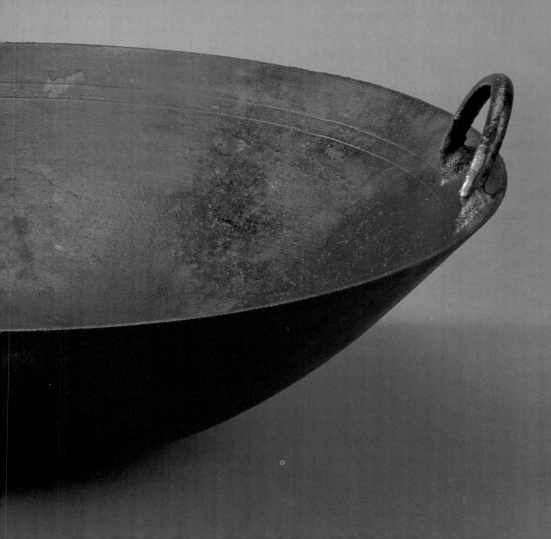

Across the Street from Portland's Chinatown

The Chinese Merchants, a painting by Childe Hassam (1859–1935), represents Chinatown in Portland, Oregon, as a center of commercial and domestic life for the city's Chinese immigrants and as an object of fascination for white audiences. Created in the decades after 1882's Chinese Exclusion Act, the image offers a glimpse into a self-contained neighborhood as well as a document of how white artists shaped narratives about Chinese American life in the early twentieth century. When Hassam created this painting, Portland's Chinatown was the country's second largest. Oregon's Chinese population migrated largely from the southern Chinese region of Guangdong to work in mining. The community grew to fill the burgeoning needs of the shipping, canning, and railroad industries.

Chinese populations in Oregon fluctuated based on US government edicts that progressively shrunk quotas before cutting off almost all legal immigration. The Page Act in 1875 forbid Chinese women of "immoral" character from entering the United States. In 1882, the Chinese Exclusion Act further barred Chinese laborers from entering the country to protect white labor interests. Chinese immigrants already in the United States, largely unmarried men, congregated in cities to escape the racism and violence they encountered in rural settings. Banned from attending public schools and from marrying white Americans, Chinese residents lived within the neighborhood's unofficial boundaries and founded institutions and businesses to support themselves.

White artists and writers alike delighted in visiting these spaces and created a wide range of representations that perpetuated stereotypes about Chinese immigrants and their presumed inability to assimilate into American life. Artists created picturesque scenes with saturated colors to evoke an alluring but seemingly foreign place. As reporter Will Brookes explained, "The Chinaman has a decided eye for color—or perhaps it would be nearer the truth to say an eye for decided colors—and revels in startling combinations of green, yellow, and red." Hassam borrowed aspects from such depictions, using dashes of red and gold that suggest posters pasted on building walls and peppering the image and the bespoke frame with marks suggesting Chinese characters illegible to white audiences.

Other white artists and writers promised audiences special access beyond the neighborhood's colorful facades. In 1886, Portland's *West Shore* magazine published a journey through Chinatown's subterranean warrens, noting that, behind the commercial storefronts, "labyrinths and corridors, hidden stairways and secret doors, peepholes, signals, and bars make a fortress of the district beyond the outer works of which the prying white man may not go unless on sufferance or by force." The first illustration accompanying the article presents a street view not unlike Hassam's vision. Additional images, however, offer glimpses into gambling halls and opium dens to enflame fears of Chinatowns as corrupting spaces for illegal activity.

Hassam's rendering resists either a fully picturesque or lurid view by envisioning a neighborhood by and large beyond the grasp of artist and viewer. Hassam's loose brushwork accentuates the canvas's surface and restricts the illusion of recessed space. Hassam also places barriers between the viewer and the viewed with—an expanse of sidewalk, a curb, and bars of sunlight. Together they create distinct regions so that Chinatown and its citizens appear on a stage set, captivating but ultimately inscrutable.

—Diana Jocelyn Greenwold

Painter Childe Hassam visited Oregon during the summer of 1908, completing this view of Portland's Chinatown after his return to New York.

Filipina/os in California's Asparagus Fields

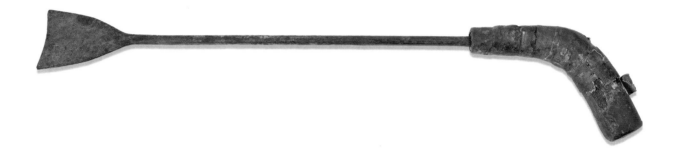

The first patent for an asparagus knife was created in 1919. Its wooden handle and long metal stem with a V-shaped blade enabled farmworkers to drive the forked blade into the soil and efficiently cut the bottom of the asparagus stalks covered by two to three inches of dirt. The length of the tool often varied, depending on the height of the person using it. A longer stem helped to reduce back strain from bending over.

The repetitive motion of bending over while harvesting rows of crops garnered the name "stoop labor," which carried pejorative connotations. In California's asparagus fields, for example, growers throughout the twentieth century used the term to refer to nonwhite farmworkers, especially Mexicans and Filipina/os who were characterized in racial terms as short in stature, resilient to toiling in the sun under grueling conditions, and physically and intellectually inferior to white people, thus making them suited to manual labor. Such characterizations suggested that farm work was undignified in contrast to other forms of work. These perceptions naturalized racial prejudices and discrimination that were seen as intrinsic to certain groups of laborers and sought to diminish their personhood. Filipina/o farmworkers often bore the brunt of this racialized term.

This asparagus knife, found among twenty-seven steamer trunks and suitcases that date back to the late nineteenth and early twentieth centuries, was discovered in a fraternal lodge in Stockton, California. Local nonprofit Little Manila Rising donated to the Smithsonian one of the steamer trunks containing the personal belongings of a Filipino migrant, including photo albums, letters, clothing, farm paystubs, and a half-dozen agricultural tools. This knife was used by a Filipina/o farmworker who worked in the asparagus fields in the San Joaquin Delta between the 1920s and 1970s. Together, this knife and the suite of objects in the steamer trunk tell a story of the crucial role that Filipina/os played in shaping California's agriculture industry.

Stockton sits in the northern part of California's Central Valley and the eastern part of the San Joaquin Delta, considered one of the most fertile agricultural sites in the world. Commercial farms grew wheat, barley, tomatoes, orchard crops, and especially asparagus, which was considered the "queen" crop of the delta due to its profitability. By the 1880s, the San Joaquin region was known as the "breadbasket of the world." Between the 1920s and 1940s, agriculture in the San Joaquin Delta became a multimillion-dollar industry whose success was built on the backs of immigrant laborers, mostly from Asia and Mexico.

Left: Asparagus knife used by seasonal workers for harvesting asparagus in the San Joaquin Delta, Stockton, California. Above: Filipino cutters in the asparagus fields on Ryer Island, California, photographed by Dorothea Lange on April 4, 1940.

Commercial growers relied on the indispensable labor of hundreds of thousands of seasonal workers to harvest crops. After Congress passed the Johnson-Reed Immigration Act in 1924, establishing a quota system to numerically restrict "undesirable immigrants" from parts of Europe and Asia to the United States, growers turned to Mexico and the Philippines to recruit workers. Under the 1924 Immigration Act, Western hemisphere countries like Mexico were exempted from the quota system and Mexican migrants were not subject to numerical restrictions. As for the Philippines, after its annexation by the United States in 1902, making it a US territory, Filipina/os were considered US nationals and could travel without restrictions within US territories. By the mid-1920s, Filipina/o and Mexican laborers could be found in the Delta and the San Joaquin Valley from late February to June, the typical season for growing and harvesting the lucrative asparagus crop.

By 1930, more than 10,000 Filipina/os lived and worked in Stockton, which served as an important hub for many who were migrating up and down the West coast in search of seasonal agricultural work. Some migrated from Hawai'i after completing labor contracts in sugar plantations; some came directly from the Philippines, primarily from the Ilocano and Visayan regions; and others were college students studying in the United States who needed to earn money through a temporary summer job. Regardless of their class and regional backgrounds, all gravitated to Stockton because of the demand for farmworkers. But they also worked in the fields because they were systematically barred from other better paying occupations due to institutional discrimination and racism. White growers, including some Chinese and Japanese labor contractors, deemed Filipina/os as suited for "stoop labor." Such racist characterizations often relegated Filipina/os to the lowest rung of the racial hierarchy and justified their exploitation in the fields through low wages, substandard housing and working conditions, and unscrupulous hiring practices.

Despite this discrimination in the fields, Filipina/os saw the dignity and value in their labor. As early as the 1920s, Filipina/o agricultural workers began organizing for better pay and working conditions. Their grassroots labor organizing from Alaska's salmon canneries to the fields in the San Joaquin Valley would play a pivotal role in shaping a powerful labor movement for farmworker's rights in the 1960s, directly influencing organizations like the United Farm Workers Movement.

—Sam Vong

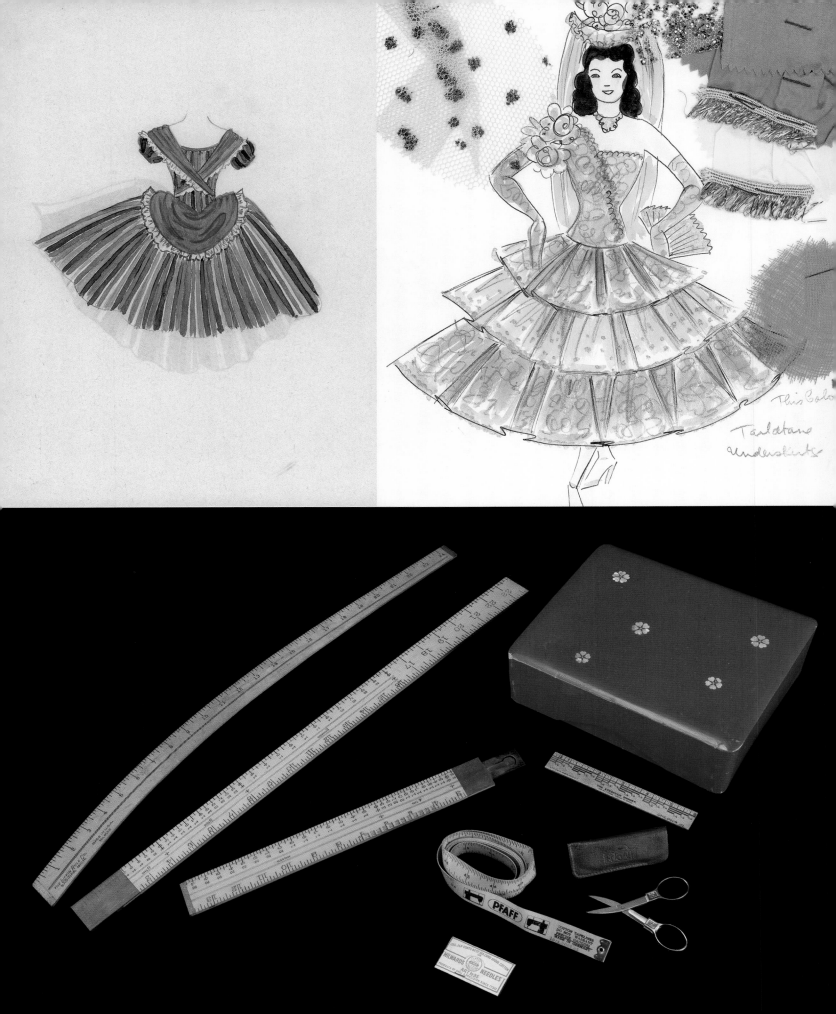

Tending to Details

Measuring tape, scissors, needles, and thread—tools for tending to details. May Ishimoto (unknown–2009) had to be precise and fast to alter garments for the perfect fit or make repairs on the fly when dancers were on stage. When you see her handiwork up close—for example, a tutu she designed and made for Marianna Tcherkassky, which is now in the Smithsonian's collection—you can certainly appreciate the care in her craft. You might think that detail wouldn't make much difference for an audience member sitting in an auditorium hundreds of yards away, but countless numbers of performers relied on Ishimoto's work to withstand the rigor of the road—from rehearsals to publicity shoots, to recitals, to the final encore of a season. In her thirty-year career as a wardrobe mistress and costumer, Ishimoto worked for the National Ballet of Washington, DC; the New York City Ballet; and the American Ballet Theatre.

Mikhail Baryshnikov, with whom she worked at the American Ballet Theatre, said of her: "[May's] quiet spirit and dedication to the theater were reminders to every American Ballet Theatre dancer that beauty is found in the smallest details . . . a bit of torn lace, a loose hook and eye, a soiled jacket—these were her opportunities to pour energy into an art form she loved, and we were the richer for it."

The Smithsonian has many examples of how Ishimoto tended to those details, including the sewing apron she wore to work and so many of the elements used in the making of costumes—beads, rhinestones, sequins, and a small cache of passementeries (edgings, tassels, and fringes).

Included in the collection are several examples of Ishimoto's pencil and watercolor designs, many with bursts of color, penciled-in measurements for various items like tunics with "draping shoulders" and skirts "cascading from hips." Many of these sketches include swatches of contrasting colors to provide detail on how she contrasted and complimented colors and edge elements. Her sketches featured figures in midair or *en pointe*. All of these are helpful for understanding how artists transform their inspirations on a page to fully realized pieces that take flight on a stage.

In 1987, when the National Museum of American History opened its exhibit on Japanese American history during World War II, Ishimoto talked to a reporter about her memories of being a young woman at the Jerome, Arkansas, concentration camp. She said that the exhibit's rebuilding of barracks didn't look quite right: They seemed too comfortable and pleasant. Always attentive to details, May noticed that "the floorboards should have been made of green wood that contracted to leave wide cracks through which bugs and dust flew in."

—Theodore S. Gonzalves

Top: Drawings of ballet costumes by May Ishimoto. Bottom: Red lacquer box and tools used by May Ishimoto when she worked as costume mistress for the American Ballet Theatre, 1973–90.

After-Dinner Tradition

The fortune cookie as it is has come to be known is bound up with the borrowing and adaptation of cultural practices on both sides of the Pacific. At the heart of the story are family businesses making a humble dessert that has become uniquely American. The story begins at the 1894 world's fair in San Francisco, also known as the Midwinter Exposition.

M. H. de Young, who helped to plan the 1893 Chicago world's fair, thought the idea of bringing a similar event to San Francisco would be great, especially since the nation was undergoing an economic downturn. Tourism to the rescue! The fair spanned 160 acres inside Golden Gate Park, complete with ethnographic displays of hula dancers from the Sandwich Islands (now known as Hawai'i), Alaskan Native persons, West Africans, Germans, and Middle Easterners.

When plans for a Japanese Village were drawn up, planners brought to the table the idea of pulling visitors around the grounds in seventy-five rickshaws. Members of the Japanese community objected. It would be perfectly fine for Japanese to pull other Japanese in Japan, but that kind of work in the United States, they thought, should be done by horses. The organizers altered plans. They found Germans, who darkened their faces and donned the appropriate Asiatic garb.

At the fair's conclusion, the Japanese Village was converted to a tea garden and the park's superintendent requested that Japan-born landscape designer Makoto Hagiwara (1854–1925) serve as the caretaker. According to researcher Yasuko Nakamachi, Hagiwara and family invited visitors to enjoy the gardens, serving tea and offering treats that had been adapted from tsujiura sembei, miso- and sesame-flavored savory crackers that contained small messages inside. Perhaps to appeal to Westerners' sweet tooth, the flavor profile changed.

Suyeichi Okamura founded the Benkyodo Company, makers of manju and mochi, in San Francisco in 1906 (one of the original businesses in that city's Japantown).

Hagiwara contracted with Okamura to scale up production of the cookies.

The cookie's jump from Japantown to Chinatown could be accounted for in a couple of ways. According to Nakamachi, during the 1920s and '30s, some Japanese immigrants owned American-style Chinese restaurants, where they sold fortune cookies. San Francisco served as a major military stop for soldiers and sailors having their fill—many for the first time—of Chinese American food. As they rotated back home, they requested the fortune cookies they tried in San Francisco, spreading the popularity by word of mouth. Chinese-owned businesses began producing and marketing the popular cookies for Chinese-owned restaurants to serve with meals.

Another likely explanation for the cookie's cultural shift could be found in nativist anti-Japanese sentiments that surfaced in the 1920s (resulting in the Johnson-Reed Act of 1924 that effectively excluded immigration from Japan) and again during World War II. Hagiwara's family home was destroyed as he and his family were imprisoned in Topaz, Arizona. The Japanese Tea Garden was renamed the "Oriental Garden."

Today, the story of this simple cookie continues to unfold. After 115 years of operation in San Francisco by the Okamura family, the Benkyodo Company closed its doors in 2022. You can still visit the grounds that Makoto Hagiwara tended. Its name has been restored to the Japanese Tea Garden at 75 Hagiwara Tea Garden Drive, in San Francisco's Golden Gate Park.

Gary T. Ono, grandson of Makoto Hagiwara, recalled how a Chinese American in Chinatown accounted for the cookie's routes and roots: "The Japanese invented it, the Chinese marketed it, and the Americans eat it."

—Theodore S. Gonzalves

Top: Nancy Chan making a fortune cookie at Golden Gate Fortune Cookie Factory on January 21, 2011. Bottom: Fortune cookie baking mold stamped with an image of Mt. Fuji, pointing to its Japanese origins.

Weaving a Life

Kay Sekimachi (b. 1926) has earned an international reputation as a "weaver's weaver." The task of weaving is one of humankind's earliest activities, but there is much more to Sekimachi's story than the production of everyday objects. Collectors, curators, and critics agree that Sekimachi's repertoire of three-dimensional woven objects represents some of the finest fiber art created in the twentieth century.

Born in San Francisco in 1926, Sekimachi spent a short time in Japan but was raised primarily in the United States. Cutouts of Jane Arden paper dolls sparked her imagination as a child. She created hundreds of outfits and accompanying stories for her and her two sisters to enjoy. When her father died, the responsibility to manage the upbringing of three daughters fell to Kay's mother. And thus begins the braiding of two arcs in Sekimachi's life—the importance of women providing support to each other (as peers as well as across generations) and the inspiration provided by Japanese tradition.

Sekimachi was born just two years after a particularly aggressive nativist campaign succeeded in the passage of an anti-Japanese law preventing Japanese immigration. With the United States finally entering World War II in 1941, Sekimachi remembers those tense months leading to incarceration—how her mother destroyed their Japanese record albums and burned books because neighborhood talk warned of having anything Japanese related in the house. She saved her paper dolls, though.

Her family was first relocated to Tanforan Assembly Center in San Bruno, California, where, despite the uncomfortable surroundings and stress of relocation, she was able to take art lessons from the legendary Chiura Obata. From there, they were moved to the Jerome concentration camp in southeastern Arkansas. Sekimachi noted the presence of Miné Okubo, also a camp art teacher, who served as a role model and later became a friend.

Photograph of Kay Sekimachi's hands, 1950. Right: Leaf Vessel *by Kay Sekimachi, 2012.*

Life after camp involved working as a domestic before returning to the San Francisco Bay Area where she continued her art studies at the California College of Arts and Crafts. At the campus' weaving room, she was so taken by the looms that she spent her last $150 on one for herself.

Starting in 1951, Sekimachi would be influenced by the teaching and mentorship of the German-born weaver Trude Guermonprez, who encouraged Sekimachi's vocation as a teacher as well as to experiment in her art. The results of her work in the 1960s proved to be profound—Sekimachi's abstract, three-dimensional woven objects using monofilament demonstrated weaving as fine art. In 1972, Sekimachi married woodturner Bob Stocksdale, with whom she would collaborate on art projects.

In 1974, Sekimachi applied for a grant from the National Endowment for the Arts to study in Japan. "It was like coming home," she said in a 1993 interview. Her return meant rejoining not only a family of weavers (both her mother and grandmother wove), but also a village where women engaged in the work. In Ibaraki, the prefecture where her parents were from, is the city of Yūki, known for its tsumugi silk-weaving, recognized by UNESCO as a prized example of intangible cultural heritage. Sekimachi recalls her grandmother saying: "To be a good weaver, you have to feel like a thread."

—Theodore S. Gonzalves

Sweatshops in America

I n August 1995, a multiagency task force led by the California Department of Industrial Relations raided an El Monte, California, sweatshop. The seven-unit apartment complex housed seventy-two undocumented Thai immigrants, most of whom were women. The highly publicized raid of the El Monte sweatshop shocked the nation as it highlighted how what was thought to be something that only took place in other countries could also happen in the United States. The stories of the seventy-two enslaved workers at El Monte have become a part of the narrative of US national history, and the objects seized from this raid tell these stories. Twenty-four forged documents were seized in the raid, including a falsified Thai passport.

The largely family operation run by Suni Manasurangkun, her sons, and four employees solicited experienced garment workers in Thailand. Most recruits were young female workers lured with the promise of a clean factory, good pay, and weekends off. Unaware of the truth of their future working and living conditions, they signed contracts that were in reality indenture agreements, committing them to a three-year labor term and to repay 120,00 baht (about $5,000 in 1997) for transportation costs.

The workers were smuggled into the US using fraudulent passports that El Monte operators doctored from real passports belonging to other people. On arrival, sweatshop operators confiscated the passports. Sewing machines were also recovered from the El Monte raid. Workers were forced to sew at these machines for eighteen hours a day, seven days a week for a meager pay of sixty-nine cents an hour. Debt, guards, and threats of physical harm to the workers and their families in Thailand discouraged them from escaping.

In the many years since their release, the seventy-two Thai workers have raised families, started businesses, and become American citizens. Some have become active in the effort to challenge human trafficking.

The Asian Pacific American Legal Center represented the El Monte workers in court. Julie Su, one of the attorneys, explained: "The slave labor sweatshop in El Monte reminds us that flagrant abuses of labor and human rights occur not just in distant countries. Sweatshops in America are not the products of individual contractors who choose to flout the law. They are the result of corporate decisions and corporate indifference."

These objects remind us that history's hurts don't remain in the past. According to research published in 2017 by the International Labour Organization, the Walk Free Foundation, and the International Organization for Migration, the number of people trapped in modern slavery numbered forty million, disproportionately affecting the lives of women and girls.

—Thanh Lieu and Theodore S. Gonzalves

Sewing machine and fake passport seized in a 1995 raid on a sweatshop in El Monte, California.

Above: Electronic Superhighway: Continental U.S., Alaska, Hawaii *by Nam Jun Paik (pg. 86). Right: Electronic calculator (pg. 84).*

CHAPTER FOUR

Innovation

Innovation springs up in many ways—as complements to Western medicine, technical advances to compute and communicate, as well as ways to conceive of our diverse, media-saturated society. Persons of Asian and Pacific descent have innovated out of necessity, just like everyone else. And whether as transplants or as homegrown locals, they have also demonstrated the ability to challenge society's expectations about what it means to be either Asian American or Pacific Islander. The stories in this section give us new ways to see the limits and possibilities of identities and reminders of how to make a way out of no way.

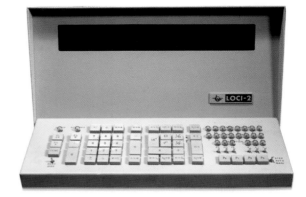

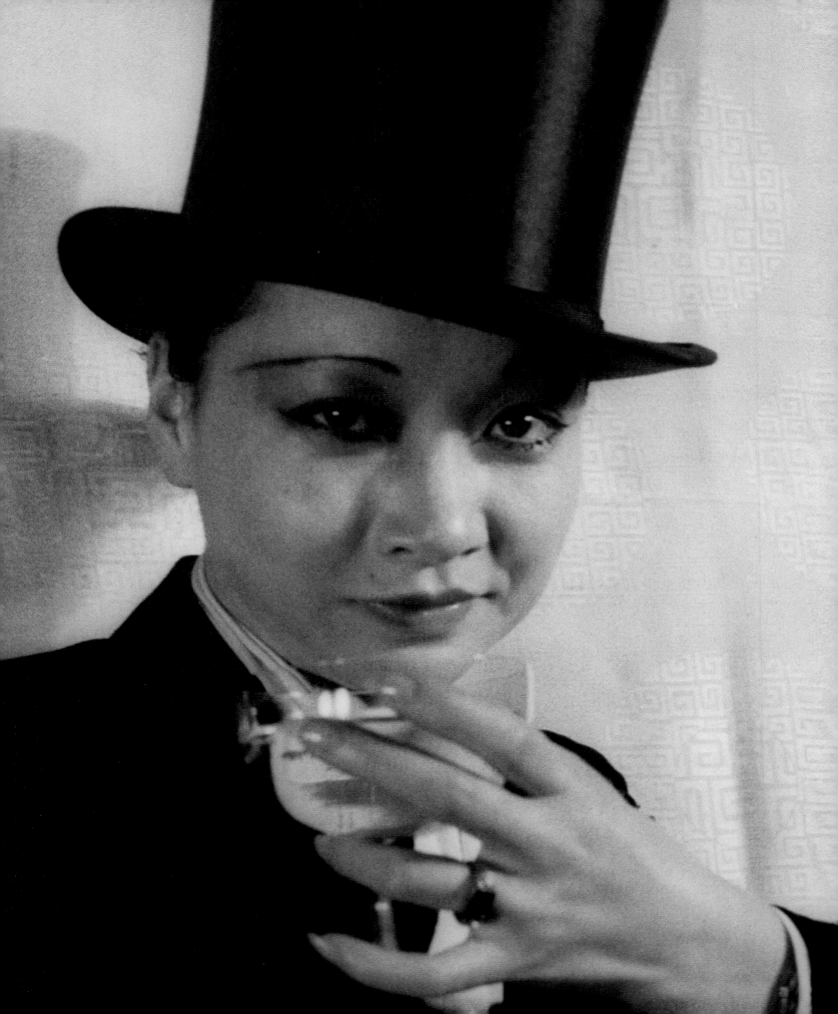

Anna May Wong

Anna May Wong (1905–61), the first Chinese American film star, began gracing the silver screen during the Roaring Twenties amid the early years of Hollywood's Golden Age. Photographer Carl Van Vechten (1880–1964) created this portrait of her in 1932. "She was my first muse," he wrote in his letters.

A third generation Chinese American, Wong was born Wong Liu Tsong in Los Angeles, California, in 1905. As a young girl, she became fascinated by the film and acting industry. Frequently, she would visit Hollywood sets during filming, squeezing through crowds to get the best view. "I'd stare at these glamorous individuals," she remembered, "and then I would rush home and do the scenes I had witnessed before a mirror."

Wong, eager for a turn in front of cameras, dropped out of high school to pursue a full-time acting career. At this time, Hollywood studios cast women in secondary, romantic roles, opposite white male leads. Women of color, however, were barred from those roles. Miscegenation laws in many states forbade interracial relationships, both in real life and on screen. Hollywood restricted Wong to playing background characters that aligned with American stereotypes toward Asians.

Hollywood's racism limited Wong's aspirations. Even when Wong had the opportunity to work in major films like the *Thief of Baghdad* (1924), she was typecast in supporting roles like Mongol slave, concubine, or scheming dragon lady.

Wong left the United States for Europe in 1928, seeking better opportunities. In England, she earned the lead in a silent film, *Piccadilly* (1929). Around this time, movies with spoken dialogue began gaining commercial popularity, leading Wong to learn French and German. Upon returning to the States, she starred in *Shanghai Express* (1932) alongside famed actress and singer, Marlene Dietrich, whom she befriended during her time in Berlin.

In the production *The Good Earth* (1937), Wong eagerly sought the main part of O-Lan, a sympathetic Chinese wife. However, when white lead Paul Muni was cast as the

husband, producers ruled her out. According to th[e] miscegenation rules, the role would have to go to a woman. Ultimately, Luise Rainer was cast as O-Lan. "more Asian," Rainer applied tape to the sides of her e[yes] openly criticized Hollywood casting. "There seems lit[tle] in Hollywood, because rather than real Chinese, pro[ducers pre]fer Hungarians, Mexicans, American Indians for Chi[nese roles.]

Wong spent most of her career acting on stage [and] films until the outbreak of World War II. She deci[ded to put] her career on hold and worked from the United S[tates for] Chinese war relief. She later reentered the enterta[inment] industry in the new, popular medium of televisio[n, where] she became the first Asian American to star in a tel[evision] series, *The Gallery of Madame Liu-Tsong*.

Wong's achievements were recognized by the i[ndustry] with her induction to the Hollywood Walk of Fam[e in 1960,] a year before her death. During her lifetime, she a[ppeared in] more than sixty movies and continues to inspire [Asian] American women in film.

Left: Photograph of Anna May Wong, by Carl Van Vechten, 1932.
Right: Poster for the film The Lady from Chungking *(1942)*

—Chelsea R. Cozad

Groundbreaking Cinematographer

In a photograph by George Hurrell (1904–92), the cinematographer James Wong Howe (1899–1976), lit dramatically, sits perched above one of the tools of his trade. "I think light is the most important thing in photography," he remarked about his work in a documentary by the American Film Institute. Wong Howe was born Wong Tung Jim in Taishan, Guangdong, China. He moved to the Pacific Northwest at age five, along with his family, to join his father who had emigrated earlier.

He came of age alongside Hollywood and became a groundbreaking cinematographer with a career spanning six decades encompassing more than 130 films and ten Oscar nominations (two wins for the 1955 film *The Rose Tattoo,* and the 1963 film *Hud*). His technique, talent, and technical innovations left a lasting impression on American film. Not only was Wong Howe the first person of color invited to join the American Society of

Cinematographers in 1933; he was also the first Asian cinematographer to be nominated for the Academy Award for Best Cinematography, for 1938's *Algiers.*

Wong Howe's achievements in Hollywood are even more remarkable considering the prevailing attitudes in the country toward Asians and Asian Americans. There was significant prejudice and fear aimed at existing Chinese communities in the United States. Wong Howe arrived in the states when the 1882 Exclusion Act was still in effect, forbidding any new Chinese laborers from entering the country and denying him citizenship until the Act was repealed in 1943.

While perfecting his craft, Wong Howe continued to deal with discrimination and racism. Despite the accolades and affirmation by his colleagues and collaborators, there were continuous reminders of his "otherness." He met his future wife, Sanora Babb, a white woman and talented author, while working in Hollywood, but he could not legally marry her in California until that state's anti-miscegenation law was overturned in 1948. Even though Wong Howe and Babb were married in France in 1937, the couple did not publicly acknowledge it. It not only broke the law but went against the morality clauses of Hollywood's studio system.

As Wong Howe quipped, he made "old stars young, plump stars thin, ordinary faces beautiful." His cinematography and lighting set the stage for some of America's most compelling films.

—Cedric Yeh

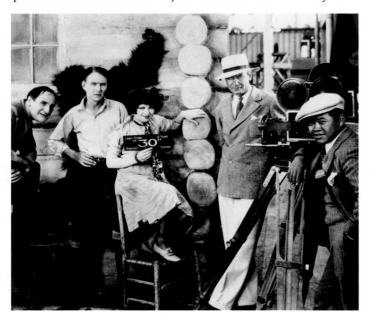

Left: Behind-the-scenes of Mantrap, *1926, with James Wong Howe (right). Right: Portrait of cinematographer James Wong Howe, by George Hurrell, 1942.*

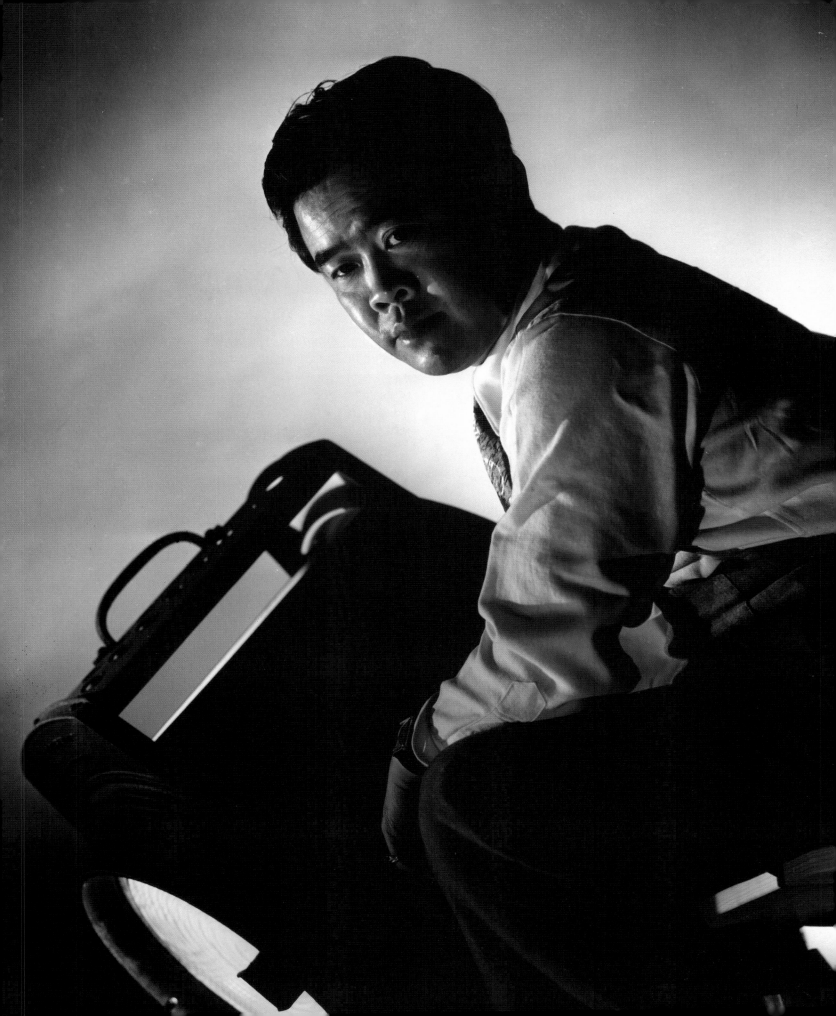

Yayoi Kusama's Forlorn Spot

Arestless and prodigious innovator whose practice spans drawing, painting, sculpture, film, collage, installation, and performance, Yayoi Kusama (b. 1929) was among the first artists from Asia to gain global prominence after World War II. Today she remains one of the world's most celebrated contemporary artists.

Kusama has described herself as an "obsessional" creator, often evoking in her work a hypnotic, dreamlike space that echoes the vivid hallucinations she has intermittently experienced since a young age. Born to a prosperous family in the Nagano prefecture of Japan in 1929, Kusama endured grueling conditions during and after World War II. She studied *Nihonga* (a modern Japanese style of realist painting) in Kyoto before forging her own artistic path. Eager to escape the social and aesthetic strictures of postwar Japan, and inspired by European and American modernism, she set out for the United States in 1957. After a brief sojourn in Seattle, she arrived in New York where she quickly became part of the avant-garde scene, her work becoming known within the context of pop art, minimal and postminimal art, and, by the late sixties, the hippie counterculture.

During her sixteen years in America, her artistic output was astonishingly inventive: she developed her austere *Infinity Net* paintings, phallic soft sculpture known as *Accumulations*, the immersive *Infinity Mirror Rooms*, and an adventurous performance practice that included nudist antiwar "happenings." In 1973, seeking new business opportunities, she returned to Japan. After suffering multiple hospitalizations for physical and psychological ailments, she admitted herself in 1977 to the Seiwa Hospital for the Mentally Ill, where she has lived voluntarily since.

Four works—*Autumn* (1953), *Forlorn Spot* (1953), *Deep Grief* (1954), and *Fire* (ca. 1954) —were discovered among the holdings of artist Joseph Cornell donated to the Smithsonian American Art Museum after his death. Rendered in watercolor, ink, pastel, and tempera paint, these delicate compositions represent a crucial body of work that bridged Kusama's transition from Japan to the United States. Created in the mid-1950s, when the artist was still living in Japan, they reveal her rejection of the conventions of Nihonga and her drive toward experimentation. Essentially abstract, their imagery suggests microscopic or cosmological topographies, intimate spaces that she would later expand on in her *Infinity Mirror Rooms*. Drawings such as these gained Kusama her first American supporters—notably, the painters Georgia O'Keeffe and Kenneth Callahan, who corresponded with the young artist and helped secure her first exhibition in the United States.

The drawings were among the roughly 2,000 that Kusama brought with her when she left Japan, hoping to sell them to help support herself. Cornell purchased four examples in 1964. The two artists had first met in 1962 and maintained a close bond until his death in 1972. Known for his intricate boxed assemblages and collages, Cornell dedicated poems and artworks to Kusama, and occasionally gave the impoverished younger artist pieces of his work to sell, allowing her to earn a commission. After Cornell's death, Kusama returned to object-making from performance, creating collages from magazine cuttings given to her by her friend. These surrealist-inflected works were in part an elegy to Cornell and indicate the depth of their relationship, which Kusama has described as passionately romantic yet platonic.

Forlorn Spot, part of the "Lost Kusamas," testifies to the artist's remarkable transnational career and her unique role within the story of post-war American art.

—Melissa Ho

腹埶咽乾此灸三壯針入三分
不能行大風暴不却入目驚視如見星尿如黃水
樂心悶暴雲及諸淋目痛小腹偏痛嘔逆臥偏
墜汗出面黑病不欲食婦人淋瀝陰挻出四支
左取右取左立卪女子不月水驚喜悲不樂

清冷淵
二間
三間
陽谷
前谷

Acupuncture Kit

One quality that makes humans unique is our ability to heal one another. Throughout time, we have developed innumerable methods for dressing wounds, curing ailments, and maintaining health in our communities. While new medical procedures are developed every day, some have existed for centuries and even millennia—human history is rife with stories of how war, migration, power struggles, and pop culture have shaped what *care* means to us today.

The National Museum of American History holds a large collection of medical instruments that each offer a glimpse into how treatments from all over the world have become a part of everyday practice in the United States. One example is an acupuncture instrument set donated by Kiel's Inc. Produced by the Hwa To Brand in China, the black plastic case, with gold lettering on the cover, contains a set of long, thin metal needles, needle injectors, tweezers, and additional instruments, along with an instruction manual. Acupuncture, a medical practice invented in China more than 2,000 years ago, entails inserting needles shallowly into specific points of the body associated with balancing qi—a notion of life force central to Chinese medicine. The treatment is used to address a wide array of conditions, including arthritis, muscle pain, stress, and even as an anesthetic.

While acupuncture had fallen in and out of popularity in different parts of the world, it received widespread attention in the United States as China emerged from global isolation in the mid-twentieth century, opening the door for increased cultural exchange. Moments often attributed to the American mainstream's adoption of acupuncture include President Richard Nixon's historic trip to China in 1972, and an article published in the *New York Times* in 1971 by reporter James Reston, "Now, About My Operation in Peking," which details his use of acupuncture during an emergency appendectomy while in the country.

The heightened popularity of acupuncture compelled the National Institute of Health and the American Medical Association to investigate the effectiveness of acupuncture as a medical procedure, and its eventual legalization across the country. While this allowed for the practice to become widely accessible, it also resulted in the policing of private acupuncture clinics largely operated in Chinese ethnic enclaves. In 1972, the State of New York's Department of Health recognized acupuncture as a medical practice which could only be performed by medical doctors. Soon after, practitioners in Chinatown, Long Island, and other New York City neighborhoods were forced to discontinue their services despite holding licenses from Hong Kong or China. A *New York Times* article entitled "Acupuncture Patients Fear Ban" took accounts from New Yorkers of various backgrounds grieving over the imminent closure of the clinics that they came to depend on when all other medical interventions had failed them.

Acupuncture is an example of a healing modality that originated as a traditional practice and has now become widely accepted by Western medicine. In America and throughout the world, some of the most heated disputes pertain to policies regarding the validity of various medical procedures, and how one can seek treatment concerning birth, sickness, and death. Acupuncture's storied journey represents a deeper history regarding who holds governance over a person's body.

Left: Page from a Chinese book on acupuncture, ca. 1271. Right: An acupuncture instrument set made by the Hwa To Brand, 1988.

—Adriel Luis

Scripting Unity through Literacy

In 1937, an Indian man, Hari Govind Govil (1899–1956) patented the typeface of a complex font for Linotype that would facilitate the entry of Hindu culture to the West while bringing major changes to the publishing and newspaper industry in South Asia.

Govil's 1937 patent would eventually allow Linotype machines to print Devanagari, a dominant script of South Asia that, by 1950, would be considered the official script of the Union of India. Newspaper articles hailed this development as a stride for increasing the literacy of one-sixth of the world's population. Before the era of computers, machines like the Linotype were the key to advancing knowledge through the printed word. But before this achievement could take place, Govil had to embark on a journey far from home.

As a university student in Benares, Govil was ambitious, but unhappy with the traditional style of education in India. He decided to travel to the United States, hoping to benefit from what he viewed as a more flexible and innovative culture. In the process, his perspective on India and its connections to the West gained both depth and breadth.

The 1917 Immigration Act passed by Congress created a large "Asiatic barred zone" stretching from the Middle East to Southeast Asia in order to exclude South Asians from migrating to the United States. The act made exceptions for certain professions as well as for students, allowing Govil to make his way.

Soon after his arrival in the US in 1920, Govil began several years of correspondence with his hero back home, Mohandas Gandhi, who had been sharpening the tactics of nonviolent noncooperation against the British. In 1922, Gandhi provided encouragement to the young student: "Every worker abroad [such as yourself] who endeavors to study the movement and interpret it correctly helps it."

Govil secured a position at the Mergenthaler Linotype Company in New York, and became fascinated with the technology—both its potential to enhance education and the written arts, and to facilitate cultural and political exchange. Govil designed his type with interchangeable parts, so that it could be used to compose text in related South Asian languages, such as Hindi, Gujarat, Bengali, Behari, Nepali, and Jaina.

Govil became a proponent for Indian nationalism. Soon after he received the note from Gandhi, Govil penned an editorial for an American audience, announcing that a new chapter of world history would be marked by the Indians' adoption of Gandhian nonviolence.

In 1924, Govil established the India Society of America, Inc., in New York City, surrounding himself with support from an impressive cross section of advisors, including missionary/educator Sidney L. Gulick, ACLU cofounder Jane Addams, choreographer Ruth St. Denis, journalist Heywood Broun, NAACP cofounder Oswald Garrison Villard, and philosopher/education reformer John Dewey, among many others. With Govil at the helm, the society launched several well-publicized activities "to promote cultural relations between India and America," including lectures, receptions, art exhibits, film screenings, radio programming, and publications.

Writing for the *Hindustan Review* at the society's founding, a fellow Indian nationalist, V. V. Oak—also living in the United States at the time—suggested that Govil's tactical use of culture and the arts was the right means to achieve the ends of Indian nationalism.

In 1929, Govil appeared to echo Oak's sentiments by observing that India's "spiritual achievement" was just as significant as any scientific achievement by the West. The creation of a simple font forged the link he sought. In the same year that Govil applied for his patent, the *Times of India* quoted his aims: to create a "uniform method of writing, and I think this would wield her [India] together."

—Theodore S. Gonzalves

Portion of Hari Govind Govil's patent application for a typographical font to allow for the printing of Devanagari script for Mergenthaler Linotype, 1937.

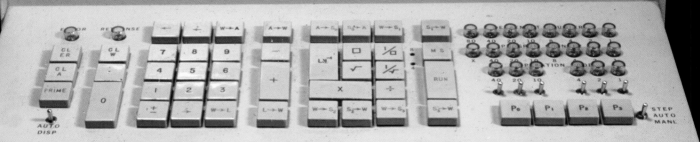

Finding Solutions

The world as we know it today—one where we write, store, send, and retrieve vast amounts of information with simple gestures—would be vastly different if not for the contributions of Asian immigrants and entrepreneurs like An Wang (1920–90). His research and manufacture of magnetic core memory helped to mark a new chapter in the long history of American invention and innovation. His story began in Shanghai in 1920.

In his memoir, *Lessons*, Wang notes how the struggle between Japan and China would be critical in shaping his youth—an "Age of Confusion," as he called it—"a living terrible memory to those who suffered through it." In colorful passages, Wang recalls the early 1930s as a time when the Japanese government "began to look at China the way a cat looks at an untended Thanksgiving turkey." The result was the seizing of Manchuria by the Japanese military in 1931 and the bombing of his home city. Mandatory attendance at political rallies to rouse the populace disturbed him. He steadied himself by turning to math and physics. At Chiao Tung University, Wang studied electrical engineering and graduated in 1940.

His contribution to China's war effort against the Japanese involved assembling radios and communications equipment from scavenged parts. The conditions were eye-opening for him, as he not only heard of atrocities from the opposing armed forces, but he also witnessed the corruption of local Chinese officials. It was during his service that Wang heard of a program to train Chinese engineers in the United States whose skills would be needed after the war.

In 1945, An Wang arrived in the United States for a two-year apprenticeship, after which he applied to a doctoral program in applied physics. In 1948, he completed his PhD at Harvard and was conducting research at the campus's Computation Laboratory under the direction of Howard Aiken. After leaving the lab in 1951, Wang established Wang Laboratories.

His research on magnetic core memory became the foundation for several profitable projects and products, including the Wang LOCI calculator, which sold in 1965. As Wang described it, this device (pronounced "LOW-sigh") could "add, subtract, multiply, divide, compute roots, and generate exponential values with the stroke of a few keys." Instead of a room-sized mainframe that cost hundreds of thousands of dollars, Wang's LOCI could fit on a desk and sold for "only" $6,500. Some of his early adopters were the Lawrence Livermore Labs in California and the French National Railroads. In their first year, the company sold twenty calculators. The following year, they were selling ten of the LOCIs per month.

As popular as the LOCI was, it was only a transitional item in the company's young history. Initially, Wang and similar companies were focused on the needs of the highly specialized markets of scientists, government, and industry. With the arrival of their Model 300 calculator aimed for use by a wider public, computing was about to get personal. At the height of the company's financial success, Wang Laboratories earned $3 billion in profits annually. As Wang put it, "We were guided by the idea that people do not want technology; they want solutions to problems."

—Theodore S. Gonzalves

Wang LOCI-2 electronic calculator, designed by An Wang for Wang Laboratories and produced in Tewksbury, Massachusetts, ca. 1965.

Mapping a Mediated Nation

Born in Seoul, Korea, artist Nam June Paik (1932–2006) first came to the United States in 1964. As a music composition student, first in Japan and then Germany, he had already gained an international reputation for his barrier-breaking "action music" performances and experimentation with consumer technologies in his installations. From his new home-base in New York City, he became a leading force in the adoption by late twentieth-century artists of television sets, videotape cameras, robotics, synthesizers, and broadcasts as "paintbrushes." Unsurprisingly, he was also one of the first to predict in 1974 the globe-altering potential of what he termed the "electronic superhighway," now called the internet.

Electronic Superhighway: Continental U.S., Alaska, Hawaii (1995) is a monumental centerpiece of the Smithsonian American Art Museum's top floor galleries. Responding to then-president Bill Clinton's promise to build a "data super-highway," Paik uses this work to stake his claim as an early visionary of a world connected and defined by nonstop media. His room-filling map of America is literally composed of television sets—336, to be exact—stacked in various sizes to mimic state shapes, which are outlined by 575 feet of multicolored neon tubing and visibly supported by scaffolding and 3,750 feet of wiring.

Matching video content plays on the screens within each state's border, showing Paik's personal or pop culture associations with that place. An artist-edited montage of Bill and Hillary Clinton and Paik's performance partner Charlotte Moorman, all Arkansas natives, represents that state, while a simple shot of potatoes stands for Idaho. For other locations, Paik uses unedited classic movie musicals such as *The Wizard of Oz* for Kansas and *Oklahoma* for Oklahoma.

While playful, these choices also suggest how media shapes divergent identities and reinforces divisive cliches. For Alabama, Paik selects a documentary about the Montgomery Bus Boycott, with speeches by Martin Luther King Jr. and Malcolm X that the artist wanted to audibly stand out among the cacophonous soundtracks. While the neon lights and flashing images visually evoke traveling by car along a mid-century American highway—an earlier symbol of freedom and connectivity—the audio reminds viewers that traveling with equal assurances of liberty and safety is still an unrealized promise for many in these United States.

The fifty state videos are joined by a closed-circuit camera and tiny monitor, both tucked into the map exactly where this work is located, in Washington, DC. When visitors stand in the gallery and wave at this camera, they see themselves as part of this complex picture of America—a hyper-mediated but hard-to-grasp entity that can overwhelm even as it entices. The viewer's presence in this mosaic affirms that this is not just a map, but a portrait of a nation simultaneously committed to individualism, regionalism, and an ideal of unity—one nation somehow melded out of clashing color and content. Made toward the end of a fifty-year career, this work exemplifies Paik's invitation for audiences to critically engage the technologies of their day and his continued relevance for viewers navigating our high-tech future.

—Saisha Grayson

Electronic Superhighway: Continental U.S., Alaska, Hawaii, *art installation by Nam June Paik, 1995.*

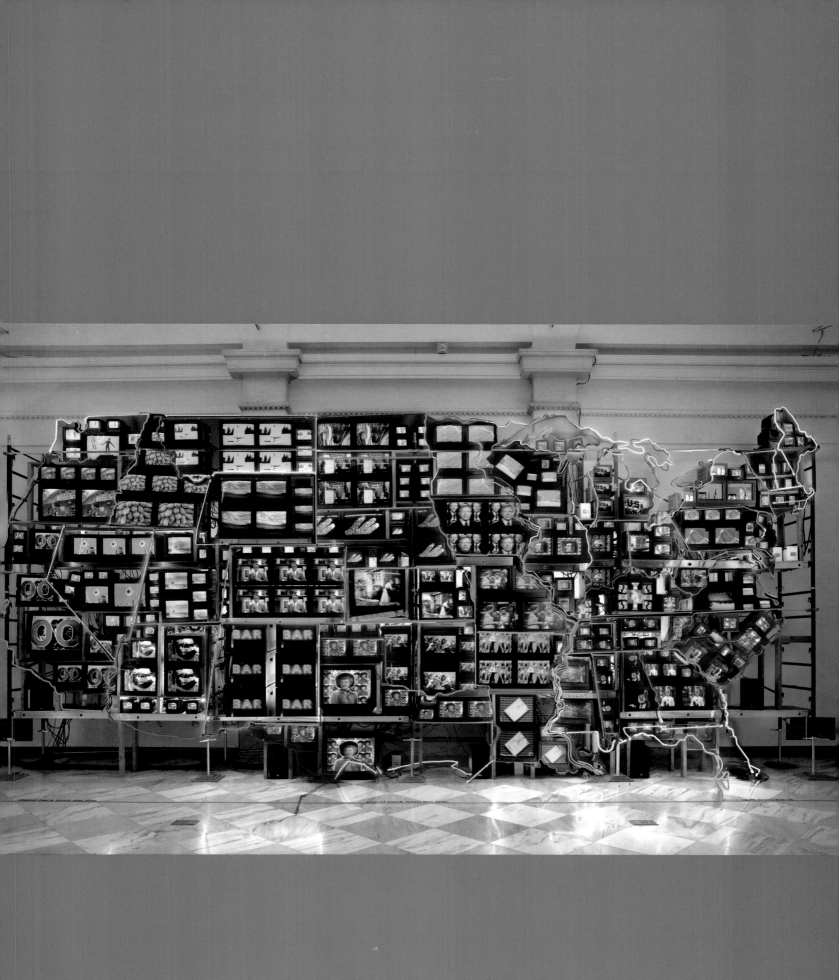

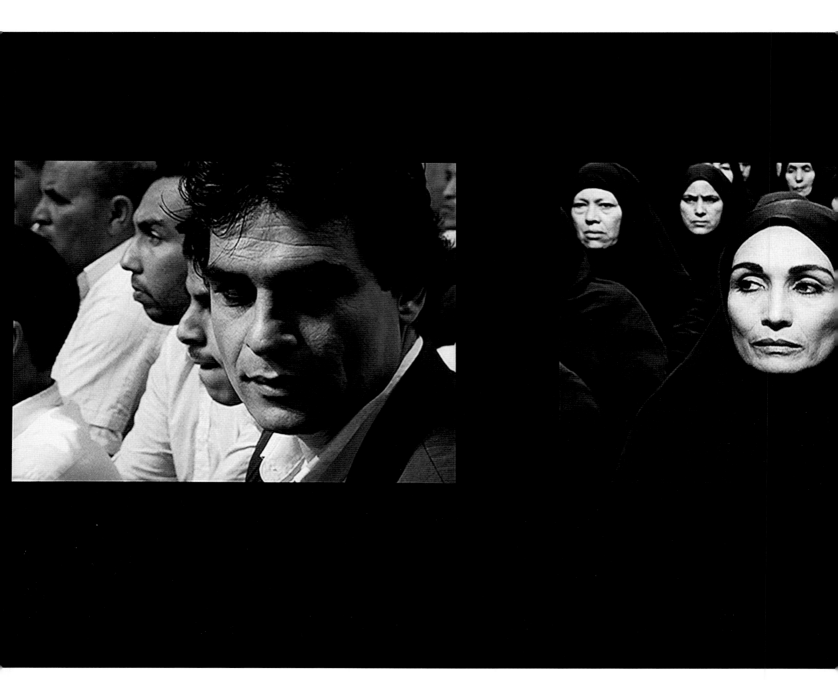

Above: Still from Fervor *by Shirin Neshat, 2000 (pg. 104). Right: Child's hanbok (pg. 94).*

CHAPTER FIVE

Belonging

Asian Americans and Pacific Islanders have aimed for a sense of belonging in the United States, in their overthrown kingdoms, in their war-ravaged homes, in invented communities, and in improvised settings. But belonging is not exclusively specific to thinking about place. The objects in this section speak to senses of belonging that also involve loss, insecurity, and uncertainty. Between the 1840s and the 1940s, Asian Americans were initially welcomed as cheap labor while later being excluded by dozens of federal immigration laws, contributing to a sense of perpetual foreignness. A sense of belonging can involve persons and groups who help to redefine what it means to find acceptance, kinship, and love in the places they have attempted to call home.

Finding Purpose

Meteorites are rare because they typically burn up when entering Earth's atmosphere. Every specimen found offers an opportunity to contextualize Earth's place in the galaxy. On September 28, 1944, the Smithsonian received in the mail a small sample of this iron meteorite measuring 3 cubic feet and weighing 1,164 pounds. Sent by Yoshio Nishimoto and Akio Ujihara, the return address was 34-7-D Topaz, Utah, one of America's concentration camps.

Nishimoto (1903–94) and Ujihara (1899–1991) were middle-aged men working in California when Executive Order 9066 upended their lives and livelihoods. Nishimoto ran a boarding house in Stockton, where he was born and raised. Ujihara was working in landscaping in Los Angeles after earning a degree from the Polytechnic Engineering College in Oakland. In camp, they, like others, faced hours devoid of the purpose and hard work that had defined their prewar lives. To lift their spirits, inmates organized activities in which they produced painting, ikebana, woodwork, bonsai, and even lapidary—the cutting and polishing of stones.

The two men were part of the Topaz Lapidary School. In September 1944, while searching for chalcedony near the Drum Mountains, they noticed a large rock with a peculiar shape and "swiss cheese"-like depressions on the surface. They surmised it was metallic because of the "bing" sound it made when struck with a pick, the spark a fragment gave off against a grinding wheel, and a series of other tests they ran with a magnet and compass.

Nishimoto and Ujihara eventually reached E. P. Henderson, Smithsonian associate curator of minerology and petrology, who immediately recognized the significance of the find. Henderson cautioned the men from spreading word of the specimen's whereabouts lest commercial dealers try to undermine their claim to it. He asked about their interest in minerology, sent them readings, and expressed a hope that they would one day visit DC. His letters were overwhelmingly supportive. But in one letter to the camp's evacuee property officer, he writes, "I assume that neither of the men are military prisoners of war." His aside reflects how little the public understood about the nature of Japanese American incarceration. Topaz was among ten camps run by a civilian agency, and it was populated by people forcibly removed from their homes in the United States.

Nishimoto and Ujihara in turn wrote to Henderson about their personal histories, how they discovered the meteorite, complained about inaccurate information in a press release, and arranged for the meteorite to be shipped to DC. They were compensated $700 for their discovery, and Henderson arranged for them to receive prepared cuttings from the meteorite.

After the end of World War II, Nishimoto and Ujihara returned to their California communities and continued their mineralogical pursuits in regional clubs. In one of Ujihara's 1944 letters to Henderson, he commented on how their exchanges reminded him of the intellectual inspiration he had felt in college. In another he wrote, "I lost my home, business, and major part of my savings due to the evacuation. But it is only infinitecimal [sic] compared to the millions of people of war zones. My only desire is that by this incident it may benefit to the scientific world and in some way it may help to open a way to establish a better world for the coming generations."

—Sojin Kim

Meteorite discovered by Yoshio Nishimoto and Akio Ujihara near the Drum Mountains, Utah, 1944.

Hawaiian Sovereign of Change

Under the foresight and brilliance of Keaweawe'ula Kīwala'ō Kauike aouli Kaleiopapa, aka Kamehameha III or affectionately known by his subjects as Kauikeaouli, the Kingdom of Hawai'i was the first non-European country recognized under international law on November 28, 1843. Recognition of state independence was enacted with the signing of the Anglo-Franco Proclamation. That treaty was the first of many between the Kingdom of Hawai'i and other nation states that saw Hawai'i's presence grow to over ninety ligations and embassies around the globe.

As a burgeoning country and strategic location in the Pacific, the Kingdom was a destination for exchange, provisioning, and trade. With the interisland commerce and world appetite for Hawaiian goods like sandalwood and sugarcane, the Kingdom needed a unified currency. To compound the matter frequent foreign coin shortages in the islands added to the urgent need for a stable currency. In May 1846, Kamehameha III sought to alleviate the monetary shortages by commissioning the Kingdom of Hawai'i keneta (one cent).

The keneta was designed by Edward Hulseman and reputed to have been minted in the United States at the private mint of H. M. & E. I. Richards of Attleboro, Massachusetts. The value of the keneta was proportionate to the United States penny and the original minting consisted of 100,000 copper keneta backed by silver in the Kingdom of Hawai'i treasury. Not all Hawaiian subjects were enthusiastic with the results of their first coin. The newly minted coins that were delivered to Hawai'i via ship had a rough casting and worn appearance from being transported in the bilge portion of the ship's hull. Even worse, the poor engraving of Kauikeaouli's image and the misspelling of "Hapa Haneri," which should have been "Hapa Hanele" (portion of one hundred), made for a less than desirable debut.

The keneta within the National Museum of American History's collection is known as the "Large Bust" version where the number four on the date has a crosslet. Another version of the keneta has a plain non-crosslet four referred to as the "Small Bust." The image on the front of the keneta is a bust of Kauikeaouli with the phrase "Kamehameha III. Ka Moi" (Kamehameha III. The King). The back of the coin displays a laurel wreath and the phrase, Aupuni Hawai'i (Hawaiian Nation). What began with a somewhat disappointing one cent led to the further minting of Kingdom of Hawai'i national coins and paper denominational currency used throughout the islands by nationals and foreigners alike.

—Kālewa Correa

Copper Keneta (one cent) featuring the profile of King Kamehameha III of the Hawaiian Islands (1813–54), the first of only five coins issued for general circulation in the Kingdom of Hawai'i.

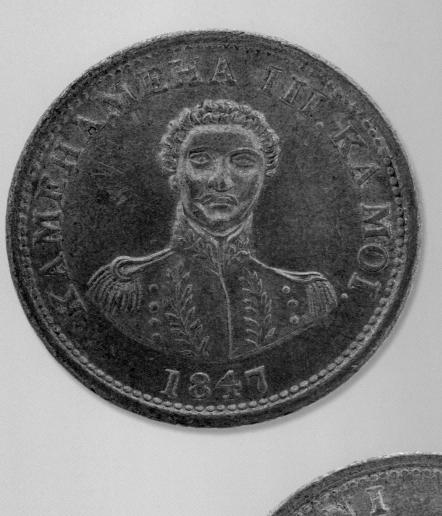

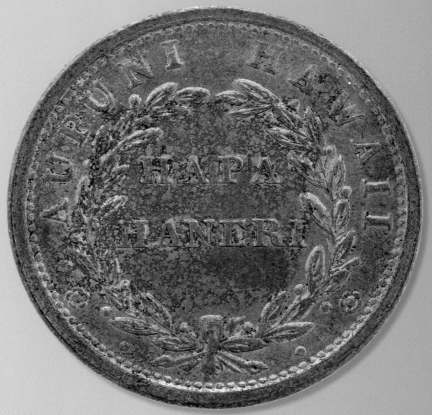

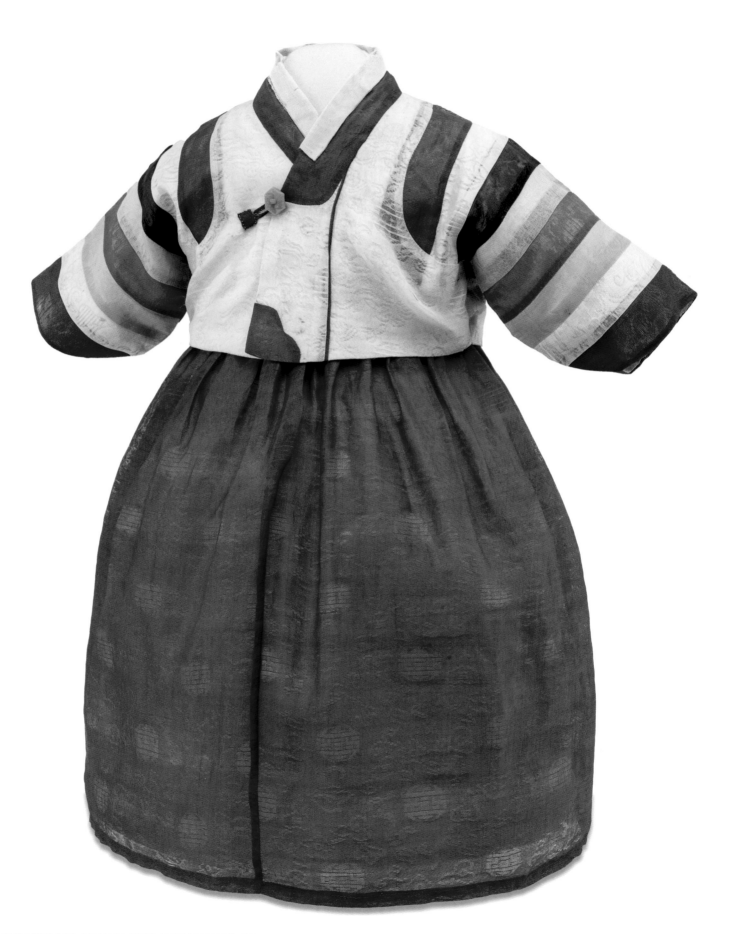

Fabric of Connections

The word hanbok, meaning "Korean clothing" or "Korean dress," is used to distinguish the often-colorful Korean style of clothing from Japanese or other styles. Hanboks can be traced back to the Three Kingdoms era of ancient Korea, from roughly 57 BC to 676 AD, with connections to ancient styles of clothing found throughout China and Central Asia. Hanboks have survived as a style of formal, informal, and everyday dress for children, men, and women in all social classes throughout history. During the Japanese occupation from 1910–45, wearing white hanboks—the most common form of hanbok worn by everyday people—was outlawed. Linguist Choi Nam-Seon has written that ancient Koreans wore white to represent the nation, a practice maintained to affirm their national identity. During the occupation years, wearing a white hanbok was an expression of resistance.

Since the occupation years and the introduction of Western clothing styles throughout the twentieth century, the hanbok has become a less frequent style of everyday dress. Today, the hanbok continues to be a significant form of dress for ceremonial and formal events, such as weddings, funerals, and festivals. Some people continue to wear hanboks every day in modest styles and colors. Fashion magazines, such as *Vogue Korea*, have published editorials featuring modern hanboks with shortened skirts and different fabrics with new tones and patterns, paired with modern hairstyles and jewelry. With the recent popularity of Hallyu, the "Korean Wave" of pop culture through television dramas, music, movies, and more, we can see traditional and modern forms of hanbok. Take, for instance, any of the period K-dramas. *Kingdom*, a Joseon Dynasty period piece and zombie thriller, shows a variety of hanboks, from the ultra-colorful styles of royalty to the less colorful and white hanboks worn by commoners.

In South Korea, hanboks are more accessible through boutiques, rental companies, and online shopping. But what does the hanbok mean for diasporic and Korean American communities? Liz Sohyeon Kleinrock, a transracial adoptee born in South Korea shared, "I cried the first time I wore a hanbok and saw my reflection in the mirror. Any sense of imposter syndrome and feeling 'not Korean enough' faded away. Hanboks have been worn by my people for thousands of years, and here I am as living proof that our legacy continues." Rep. Marilyn Strickland, the first Korean American and first Black American elected to Congress from Washington state, wore a hanbok to her swearing-in ceremony in Washington, DC, to honor her Korean immigrant mother. She said, "It [the hanbok] is something that you wear for a very special occasion. It is very traditional and historic. I wanted to honor my mother. . . . I knew that she'd be watching [the ceremony] and so I wanted her to see me wearing that, to honor my history and to honor her."

Today, in Korean American communities across the United States from Los Angeles to New York City and Northern Virginia, hanboks can be found in family-run businesses and worn at community festivals and events, with styles ranging from traditional to modern, colorful to modest. Ultimately, from ancient times to today's interconnected world, the hanbok offers meaningful, perhaps welcomed or pained, connections to culture, memory, homeland, and a sense of place and belonging, no matter where one is in the world.

—Andrea Kim Neighbors

Child's hanbok (traditional Korean dress) with jacket worn by Betty Holt Blankenship in 1955.

Hawaiian Flag Quilt

The ancient practice of kapa moe involved beating the soft bark of the wauke (paper mulberry) plant into a fine textile upon which designs could be added. The resulting fabric—used in ceremonial events, as trade items, and bed coverings—serves as the foundation for Hawai'i's quilt-making tradition. In the early 1800s, the wives of American missionaries and the spouses of Western royalty shared their quilting techniques with Hawaiian women, who combined them with Native practices. Motifs for the quilts included images of flora inspired by the beauty of local plant life that had provided nourishment for thousands of years. Hawaiian quilts are still given as gifts to mark special occasions such as births or to honor esteemed individuals.

Rosina Kalanikauwekiulani Ayers (1877–1966) owned this Hawaiian flag quilt, which represents another distinct subset of the tradition; rather than depicting images of plants and nature, the subject matter is an emblem of the Hawaiian nation. The quilt was gifted to her when she married a doctor from the US continent, Robert Dinegar, in 1898. In the local paper, the *Wailuku Maui News,* Dinegar was listed as having an active practice in Puunene as late as 1906. Ayers's mother supposedly served Queen Lili'uokalani as a court interpreter. By 1909, Dinegar and Ayers had moved to Albany, New York, leaving behind a Hawai'i that had witnessed the tumultuous end as a sovereign nation.

The popularity of Hawaiian flag quilts coincided with the changing nature of Hawai'i's sovereignty throughout the nineteenth century. The traditional quilt design involved four Hawaiian flags positioned around a central image, usually royal coats of arms along with text such as "Ku'u Hae Aloha" usually translated as "My Beloved Flag." In Ayers's quilt, the Hawaiian text translates to words attributed to King Kamehameha III from a speech in 1843, "The Life of the Land is Perpetuated by Righteousness." The appearance of the two guardians in the central coat of arms is apparently not common in many Hawaiian flag quilts.

The tradition of quilts incorporating the Hawaiian flag speaks to larger social and political conversations on the islands. Native Hawaiians did not remain silent in the run-up to annexation. On September 6, 1897, an organization called the Hui Aloha 'Āina held a public meeting to discuss Congress's plan. The organization's president, James Kaulia, raised his voice: "We, the nation (lāhui) will never consent to the annexation of our lands, until the very last patriot lives." The quilt was gifted to Ayers and Dinegar during the same year that Hawai'i would be formally annexed to the United States—five years after the overthrow of the sovereign Hawaiian kingdom by American businessmen with the help of a marine detachment. Quilts such as these would have been poignant reminders of the struggle for control over one's sovereign government but also an expression of support for the deposed Queen Lili'uokalani.

—Theodore S. Gonzalves

Hawaiian flag quilt gifted to Rosina Kalanikauwekiulani Ayers and Robert Henry Dinegar on the occasion of their wedding in 1898.

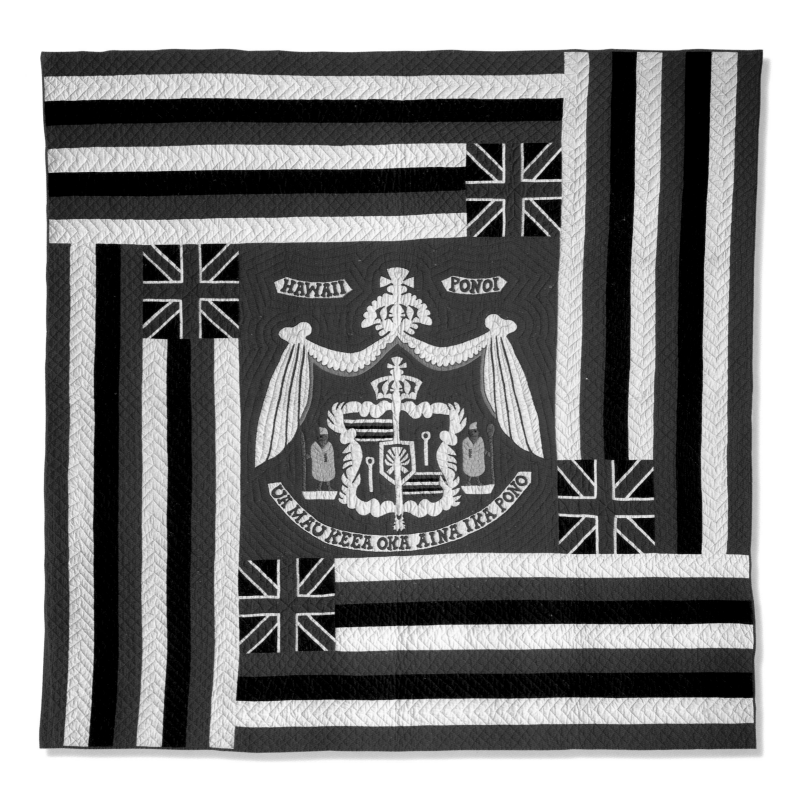

1st Filipino Infantry Insignia

The "date which will live in infamy" is actually two days. The first refers to the Japanese attack on US forces at Pearl Harbor in Hawai'i, at that time a territory of the United States. The second attack occurred ten hours later, in Manila, where the US had established its strategic foothold to Asia in 1899. At the time of the attack, the Philippines was a US commonwealth. For thousands of Filipinos on Hawai'i and in the continental United States, the simultaneous attacks were devastating. Many wanted to join the US military and defend their families, either in the US or in the Philippines.

Labor recruiters in 1903 had lured many Filipinos to work on plantations in Hawai'i. In the mid-1920s, responding to contractors offering jobs on the West Coast of the continental United States, workers arrived in the tens of thousands, hoping for better conditions. They found work in agricultural fields and factories or as domestics and cooks, but there was little opportunity for advancement or citizenship.

Nativists had for years been pressing for the exclusion and deportation of Filipinos from the country. The passage of the 1934 Tydings-McDuffie Act changed the legal status of thousands of Filipinos from US nationals to aliens. While the United States' entrance into World War II offered millions the opportunity to serve in the armed forces in a global war on two fronts, thanks to the Tydings-McDuffie Act Filipinos were not allowed to serve in the military. Nevertheless, it took only two weeks from the time of the Pearl Harbor attack for Congress to amend the Selective Service and Training Act to allow enlistment of citizens and "every other male person residing in the United States." It took a global war to welcome Filipinos back. To the long list of backbreaking work that they had done as farmers,

PARADE - END OF BOND RALLY, SAN LUIS OBISPO, CALIFORNIA.
SWEARING IN OF 1000 MEN AS CITIZENS OF THE UNITED STATES, CAMP BEALE, CALIFORNIA.

factory workers, domestics, and cooks, they could now add soldier, sailor, and steward.

Two hours south of San Francisco, at the southern end of the Monterey Bay, the US Army activated the 1st Filipino Infantry Regiment and the 2nd Filipino Battalion at Fort Ord, California. The "1st Fil," as it has been referred to, earned battle honors for service in New Guinea, Leyte, and the Southern Philippines. The unit also earned the Philippine Presidential Unit Citation.

The shoulder sleeve insignia for the 1st Filipino Infantry Regiment depicts Mount Mayon in the Philippines, the country's most active volcano. The stars above represent the archipelago's three major regions—Luzon, the Visayas, and Mindanao—often referred to in a portmanteau as "Luzviminda." The three stars appear in the Philippines' national flag. According to a regimental yearbook, the black background refers to the erupting volcano while the contrasting piping refers to the "golden opportunity of restoring the country to its rightful owners."

Left: Insignia worn by members of the 1st Filipino Infantry Regiment, active 1942–1946. Right: The 1st Filipino Regiment in Camp Beale, California.

—Theodore S. Gonzalves

Zarina's Poetic Legacy

Artist Zarina Hashmi (1937–2020), professionally known as Zarina, was born in Aligarh, the center of modern education and scholarship for Indian Muslims in pre-Independence, pre-Partition India. As a child, Zarina and her family fled to Pakistan during Partition, bearing witness to catastrophic sectarian violence during the mass migrations and solidifying the themes of home, displacement, borders, and writing that recur in her art. After returning to India and earning a degree in mathematics from Aligarh Muslim University, Zarina studied a variety of printmaking styles in Thailand, France, and Japan. In the 1960s, the last of Zarina's family left their ancestral home of Aligarh for Pakistan, cementing the indelible sense of loss and displacement that would become major themes in her art. Following her husband's death in the late 1970s, she settled in New York to continue her five-decades-long career as an artist, educator, and feminist leader in the fine arts.

Zarina's body of work often features references to Islamic geometric design and explores fluid concepts of home, reflecting her identity as a displaced Muslim, Indian woman, and world traveler. The layout of Zarina's childhood home in Aligarh, highlighting a traditional South Asian design of four outer walls enclosing a courtyard garden and living area—the home's inner sanctum—became an influential motif in her art.

In *A House of Many Rooms,* Zarina offers short, poetic phrases alongside sparse, map-like drawings on her medium of choice, handmade paper. "Paper is an organic material, almost like human skin," she once noted about her preference for working with and on paper—explaining in a few words the depth and intimacy of her timeless, minimalist art. The series of four etchings are characteristically minimalist, utilizing the techniques of space and repetition to evoke feelings of quiet loneliness, movement, and dispossession. She created the prints as a reference to the small Paris apartment where she lived with her husband, echoing her lifelong reflections on the meanings of home and displacement.

—Nafisa Isa

House of Many Rooms *by Zarina Hashmi, two of four etchings on paper, 1993.*

Once I lived in a house of many rooms

I walk from room to room

THE STAR-SPANGLED BANNER

Layered Translations of *The Star-Spangled Banner*

Scaled to the human body, Christine Sun Kim's large drawing *The Star-Spangled Banner (Third Verse)* (2020) confronts viewers, asking them to consider their personal relationship to the titular subject, the national anthem of the United States. Kim (b. 1980) developed this piece to process her own conflicting feelings after being invited to perform this song for millions as the American Sign Language (ASL) interpreter for the 2020 Super Bowl, and then learning the broadcast undermined any purported accessibility by cutting away from her after a few seconds.

As Kim wrote in a subsequent op-ed for the *New York Times,* "As a child of immigrants, a grandchild of refugees, a Deaf woman of color, an artist and a mother, I was proud to perform the national anthem . . . to express my patriotism and honor the country . . . that, at its core, believes in equal rights for all citizens, including those with disabilities." However, she declares her performance simultaneously an act of patriotism and of protest, marking the distance between professed beliefs and realities in the United States, from the time of the anthem's writing to today. Aware of standing at the intersection of multiple identities still struggling for equity, she points to the disproportionate police violence that people of color and people with disabilities experience in America. Tackling this requires that disability and racial justice advocates, like her and sidelined football star Colin Kaepernick, use moments in the national spotlight to demand that promises turn into actual equality and access.

Drawing inspiration from this dissonance, Kim turned her performance preparation and research into a series of score-drawings that show her translating phrases into the ASL words and syntax that would match her movements to the rhythms of the sung verse. In this piece, her signature thick charcoal lines and slightly smudged words bring attention to the infrequently sung third verse, in which lyricist Frances Scott Key, a slaveholder, declares:

No refuge could save the hireling and slave
From the terror of flight or the gloom of the grave

In her accompanying artist statement, she explains that she placed the boldface words under the long, striped notes "as if they're part of the flag." These lyrics are interpreted by some historians as Key's disparaging of the enslaved Black Americans who fought with the British in hopes of emancipation. In Kim's visual interpretation, then, both the anthem and the flag are complicated by slavery's centrality to the country's founding and the way this historical fact remains embedded in contemporary patriotic rituals.

Kim was born in 1980, in Orange County, California. Her hearing parents, recently arrived from South Korea, learned to sign along with spoken English as part of building their family life in the United States. Kim's art attends to the many layers of translation required by all modes of communication. As a self-described sound artist, she approaches this field conceptually, psychologically, and socially, rather than as a singular medium. She creates billboards, murals, videos, performances, works on paper, and audio installations to illuminate the pervasive, multisensory social world of sound and assert her place in it.

—Saisha Grayson

The Star-Spangled Banner (Third Verse) *by Christine Sun Kim, 2020.*

Duality of Identity

Immigrant experiences often evoke a sense of *duality*—a splitting of culture, of nationality, of self. Few artists illustrate this in their work as vividly as Shirin Neshat (b. 1957), who makes films and photographs that meditate on the complex ways that identity, culture, and land intertwine. Her short film *Fervor* is composed of two screens displaying landscapes, buildings, and bodies in sharply contrasted black and white. The screens sometimes mirror each other, and at other times diverge, separating the subjects of the story by gender. This duality is emphasized further by the film's main scene, which takes place in an Iranian town's Friday prayer, where a black curtain physically segregates men from women, while a speaker professes the virtues of chastity.

Fervor is a meditation on gender roles in Iran where Neshat was born, at tension with the perspectives she adopted in America where she experienced adulthood. She left Iran in 1975 to study art at the University of California, Berkeley, just before the Iranian Revolution of 1979, which resulted in a mass upheaval of Western influences, including beliefs about a woman's place in society. Twenty years later, when Neshat returned to Iran, she reckoned not only how much her homeland had transformed, but how much she had as well. In the Iran where Neshat grew up, women's fashion was similar to that in America. In the 1990s, Neshat encountered women dressed in full-bodied black chadors—which have since become signature imagery in much of her work.

One of *Fervor*'s protagonists is a woman dressed in such a chador, and as the film opens, the right-side screen follows her walking down a dirt road. On the left screen, similar shots depict a man walking down the same road toward her. The two eventually cross while barely acknowledging one another, aside from slightly slowing their pace, the man glancing back as the woman continues walking with a subtle smile. Our protagonists reappear in the next scene, this time assigned by gender group at Friday prayer. The music and the speaker's voice intensify as the two characters seem to sense each other's presence, intermittently looking toward each other as if through the veil separating them, with decreasing attention to the speaker. As the crowd begins chanting with the speaker, the woman stands and exits, leaving everyone behind her, including the man.

Fervor was filmed in 2000, just as the United States was undergoing its own shift in relationship with Islam. A characteristic of the Islamophobia that intensified in America following 9/11 is a misperception that Muslims are of a single mind and identity—a stereotype that can also be applied to the attire that some Muslim women wear. *Fervor* is Neshat's invitation to look deeper—to recognize that every story has another side, that each figure in a crowd is a unique individual.

—Adriel Luis

Still from Shirin Neshat's Fervor, *2000.*

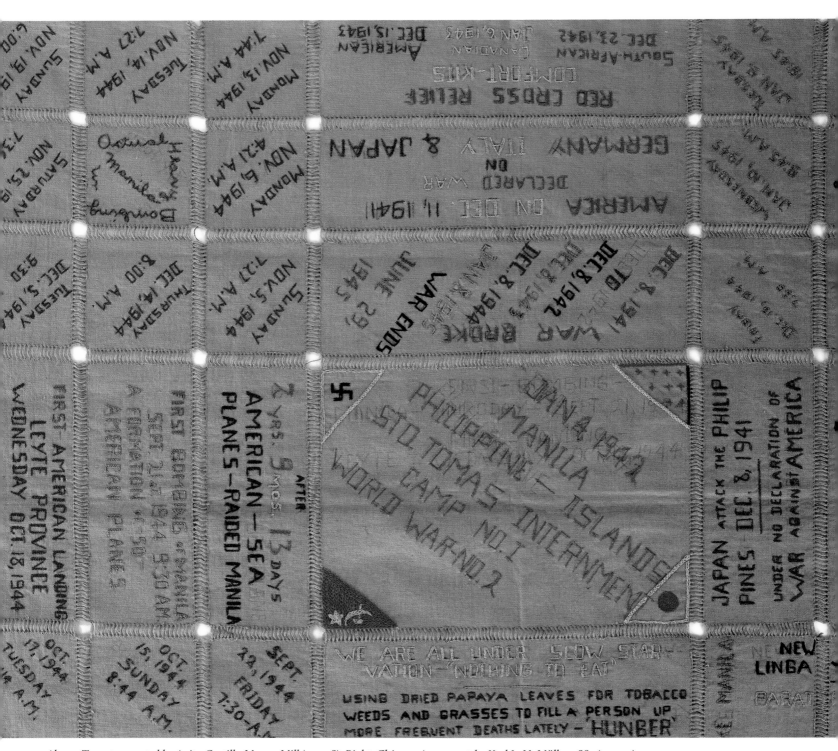

Above: *Tapestry created by Anita Castilla Monzo Mill (pg. 118). Right:* Chinese Argument *by Karl L. H. Müller, 1882 (pg. 110).*

CHAPTER SIX

Tragedy

The task of bearing witness to tragedy should be clear-eyed, thorough, and unceasing. Anti-Asian violence has a long arc with complicated contexts, including blaming Asians for introducing disease or taking the jobs of "locals." Perhaps one of the worst aspects of brutality faced by Asian Americans and Pacific Islanders is the internalizing of American society's race codes that accept the terms of white supremacy's dehumanization. Some of the objects in this section embody hurtful sentiments. However, two items—the work by Jimmy Mirikitani and the tapestry woven by Anita Monzo Mill—convey the will to address the tragedy of war. No group should be defined solely by the worst that has been done to them.

Reverse Ethnography

A photograph from the Smithsonian's ethnology exhibit presents the viewer with a large and imposing room located in the eastern side of the building's first floor. Within the room are numerous large, glass cases enclosing various items. One case, in the foreground, displays what appear to be six human figures. There is no explanation of who the persons might be or what they are doing. Labels refer only to "Samoans" and "Polynesians." We do not know why the curators chose to pose the adult couple in the case in that way, nor do we know about the young persons at their feet, or in what activity they are engaged.

The image is from Bulletin 80 of the United States National Museum, *A Descriptive Account of the Building Recently Erected for the Departments of Natural History*, from 1913. The focus of the document is on the venue, not the exhibit: "The latest of the great museum buildings of the world" tasked with displaying "all objects of art and of foreign and curious research." The building's footprint was massive, more than 106,000 square feet of exhibition space. The ethnology section alone took up 35,000 square feet.

Smithsonian staff had no shortage of objects to choose from in creating the display. Years before Congress established the Smithsonian in 1846, scientists, military officials, and civilian naturalists embarked on a massive collecting effort that yielded thousands of items. Six vessels of the United States Exploring Expedition, commanded by Charles Wilkes, launched from Hampton Roads, Virginia, with 346 men. The route was global, with stops along the eastern and western coasts of South America, Tahiti, Samoa, Sydney, Antarctica, Hawai'i and Polynesia, Puget Sound, the Philippines, Borneo, Singapore, and New York.

Scholars have detailed records of what the Wilkes Expedition netted: 4,000 ethnographic artifacts, 50,000 pressed plants, 2,150 birds, 134 mammals, 588 fish, 300 fossil species, 400 species of coral, 1,000 crustacean species, and 208 jars of insects.

To dress the case with items from Samoa, Smithsonian curators could choose from many objects: arrows, copious amounts of tapa (bark cloth), skirts, baskets, bowls, cups, dishes, fans, fishing hooks and lines, and war clubs.

One of the cultural group categories used to identify the objects, which included Tonga, Maori, and Fijian, was that of "savage islander."

It can be challenging to make sense of ethnographic displays from more than a century ago. Artists like Coco Fusco and Guillermo Gomez-Peña developed a tactic that they described as a counter-quincentenary project slated for 1992. In their interactive display called *Two Undiscovered Amerindians*, they performed "traditional" actions—sewing dolls, lifting weights, watching television, and working on a laptop computer—all from the protective enclosure of a cage. They presented themselves as "Guatinau" and uttered gibberish while two guards (their coconspirators), fielded questions. The performance artists conceived of the project as a "reverse ethnography"; commentary on Western concepts of the exotic, primitive Other; and a way to challenge simplistic approaches by dominant cultural institutions to celebrating multiculturalism.

Two Undiscovered Amerindians toured London's Covent Garden, Madrid's Columbus Plaza, New York's Whitney Museum, Sydney's Australian Museum of Natural History, Chicago's Field Museum, the University of California (Irvine)'s Fine Arts Gallery, and the Smithsonian's National Museum of Natural History.

In watching the watchers, the artists played with a very old practice—one dating to 1493, according to Fusco; she claimed that Christopher Columbus returned to Spain and displayed a Caribbean Arawak until that person's death two years later. Thinking about the figures posed in the Smithsonian case, there are many viewpoints and stories to imagine—whether those of Pacific Islanders, curators, or visitors.

—Theodore S. Gonzalves

Anthropology Hall, United States National Museum, 1913.

Chinese Argument

Museums can find it difficult to responsibly exhibit items that might trigger negative responses among visitors. Institutions will frequently rotate items out of display, perhaps shortening exhibit periods or deciding not to make them available for public view. Other venues like Ferris State University's Jim Crow Museum of Racist Memorabilia touts the "nation's largest publicly accessible collection of artifacts of intolerance." There is no ideal solution. But establishing context with the best scholarly research and community-based relationships is indispensable. The Union Porcelain Works figure is no exception.

Sculpted around the 1880s by the German-born American sculptor Karl L. H. Müller (1820–87), this porcelain figure was donated to the National Museum of American History by the descendants of Thomas Carll Smith, the proprietor of Union Porcelain Works (UPW) based in Greenpoint, Brooklyn, New York. Smith bought the company in 1862, expanded and modernized UPW's operations and turned it into a major player in porcelain production. They produced a variety of decorative wares—dinnerware, tea sets, vases, tiling, and accents used throughout the interior and exterior of houses, apartments, and offices.

Smith hired Müller in 1874 to serve as chief designer. In two-years' time, the nation was to mark its centennial, and Smith aimed to create a unique style of American ceramics—one distinct from European practices—before then. UPW's designs turned to American literature and folklife for inspiration. Müller's vases celebrated a century of progress.

The Figure Group depicts a young white boy wearing a Liberty cap, with his right arm around a classic national symbol, the American eagle. They sit atop a tree trunk in what appears to be a large nest. The boy's left hand presses down on the back of what seems to be a young Black boy peering over the edge of the nest, like a fledgling. Clinging precariously to the side of the trunk is a young Chinese male, shown wearing his hair in a traditional queue (long single braid, a Chinese practice dating back several centuries). He either fell or was pushed out of the nest or is attempting to climb up over its edge.

In museums located in Indianapolis and Brooklyn, similar figurines attributed to Müller are titled "Chinese Argument," and have invited a variety of interpretations. Collector Matthias Blume opines that the object conveys a message that is "likely a cry against" the late nineteenth century attitude of Chinese exclusion. Bonnie Lilienfeld, ceramics curator at the American history museum, finds the message of the figurine to be ambiguous: "Is it sympathetic toward the foreigner working hard to get into the nest, or does it imply that there is no more room?"

Barry Harwood, curator of the decorative arts collection at the Brooklyn Museum, finds no ambiguity, instead hearing an echo: "The Chinese had been here even longer than the recent immigrants, but they were willing to take any job, and of course, these were jobs that the European immigrants probably didn't want. You think about today with the Mexican and Latino immigrants—it was the same thing. As I said, not a very proud moment." Initially welcomed by companies to mine gold and build what would eventually become the transcontinental railroad, Chinese workers faced growing resentment by nativists who were eventually successful in convincing Congress to pass the Chinese Exclusion Act of 1882 (along with the Page Act of 1875). This federal legislation denied immigration to the United States on the basis of ethnicity and national origin.

The need for Asian labor persisted. Recruitment from Japan, India, Korea, and the Philippines continued. And so followed nativists' narrow vision of the American community. Lynching, violence, and riots intimidated Asians throughout the 1870s to the 1940s. Congress continued to pass repatriation, deportation, and exclusion laws in 1917, 1924, and 1934. While the 1882 exclusion act was repealed in 1943, the notion that Asians and Pacific Islanders were perpetual foreigners stubbornly persisted.

—Theodore S. Gonzalves

Chinese Argument, *a porcelain sculpture by Karl L. H. Müller created for Thomas Carll Smith's Union Porcelain Works, ca. 1882.*

St. Louis World's Fair Pamphlets

The relatively short four-month Spanish-American War of 1898 served as a prelude to the lesser-known and brutal US-Philippine War (1899–1913). While the US was still waging war in different parts of the Philippines, a variety of interests converged in what would become detailed exhibits, first in Buffalo in 1901 and again in 1904 in St. Louis, an exposition to mark the centennial of the Louisiana Purchase. Antero Cabrera, just a sixteen-year-old teenage boy, became a highly sought-after interpreter, able to facilitate communication across a number of groups in the Chico River area of the Cordillera region in the northern Philippines. Anthropologist Albert Jenks had been conducting research in the Bontoc region that would be published in 1905 and sought out Antero's help. Antero was not only able to secure objects from different families in the area; he facilitated contact with American businessmen who drew up employment contracts for their performance work at the fair.

An orphan in the Philippines who studied in missionary schools, Antero worked as a house boy for three Americans: an anthropologist, a missionary, and a businessman. His ability to speak multiple languages and dialects served him well as the Americans planned exhibitions in the United States that would feature Filipino persons and objects.

The story of Antero Cabrera is unique. He was neither an immigrant who moved from the "old world" to the new, or the figure of the exploited unskilled laborer who couldn't seem to find any breaks along the journey. He's remembered, along with a generation of travelers to the United States, as part of the *Nikimalika*, a Bontoc expression for "those who went on the early journeys to America (*Malika*)."

In all, about 1,200 Indigenous persons and Filipinos journeyed to the St. Louis World's Fair, a trip that likely took them more than a month to complete. Twenty million visitors passed through the gates during the fair's seven-month run, gawking at everything from advances in technology, such as wireless telephony, to culinary novelties. The Philippine Village was the fair's biggest attraction, a 47-acre theme park (the entire fair consisted of 1,300 acres) that mirrored what westerners understood as the main regional differences of the Philippines and its people.

Multiple groups of Filipinos and Indigenous persons engaged in a variety of activities that ranged from blacksmithing and weaving, to decontextualized mourning rituals, to modern synchronized marching and uniformed band arrangements. The narrative wasn't simply to demonstrate that persons from the Philippines were "savages," but rather that the bloody war costing the lives of thousands of American volunteers was worth it. Overall, the varied presentations conveyed a self-congratulatory narrative of progress where Americans could be credited. The then president of the United States could also claim that the Philippines was a safe bet for capital investment.

The descendants of the Nikimalika recall how their ancestors came back from the fair with a variety of items: US coins, American styled clothing, photographs, medals, and guns. Scholar Patricia Afable notes how some in this early generation of performers also returned with changed attitudes: "the young travelers had gambled their money away, come home 'spoiled,' became 'dandies,' and [were] unable to return to the rigors of rural agricultural life." The Nikimalika remember Americans at the fair as being kind, indulgent, and gullible.

The concept of the "human zoo" has itself become the subject of major exhibits, at the Musée du Quai Branly in Paris and the Africa Museum of Belgium, that reconsider how global ideas of race, power, and domination converged at the world's fairs. These efforts are part of overdue but necessary conversations about the ethics of interpreting and presenting knowledge by and about humans.

—Theodore S. Gonzalves

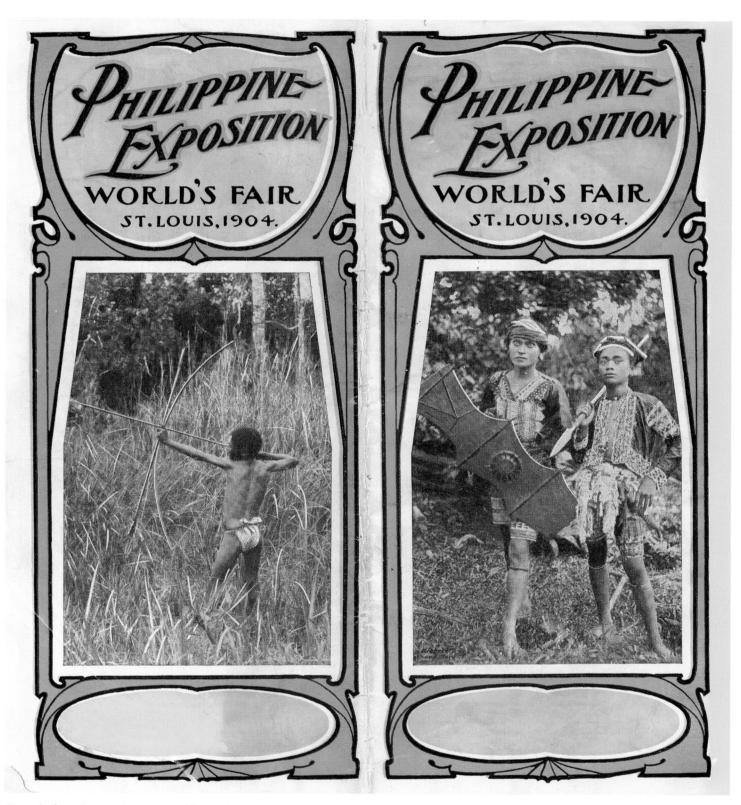

Keepsake from the 1904 St. Louis World's Fair focusing on the exposition's biggest attraction, the Philippine reservation.

Moro Brass Helmets

The earliest Smithsonian Institution weapons collection arrived in 1838 as part of the Wilkes expedition. These include thousands of swords, daggers, spears, chest armor, and shields. Ethnology curator Herbert W. Krieger's 1926 report, issued in the aftermath of two major conflicts in the Philippines—the Spanish American war (April–December 1898) and the US-Philippine war (1899–1902)—pointed to the "stimulus aroused by the Spanish-American War and the native insurrection in the Philippines," which accounted for an influx of the weapons cache at the museum.

A variety of brass helmets were donated by US Army officers. The Smithsonian's own Robert B. Grubbs's collecting work also added an assortment of weaponry such as serpentine lance blades and leaf-shaped daggers. Grubbs was no expert in the history of Southeast Asian weaponry, however, as an earlier Smithsonian report from 1913 titled "A Review of the Philippine Land Mammals in the United States National Museum," lists him as having collected thirty-five specimens for the museum—one colugo (a so-called flying lemur) and thirty-four bats. Such was the ad hoc nature of expertise at the Smithsonian at the time.

In describing the cast brass helmet shown here, Krieger made a point of noting the helmet's resemblance to those worn by sixteenth-century Europeans, of the burgonet or morion variety. He cites a painting by the famous Filipino artist Juan Luna, *El Pacto de Sangre* (1886), which depicts Datu Sikatuna engaging in a 1565 blood compact with the Spaniard Joaquin Legaspi, where the parties validated their agreement in the mixing and drinking of blood droplets. Sikatuna's face is obscured but the armor and distinctively shaped helmets worn in the painting provided historical and cultural references for Krieger.

Moros (native Muslims of the Philippines) adopted the design, and also added their own flourishes to the helmet's plating. Krieger notes the "floriated arabesque pattern" found on other related weaponry that Army officers obtained from Filipino fighters.

The Moro armor in the Smithsonian's collection is also a grim reminder of not only what gets voiced but also what is silenced in the archive. Many popular and scholarly accounts of the Philippine war frame it at the margins of the earlier Spanish-American conflict. Even as President Theodore Roosevelt triumphantly declared victory in 1902, fighters in the southern Philippines resisted American colonization until 1913. Not all Americans celebrated the final victory. Moorfield Storey, president of the American Anti-Imperialist League, responded to the shocking news of what was described as the Moro Crater Massacre in 1906, where nearly 1,000 Filipino men, women, and children were killed by an American detachment. Storey linked racial violence at home and abroad: "The spirit which slaughters brown men in Jolo (an island in the southern Philippines) is the spirit which lynches black men in the South." He later served as the president of the National Association for the Advancement of Colored People.

—Theodore S. Gonzalves

Moro brass helmet from Iligan, Mindanao, Philippines, ca. early 1900s.

Mirikitani: Grand Master Artist

Emerging from a thicket of verdant bamboo, a large white and black striped cat crouches expectantly by a stream that meanders along the bottom of the composition. The arching and sloping black stripes are a landscape unto themselves. The dynamic rhythm of the interlocking bands of black lines recalls a mountainous topography, one that is reminiscent of the landscape of Hiroshima, where the artist, Jimmy Tsutomu Mirikitani (1920–2012), spent his childhood. This geographic grounding is underscored by the work's title, *Cat in Bamboo, Hiroshima*. Cats—at rest, curled around vividly orange *kaki* (persimmons), peering mischievously up at fish-ladder tables—are a reoccurring theme in the artist's extensive oeuvre. Although the cat in the bamboo grove gazes with rapt attention at something beyond what can be seen in the image, Mirikitani positions this scene so close to the work's foreground that viewers are invited into an intimate dialogue with the cat.

Born in 1920 in Sacramento, California, to Japanese Issei (first-generation immigrant) parents, Mirikitani moved to Hiroshima, Japan, as a young child. He was part of a generation of Japanese Americans known as Kibei, born in the United States but primarily educated in Japan. Mirikitani took up painting at the age of five. At eighteen, he returned to the United States to continue pursuing a career as an artist and escape the intensifying militarism of Japan. In 1942, Executive Order 9066 separated Mirikitani from his sister, Kazuko, and forced them into different concentration camps. While incarcerated at California's Tule Lake, Mirikitani found ways to continue to make and teach art. Years later, he explored his traumatic experience in his art—picturing scenes of the prison camp as disquietingly vacant—human presence inscribed onto the landscape through ghosted barracks and tombstones. Mirikitani's work engages the way that the violence enacted by the United States government domestically spiraled outward. Many of his works depict the catastrophic consequences of the atomic bombing of Hiroshima. Marked by fragmentation, imperial violence, loss, resilience, refusal, and survival, his works about the dehumanizing experience of incarceration and the atomic bombings of Japan are insistent reminders that these histories cannot exist at the margins of our collective national memory.

Incarceration, familial separation, the illegal stripping of his American citizenship, and the destruction of his childhood home profoundly shaped Mirikitani's life. Between the 1980s and 2001, Mirikitani experienced significant periods of homelessness, but never stopped making, selling, and teaching art. His works are important records of resilience, places where one can imagine alternative national narratives and identities. In *Cat in Bamboo, Hiroshima*, Mirikitani forestalls the images of atomic horror that are often associated with the city, instead presenting an intimate memory of home. In the bottom right corner of the work, he claims his place within a larger history of art. Noting his membership in the prestigious Nihon Bijutsuin [Japan Art Institute], he places his work within a genealogy of Japanese art, choosing to identify himself through the lineage of his teachers—the painters Kawai Gyokudo and Kimura Buzan. *Cat in Bamboo, Hiroshima* evidences his ongoing and abiding connection to place and people.

—Grace Yasumura

Cat in Bamboo, Hiroshima *by Jimmy Tsutomu Mirikitani, 2005.*

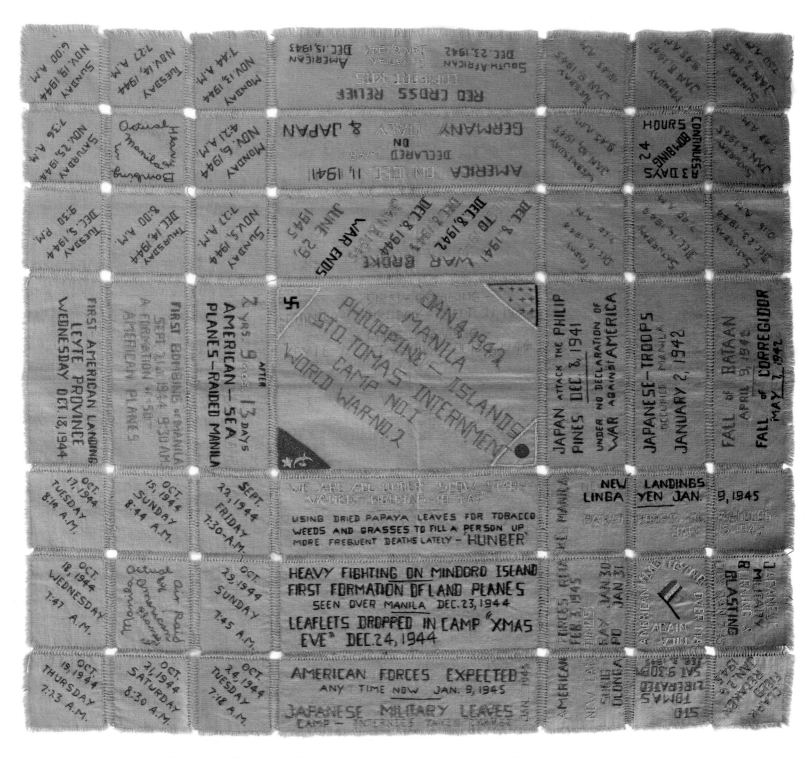

Tapestry created by Anita Castilla Monzo Mill, created while in the Santo Tomas Internment Camp, Philippines, ca. 1940s.

Memories from a World War II POW camp

A brown tapestry, made of what appears to be sack cloth, has been sectioned into embroidered squares and rectangles. But where you might expect to see sewn flowers or decorative curlicues, instead there are words and dates commemorating events in a war. Anita Castilla Monzo Mill (1914–unknown) created the tapestry while incarcerated.

Anita was born in Manila, Philippines, and raised by a Spanish father and Filipina mother. She had two brothers and two sisters. All three sisters married American servicemen. She met her husband, Herman B. Mill, at her sister's wedding, and they were married in May 1941. She secured a job as a private secretary for an English firm in Manila. Herman worked as a civil servant at Nicols Field, where the US Army was stationed, among the first places destroyed by the Japanese on December 8, 1941.

When the Japanese took control of the Philippines, Anita and her husband were placed in the Santo Tomas Internment Camp in Manila—the largest of several camps managed by the Japanese forces in the Philippines. While in camp, she gave birth to their son Joseph. According to Red Cross worker Marie Adams, conditions in the camp were difficult and declined drastically toward the end of the war.

While she was interned Anita decided to make this tapestry. Anita said she made the embroidered tapestry "to remind me how inhuman, cruel, and ugly is the war." The Japanese military distributed newspapers in the camp, which Anita read and then inserted dates and events into her tapestry, which she organized like an impersonal diary focused on events of the war—bombings, raids, and landings. The tone is clinical, her embroidery patient.

She carefully narrated events starting with the Japanese military invasion of the Philippines on December 8, 1941, to February 3, 1945, where the text reads, "Sto. Thomas Liberated. Saturday 9:30 pm." The largest cell in the center reads like several headlines: "Manila, Philippine Islands / Sto. Tomas Internment Camp No. 1 / World War No. 2." In the corners of that cell are symbols associated with the warring nations: a swastika; a sickle, hammer, and star; a red sun; and red, white, and blue threaded into stars.

Four large quadrants function like individual chapters. In one section, eight dates spanning a six-week period surround a central small square with the text, "Raid by American Planes." Another similar section has days, dates, and times surrounding another note, "Heavy Bombing in Manila."

One of the few cells without dates offers a bleak picture of conditions in the camp: "We are all under slow starvation. Nothing to eat. Using dried papaya leaves for tobacco. Weeds and grasses to fill a person up. More frequent deaths lately. Hunger."

Another section tells of the tide turning in the war outside the camp with her inclusion of new landings, news of the retaking of an airfield, and at the center of this section: "American flag flying over Manila again."

Upon leaving camp, Anita and her family went to the United States and briefly moved in with Herman's family in Minneapolis before he found a civil service job with the Veteran's Administration. Herman studied law by night and eventually became a lawyer. He also joined the Air Force Reserve as a private and retired as a lieutenant colonel. He passed away September 24, 2003. In her correspondence with Smithsonian staff in 2008, Anita hoped that her tapestry would "speak" for her long after she passed away.

—Cedric Yeh

Balbir Singh Sodhi

n this photo, Balbir Singh Sodhi (1949–2001) is smiling with his nephew. It's a perfect symbol for how he lived his life—supporting family in the United States and in India. Sodhi arrived in the 1980s, the eldest of several brothers who would later own businesses and drive taxi cabs. He sent money home to his wife and other family members. Sodhi often spent time with the families of his brothers, Rana and Harjit.

Sodhi's store was the Mesa Star, located about a half hour drive east of downtown Phoenix. He was well-liked. The local kids in the area called him "Mr. Bill." He'd offer them candy. In the days after the September 11 attacks of 2001— carried out by members of an international terrorist organization— Sodhi reached out to his brother, Rana, to see if he could bring American flags to be placed in front of the Mesa Star. He shopped for flowers to plant at the front of the store and donated $75 to an emergency relief workers fund. Throughout the country, Americans were expressing their unity with victims, survivors, and first responders where attacks had taken place in New York; Washington, DC; and Pennsylvania.

On September 15, 2001, Sodhi's brothers received word that Balbir had been killed at his store. Frank Silva Roque, an aircraft mechanic, told coworkers that he wanted to shoot some "rag heads." Roque drove to the Mesa Star and fired through his truck's open window, killing Sodhi. Roque then drove to the home of an Afghan couple, firing another three shots before making his way to a gas station where he fired another seven at a Lebanese store clerk. The couple and clerk were not injured.

When law enforcers arrested Roque, the shooter said: "I'm a patriot and American. I'm American. I'm a damn American. How can you arrest me and let the terrorists run wild?" He was found guilty of first-degree murder and sentenced to death. The Arizona Supreme Court changed the death sentence to life imprisonment. Before Roque died in prison in 2022, he spoke with Rana and expressed sorrow for killing his brother. Sodhi's brother wrote in an editorial about how the killing of ten Black people in Buffalo, New York, made him think about the context of Balbir's death twenty-one years before: "[W]e must acknowledge that white supremacy is a horrible disease that keeps spreading from generation to generation."

The Sodhi family placed a plaque to mark the location of Balbir's death. It memorializes those who died on September 11, 2001, and all the backlash victims and reads in part, "On Saturday, September 15, 2001, Balbir Singh Sodhi, a Sikh, was shot here at this corner while planting flowers in front of this shop. In the tradition of the Sikh faith, he wore a turban and beard. He was killed simply because of the way he looked."

—Theodore S. Gonzalves

Above: Sikh turban worn by Balbir Singh Sodhi. Right: Balbir Singh Sodhi with his nephew, date unknown.

Above: Rally in San Francisco, California, 2020 (pg. 142). Right: Pin for Agricultural Workers Organizing Committee, 1965 (pg. 156).

CHAPTER SEVEN

Resistance and Solidarity

The premise of the name "Asian American and Pacific Islander" is solidarity, to actively join with another to declare allyship and community. The most visible and valuable tradition of this group is that of resistance—whether local or diasporic, in court rooms or on picket lines, in support of national liberation or sovereign recognition. There is no room here for the model minority—a myth that has pitted groups against each other or universalized the experiences of a single ethnic minority. This section's objects are drawn from several decades of speaking out and taking stands. Asian Americans and Pacific Islanders and their histories of resistance and solidarity are noisy.

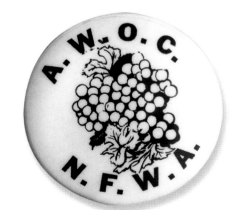

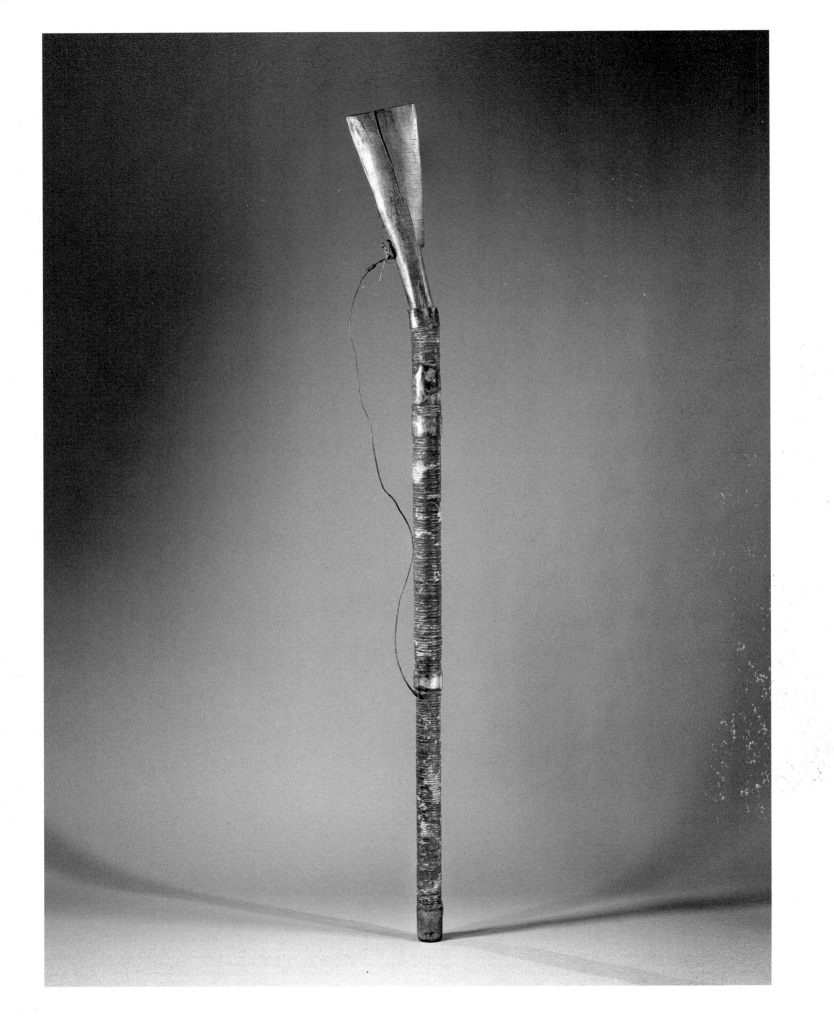

Filipino Homemade Rifle

On June 12, 1898, after 333 years of Spanish rule, the Philippines became the first nation in Asia to declare itself free of colonial rule. Revolutions are rare. Regimes and royal families are tough players from whom to wrestle power. Resistance, however, can take many forms—above and below ground, violent and nonviolent, as hidden (and slyly coded) transcripts or in thunderous public declarations of independence that signal a new chapter in the body politic of a nation.

Even though the United States' own Declaration of Independence served as a direct inspiration for Filipino revolutionaries in the late 1800s and American claims to sovereignty and freedom were rooted in the deep contradiction of settler colonialism, US political and military representatives refused recognition of the Filipino government. The refusal to recognize Philippine independence would set the two nations on a collision course for war when shots first rang out between two standing armies on February 4, 1899.

The US senator from Indiana, Alfred Beveridge, made plain the justification for war in a 1900 speech: "[J]ust beyond the Philippines are China's illimitable markets. . . . The Pacific is our ocean. . . . The Philippines give us a base at the door of all the East. . . . Most future wars will be conflicts for commerce. The power that rules the Pacific, therefore, is the power that rules the world. And, with the Philippines, that power is and will forever be the American Republic."

The Filipino national liberation army, launched an armed unified struggle against Spain in 1896, eventually routing Spanish forces. The US Navy had held Manila Bay and destroyed the Spaniards' decrepit fleet around Manila, but soon started ferrying in thousands of US Army troops to the islands, leaving Filipinos wondering when their American friends were ever going to leave. They didn't have to wonder too long, for a secret plan was hatched between the American and Spanish officers (with Belgium's ambassador as the go-between) to save Spanish honor from surrendering to their colonial charges. Spain's remaining land forces would exchange live fire with US naval forces in a mock battle on August 13, 1898, resulting in an American flag planted on Philippine soil. A nearly four-month standoff would occur between Filipinos and the American liberators until a US soldier opened fire on February 4, 1899, and Filipino revolutionaries aimed their fire on a new colonial power.

The Smithsonian played a role in this theater as well. Frank Hilder, a former British officer, was tasked by the Smithsonian to collect objects for an exhibition of items—not from a sovereign people, but from an active war scene and with the help of the US military. Over a period of six weeks in the Philippines, Hilder and his assistants gathered nearly 1,000 items, many of which would be put on display at the 1901 world's fair in Buffalo, New York. Among the "curios" nabbed by the curators and museum agents: skulls of Filipinos, agricultural products, uniforms, insignia, and, of course weapons, including, according to historian Paul A. Kramer, "bamboo cannons held together with telegraph wire."

The homemade nature of Filipino weaponry and ammunition was borne out of necessity. Facing a naval blockade, Filipino revolutionary fighters could not replace their materiel from foreign allies to compete against the United States' limitless arsenal. Military historians noted how Filipinos were forced to make their own gunpowder and shell casings. The standing army tossed their uniforms and switched to guerrilla warfare, tactics that would inspire and be analyzed by revolutionaries and reactionaries alike in decades to come—"the war of the flea."

The Americans declared their mission accomplished in 1902. But armed revolutionaries persisted for at least a decade. At his execution in 1907, Filipino general Macario Sakay shouted: "I want to tell you that we are not bandits and robbers, as the Americans have accused us, but members of the revolutionary force that defended our mother country the Philippines! Farewell! Long live the Republic and may our independence be born in the future!"

—Theodore S. Gonzalves

Homemade Filipino gun used during the US-Philippine War. Members of the Filipino army resorted to making their own weapons and ammunition.

Printmaking and Politics

The desperate plea by a mother in *No More Hiroshima/Nagasakis* captures the recurring activism for nuclear disarmament by Chinese American artist Nancy Hom (b. 1949). Based in the San Francisco Bay Area, Hom has been a leading multimedia artist, poet, curator, and community organizer in the Asian American art movement. Her signature printmaking style of striking, bold blocks of color defined the many activist prints and posters she created as part of her social justice and cultural solidarity work. Influenced by the many political influences of the Bay Area, including that of the African American, Chicano, and Chinese as well as the Cuban poster movement, Hom represented the transcultural realities of her artistic communities.

On June 12, 1982, an estimated one million people filled the streets of New York to call for world nuclear disarmament. To contribute to this international, historical moment and emphasize Asian voices, the San Francisco- and Los Angeles-based Asian Pacific Americans for Nuclear Awareness (APANA) organizing committees and the New York-based Asian American Caucus for Disarmament collaborated with Hom to create the cover image for an informational booklet about their collective desire to eliminate nuclear weapons and to gain visibility for hibakusha aid. Hibakushas are survivors of the atomic bomb attacks on Hiroshima and Nagasaki in 1945. As a result of the explosions and radioactive exposure, these survivors and their children faced ongoing discrimination, chronic health issues, and social segregation. The groups also highlighted other concerns, such as a call to end registration for the draft, redirect military funds to community services and ethnic studies, and end racism. Using the original cover image, Hom created a limited-edition screen print of the cover for the group to use.

The stark color palette of *No More Hiroshima/Nagasakis* stems from the work of Cuban graphic artist René Mederos and Bay Area Chicano artist Rupert García. The common political graphic ethos is to visually approach messages so they may be deciphered from across the room. Largely self-taught in screen printing, Hom learned the printmaking technique from fellow artists, including Paul Kagawa at Japantown Art & Media Workshop, Leland Wong and Jim Dong at Kearny Street Workshop, and master printers Jos Sances and René Castro at Mission Gráfica. Hom was often one of the few women in this printmaking field. She articulated the experience of womanhood in her work by centering women and children as the primary figures in her compositions. Her matrilineal symbols are also a visual connection to her experience as a Chinese immigrant and her personal connection to her ancestral homelands.

In 2018, Hom revisited her *No More Hiroshima/Nagasakis* poster and updated the text to read "Let Them Stay" in solidarity with her immigrant communities. The digital print served as a political poster for the Families Belong Together national marches in protest of the Trump administration's family separations and detentions at the border. She continued the image's reuse when she included it in her 2019 mandala installation, *Evolving San Francisco*, about the changing history of the city. Hom's prolific and lifelong engagement as a community-centered creator defined cross-cultural Bay Area activism. Her continued service to supporting the oppressed makes her one of the leading figures in political graphics history and one of the foremost creators of Asian American art.

—Claudia E. Zapata

No More Hiroshima/Nagasakis: Medical Aid for the Hibakushas *by Nancy Hom, 1982.*

NO MORE HIROSHIMA / NAGASAKIS
MEDICAL AID FOR THE HIBAKUSHAS

NO DRAFT; NO U.S. INTERVENTION ABROAD

REDIRECT MILITARY FUNDS
FOR COMMUNITY SERVICES & ETHNIC STUDIES

END RACISM IN THE U.S.

For more information.
LA: Asian Pacific Americans for Nuclear Awareness (APANA)
 (213) 626-2249
SF: APANA Organizing Committee
 (415) 731-5728
NY: Asian American Caucus for Disarmament
 c/o (212) 233-5735

© N. HOM 1982

VIET NAM AZTLAN

ĐOÀN KẾT CHIẾN THẮNG UNIDOS VENCERAN

ĐOÀN KẾT SOLIDARIDAD

CHICANO VIET NAM

FUERA

CHICANO VIETNAM PROJECT
P.O. Box 331
Berkeley, Calif. 94701

MALAQUIAS MONTOYA

United, Victory

Political graphics are calls to action. For artists using centuries-old silk screen techniques, printers make multiple copies of brightly colored posters to catch the attention of passersby, and to let people know about upcoming actions or workshops. Artists, designers, and others aim for bold statements. The visual elements in posters often reference historical figures or portray movement members in heroic settings. These images often provide direct contrasts to those featured in mainstream magazines and movies.

Posters like Malaquias Montoya's *Viet Nam/Aztlan* convey an urgent message. About his 1973 work, Montoya (b. 1938) said, "I felt at that time, that we [Chicanos] had more in common with the Vietnamese people than with those that were sending us to die in a foreign country, hence the images of the two cultures—their hands connecting and symbolizing solidarity."

The text in Vietnamese translates to "unity, victory." The Spanish text, "united, they will win." At the top of the poster, two locations—Viet Nam and Aztlan—link two actual locations. The latter is often described as a mythic place. For Chicano activists, Aztlan was not a myth. It is a reference to both a time and a place that predates invasion and death brought by the West.

Scholar Carlos Muñoz recalls that "Aztlan was the name used by the Aztecs to refer to their place of origin. Since the Aztecs had migrated to central Mexico from 'somewhere in the north,' Chicano activists claimed that Aztlan was all the southwestern United States taken from Mexico in the 1846–48 US-Mexican War. This included California, Texas, New Mexico, most of Arizona, large parts of Colorado, Nevada, and Utah, and a piece of Wyoming."

For Asian American activists like Chris Kando Iijima and Yuri Kochiyama, opposition to the Vietnam War—as a person of Asian descent in the United States—also served as an expression of solidarity, as well as strategy to see oneself as part of a global majority.

Whether fighting a war of national liberation or engaging in cultural nationalism, Montoya's centering of a single word at the bottom of the poster applied to both Chicano and Vietnamese struggles: "Get Out!"

—Theodore S. Gonzalves

Viet Nam/Aztlan *by Malaquias Montoya, 1973.*

Bowl of Rice Party Banner

Wartime often encourages generous acts of philanthropy. Bowl of Rice parties were held throughout the country annually from 1938 to 1941 to aid the people of China during the Second Sino-Japanese War. These large, community-based fundraising drives aimed to help Chinese civilians affected by the war. Organizers held the events in the major Chinatowns of the day—New York City and San Francisco—as well as in 2,000 cities throughout the country. The fundraising activities included elaborate dinners, concerts, sporting events, radio shows, and pageants. A banner like this would have been displayed along the busy streets that formed parade routes.

Missionaries and other Westerners working in China reported that many were affected by the war. The figures of those affected ranged from 60 million to 160 million—in need of food, medicine, and shelter. Dramatic accounts stated that refugees were facing "the greatest health danger that the world has known since the Black Death." In the United States, Colonel Theodore Roosevelt Jr. was named the national chairman of the United Council for Civilian Relief in China, an organization that staged the first of these events in June 1938 in New York City with 85,000 attendees. Members of the Chinese community living in the United States formed the Chinese War Relief Association. The 1940 Bowl of Rice party in San Francisco's Chinatown drew crowds as large as 275,000, raising $80,000.

These fundraising drives featured a common effort but had multiple goals. Western missionaries saw these drives as part of their humanitarian duty in a foreign land. But think about the overseas and Chinese American communities in the United States. Elders in New York City and San Francisco would have been old enough to witness the passage of the 1875 Page Act and the 1882 Chinese Exclusion Act—laws that anchored anti-Chinese sentiment in what would become a formally segregated nation. The motto of New York City's Chinese Hand Laundry Alliance—"To Save China, To Save Ourselves"— made things explicit. Chinese in the United States saw their local struggles for civil rights as part of international conflicts. The Bowl of Rice parties became opportunities for organizers to fight the discrimination they faced in their new homes by pressing for the liberation of their homeland. This is a reminder that living and working as a member of a diaspora is not merely to leave behind the old in exchange for the new. In their global travels, many continue to be deeply connected to adopted and original homes.

—Theodore S. Gonzalves

Banner displayed in 1940 during a Bowl of Rice party to support Chinese civilians devastated by the Japan-China war of 1937–1945.

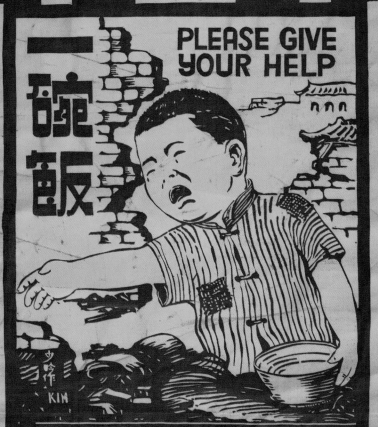

Benji Okubo's Art Class '43

Drafted While Incarcerated

Artist and activist Yosh Kuromiya (1923–2018) was born in Sierra Madre, California, just a few miles east of Pasadena. His art studies at a Pasadena community college were interrupted by World War II when he was sent to the Heart Mountain Relocation Center in Wyoming. At Heart Mountain, Kuromiya continued sketching and drawing. The Smithsonian has collected several of his works from this time period.

In an interview, Kuromiya said sketching was "my way of relating to my environment, and accepting it as my home." The person depicted in this sketch is his teacher, Benji Okubo (1904–75), brother of artist Miné Okubo.

The US military instituted a wartime draft, including Japanese American men who had been jailed without due process. While thousands enlisted, others openly refused the order to serve in the military, claiming that the evacuation and internment of Japanese and Japanese Americans violated their civil liberties. A movement was developing and the Heart Mountain Fair Play Committee caught Kuromiya's attention. Organizers at camp rallies spoke about the Constitutional protection of rights and the need to adhere to them especially during wartime.

Kuromiya was one of the 315 men who refused to be enlisted while being incarcerated. Some community members branded them traitors while many of the resisters believed their draft refusal was a deeply profound act of patriotism. Most of these individuals were convicted of draft evasion and sentenced to three years in federal prison. In 1947, President Truman pardoned the convicted men.

The draft resisters participated in a long tradition of principled civil disobedience that includes the likes of Bayard Rustin and Alice Paul. Yosh Kuromiya believed, "As an American citizen, that we all had an obligation, a responsibility, to publicize or to raise the issue of the incarceration. . . . Somebody had to say somethin'."

—Theodore S. Gonzalves

Yosh Kuromiya's sketch of his art teacher, Benji Okubo, 1943.

Fred Korematsu

Fred Korematsu (1919–2005) had already faced discrimination even before the Pearl Harbor attack on December 7, 1941. As a person of Japanese descent in the United States, he had been taunted and refused service for how he looked and where his ancestors came from. The racist treatment faced by Japanese and Japanese Americans in the 1940s echoed anti-Japanese sentiment from the 1920s.

With President Franklin D. Roosevelt's Executive Order 9066 officially removing 120,000 persons of Japanese descent to relocation centers and concentration camps, Korematsu refused. He wanted to stay with his white girlfriend. Korematsu changed his name and even underwent plastic surgery to alter his appearance. He was eventually discovered and jailed. The American Civil Liberties Union, looking for a way to challenge incarceration, took an interest in his case.

Korematsu was sent to Topaz, Utah, to be with his family, along with 9,000 other Japanese and Japanese Americans. He continued to appeal his case, eventually having it heard in the Supreme Court, where in 1944, his original arrest was justified due to military necessity (*Korematsu v. United States*, 1944). Six justices voted to uphold the incarceration. The majority opinion is the last word, but it's important to recall the dissent. Justice Robert Jackson said, "The Court for all time has validated the principle of racial discrimination." Justice William Francis Murphy noted: "This exclusion order falls into the ugly abyss of racism. It results from the erroneous assumption of racial guilt rather than bona fide military necessity. I dissent, therefore, from this legalization of racism."

In the early 1980s, researcher Aiko Yoshinaga-Herzig made a shocking discovery: documents from the then FBI director reported that there was no evidence for Japanese or Japanese Americans acting as spies, and that the internment was based on political pressure, not military intelligence. Further, the research demonstrated that government lawyers

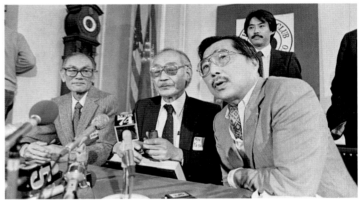

arguing against Korematsu had suppressed this evidence during the Supreme Court hearing.

Korematsu's legal team reopened the case in 1983, seeking acknowledgment that the original conviction was based on a factual error. The presiding judge offered Korematsu a pardon. Korematsu reportedly said: "We should be the ones pardoning the government."

Decades after his own case had been decided, Korematsu continued to apply the lessons he lived through to the experiences of others in the years after the 9/11 attacks. In 2003–04, Korematsu filed amicus briefs before the Supreme Court on behalf of Khaled A. F. Odah, Safiq Rasul, and Yasir Esam Hamdi, including those detained at Guantanamo Bay, many of whom were captured in Afghanistan during and after the 2001 war. The brief stated: "The claim . . . that the government may detain individuals indefinitely without any fair hearing overreaches the bounds of military necessity. To avoid repeating the mistakes of the past, this Court should make clear that the United States respects fundamental constitutional and human rights—even in time of war."

—Theodore S. Gonzalves

Above: Fred Korematsu (left), at a press conference in 1983. Right: Fred Korematsu, unidentified photographer, ca. 1940.

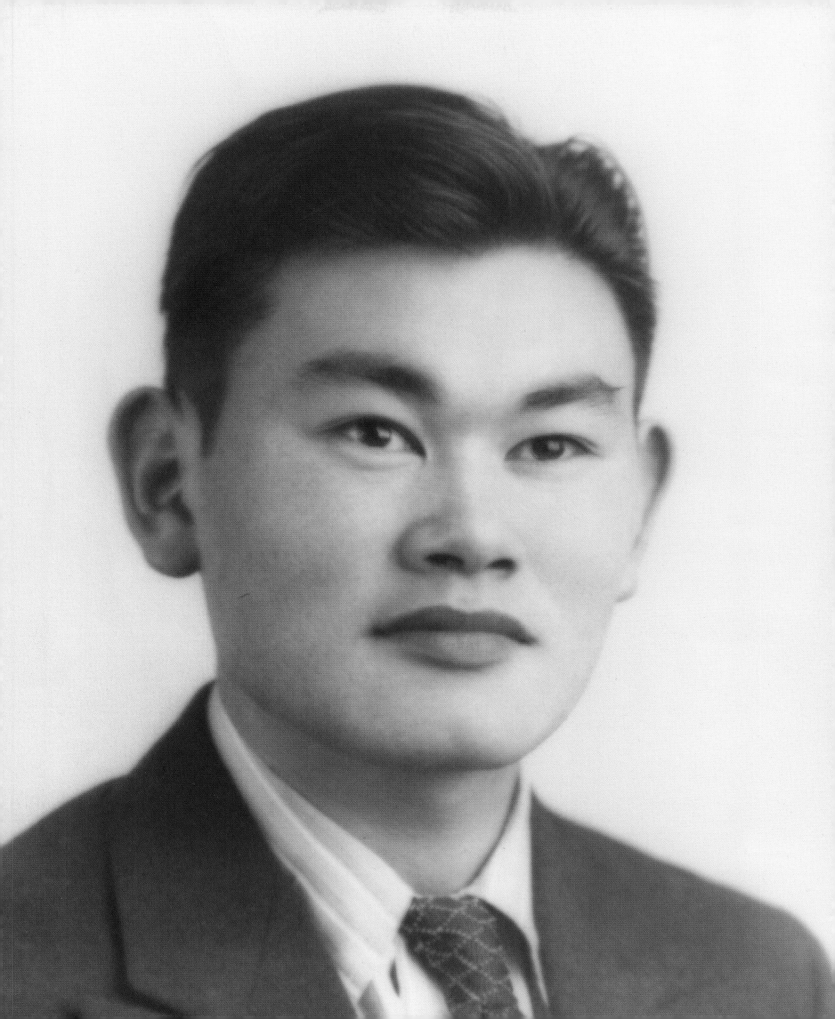

Organizing in the Fields

A small round pin, imprinted with an image of grapes, identifies the two organizations that joined forces to become the United Farm Workers, a powerful union dedicated to improving conditions for agricultural laborers. While that merger represented the start to a groundbreaking civil and human rights organization, the pin also serves as a reminder of decades of labor activism led by Filipinos in the United States.

By the time of the landmark Delano grape strike of 1965, Modesto ("Larry") Itliong (1913–77) had thirty-five years of organizing experience. In 1930, he had walked out of lettuce fields in northern Washington state. He organized spinach cutters in Salinas, California, and cannery workers in Alaska. Rank and file members of the United Cannery, Agricultural, and Packinghouse Workers of America elected him to Vice President of Local 7. He later joined the Agricultural Workers Organizing Committee (AWOC), which had a large Filipino base. His varied work experiences and ability to speak several languages and dialects served him well as a strategist.

AWOC put that knowledge to use as grape harvesting season approached in the late spring of 1965 in Coachella, California. With the valley warming up between the San Jacinto Mountains and Joshua Tree National Park, Itliong and his fellow workers coordinated a strike of 1,000 persons. On May 3, 1965, the AWOC struck against seven vineyards, seeking an hourly pay rate of $1.40, an increase of 15 cents. The labor action lasted a week with the growers relenting. The workers had won the wage they were seeking but were not able to secure a contract. The fight was about more than wages. Workers at the time testified to the use of unsafe tools, the lack of clean toilets, and the need for protection from one-hundred-degree heat.

Itliong and the AWOC used that knowledge for their next target. About 250 miles north of Coachella, Delano's grape-picking season was coming due in a few months. The stage had been set for a much larger action.

On September 8, 1965, the AWOC voted to strike in Delano. Itliong turned for support to Dolores Huerta and Cesar Chavez of the National Farm Workers Association (NFWA), with a large Mexican American base. Many Filipino workers believed they were running out of time. Itliong's group consisted of mostly Filipino men in their fifties and sixties, many of whom had been facing down labor actions (frequently violent) in small groups. Anti-miscegenation laws restricted their ability to create traditional family structures. Chavez was at first reluctant to join the AWOC strike. He needed two or three years to better organize his mostly Mexican American base.

"It was basically put up or shut up," Paul Chavez, son of the late Cesar Chavez, said. "They went out and basically forced everyone into action. That credit belongs to the Filipinos—the brothers." A week later, the NFWA decided to join the AWOC. The following year, in 1966, the two organizations formally merged. By 1970, the first grape grower signed an historic contract with what became the United Farm Workers.

A year before he passed away at the age of sixty-three, AWOC's most charismatic leader said to students in 1976, "I'm a mean son of a bitch in terms of my direction fighting for the rights of Filipinos in this country. Because I feel we are just as good as any of them. I feel we have the same rights as any of them. Because in that Constitution, it said that everybody has equal rights and justice. You've got to make that come about. They are not going to give it to you."

—Theodore S. Gonzalves

Pin for Agricultural Workers Organizing Committee, 1965.

Yuri Kochiyama

By the time this photo was taken, Yuri Kochiyama (1921–2014) had become a seasoned activist. Her life seems mythic from the outside. But Yuri's journey is a reminder that activists are made, not born.

Yuri Kochiyama was born Mary Yuriko. Her father, Seichi Nakahara, was a fish merchant; her mother, Tsuyako Sawaguchi, a teacher. Growing up in a mostly white part of San Pedro, California, Yuri (as she later went by) described herself at the time as being provincial, apolitical, and church-oriented. When Pearl Harbor was attacked by the Japanese military, the world she saw through a twenty-year-old's eyes changed for the worse. Her father, a prominent businessman in the community, was jailed by the FBI for alleged espionage. He died in 1942. Like thousands of Japanese and Japanese Americans, Yuri's family was unlawfully detained by the US military. They were initially sent to an assembly center—a horse stall in Santa Anita, California—and later to a concentration camp in Jerome, Arkansas.

From her time in camp, Yuri's personal perspective shifted: "I fell in love with my own people there. It was the beginning of a search for my identity." She met Bill Kochiyama in 1943. He was a member of the storied 442nd Infantry Regiment, which was almost entirely made up of Japanese American soldiers, and their romance survived his deployment. After marrying in 1946, the couple moved to New York City, where they raised six children.

On Friday and Saturday nights, the Kochiyamas opened their home for social gatherings, with artists and lecturers passing through town. Others simply needed a place to stay. Those cultural connections served as the foundation for their activist lives. The national news of the *Brown v. Board of Education* decision, the Montgomery Bus Boycott, and the struggles of the Little Rock Nine reflected and informed Yuri's own local campaigns. The Kochiyamas joined the Harlem Parents Committee, where they called for the installation of streetlights to help kids stay safe.

Her earliest organizing efforts in NYC with fellow Asian Americans centered around opposition to the Vietnam war, which she understood as immoral and racist, and one that violated the self-determination of the Vietnamese, Laotian, and Cambodian peoples.

In 1980, waiters at the Silver Palace, New York Chinatown's largest restaurant, disputed management's insistence on having the wait staff share a greater portion of their tips with the owners, a major source of their already low income. Management fired fifteen of the waiters, who then organized a picket, eventually involving wider support from the community, including activists like Yuri. Management relented. The workers scored a victory with the Silver Palace as Chinatown's first restaurant to be organized.

While Yuri was in front of the camera on the picket line at the Silver Palace, behind the camera was another activist: Corky Lee (1948–2021). Lee's father, a World War II veteran, operated a hand laundry in Queens. Lee's work as a photojournalist captured the Asian American movement's intensity and its lyricism—from images of police brutality at protests to quiet moments in public parks or side streets. During his lifetime, Lee was widely acknowledged as the "undisputed unofficial Asian American photographer laureate" by community activists, educators, and fellow photojournalists. Much of his work attempted to address the fullness of Asian American and Pacific Islander life.

Not only did Lee capture dramatic and poignant moments like the image of Kochiyama at a protest, he also staged photos that could address omissions of Asian Americans from the historical record. On the 145th anniversary of the joining of the transcontinental railroad, Lee assembled hundreds of persons—many of whom were descendants of Chinese laborers who were excluded from the celebratory image snapped at the original event in 1869—in an act that he described as photographic justice: "This is a way for Chinese Americans as well as Asian Pacific Americans to reclaim a part of their history that have been long forgotten and neglected."

—Theodore S. Gonzalves

Yuri Kochiyama photographed by Corky Lee in New York City, 1980.

Disneyland, California, *by Tseng Kwong Chi from the series* East Meets West *(1979), printed 2013.*

Ambiguous Ambassador

In 2021, the Smithsonian acquired six photographs by Tseng Kwong Chi (1950–1990) from his signature series *East Meets West*. In these images Tseng inhabits a persona he referred to as the "Ambiguous Ambassador." Wearing a Mao suit (the gray uniform associated with the Chinese Communist Party) and mirrored sunglasses, he poses next to landmarks and monuments across the globe, many of them famous as emblems of national identity. Tseng's knowing performance of "Chineseness" against such backdrops as Disneyland or the World Trade Center parody the tourist snapshot, Western stereotypes of the Chinese, and Cold War politics all at once. Comprising roughly 150 photographs created over the course of a decade beginning in 1979, *East Meets West* illuminates the unfixed, socially constructed nature of identity.

A Chinese man in a Chinese uniform would seem to present a hyper-intelligible identity to the world, one in which race, culture, and nationality are unambiguously aligned. Indeed, when Tseng began wearing the Mao suit out in public around 1979, he would often be mistaken for a Chinese Communist official—someone of and from China. The reality of Tseng's multifaceted and transnational identity was far more complex. Born in Hong Kong in 1950 to parents who fled China after the Communist Revolution, Tseng never set foot in mainland China. He immigrated to Canada with his family in 1966. As an adult, he moved to Paris, where he studied photography and, in 1978, moved to New York City. There he found his niche in the burgeoning East Village performance art scene, particularly among the groovy, gender-fluid cohort that congregated at Club 57. As for the Mao suit, it was a thrift-store purchase.

Tseng's self-presentation in *East Meets West* reveals his acute awareness of the stereotypes of Euro-American Orientalism. His robotic demeanor in such images as *Disneyland, California* invite stock associations of the Chinese as "Yellow Peril," and the repetition of this pose in numerous photographs would seem to tap into white America's century-long dread of being overrun by Asian immigrants. But upon examining the entire series, it becomes evident that the Ambassador's pose is just that—a pose, changeable and fluid. He appears stoic, even threatening, in some pictures; whimsical or stylish in others. Some of the earliest photographs picture Tseng coolly strolling the boardwalk and beaches of Provincetown, appearing more like a visitor from a French New Wave film than the People's Republic of China.

The shutter release Tseng plainly grasps in these photographs reminds us that he is the author of these varied depicted realities. Given that racial identities circulate and perpetuate via staged images—and that European American assumptions have traditionally driven those images—this is a significant gesture. The guise of the "Ambiguous Ambassador" was a calculated artistic strategy—but also, for Tseng, lived experience. His refusal to be anything other than ambiguous was a challenge to conventional codes of identity and a demand for new, more fluid conditions of being.

—Melissa Ho

Rallying Against Racism

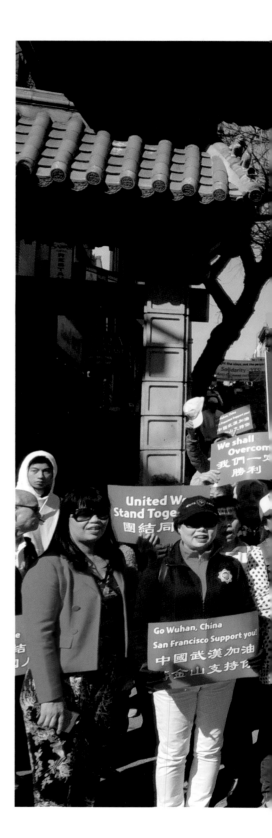

On February 29, 2020, eleven days before the World Health Organization declared the novel coronavirus a global pandemic, members of San Francisco's Chinatown community assembled 1,000 persons for a rally and a march. At the head of the procession was a banner that measured eleven feet wide by four feet tall. The first of three lines is in English and reads "Fight the Virus, NOT the People!" The lower two lines of Cantonese text translate to "Together we support the businesses, [we are] against discrimination" and "[We] support fighting the global pandemic, add oil." That last bit about the oil is a famous Chinese idiom, meaning "keep it going" or "keep it up with courage and determination."

One of the organizers of the protest, retired superior court judge Julie M. Tang, worked closely with members of the Chinese Consolidated Benevolent Association. They organized a diverse coalition consisting of youth, social service groups, shop owners, tenants, and elders. Judge Tang said: "We decided to go out to the streets and shout out our concerns. We want everyone to know what we were worried about: Our lives, our jobs, our businesses, and our survival in the United States."

During the rally, several civic, business, and community leaders spoke. Standing in Portsmouth Square, the event's emcee, Reverend Norman Fong of the Chinatown Community Development Center, opened with a prayer to the victims of the virus in China. Another speaker, Vincent Pan of Chinese for Affirmative Action, warned of the "other virus" to watch out for—namely, bigotry—a disease that continued to spread via human contact and was incredibly dangerous. Others spoke out against anti-Asian discrimination, xenophobia, hate crimes, and the scapegoating that was already taking place as a result of the virus' connection to mainland Asia. At the conclusion of remarks that afternoon, organizers led the group on a half-mile march south to the base of the Dewey Monument in Union Square, an historic central meeting point for protest in the city.

The San Francisco Chinatown banner joins a growing collection of protest-related items, from pink knit hats worn during the 2017 Women's March in Washington, DC, to a tiki torch and shield used at the Unite the Right rally in Charlottesville, Virginia, from the same year. The banner also reminds us of the long traditions of resistance and solidarity that are at the heart of Asian American public life.

—Theodore S. Gonzalves

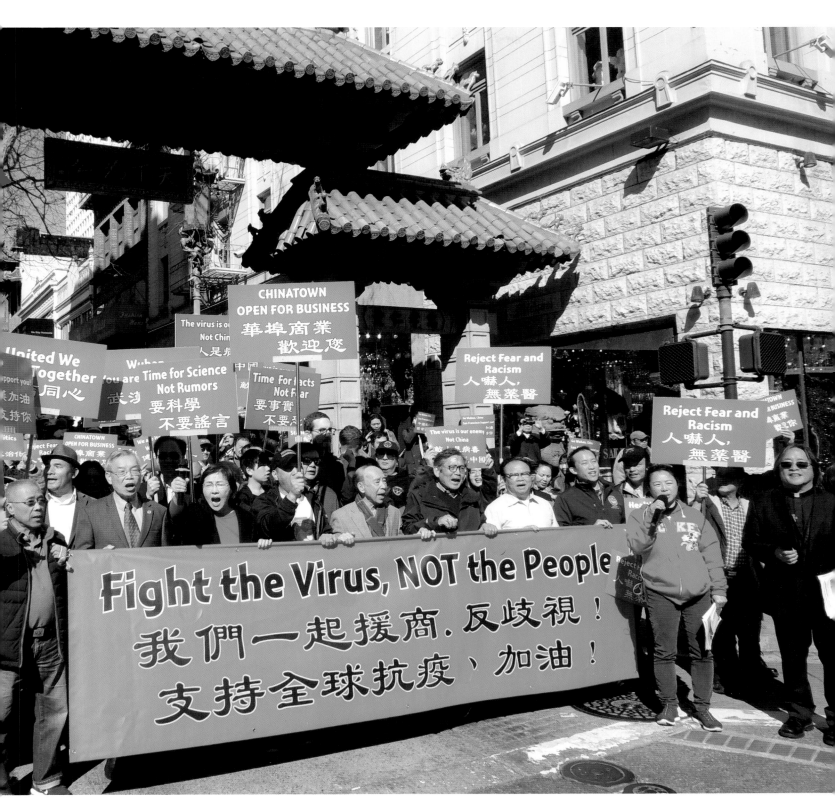

Image of a San Francisco, California, rally and march on February 29, 2020. The banner, reading "Fight the Virus, NOT the People," is also in the Smithsonian collection.

DC Funk Parade

Any resident of the District of Columbia will tell you there's more to the nation's capital than monuments and government offices. Beyond the federal city and the National Mall, there are dynamic communities—places to eat, listen to music, browse books, shop for produce, worship, dance, think, or do absolutely nothing at all. On a sunny May afternoon, photographer Susana Raab captured the District's vibrant energy at the 2018 DC Funk Parade. Participants made their way from the Howard Theatre at the corner of T and 7th Streets Northwest to the Lincoln Theatre on historic U Street.

Dragons and lions have appeared in all sorts of festive occasions for centuries, first in Asia and now throughout the world. And in the District of Columbia, Asian cultural traditions have found anchoring and expression in the lives of Asians and non-Asians alike. Cultures are not just static *products* that are bought, sold, consumed, and disposed of—although certainly they are those things. Cultures are *processes*—alive, messy, melded, molded, and funky.

At the lead position in this photo is Abdur-Rahim Muhammad (b. 1948), a native Washingtonian who also has deep roots in Boston's Roxbury neighborhood. In his youth, Muhammad was inspired by fellow Roxbury resident, Malcolm X, as well as the community-based works of the Nation of Islam. In his memoir, *Dragonz Rizing: Reclaiming My Time After Wandering Through the Valley*, Muhammad recalls how a childhood friend introduced him to karate where "bullying or punishing innocent people was unacceptable behavior and not tolerated" under his sensei (teacher) Kent Davis. He complemented Asian martial arts training with self-defense skills he simultaneously developed at the Boston masjid (mosque).

The 1973 release of Bruce Lee's film *Enter the Dragon* inspired Muhammad to continue learning about martial arts, which he did under sifu (teacher or master) Bing Cheung Chin before heading to Washington, DC, and finding his way to the District's Chinatown. There, Muhammad studied under Dean Chin's senior instructor, sifu Deric Mims. Muhammad would spar with another of Mims' students, Duke Amayo, who would later front the band Antibalas. Traces of Amayo's journey can be heard in the band's 2020 album *Fu Chronicles*, which the singer describes as "the first chapter in [which] kung fu meets Afrobeat."

It was at Dean Chin's kung fu school that Abdur-Rahim Muhammad would internalize a poem: "learn kindness, learn justice, and then learn kung fu." The DC native took deep lessons from Asian martial arts. He explained that the emphasis was on the "noble character traits of honor, dignity, respect, kindness, fairness, and justice. As the spiritual component of my martial arts practice began to reveal itself, it became [as] important to me as waking up in the morning."

With the passing of sifu Chin in 1985, Deric Mims continued training the school's students. Muhammad opened his own studio on DC's U Street in 1995. He named the school Hung Tao Choy Mei Leadership Institute, which incorporated traditional African and Chinese cultural arts and where his staff offers free instruction to local students. It's the same street that has been home to his family as well as the political and cultural leaders of so many in the Black community for decades.

Abdur-Rahim Muhammad's journey is a deeply polycultural one, inspired by the work ethics of his students and the community's support: "We are now empowered by our kung fu ancestors as well as our family ancestors."

—Theodore S. Gonzalves

Participants in the 2018 DC Funk Parade march from the Howard Theatre to the Lincoln Theatre in Washington, DC, an event that honors the local funk scene with live music around the U Street corridor.

Above: Ruby Ibarra performing at the 2019 Smithsonian Folklife Festival (pg. 164). Right: Campaign pin for Jesse Jackson (pg. 158).

Community

Asian American and Pacific Islander communities are imagined (which is different from saying they are imaginary), beloved, and deeply complicated. In this section, we emphasize the role of the remix: to take what's been handed down and have it reworked, recontextualized, and redeployed in sometimes radically different settings from so-called origins. American cultures are constantly being revised, with traditions having to be invented. The same is true for AAPI experiences. Founding or joining a community is an opportunity to consider an infinite number of beginnings. These objects featuring music, sports, politics, religion, marriage rites, and art reveal many ways that communities are called into being with what's readily available.

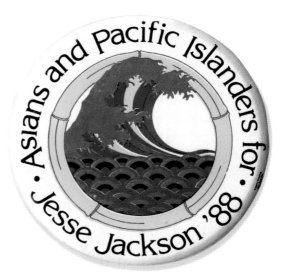

KA

MOOOLELO HAWAII.

I KAKAUIA E KEKAHI MAU HAUMANA O

KE KULANUI, A I HOOPONOPONOIA

E KEKAHI KUMU O IA KULA.

―――――――

LAHAINALUNA:

MEA PAI PALAPALA NO KE KULANUI.

1838.

Uncovering Native Hawaiian Histories

The kānaka maoli (Native Hawaiian) historian Davida (David) Malo (1795–1853) was born in Keahou, North Kona, Hawaiʻi Island, in the Hawaiian Kingdom. Davida was not only one of Hawaiʻi's most prolific historians but was also a person with a multitude of talents and vocations. He was a politician, educator, counselor, and ordained minister, to name a few.

Davida is credited as one of the three great Native Hawaiian historians along with John Papa ʻĪʻī and Samuel Kamakau. As the oldest of the three, Davida experienced a massive shift of Hawaiʻi's standing in the world, seeing it go from a Pacific provisioning outpost to become the first Pacific nation state. His legacy was to preserve and present traditional Native Hawaiian histories and moʻolelo (stories) in a time of rapid change and mass depopulation of Native Hawaiians in his homeland.

The diseases introduced by Captain James Cook and his men at the time of first European contact on January 18, 1778, were still ravaging throughout the Hawaiian population at the time of Davida's birth. Researchers have estimated the Native Hawaiian population to be 1 million at its high point, with an average of roughly 683,000 at the time of Western contact. By 1840 that population had declined by over 84 percent to about 24,000. The monumental loss of kānaka maoli and cultural heritage made the ethnographic work that Davida performed so much more critical than just retelling stories—he was preserving the past for future generations. Davida Malo was not without his critics; while he was considered the first great Native Hawaiian historian, his later writings were often tempered and filtered by his Christian faith. Moments of societal judgment, criticism, and historical omission can be found in his written accounts.

His best-known work, *Moʻolelo Hawaiʻi* (*Hawaiian Antiquities*), is a seminal work about Native Hawaiian culture, traditions, and lore. When paired with fellow historian John Papa ʻĪʻī's *Fragments of Hawaiian History*, a reader can navigate and triangulate a glimpse of pre-contact Hawaiian life. The rare book in the Smithsonian Libraries Cullman Library collection entitled *Ka mooolelo Hawaii. I kakauia e kekahi mau haumana o ke kulanui, a i hooponoponoia e kekahi kumu o ia kula* (*The Hawaiian History. Written by certain students of the college, and edited by a teacher of the school*) was attributed to Davida Malo as one of his earliest compiled works. Yet the book itself is surrounded in some myth and mystery, especially with the school's headmaster Sheldon Dibble taking credit as the author. Despite some of Davida Malo's conservative Christian writings and views later in life, his brilliance and penchant for historical preservation have helped to keep traditional kānaka maoli culture alive and thriving into the twenty-first century.

—Kālewa Correa

Left: Ka mooolelo Hawaii, *attributed to historian and minister Davida Malo, has been cited as the first Hawaiian history written and published in Hawaiʻi, published in 1838. A copy is held in the Smithsonian collection of rare books at the Cullman Library. Above: Davida Malo, ca. 1848.*

Picture Bride Kimono

While the Gentlemen's Agreement between the US and Japan in 1908 ended the migration of Japanese laborers, a loophole allowed for family members of Japanese residents to immigrate to the United States. In 1910, Japanese "picture brides" first began to arrive to Hawai'i and the United States. These pioneering women worked both at home and in the fields—caring for children and the household as well as earning pay by tending to laundry and cooking for the large, existing male workforce or by creating small businesses.

The picture bride system involved arranged marriages for Japanese males in Hawai'i and the continental United States. Because travel costs were high to and from the homeland, photos and letters were exchanged. Such marriages changed the gender composition of these early labor migrant communities, which until that point had been designed by recruiters as male-dominated workforces. Under Japanese law, the couples were married before the women traveled abroad, their names entered in the registries of their home villages. The exchange of photos allowed the couples to be able to identify their partners upon arrival at the immigration station.

As families took root, attitudes changed about where "home" was and where it could or should be. The idea of going back to a homeland was slowly replaced by the practicality of settling and building a life in these new locales.

It took only a decade for US nativists to object to the baby boom that increased the Japanese population in Hawai'i to 109,274 and on the continent to 104,282. The United States and Japan agreed to end the issuing of passports to picture brides. About 22,000 picture brides traveled from Japan to Hawai'i and the continent, and 1,000 more traveled from Korea in roughly the same period.

In 1983, Cathy Song (b. 1955) published a moving collection of poems titled *Picture Bride.* Of Korean and Chinese heritage, she reflects on her upbringing in Hawai'i as well as the travels of her ancestor, still in her twenties. "What things did my grandmother take with her?" she asks in the title poem.

> And when
> she arrived to look
> into the face of the stranger
> who was her husband,
> thirteen years older than she,
> did she politely untie
> the silk bow of her jacket
> her tent-shaped dress
> filling with the dry wind
> that blew from the surrounding fields
> where the men were burning the cane?

—Theodore S. Gonzalves

Kimono with an obi (sash) that Shizue Sato Nagao brought with her when she immigrated to the United States as a picture bride in 1917.

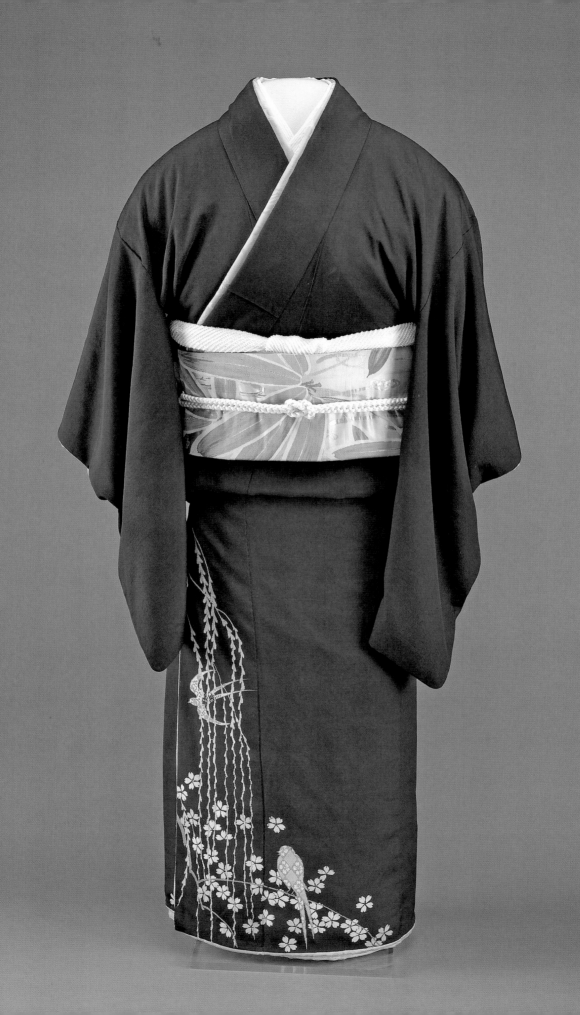

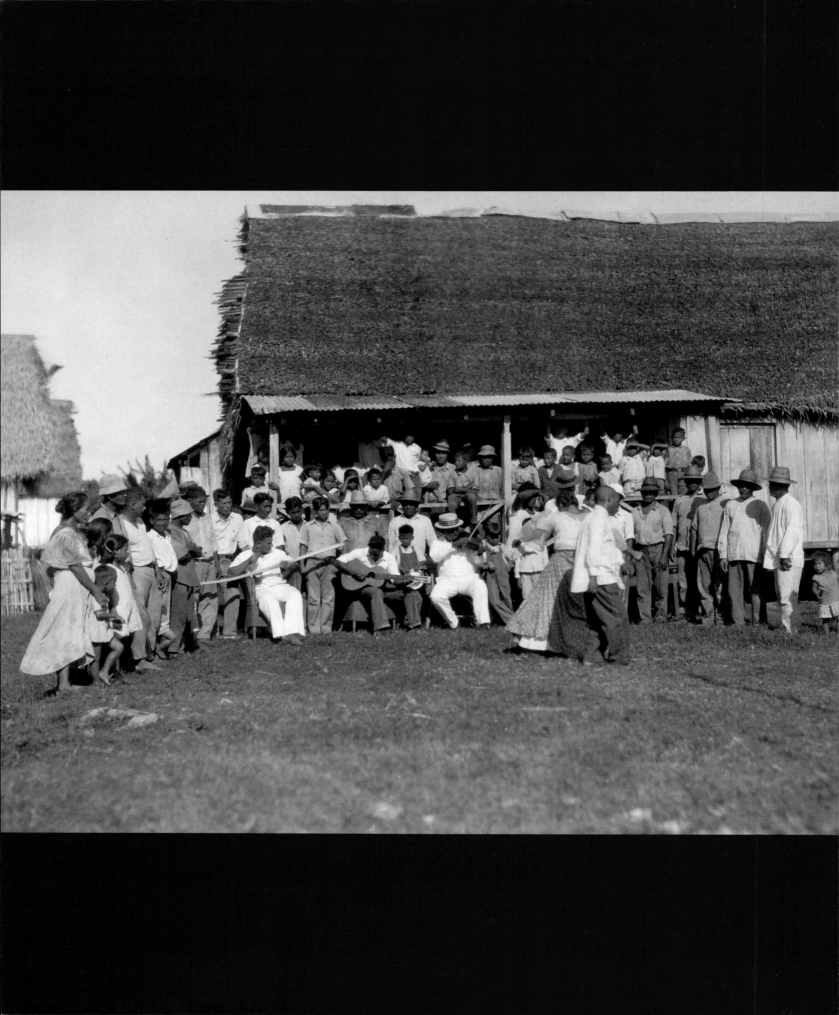

Dancing with Tradition

n this photograph, people seem to have gathered for a celebration. It may have been a perfect day for dancing. We don't have much information to go on. The details of the photo are scant, but what is included in the record serves up some interesting clues.

The National Anthropological Archives has many photographs divided into locations from all over the world. In this case, a photo from Agana (since 1998, Hagåtña), Guam, the island's capital. Because accompanying records identify a "Man and Woman Dancing Outside Pole and Thatch House; Spectators Nearby," it's likely the photo was taken some time before the end of World War II, when that kind of building construction was in wide use. While this photo is undated, it's part of a larger cache of images dated to 1933. There's enough detail to see a structure raised from the ground to allow for air to cool the building from below. Local wood and bamboo would have been split for siding and flooring, held together by wood or metal pins. The thatched roofs were made of soaked coconut leaves and lashed by cordage to the main units.

Seated in the center of the crowd are a guitarist and violinist who set the tempo and provide the melody with Western instruments. Perhaps the tune is in three-quarter time, like the batsu of the Spanish colonial period spanning more than three hundred years. The setting could be a rehearsal for a special presentation at any one of the rituals that help us mark special moments like births, christenings, marriages, and deaths. Or maybe this is a scene from a thatching party, where friends and family often gathered after the hard work was done.

The arrival of the Americans in 1899 brought another layer of colonial culture, redefining what was popular and spreading it widely via radio. Scholar Judy Flores points to culture bearers like Francisco Rabon (b. 1954) who would spend decades attempting to reconstruct native and Indigenous dance repertoires.

Recognized as a Master of Chamorro dance by the Guam Council on the Arts and Humanities, Rabon's work has been part of a larger constellation of thinking and activism that began in the 1970s when, according to Flores, Chamorros and other Pacific Islanders "began to question their relationship with their colonizer." Social movements across the globe and local campaigns closer to home allowed people to find their voices on issues like corporate development of beaches; military cleanup of unexploded weapons; health, housing, and educational disparities; and ancestral practices related to agriculture, voyaging, music, chanting, and dance.

In 1984, Rabon established his Chamorro dance group, Taotao Tano' (People of the Land). A signature piece of the group is the Bailan Uritao, a dance of young warriors. In crafting the repertoire, Rabon's work can be understood as an invitation to make connections through dancing and chanting: "I am not trying to bring back thousands of years of lost traditions; I am only creating an awareness to show that we existed thousands of years before colonization occurred. There are people who choose not to acknowledge this fact, I choose to embrace it and teach younger generations to be proud of our ancestors, where we came from, and who we are now. I do not feel that we are authenticating lost traditions, but instead are re-creating traditions."

—Theodore S. Gonzalves

Crowd in Guam gathered for dancing and music, ca. 1933.

A Star in Her Own Right

In front of a white dome-shaped building marked "McDonald Observatory" and a line of predominantly white men awaiting their turn to enter, stand a young couple: Subrahmanyan Chandrasekhar (1910–95) and Lalitha Doraiswamy Chandrasekhar (1910–99). Subrahmanyan, who would go on to become a world-renowned, Nobel Prize-winning astrophysicist, wears a suit like the other men in the photo, while Lalitha stands apart in her light-colored sari as the only woman in frame.

This photo was taken at the 1939 dedication of the McDonald Observatory in Fort Davis, Texas, which the Chandrasekhars attended alongside the country's foremost scientists. Arriving a decade before South Asians would have the right to become naturalized US citizens, the Chandrasekhars lived in Williams Bay, Wisconsin, where Subrahmanyan taught at the University of Chicago's Yerkes Observatory and quickly established himself as a leading theoretical astrophysicist.

Lalitha, an accomplished scientist, educator, and musician in her own right, came from a family of highly educated women—unusual in both India and the United States at the time. Though she made clear that her priority was to support her husband's career, Lalitha pursued her own interests through activism. Using her intelligence, musical talent, and tenacity, she was determined to build a community and combat stereotypes about India and Indians, despite being a new immigrant in a segregated society.

In addition to lecturing on history, politics, economics, and culture, she also held concerts, in which she sang or performed on the veena, a classical Indian musical instrument. In short, Lalitha created a full life in Wisconsin through her tireless efforts, both as a supportive wife and an engaged community member.

During the early 1950s, Lalitha joined the Democratic Party of Wisconsin, signaling her lifelong commitment to political organizing for progressive causes. Her passion for organizing and progressive politics would lead the Chandrasekhars to become US citizens in 1953, and though her involvement with the Democratic Party would eventually decrease, Lalitha's activism, curiosity, and support for social justice efforts would endure for the rest of her life.

—Nafisa Isa

Subrahmanyan Chandrasekhar and Lalitha Doraiswamy Chandrasekhar at the dedication of the McDonald Observatory, photographed by Watson Davis, 1939.

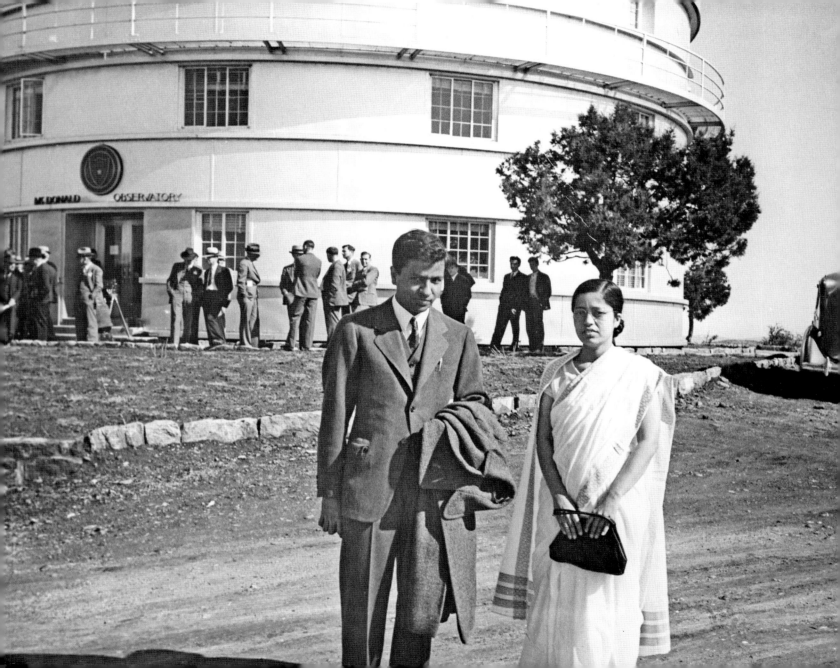

MUSIC FROM
WESTERN SAMOA
FROM CONCH SHELL
TO DISCO

Recordings, notes and photographs: Ad & Lucia Linkels

Unified Melodies of Language, Culture, and Faith

Located in western Polynesia, the Samoan archipelago is made up of an area encompassing 3,030 square km. This island chain has been inhabited by the Samoan people for at least 3,500 years according to Western archeological timeframes. Samoan culture has a long and rich musical history that spans nearly four millennia. Traditional Samoan instruments include the *pātē* (slit drum) and the *fala* (rolled mat). Both instruments are played by beating them with sticks.

Music has played a significant role in traditional Samoan culture; it was used to pass down important information through the generations. Pre-western contact Samoa had no known written language; history was passed down via oral tradition. Fast forward to 1830 when Christianity was introduced to Samoa by Reverend John Williams and the London Mission Society. The sacred music of the church heavily influenced and pervaded the traditional music of the islands, creating a hybrid musical style.

This mix combined the Samoan language and melodies with sacred church music. Compositions also changed by combining traditional instruments with those that were introduced by missionaries. Some of the introduced instruments include the *kitara* (guitar), *ukele* ('ukulele), and later the organ.

In the Smithsonian Folkways collection, the album entitled *Music from Western Samoa: From Conch Shell to Disco* was recorded in 1982 by the team of Ad and Lucia Linkels. The Linkels are ethnomusical legends because of their work throughout the Pacific, with numerous publications and albums credited to them. This album of various artists brings the diverse sounds of Western Samoa to its audience by embodying different styles, from conch shell calls to complete choral arrangements.

Tracks from the album like *Velo Mai Lau Disco* by the Fatausi Brassband are reminiscent of German Polka or Mexican Banda music with a full complement of brass instruments and an upbeat tempo. Songs like "Lau Lupe," by the Youth Group from Saleufi, Apia, are beautifully harmonized and driven by the pātē and guitar. The one constant throughout the album and its songs is the use of Gagana Sāmoa (the Samoan Language)—the binder that keeps the Samoan culture intact and prepared for the next thousand years.

—Kālewa Correa

Album cover for Music from Western Samoa: From Conch Shell to Disco. *Recorded by Ad and Lucia Linkels, 1982.*

Campaign Pins

Pins, bumper stickers, flyers, posters, and clothing are part of every political campaign. They're the way people can express support for their champion in the ring. These items convey slogans and images—but more importantly, they serve an important function as calls to action to entice the viewer and reader to get involved. It makes sense that the origin of the term campaign goes back to the martial context of open fields where armies would mass, rest, and coordinate for the attack. The candidate at the top of the ticket isn't alone. A campaigner—if they do the job right—will enlist the public in their goal to overtake their opponent in the race.

In 1989, African American attorney and Manhattan borough president David Dinkins was making a run for the office of New York City mayor. To conduct his walk-throughs in NYC's Chinatown, candidate Dinkins secured the help of an advance team that could speak Mandarin. According to accounts of the campaign, Dinkins's run was supported by the influential Chinese Consolidated Benevolent Association.

In 2020, Filipino American activist Vellie Dietrich-Hall aimed for a spot as a delegate for the Republican National Convention. She had previously served as the cochair of Asian Americans for Bush–Cheney in Virginia, 2004–05. In her appeal, the hopeful candidate noted that the large and growing population of Asian Americans in the Commonwealth represented what she called "low-hanging fruit that can easily be picked because their beliefs align well with the Republican creed—strong family values, self-reliance, belief in God and importance of education."

She acknowledged that her party faced a challenge: despite the GOP's attempt to be more inclusive, the party's rank-and-file were not diverse and the Democrats, in her words, out-hustled her party for Asian American votes.

Both examples speak to the notion of Asian America as a coalition, which is, in practice, localized, tactical, changing, and assembled for specific purposes. Coalitions aren't built to last. They're created to achieve specific aims, which is how you can find Asian Americans and Pacific Islanders in a range of political parties or even in no party at all.

The tactical use of these pins—and what they mean for a racial group's identity—calls to mind the foundations upon which the term "Asian America" was founded. One of the persons who helped to lay those foundations was singer, songwriter, and activist Chris Kando Iijima. Here's how he explained Asian Americans coming together: "Asian American identity was originally meant to be a means to an end rather than an end in itself. It was created as an organizing tool to mobilize Asians to participate in the progressive movements of the times. It was as much a mechanism to identify with one another as to identify with the struggles of others, whether it was African Americans or Asians overseas, and that it was less a marker of what one was and more a marker of what one believed."

—Theodore S. Gonzalves

A poster and campaign pins reflect Asian American and Pacific Islander participation in electoral politics.

ASIAN AMERICANS FOR BUSH-CHENEY

ASIAN-AMERICAN &
PACIFIC ISLANDERS
FOR
STACEY ABRAMS

Stacey Abrams, Sarah Riggs Amico, Charlie Bailey and John Barrow – Delivering for Georgia

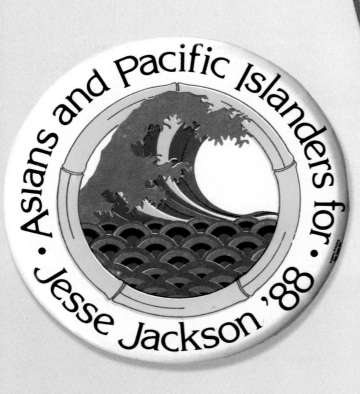

Asians and Pacific Islanders for · Jesse Jackson '88 ·

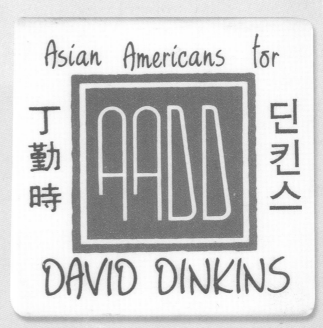

Asian Americans for

丁勤時 AADD 딘킨스

DAVID DINKINS

PAREDON RECORDS P—1042

THAILAND:
SONGS FOR LIFE
SUNG BY CARAVAN
Songs of the peasant, student and worker struggle for democratic rights

เพลงเพื่อชีวิต
โดย
คาราวาน

RECORDED IN THAILAND

Songs About Our Life

Where does community take hold? For Asian Americans, community can mean several places, not just a single location. Asian Americans have been immigrants who have taken root, sojourners who were only supposed to be passing through, or members of groups scattered locally or overseas—in other words, part of a diaspora. Simply put: Asian American communities are here and there. Scholars like Mark Padoongpatt note how Thai communities formed in the diaspora—not simply as natural outgrowths of the global pushing and pulling of immigrants into new places—but as part of long histories of entangled empires and capital's complicated labor flows.

An album by the Thai group Caravan offers an example of how community members have tried to collapse long distances—in this case, through the social power of music. Released in 1978, Caravan's *Thailand: Songs for Life* is tied to events in Thailand during the mid-1970s, when student social movements captured the imagination of what was happening in the country by mixing a variety of perspectives—rural, urban, student, worker, rebel, intellectual, and dreamer. They called their music phleng phua chiwit (songs for life), a local style in folk traditions, but with lyrics that paid close attention to stories about Thailand's class and political struggles. And because music is one of those activities where influences can effortlessly seep in, it's easy to see how Caravan's music paralleled the musical changes going on continents away, akin to Latin America's nueva cancion (nuevo cancionero in Argentina and nuevo trova in post-1959 Cuba)—music that had the urgency of the day's headlines but was firmly grounded in radical traditions of the past.

In the liner notes of the album, Caravan wrote of the Union of Democratic Thais (UDT), an organization that supported efforts for global audiences to learn about the tumult taking place in their homeland. UDT programmed speaking events, film screenings, and cultural performances, all with the aim of relaying news from Thailand that didn't make it to the major TV or radio networks. In doing so, they developed knowledge about the diaspora from New York; Washington, DC; Chicago, and Los Angeles as well as France, Japan, Hong Kong, New Zealand, Australia, Sweden, and Germany.

Caravan's songs were banned on the radio and in print in Thailand. Such is the fate of countless musicians attempting to sing truth to power in the midst of reactionary regimes. The album's liner notes recount the story of a tobacco farmer from the north who sang one of Caravan's outlawed songs while at work: "I can be arrested for singing this, but so what?" he said, "[These songs] are about our life. The words on leaflets given to us by the students. We burnt them up after October 6 [1976, with the return of a military dictatorship], but the words are in our hearts."

—Theodore S. Gonzalves

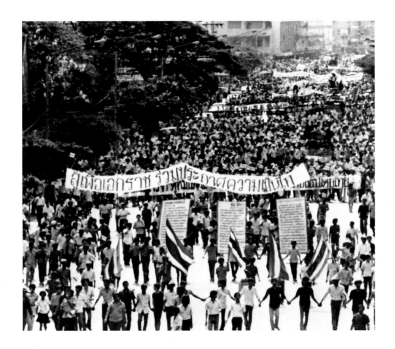

Left: Album cover for Thailand: Songs for Life, *released 1978. The recording became influential for many Southeast Asian organizers living abroad. Right: Students marching in the streets of Bangkok on March 21, 1976.*

Revelation in Portraiture

Art is a journey into a space between the known and unknown. This may be why Pakistani-born, New York-based Shahzia Sikander's work often reflects the experience of standing at the intersection of many cultural and social influences, but is always distinctly Pakistani, Muslim, and South Asian.

Born in Lahore, the "cultural heart" of Pakistan, Sikander (b. 1969) began questioning the postcolonial stigmas surrounding South Asian arts and culture at an early age. She devoted herself to learning the highly technical art of Indo-Persian manuscript painting and can be credited for reviving global interest in the art form through her contemporary expressions of manuscript painting—the neo-miniature—during the 1990s and early 2000s. Through the visual language of her neo-miniatures, Sikander has explored topics such as gender, sexuality, identity, colonialism, and imperialism.

Portrait of the Artist explores how portraiture may evoke an artist's numerous cultural and artistic influences and offer—in Sikander's words—a "reflection of a human emotion." The portrait, depicting Sikander in profile overlaid with layers of organic shapes rendered in muted yellow, comes from a series of four etchings created in collaboration with playwright, poet, and novelist, Ayad Akhtar (b. 1970).

In his accompanying statement for the series, Akhtar cites the story of the Mi'raj—the Prophet Muhammad's miraculous night journey from Makka to Jerusalem, and ascension to heaven. In these works, the Prophet is presented as an artist, with the Mi'raj serving as a metaphor for the "long, winding, yearning journeys toward creative revelation."

Alongside this spiritual metaphor for the artistic journey, Akhtar also calls out the cultural dynamics that cause a Muslim artist in the West to "work in a condition of impairment." The collaborators' shared concern speaks to the impact of Islamophobia in a post-9/11 world, where Muslim artists may feel they are creating in the absence of greater understanding or empathy for their spiritual traditions—speaking what they know and feel toward a society informed by what is unknown and othered.

This portrait and the series of etchings demonstrates Sikander's proficiency in layering Indo-Persian manuscript painting techniques with other materials and artistic mediums, inviting viewers to contemplate how multiple layers of visual language, cultural references, and reflection can be in conversation with each other, the viewer, and the society beyond.

—Nafisa Isa

Portrait of the Artist *by Shahzia Sikander, 2016.*

Ruby Ibarra

Ruby Ibarra (b. 1988)—rapper, music producer, and spoken word artist—is helping to write a new chapter in the ongoing story of hip-hop, a musical art form founded by New York City youth in the 1970s. Born in the Tacloban City, Philippines, Ibarra and her family migrated to California's East Bay in the 1990s. But that's not when she first heard the music.

Before coming to the United States, Ibarra's mom introduced her to rap in the Philippines. In an interview, Ibarra recalls an album by Filipino rapper Francis Magalona (1964–2009) was the only one "that my mom had packed in her suitcase. We'd listen to that over and over again until I could recite the words verbatim. 'Mga Kababayan' ["My Countrymen," from the 1990 album, *Yo!*] is actually the very first song I ever learned to recite." Unlike prior generations

who were compelled to assimilate to a monocultural America, Ruby and her family heard messages about cultural pride sewn into hip-hop's uniquely Pinoy tradition.

Growing up in California, she was influenced by the energy and social commentary found in the music of groups ranging from The Roots to Rage Against the Machine. But at the heart of her first album, *Circa91*, fans could hear the profound influence of her mother and the inspiration drawn from a Filipina feminist tradition. Ibarra describes many of the songs on the album as an ode to her mom: "When I think of what it means to be Filipina American, I think of someone who is a survivor or someone who's resilient. Those are all traits that I definitely see in my mother."

A standout track on *Circa91* is "US," with verses and choruses linking traditions of immigrant women across

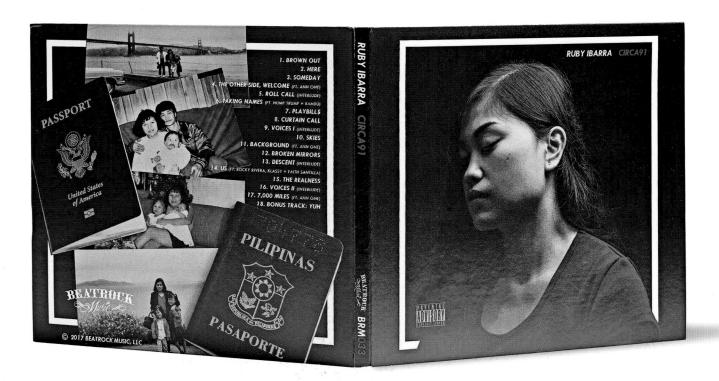

Album cover for Circa91 (left) released 2017 and jacket worn by Ruby Ibarra (right).

generations and oceans. Some of these lyrics appear on the jacket she donated to the Smithsonian: "Island woman rise, walang makakatigil (nothing can stop us) / Brown, brown woman, rise, alamin ang yung ugat (understand your roots) / They got nothin' on us (aye!) Nothin' on us (aye!) Nothin' on us (aye!) Nothin' on us."

The national language of the Philippines is Filipino, based largely on Tagalog. Ibarra's unapologetic inclusion of it—as well as her blending of it with English—is deeply American.

Of the top ten non-English languages most often spoken in US homes, four come from Asia. In addition to Filipino (other Philippine languages in the US include Ilokano and Bisayan), American homes are filled with Chinese (Cantonese and Mandarin), Vietnamese, and Korean—conduits for untranslatable memories, cherished idioms; inside jokes about coworkers, in-laws, and neighbors; and lyrics for countless albums.

—Theodore S. Gonzalves

Naomi Osaka
Masks and Racquet

On the tennis court, Naomi Osaka (b. 1997) excelled as a champion: the first Asian player to hold the top ranking in singles by the Women's Tennis Association, and the winner of four Grand Slams: two at the Australian Open (2019 and 2021) and two more at the US Open (2018 and 2020).

At the 2020 US Open, Osaka participated in a long tradition of celebrity athletes using their global platform to speak out about social and political issues. For the seven final matches, Osaka wore seven different face masks (widely required during the COVID-19 pandemic), each bearing the name of a Black person victimized by racial violence or profiling. The masks and racquet she used for the tournament join other objects at the Smithsonian—such as Muhammad Ali's robe, trunks, and gloves; Pro Football Hall of Fame inductee Randy Moss' necktie listing thirteen persons killed by police or while in police custody; or Billie Jean King's dress worn during her exhibition match against Bobby Riggs in the 1973 "Battle of the Sexes"—challenge the public to take up conversations off the courts.

In Osaka's case, she was moved by not only the murder of Minneapolis resident George Floyd (1973–2020) at the hands of a city police officer, but by the protests that brought millions into the streets all over the world. Born in Japan to a Haitian father and a Japanese mother, and spending her formative years in the United States, Osaka was impressed by the worldwide and diverse response to the death of Floyd: ". . . from Tallahassee to Tokyo, protests have included people of all races and ethnicities. There were even Black Lives Matter marches in Japan—something many of us would never have expected or imagined possible."

Osaka had the masks made in Los Angeles. In addition to Floyd, she had masks emblazoned with the following names: Ahmaud Arbery (1994–2020), Philando Castile (1983–2016), Trayvon Martin (1995–2012), Elijah McClain (1996–2019), Tamir Rice (2002–14), and Breonna Taylor (1993–2020).

Osaka stated, "It's quite sad that seven masks [aren't] enough for the amount of names."

The parents of Martin and Arbery thanked her for her actions. When asked by an ESPN reporter about the reason for wearing the masks, Osaka replied: "I feel like the point is to make people start talking."

—Theodore S. Gonzalves

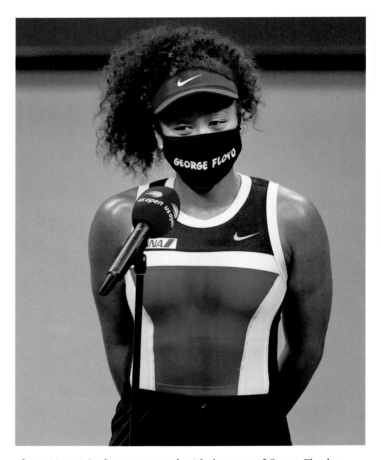

Above: Naomi Osaka wears a mask with the name of George Floyd on September 8, 2020. Right: Naomi Osaka's racquet and the seven Black Lives Matter-related masks she wore at the 2020 US Open.

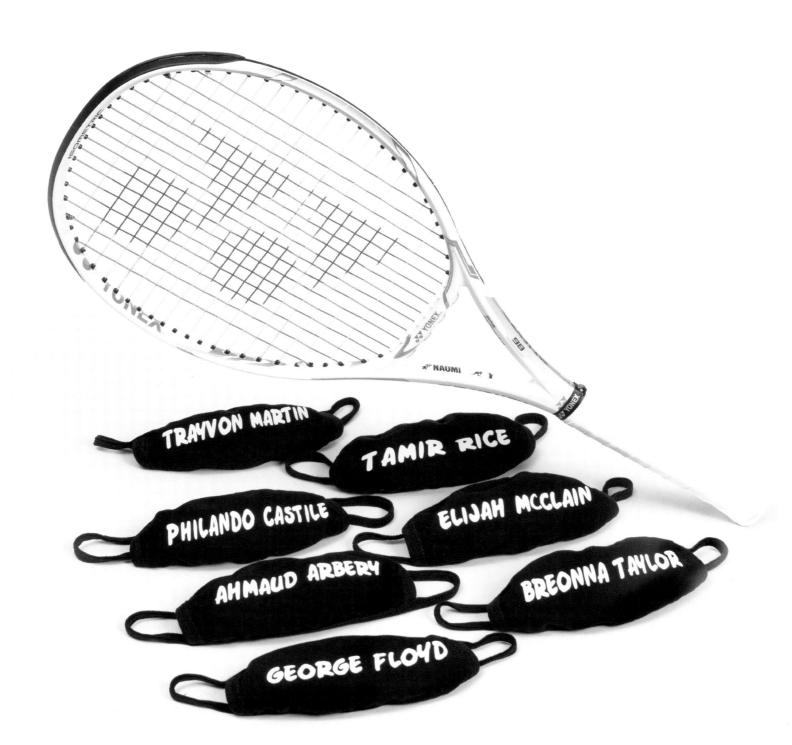

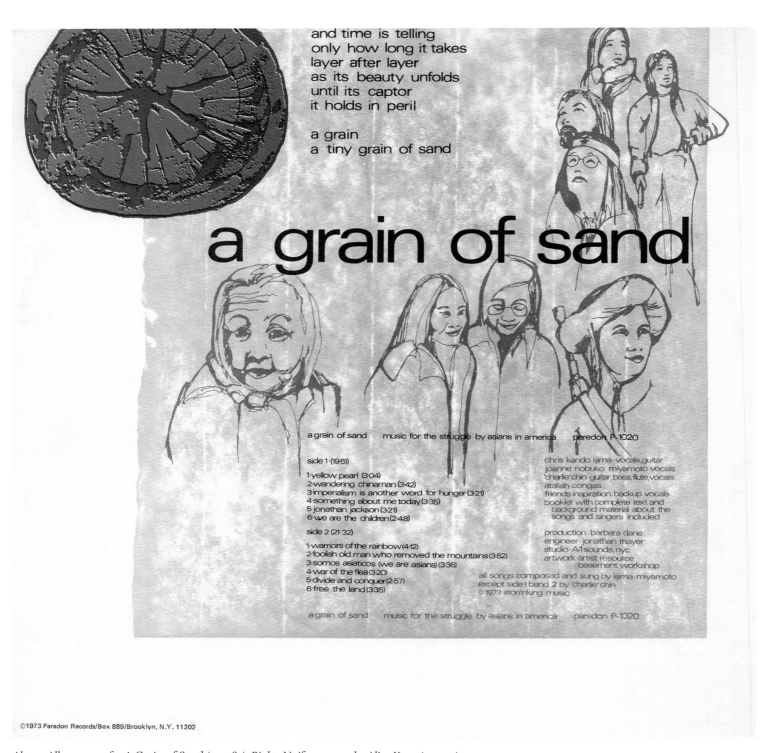

and time is telling
only how long it takes
layer after layer
as its beauty unfolds
until its captor
it holds in peril

a grain
a tiny grain of sand

a grain of sand

a grain of sand music for the struggle by asians in america paredon P-1020

side 1·(19·51)

1·yellow pearl (3·04)
2·wandering chinaman (3·42)
3·imperialism is another word for hunger (3·21)
4·something about me today (3·35)
5·jonathan jackson (3·21)
6·we are the children (2·48)

side 2·(21·32)

1·warriors of the rainbow (4·12)
2·foolish old man who removed the mountains (3·52)
3·somos asiaticos (we are asians) (3·36)
4·war of the flea (3·20)
5·divide and conquer (2·57)
6·free the land (3·35)

a grain of sand music for the struggle by asians in america paredon P-1020

chris kando iijima·vocals,guitar
joanne nobuko miyamoto·vocals
'charlie'chin·guitar,bass,flute,vocals
atallah·congas
friends·inspiration,backup vocals
booklet with complete text and
 background material about the
 songs and singers included

production·barbara dane
engineer·jonathan thayer
studio·A·1 sounds, nyc
artwork·artist resource
 basement workshop
all songs composed and sung by iijima·miyamoto
except side 1 band 2 by 'charlie'chin
©1973 stormking music

Above: Album cover for A Grain of Sand *(pg. 182). Right: Uniform worn by Alice Kono (pg. 172).*

CHAPTER NINE
Service

There is no shortage of examples of how Asian American and Pacific Islanders have been of service to each other or to nations, kingdoms, or ideals. Yes, the striking figure of the soldier in uniform reminds us of what the term can mean, but service takes many forms. And in this section, we consider a range of those meanings—from those who believe it is patriotic to oppose empire and other peoples' wars, to those who offer compassion and care without reward, including the first AAPIs to serve in Congress, to the rescuer whose voice guided people to safety during the 9/11 attacks, to diplomats, troubadours, and journalists.

From Orphan to Statesman

This 1886 formal studio portrait shows Kim Kyu-sik (1881–1950), a young Korean boy. Seated in a chair covered in a regal leopard skin fur, he seems destined for an important role. Yet, he was orphaned at a young age, possibly around the time this portrait was taken. He grew up to be an English teacher and a diplomat devoted to securing independence and stability for the Korean peninsula. The artifact underscores how geopolitics, specifically US interventions in Asia and the Japanese colonization of Korea, shaped the Korean diaspora both in the early twentieth century and beyond.

In the late nineteenth century, after centuries of purposeful isolation, Korea was forced open by treaties with China, Japan, Russia, and the United States, who all vied for access to the region's resources and strategic geography. Kim Kyu-sik was born in Korea in 1881, just one year prior to the signing of the US-Korea Treaty of Peace, Amity, Commerce and Navigation, which ushered in the arrival of American diplomats, businesspeople, and missionaries.

Kim was adopted into the family of American Presbyterian missionary Horace Grant Underwood, who lived in Seoul with his family. Christianity became an influential force in Korea during this period of political instability. American missionaries held posts as trusted counsel to the royal family, advising on matters beyond faith, including business, economic development, and infrastructure. They established churches, set up educational institutions, introduced Western social welfare practices, and even encouraged the emigration of Koreans to the United States for labor and study. American missionaries directly contributed to the first large-scale emigration of Koreans to fill the labor needs of US-owned plantations in Hawai'i in 1903—promoting the plan to the Korean government and recruiting migrants from their congregations.

Kim himself attended preparatory school in the United States and graduated from Roanoke College in Virginia in 1903. After Korea was annexed by Japan in 1910, Kim was among several Christian-educated Koreans who took up public leadership roles in a coordinated international effort across the diaspora to regain Korea's sovereignty. He served in the Korean Provisional Government in exile in China. He represented Korea at the 1919 Paris Peace Conference. And he held ministerial posts in the US-based Korean Commission in Washington, DC, from 1919 to 1921.

Kim spent most of his exile in China, finally returning to Korea in 1945 to a country that had been liberated but then partitioned between a Russia-occupied north and a US-occupied south. He was appointed to the interim legislature in the south established by the United States Army Military Government in Korea. But Kim objected to the formation of a separate South Korean government and sought cooperation with leaders in the north in hopes of reunifying the country. During the ensuing military conflict between the north and south, he was abducted and killed in North Korea. The emergence of the Korean peninsula as a frontline of the Cold War caused Kim's tragic end; it also conditioned interactions and pressures that impelled new South Korean emigration to the US—of war orphans, brides of American servicemen, students, and people escaping anti-Communist repression.

The early child portrait of Kim Kyu-sik was among a series of ethnographic specimens acquired by the Smithsonian in 1893 from the collection of Homer Bezaleel Hulbert, an American Presbyterian missionary who served in Korea in the 1880s. These items acquired from Hulbert are among a wide-ranging set of artifacts—fine arts, textiles, ceramics, religious objects—collected by military attachés or missionaries during the first decades of US-Korea diplomatic relations. They, like the portrait of Kim Kyu-sik and his storied life, speak to the broader context of international relationships and domestic stakes that compose the transnational foundation story of Asian America.

Portrait of Kim Kyu-Sik (1881–1950), 1886.

—Sojin Kim

Alice Kono's Uniform

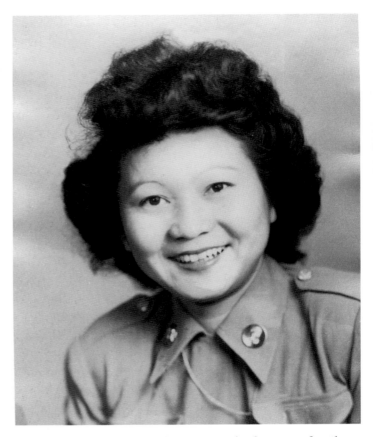

While a lot of attention has been paid to the military histories of Japanese American males during World War II, few studies have focused on the Japanese American women who served. The uniform depicted was worn by Alice Tetsuko Kono, who served in the Women's Army Corps (WAC) during the 1940s.

Kono was one of fewer than five hundred Japanese American women who served in the WAC. She had many roles and performed various tasks in the Army, ranging from driver, mechanic, cook, ordinance specialist, radio operator, to other tasks involving communications, logistics, public affairs, medical needs, and intelligence. Kono was trained as a military intelligence service linguist, where she translated captured documents sent from the Pacific as part of the "air section" while stationed at Fort Ritchie, Maryland.

Kono grew up on the island of Molokai. Her father worked as a carpenter; her mother worked in their home. She had a sister and two brothers. After the attack on Pearl Harbor on December 7, 1941, Japanese and Japanese Americans were labeled "enemy aliens" and were prohibited from serving in the US military. With the signing of President Roosevelt's Executive Order 9066 of February 19, 1942, major parts of the western US and what was then the territory of Hawai'i were designated as "military exclusion zones," preparing the way for the mass incarceration of 120,000 persons of Japanese ancestry without trial. In early 1943, Roosevelt permitted the formation of the all-Japanese American 442nd Regimental Combat Team, and later opened military enlistment to Japanese American women in November 1943.

Kono joined the WAC in 1943. Her parents didn't seem to think she'd actually be able to join: "I think my dad didn't think they would take me because I was so short; so he said, 'Oh go ahead.'" Kono enlisted out of a sense of loyalty and patriotism. "There was nobody in our family that was in the service, so I thought somebody should be loyal to the country."

After the war, Alice Kono earned a business degree and worked at a Hawai'i manufacturing company for almost thirty years.

—Theodore S. Gonzalves

Above: Portrait of Alice Kono at Fort Ritchie, Maryland, in 1945. Right: Uniform worn by Alice Tetsuko Kono, who served in the US Women's Army Corps from 1944–46.

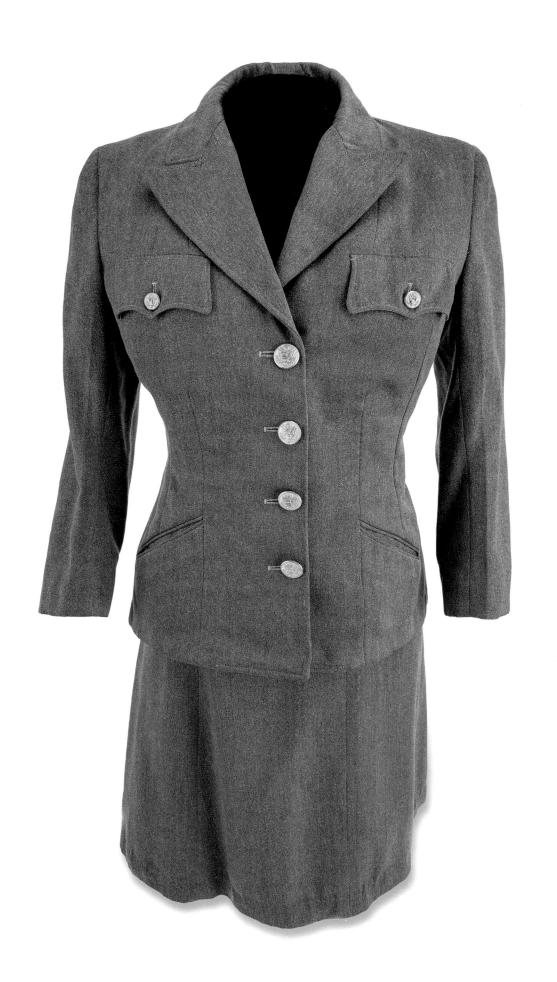

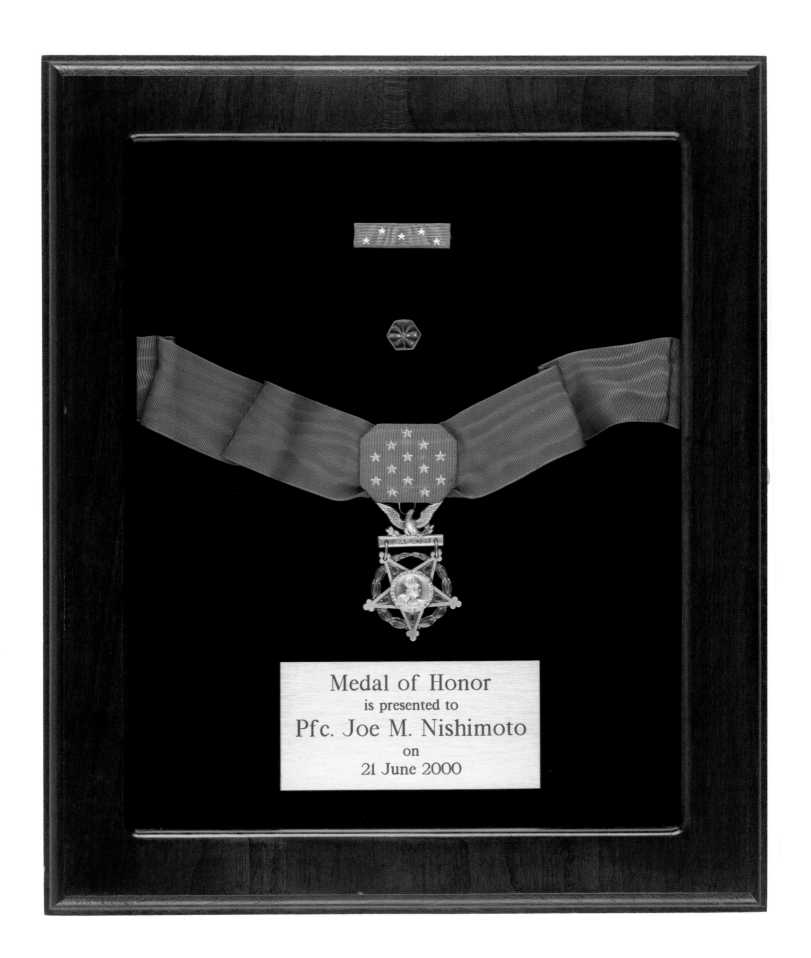

Medal of Honor
is presented to
Pfc. Joe M. Nishimoto
on
21 June 2000

Medal of Honor

The Medal of Honor is the nation's highest award for military bravery and has been presented since 1863. In 1996, Congress directed the Army and the Navy to conduct a review of Asian American and Pacific Islander awardees of the Distinguished Service Cross and the Navy Cross who served during World War II to determine if their records merited reconsideration for the Medal of Honor. On June 21, 2000, President Clinton presented the medals at a White House ceremony to twenty-two Asian Americans. The citation for this Medal of Honor awardee Joe Nishimoto (1919–44) reads:

Private First Class Joe M. Nishimoto distinguished himself by extraordinary heroism in action on 7 November 1944, near La Houssiere, France. After three days of unsuccessful attempts by his company to dislodge the enemy from a strongly defended ridge, Private First Class Nishimoto, as acting squad leader, boldly crawled forward through a heavily mined and booby-trapped area. Spotting a machine gun nest, he hurled a grenade and destroyed the emplacement. Then, circling to the rear of another machine gun position, he fired his submachine gun at point-blank range, killing one gunner and wounding another. Pursuing two enemy riflemen, Private First Class Nishimoto killed one, while the other hastily retreated. Continuing his determined assault, he drove another machine gun crew from its position. The enemy, with their key strong points taken, were forced to withdraw from this sector. Private First Class Nishimoto's extraordinary heroism and devotion to duty are in keeping with the highest traditions of military service and reflect great credit on him, his unit, and the United States Army.

In addition to Private First Class Nishimoto, the other awardees who were recognized with a Medal of Honor that day were Staff Sergeant Rudolph B. Davila, Private Barney F. Hajiro, Private Mikio Hasemoto, Private Joe Hayashi, Private Shizuya Hayashi, Second Lieutenant Daniel K. Inouye, Technical Sergeant Yeiki Kobashigawa, Staff Sergeant Robert T. Kuroda, Private First Class Kaoru Moto, Private First Class Kiyoshi K. Muranaga, Private Masato Nakae, Private Shinyei Nakamine, Private First Class William K. Nakamura, Staff Sergeant Allan M. Ohata, Technician Fifth Grade James K. Okubo, Technical Sergeant Yukio Okutsu, Private First Class Frank H. Ono, Staff Sergeant Kazuo Otani, Private George T. Sakato, Technical Sergeant Ted T. Tanouye, and Captain Francis B. Wai.

In 1947, Pulitzer Prize winning editorial cartoonist Bill Mauldin wrote about his experiences serving with Japanese American soldiers during World War II: "They were willing to take extra chances and do extra jobs in hopes that a grateful nation would maybe give their families, many of whom were in concentration camps formally known as relocation centers, a few breaks that were long overdue. . . . As far as the [US] army in Italy was concerned, the Nisei could do no wrong. We were proud to be wearing the same uniform."

—Theodore S. Gonzalves

Medal of Honor awarded to Private First Class Joe Nishimoto.

Dalip Singh Saund

Dalip Singh Saund (1899–1973) tallied several firsts for Congress: the first person of Asian descent, the first Indian American, and the first Sikh to serve in the United States House of Representatives, as the member of California's 29th district from 1957 to 1963. Born in Chhajjalwaddi, Punjab, India, Saund studied math at the University of Punjab, graduating with a bachelor's degree from there in 1919. He came to the United States to study agriculture but continued his interest in mathematics, eventually earning a master's and PhD in the subject by 1924.

Students from foreign countries can often be isolated being far from home. A key to Saund's success in his early years in the United States was his support by the Stockton Gurdwara, founded in 1912 as the first permanent Sikh American settlement in the United States. Saund served as the gurdwara's general secretary from 1948 to 1950 and as a member of its executive committee until 1953. In 2012, California's legislature marked the centennial anniversary of the Sikh community's founding. Bruce La Brack of the University of the Pacific highlighted the importance of the gurdwara founded in 1912: "The Stockton gurdwara . . . served as a combination church, dining hall, rest home, employment information center, meeting place, political forum, and sanctuary where Punjabi culture and language were understood." The early twentieth century was a precarious time for the South Asian community, especially since the 1917 Barred Zone Act prevented migration to the United States. Students were one of the excepted groups.

Saund drew parallels between his inability to become a US citizen and the long history of British colonial rule in India. He made clear parallels as well between his two heroes—Abraham Lincoln and Mohandas Gandhi—both of whom he understood as working toward the emancipation of oppressed people. He summarized these lessons in two works he authored, *My Mother India* (1930) and *Congressman from India* (1960).

Saund became involved in grassroots organizations in California that called for the granting of citizenship to South Asians. The passage of the Luce-Cellar Act of 1946 allowed Saund to receive his naturalization papers in 1949.

His community service deepened when he decided to run for a local judgeship in Westmorland, a small town in California's Imperial County. During the campaign, neighbors lobbed casually racist questions like: "Doc, tell us, if you're elected, will you furnish the turbans or will we have to buy them ourselves in order to come into your court?" Saund replied: "My friend . . . you know me for a tolerant man. I don't care what a man has on top of his head. All I'm interested in is what he's got inside of it." He won that race in 1950.

Those years as a local judge inspired even more public service. In his run for a Congressional seat, he had several things going for him. His mixed-race children conveyed a forward-looking vision of postwar social change. A new generation of young people were on the cusp of challenging a legally segregated society. And Saund's political acumen continued to develop from years as party stalwart who had worked up from committee ranks.

Saund's election in 1953—a year before the landmark desegregation resulting from the *Brown v. Board of Education* ruling—seemed perfectly timed. In his memoir, he wrote: "There is no room in the United States of America for second-class citizenship. In Uncle Sam's family there are no foster children. All American citizens must enjoy equal rights under law."

—Theodore S. Gonzalves

Dalip Singh Saund (left) *being congratulated on his election by Ray Barnes, 1956.*

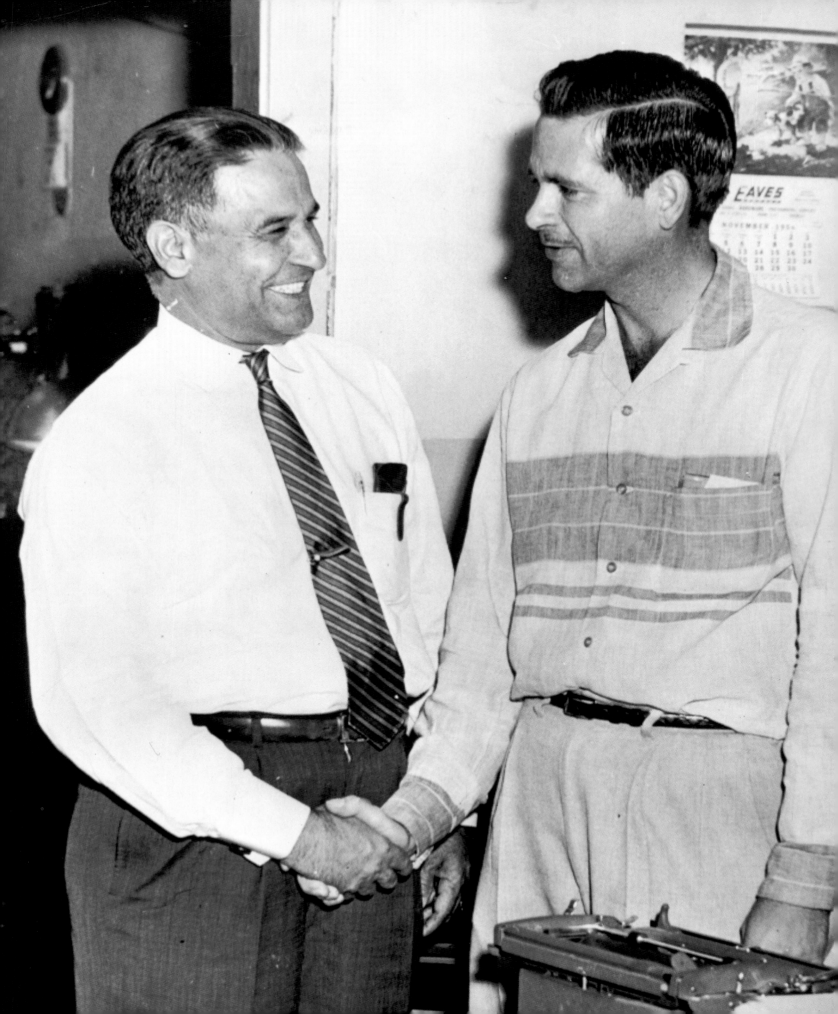

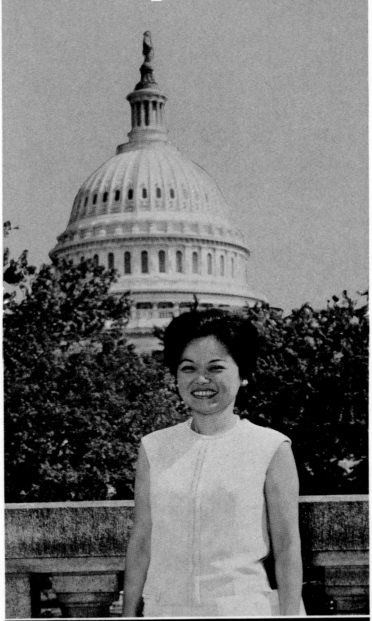

RE-ELECT
Patsy Mink

United States Congress
DEMOCRAT

Reelect Patsy Mink

Patsy Mink's initial historic campaign resulted in several firsts for a member of Congress: The first Asian American woman, the first woman from Hawai'i, and the House's first woman of color. During her long career in that body, consisting of twelve terms from 1964 to 2002, Mink (1927–2002) also took a run at the presidency and firmly established herself as one of the nation's most influential legislators with her coauthorship of the Title IX Amendment of the Higher Education Act. The legacy of her work continues to be felt by millions today.

This campaign leaflet is from Mink's first reelection campaign to the United States House of Representatives. Pitched to her "fellow citizens of Hawai'i," the inside of the flyer is illustrated with several images that point to the range of work that Mink accomplished in the 89th Congress. As a member of five sub-committees, she tackled both domestic and international legislative priorities. Among the images are Mink taking part in an inspection of a school in India; she is seen cosponsoring a conference with the Honolulu Chamber of Commerce; Mink is pictured with then senator Robert Kennedy on the occasion of a luncheon supporting children with developmental disabilities; she and President Lyndon Johnson are pictured at the White House holding the text of Mink's bill on school construction, which had been signed. Representing the state of Hawai'i gave her a unique platform at several speaking engagements throughout the country on the topic of civil rights and social justice issues.

The legislator's biography, *Fierce and Fearless: Patsy Takemoto Mink, First Woman of Color in Congress*, is coauthored by historian Judy Tzu-Chun Wu and Patsy's daughter, Gwendolyn Mink. Gwendolyn recalls her recollection of those early terms in the House: "The only woman of color in Congress, from a state not fully regarded as 'American,' she had to earn credibility in spite of who she was, where credibility was given to her white male colleagues because of who they were." Conversations at home were about politics, not the easiest of topics in any household, and included constitutional checks and balances, First Amendment protection of dissent, ethnocentrism, racism, and more. Mink noted, "I learned civics in discussing Viet Nam over cocoa and coffee with my mother before dawn."

Even after breaking barriers to join the ranks as a House member, Mink took a stand against the Vietnam war that put her at odds with many in her party, the president, and, in the mid-1960s, a sizable portion of public opinion.

Nearly a decade later, so much policy and politics had shifted, and Patsy Mink could offer this perspective in 1975: "It is easy enough to vote right and be consistently with the majority, but it is more often more important to be ahead of the majority and this means being willing to cut the first furrow in the ground and stand alone for a while if necessary."

—Theodore S. Gonzalves

Leaflet from the 1966 campaign to reelect Patsy Mink to the US House of Representatives.

Godfather of Asian American Journalism

For reporters, press IDs are both indispensable tools of the trade and part of their professional wardrobe. In the old days, they tucked them into the bands of their fedoras when out on assignments. Today, they string them around their neck from lanyards. A specific type of reporter's ID is the law enforcement press credential. These provide reporters access behind police lines, onto crime scenes, and into courthouses and prisons—all of which were the occupational stomping grounds of journalist Kyung Won Lee, aka K. W. Lee (b. 1928).

K. W. Lee is a trailblazing journalist. He was the first Korean immigrant reporter for a mainstream US mainland newspaper. For his dogged chops as an investigative reporter, colleagues have called him "a cross between Indiana Jones and Lt. Columbo" and "an obsessive, even maniacal, heat-seeking journalistic missile." To the people he has mentored, he is the godfather of Asian American journalism.

Born in Korea in 1928, Lee arrived in the US in 1950. He studied journalism at West Virginia University and University of Illinois, Urbana-Champaign, with dreams of applying the principles of a free press in his newly independent homeland. When Cold War instability and repression in Korea quashed these plans, Lee set down roots in the United States—marrying a nurse, Peggy N. Flowers, who he met in a hospital emergency room while working the crime beat in Appalachia.

His career of more than five decades spanned, in his words, from "the Jim Crow South to the Yellow Peril West." A relentless champion of the underdog, he investigated government corruption and wrote stories to humanize people typically left out of mainstream narratives. In the 1950s and 1960s, he reported on the courts, fair elections, labor, poverty, and civil rights for the *Kingsport Times* in Tennessee and later the *Charleston Gazette* in West Virginia. In 1970, he moved his family to California when he was hired by the *Sacramento Union*. During his twenty-year tenure there, he wrote an award-winning series that led to state pension reform. He also carved out time to found the *Koreatown Weekly* (1979) and establish the English edition of the *Korea Times* (1990) to provide an English-language platform for the country's growing Korean population.

Lee was involved in two watershed events that are defining reference points for Korean Americans. First, his investigative reporting at the *Sacramento Union* in the late 1970s helped to catalyze the Chol Soo Lee Movement, a national grassroots effort considered the first pan-Asian American social movement, which successfully won legal justice for a Korean immigrant on California's death row. Second, he provided a voice of leadership prior to and following the 1992 civil unrest variably described as the "L. A. Riots" or "LA Uprising." Both events put a spotlight on the experiences of Korean immigrants and how they fit into the shifting racial landscape of the United States; both raised questions about race, culture, and the American criminal justice system and revealed the deficiencies of mainstream media coverage of non-white immigrants.

In a 1992 acceptance speech for one of his many honors, Lee spoke of the accountability of media and his belief in the power of stories and accurate, balanced reporting to foster a better society: "We are all entangled in an unbroken human chain of interdependence and mutual survival. And what really matters is that we all belong to each other during our earthly passage."

—Sojin Kim

Press credential badges for Kyung Won Lee, aka K. W. Lee, when he was a reporter for the Sacramento Union.

DEPARTMENT OF THE SHERIFF
COUNTY OF LOS ANGELES
PRESS PASS
1990 1857

K.W. LEE
KOREA TIMES

THIS CARD IS ISSUED ONLY FOR THE PURPOSE OF IDENTIFYING THE ABOVE NAMED PERSON WHOSE PHOTOGRAPH APPEARS HEREON, AS AN ACCREDITED REPRESENTATIVE OF THE ORGANIZATION STATED.

Sherman Block
SHERIFF

THIS PASS IS SUBJECT TO REVOCATION BY THE SHERIFF, AND MUST BE SURRENDERED UPON ANY CHANGE OF EMPLOYMENT

SHERIFF'S INFORMATION BUREAU
HALL OF JUSTICE 974-4211

Altadena	(818) 798-1131
Antelope Valley	(805) 948-8466
Avalon	510-0174
Carson	830-1123
Crescenta Valley	(818) 248-3464
East Los Angeles	264-4151
Firestone	582-7878
Industry	(818) 330-3322
Lakewood	866-9061
Lennox	671-7531
Lomita	539-1661
Lynwood	537-6111
Malibu	456-6652
Marina del Rey	823-7762
Norwalk	863-8711
Pico Rivera	949-2421
San Dimas	(818) 332-1184
Santa Clarita Valley	(805) 255-1121
Temple City	(818) 285-7171
Walnut	(818) 913-1715
West Hollywood	855-8850

76P592 SH-AD-21 11/88

A

THE KOREA HERALD

IDENTIFICATION
NAME: Lee Kyung-won
DATE OF BIRTH: June.1,1928
POSITION: Editorial consultant

HAN JONG-WOO
Editorial consultant
President-Publisher

No. 164
身分証明書
姓　名 李慶頼 [48.6.1.生]
職　位 편집고문
住　所 강남.잠원.한신Ⓐ 120-1013

위와 같이 証明함

有効期間　自19 88 年 1 月 1 日
　　　　　至19 88 年 12 月 31 日
　　　　　19 88 年 1 月 1 日

서울特別市 中区 會賢洞3街1의12

코리아 헤럴드
代表理事社長 韓 鍾 愚

and time is telling
only how long it takes
layer after layer
as its beauty unfolds
until its captor
it holds in peril

a grain
a tiny grain of sand

a grain of sand

a grain of sand music for the struggle by asians in america paredon P-1020

side 1 · (19·51)

1 · yellow pearl (3·04)
2 · wandering chinaman (3·42)
3 · imperialism is another word for hunger (3·21)
4 · something about me today (3·35)
5 · jonathan jackson (3·21)
6 · we are the children (2·48)

side 2 · (21·32)

1 · warriors of the rainbow (4·12)
2 · foolish old man who removed the mountains (3·52)
3 · somos asiaticos (we are asians) (3·36)
4 · war of the flea (3·20)
5 · divide and conquer (2·57)
6 · free the land (3·35)

chris kando iijima · vocals, guitar
joanne nobuko miyamoto · vocals
'charlie' chin · guitar, bass, flute, vocals
atallah · congas
friends · inspiration, backup vocals
booklet with complete text and
 background material about the
 songs and singers included

production · barbara dane
engineer · jonathan thayer
studio · A-1 sounds, nyc
artwork · artist resource
 basement workshop

all songs composed and sung by iijima · miyamoto
except side 1 band 2 by 'charlie' chin
© 1973 stormking music

a grain of sand music for the struggle by asians in america paredon P-1020

A Record First

n 1973, a trio of young activists in New York City recorded *A Grain of Sand: Music for the Struggle by Asians in America* for the Paredon Records label. Equal parts political manifesto, collaborative art project, and organizing tool, it is widely recognized as among the first albums of Asian American music.

Singing of their direct lineage to immigrant workers as well as their affinity with freedom fighters around the world, Chris Kando Iijima, Nobuko JoAnne Miyamoto, and William "Charlie" Chin recorded the experiences of the first generation to identify with the term "Asian American." They shared a coalitional vision to actively recover connections to cultural heritage and histories that in previous generations had been sources of stigma. Music provided a powerful means for articulating their aspiration to reshape a society reeling from a prolonged war in Southeast Asia, ongoing struggles against racial inequity, and revelations of the Watergate cover-up. As writer and activist Phil Tajitsu Nash would state many decades later, *A Grain of Sand* was "more than just grooves on a piece of vinyl," it was "the soundtrack for the political and personal awareness taking place in their lives."

Chris Iijima (1948–2005) and Nobuko Miyamoto (b. 1939) were the grandchildren of Japanese immigrants. Their families were forcibly removed from their California homes and incarcerated in camps during World War II. Miyamoto's family returned to the West Coast after the war, where she honed her artistic talents before finding work on Broadway. Iijima's family resettled in New York City, where he attended the High School of Music and Art in Harlem, and where both parents introduced him to civil rights activism. Charlie Chin (b. 1944) grew up in Queens, the son of an immigrant father from Toisan, China, and a mother of mixed Chinese, Carib, and Venezuelan ancestry. He played banjo and toured as the guitarist for a psychedelic rock band, but he also played the cuatro, a stringed guitar-like instrument played in Latin American and Caribbean music, and di zi, a transverse Chinese flute.

Together, the artists composed the songs for *A Grain of Sand* from the content of their lives, including their emerging activism and consciousness as Asian Americans, and in the musical vocabulary of the American folk music revival, blues, soul, and jazz. Many of the songs on the album exhort the listener to action: "Hold the banner high," "Will you answer," "Take a stand." Their lyrics also reflected solidarity with Latino, African American, and Indigenous struggles. In fact, the album expresses the wider collaborations linking young activists and artists at the time. For example, the musicians found a creative home at Basement Workshop, an Asian American collective in New York's Chinatown. From this group, Arlan Huang and Bob Hsiang provided the artwork for *A Grain of Sand*'s cover and liner notes. The song "Somos Asiaticos," sung in English and Spanish, was inspired by the network of artists, many from Latin America, involved in New York's squatters' and Puerto Rican independence movements. "Free the Land" was written for the Republic of New Africa, an organization established in the late 1960s by some of Malcolm X's former associates.

Iijima, Miyamoto, and Chin performed around the country, supporting community events and sharing news between different regions. Today, the album is an important touchstone for the cultural production that emerged out of the nascent Asian American movement. It is also an artifact that speaks to the social power of music in general and more specifically to Asian American participation in creative arts as composers and performers.

—Sojin Kim

Album cover for A Grain of Sand, *featuring artwork by Arlan Huang, 1973. It is a pioneering album of music by three activists that crystallized the sentiments in the Asian American movement of the 1970s.*

Following the Voice

saac Jesse Waipulani Hoʻopiʻi (b. 1963) has been using his voice to guide listeners for years. He's probably best known for rescuing persons at the Pentagon when it was attacked by five Saudi men who hijacked American Airlines Flight 77 on September 11, 2001. The plane left Dulles International Airport and was bound for Los Angeles, California, when the attackers navigated it to crash into the building at 9:37 a.m. EST. All sixty-four persons on board, including the flight crew, perished. Another 125 died at the Pentagon.

As a Pentagon police officer on duty, but at another location, Hoʻopiʻi rushed to a scene of smoke, ash, and chaos, and called out to anyone still alive inside: "Come toward my voice!" He carried eight persons out to safety and has been credited for saving another eighteen to twenty people who followed him out from the rubble.

In a documentary film, Hoʻopiʻi stressed the need for surviving rescuers and others to seek out adequate mental health care. Hoʻopiʻi knew that the helpers also needed help.

The story of Hoʻopiʻi's heroic rescue actions at the Pentagon turned the world's attention to him. He appeared on the evening news. He was awarded the Congressional Medal of Valor. But this country's own deep tradition of racism also trained its attention to Hoʻopiʻi as well—a reminder that even high-profile heroes were not necessarily free from racial profiling. Hoʻopiʻi was pulled over twice in a car for "driving while Black or Brown." He chalked the situations up to a post-9/11 world where law enforcers continued to presume non-white guilt.

Hoʻopiʻi' has also used his talent for decades to stay rooted in his Hawaiian cultural heritage. It was his father who taught him to play ki hoʻalu (Hawaiian slack key) on guitar. Raised on the leeward side of Oahu in Waiʻanae, Hoʻopiʻi grew up in a large family of nine siblings. He joined the US Army after graduating from Waiʻanae High School and moved to the Washington, DC-area, where since 1996 he's been singing and playing as a member of the Aloha Boys along with Irv Queja and Glen Hirabayashi. He and the Aloha Boys first came together to provide live music for their niece's and daughter's performance in the Hālau OʻAulani, a school devoted to perpetuating Hawaiian culture through dance, language, art, music, history, and customs. The Aloha Boys have been featured in hundreds of live events, from local festivals in the DC metropolitan area to performances at the Smithsonian National Museum of the American Indian, the US Capitol, and to welcome the crew of the Hōkūleʻa and the Polynesian Voyaging Society in Arlington in 2016.

—Theodore S. Gonzalves

Part of the uniform worn by Isaac Hoʻopiʻi (above), an officer with Defense Protective Services at the Pentagon, credited with saving several lives during the September 11, 2001, attacks.

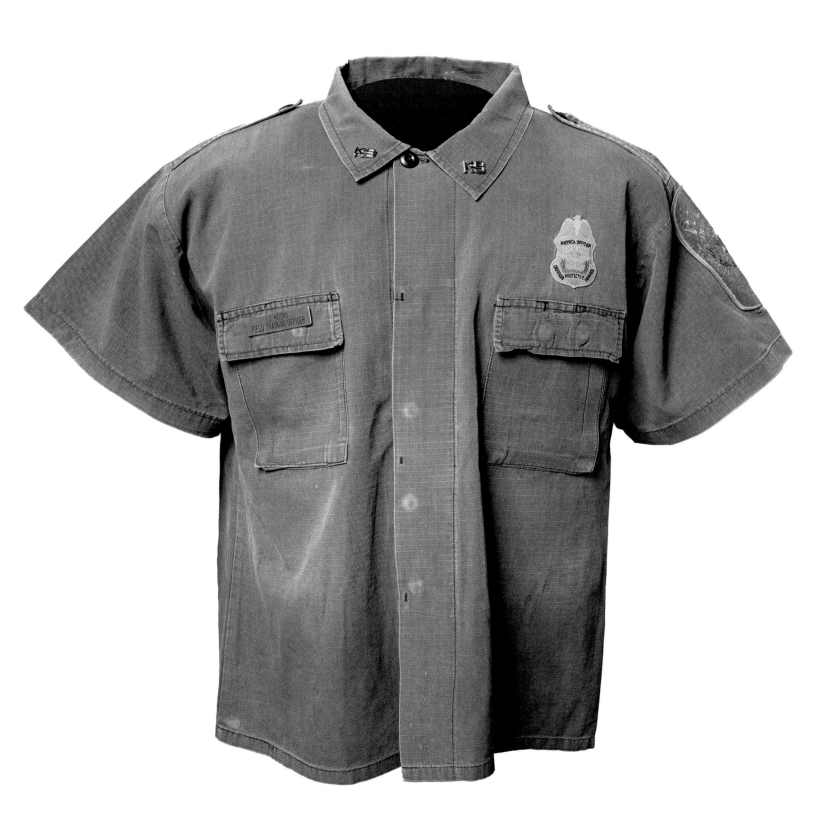

January 6th Suit

Congressman Andy Kim (b. 1982) can still remember the first time he saw the US Capitol. His parents, born in South Korea, had brought him to Washington on a family trip as a kid, and his mother strolled into the soaring rotunda with a clear sense of belonging. "We had every bit as much of a right to walk into the building," Kim later recalled, "as anyone else." At a time when almost none of the politicians in suits buzzing by looked like his family, Kim could hardly imagine that he would one day join their ranks.

Nor could he imagine what he might witness in that same hall on January 6, 2021.

Growing up in southern New Jersey, Kim has always drawn strength from that sense of belonging and duty. He rose through the ranks of public service, winning Rhodes and Truman scholarships, and working for the State Department and National Security Council, serving in Afghanistan. Along the way, Kim faced attempts to paint him as somehow foreign. The State Department blocked him from working on South Korean issues, solely based on his family background. When Kim first ran for Congress, in a district that was just 3 percent Asian American, his rivals circulated a mailer with pictures of dead fish on it, printed with the words "Real Fishy" and "Not One of Us" in the garish "Chop Suey" font. Nevertheless, Kim won that race, and another; and he was reelected for a third term representing New Jersey's 3rd District in November 2022.

On the evening of January 6, 2021, Congressman Kim walked back into the Capitol rotunda, still sure that he belonged there. He had spent the last eight hours with his staff, barricaded in his congressional office, as attackers rampaged through the building. He found the "room that I love so much" strewn with wreckage—water bottles, soiled MAGA flags, cigarettes extinguished on the statues, and fire extinguisher foam coating the floor. What Kim did next was, in his words, "Unremarkable . . . I saw a mess and I cleaned it."

Blue suit worn by Andrew Kim, a member of the US House of Representatives from New Jersey's 3rd Congressional District, when he helped to clean the US Capitol Building after the January 6, 2021, insurrection (above right).

Rep. Kim grabbed some trash bags and got down on his knees to clean the room. He filled bag after bag, as dirt and fire extinguisher foam stained his blue J. Crew suit. Photographers snapped pictures, which quickly went viral. Eventually he was called away, to vote to affirm the Electoral College results from the 2020 election. Cleaning and voting served a similar purpose to Rep. Kim. "That's all the same to me," he explained, all part of his role as an elected "caretaker" for democracy.

Congressman Kim considered throwing away his suit after that night but found two more uses for it. First, he put it on one last time, to vote to impeach Donald Trump for inciting the attack. Later that winter, when curators from the Smithsonian contacted him, Kim donated his suit to the National Museum of American History.

Getting down on his knees to clean the capitol floor seems to have only strengthened Kim's sense of belonging. He thought of the boy he was when he first visited that grand space, of his own children, and of his parents who traveled halfway around the world to live in a place that didn't speak their language, drawn by a promise that no mob could extinguish. "That is worth fighting for," Kim promised, "That is worth trying to preserve."

—Jon Grinspan

Above: Nationalities: Eleven Filipino women in native dress *by Stephanie Syjuco (pg. 212). The Feather Cape of Kekuaokalani (pg. 190).*

CHAPTER TEN

Memory

Memories can fail us. Two eyewitnesses to the same event can come up with completely different versions of what happened. All our hard drives will at some point become expensive paperweights. And then there are people we know who seem to have photographic memories—folks who can recall the tiniest of details from decades ago as if it happened earlier that day. Because so many AAPI experiences have not been cataloged and archived, Asian Americans and Pacific Islanders pour memories into anything that might be able to take the weight: canvases, cloaks, poems, and photos, so that someone or something else can carry the memory forward. To remember is not only to recall something from the past; to remember is to join scattered parts into a whole. This section leans on AAPI artists to accomplish both tasks.

Feather Cape of Kekuaokalani

King Kamehameha I (1758–1819) was the steward of Kūkāʻilimoku (war god of Kamehameha) and an intrepid believer of the kapu system (traditional Hawaiian religion). Proceeding the death of King Kamehameha I, his son Liholiho, Kamehameha II (1797–1824), decided to abolish the kapu system in favor of Christianity as Hawaiʻi's national religion. This action was both welcomed and spurned by aliʻi (chiefs) across the islands. One of the most vocal opponents to this decision was Kekuaokalani, nephew of King Kamehameha I. So much so that he chose to go to war against his cousin Liholiho to try and restore the kapu system.

The battle between Kekuaokalani and Liholiho's forces took place in 1819 at Kuamoʻo on Hawaiʻi Island. Thousands of warriors were on the battlefield armed with rifles and traditional Hawaiian weapons. Kekuaokalani's forces became inundated by Liholiho's men led by high chief Kalanimoku. Over three hundred perished that day, including Kekuaokalani and his wife Manono who fought at his side until her death.

Draped over his body was his ahuʻula (feather cape) made from the brilliant yellow feathers of the Hawaiʻi ʻōʻō (*Moho nobilis*) and red feathers of the ʻiʻiwi bird (*Drepanis coccinea*). Only the highest ranking aliʻi wore ʻahuʻula as it was believed to provide both spiritual and physical protections for the wearer. The feathers used for ʻahuʻula were collected by skilled kia manu (bird catchers) who would use a gum made of ʻulu (*Artocarpus altilis*) sap attached to a branch to capture the birds. Imitating bird calls, the kia manu would attract the birds to the area where the trap was set. Once the bird was stuck in the gum the kia manu would pluck a few feathers from the bird then release the bird back into the wild. The relationship between the kia manu and the birds that they caught was one of respect and reverence. Strict protocols and prayer were followed in the collection of feathers placing the welfare of the birds at the center.

Each ʻahuʻula took thousands of feathers to make and at times could take generations to complete for a wearer yet to be born; thus, these feathered capes were one of the highest visual and spiritual forms of mana (power) that a chief could wear. With the death of Kekuaokalani came the end of fervent opposition to Christianity becoming the national religion of the Kingdom of Hawaiʻi. The effects of that theological transformation continue to be felt throughout kānaka maoli (Native Hawaiian) culture to this day.

—Kālewa Correa

Ka Ahuʻula o Kekuaokalani (The Feather Cape of Kekuaokalani), ca. 1819.

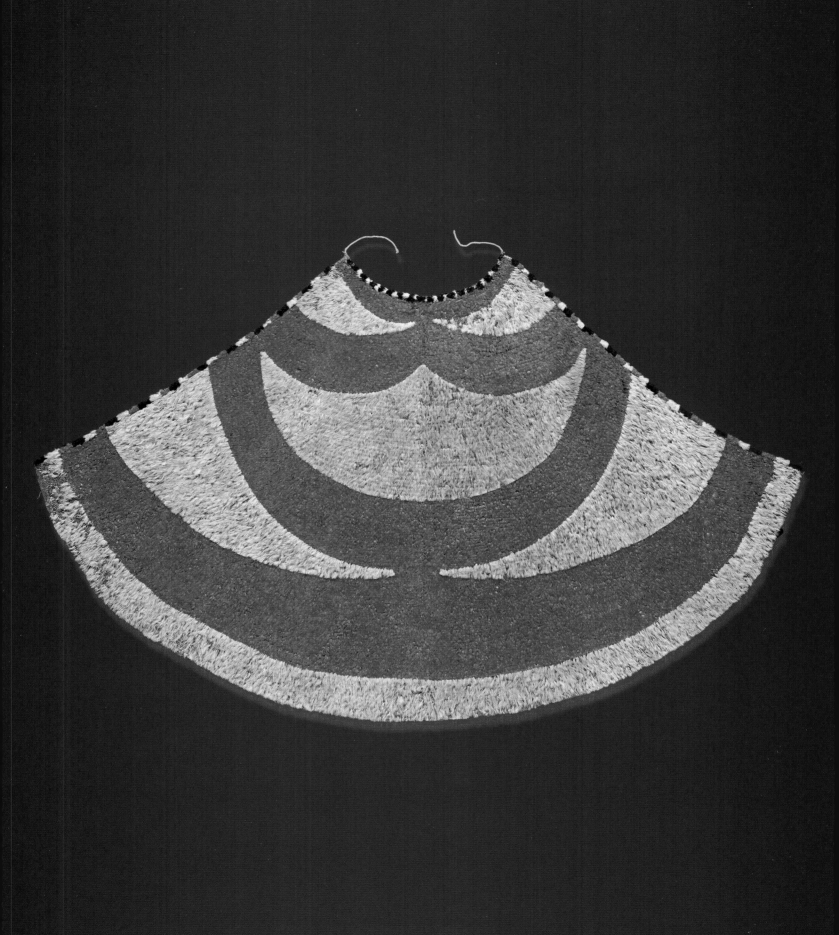

Leaving a Mark

The painting of a mother and child forms part of a triptych that was donated to the Smithsonian by Henry Sugimoto's family.

After being rounded up and sent to the Fresno Assembly Center, artist Henry Sugimoto (1900–90) and his young family were sent on a nearly 2,000-mile train ride heading east, to an Arkansas concentration camp. Sugimoto turned scenes from that journey and quiet moments of family life in an American concentration camp into a triptych. The faces of the three in *Arrival in Camp Jerome* are downcast. Like the 120,000 others sent to camps with only what they could carry, the frame seems to picture all their possessions, crammed into the smallest of spaces. They must have been exhausted from the trip.

In *My Son Hurt*, the viewer peers over the shoulder of Sugimoto's father, who reads from a telegram about his younger son, Sakai R. [Ralph] Sugimoto, Private First Class, reported wounded in France. "You will be advised as reports of condition are received," the paper says. And finally, with *Thinking of Loved One*, Sugimoto turns to another scene of anxious waiting. This time, it's his sister-in-law, cradling a baby. She's looking at a photo of her husband, Ralph, who is with the 442nd Regimental Combat Team. She may have heard the worrying news reported in the telegram. While she anxiously waits, a tower can be spotted outside the window, with guards keeping close watch.

This period of Henry Sugimoto's life was productive. Not only was he teaching high school art classes; he created approximately one-hundred art works—oil paintings on canvas, watercolors, and sketches. What's become known as "camp life" is deepened with Sugimoto's work. Some are mundane and wouldn't be out of place in any locale or time—a toddler on the floor seeking attention from a seated loved one who's reading a newspaper, or babies in a playpen. All these scenes are textured by our knowledge that a massive civil rights violation took place, justified by wartime hysteria. Henry's daughter, Madeline, provides an apt summary of what Sugimoto accomplished: the ability "to capture in images, the emotional environment in which people were living."

By the time he was incarcerated, Henry Sugimoto had traveled the world and developed an enviable reputation as an artist. Born in Wakayama, Japan, in 1901, Sugimoto was raised by his grandparents. He joined his parents in Hanford, California, in 1919. After graduating from Hanford High School, he earned a BFA from the California College of Arts and Crafts in 1928. His curiosity led him to see the European art tradition for himself. The following year, he enrolled in the Académie Colarossi in Paris and after some setbacks, exhibited his work in various salons and created nearly two hundred paintings before returning home in 1932.

Two statements by Sugimoto ring out and ring true: "[T]he mark you leave on this world can be washed away without a trace," he said, understandably a perspective that can come directly from the experience of losing one's liberty and property. In a second statement, he aims to create a body of work that is indelible: "I could not let the mark that I leave behind be such that it could eventually be washed away and disappear."

—Theodore S. Gonzalves

Thinking of Loved One by Henry Sugimoto, 1944.

Who is the Strong Woman with Child?

n viewing Yasuo Kuniyoshi's painting *Strong Woman and Child*, one may wonder about the two figures standing on a stage—a tall woman and a small child, both of whom have large eyes and strong facial features. There is a red scalloped curtain near the top of the frame, French flags to the left, and what appears to be a large weight on the floor. A white building appears in the distance off to the right, but there is also a heavy presence of red and brown tones. The two figures seem to have completed a performance and are ready to bow to the audience. The fact that the artist's name is Japanese raises questions about the relationship of the French flags to the artist, and the two figures on the stage who may, or may not, be Asian.

The artist Yasuo Kuniyoshi (1889–1953) was born in Japan and emigrated to the United States as a teenager. He worked in railroad yards and moved from Washington state to Los Angeles, where he began studying art. By 1910, he had moved to New York City and lived among influential artists like Edward Hopper, Georgia O'Keeffe, and Alexander Calder. As his art matured, he began to develop his own modernist style, holding his first exhibition in 1917 at the Society of Independent Artists. His work was regarded with respect among his peers; he exhibited frequently and was included in the prestigious 1929 Nineteen Living Americans exhibition at the Museum of Modern Art.

In 1919 he married artist Katherine Schmidt, a white woman, who lost her US citizenship and was disowned by her family as a result of marrying Kuniyoshi, who was not allowed to be a citizen. Anti-Japanese, anti-immigrant, and nativist sentiments were high during the 1910s–'20s. The 1917 Immigration Act created a "barred zone," banning immigration from the Asia Pacific region. In the 1922 Supreme Court case *Ozawa v. United States*, it was affirmed that Asians were ineligible for naturalization because they were not "free white persons," regardless of their "demonstrated acculturation and integration." It is not surprising, then, that the couple moved, for a time, to Paris.

These details of Kuniyoshi's lived experience provide critical layers for *Strong Woman and Child*, done in 1925 in Paris, France. Being in Paris during the 1920s provided the artist with a sense of safety and freedom since he was there with his wife and friends, like Alexander Calder.

Despite the promising move, the couple divorced in 1932, and Kuniyoshi returned to the United States. He married Sara Mazo in 1935. However, World War II put a hold on his art career. Like other Japanese living in the US at that time, he was declared an enemy alien. Joining with other Japanese artists in New York City, he signed a document of allegiance to the United States. To further prove his patriotism, he worked for the Office of War Information, creating war propaganda that portrayed the Japanese government's atrocities overseas. Although he was not incarcerated, the situation must've been very troubling for someone who considered himself both Japanese and American.

After the war, Kuniyoshi continued his life as an artist. Still a respected figure in the art world, he was the first artist to receive a major retrospective at the Whitney Museum in 1948, and he represented the United States at the 26th Venice Biennale in 1952. In that same year, he applied for US citizenship but, sadly, succumbed to cancer before it was approved.

In looking back at the painting, we may think about the details differently. Perhaps Kuniyoshi's Paris years were a time of hope. The woman holding the child's hand looks strong and confident. Perhaps the weight between the woman and child's feet symbolizes the collective strength of discrimination the couple faced in the United States and now had behind them, or perhaps being on the stage together provided performative strength for an audience in a different country, while dark clouds in the background seem to follow.

—Andrea Kim Neighbors

Strong Woman and Child, a painting by Yasuo Kuniyoshi, 1925.

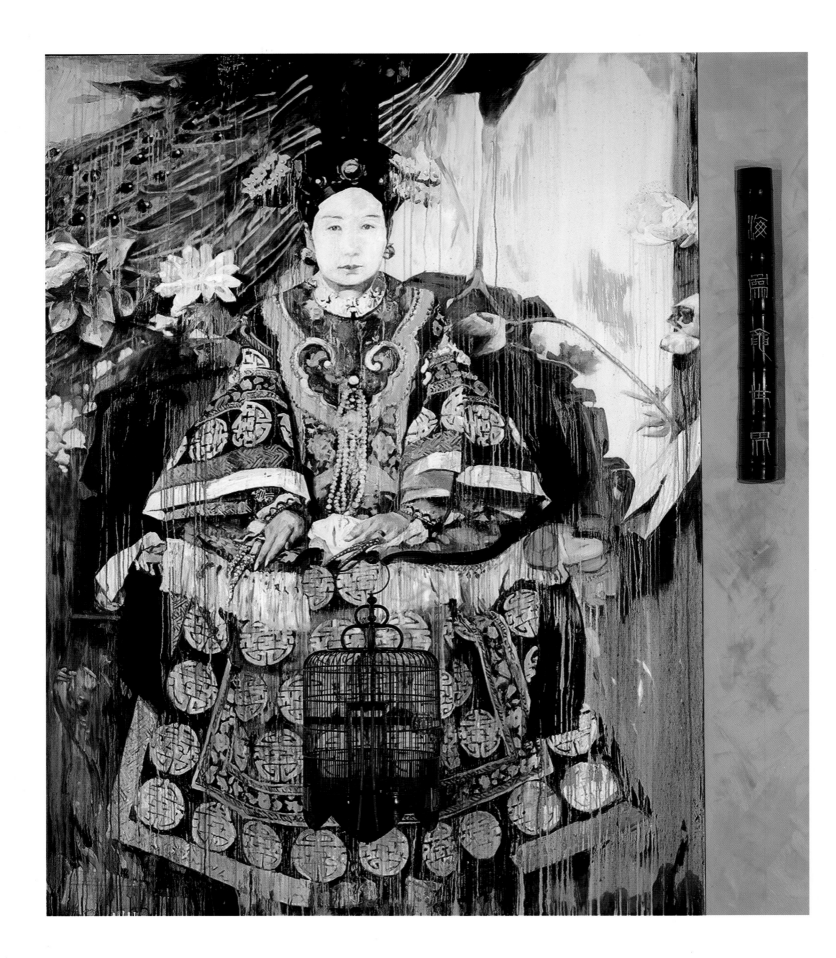

The Ocean is the Dragon's World

The Empress Dowager Cixi (1835–1908) served the Qing Dynasty from 1861 until her death. Her tenure extended over a period that proved to be consequential not only for her administration but also for the Chinese diaspora scattered throughout the Americas. The Empress Dowager has been depicted in dozens of oil paintings and photographs, and biographers have created contradictory judgments about her rule. Toward the end of her reign, the Empress Dowager supported the turn of the century Boxer Rebellion, a movement that challenged the imperialist presence on Chinese sovereign lands by going to war with the eight-nation alliance of European, American, and Japanese forces.

At her request, the Empress Dowager tasked the wife of the American ambassador in China, a person she had befriended, to create a portrait of her. The American artist Katharine Carl (1862–1938) was approached. She took residence in China to complete the work, *The Empress Dowager, Tze Hsi, of China* (1903), which was later displayed at the 1904 St. Louis World's Fair and gifted to President Theodore Roosevelt. The frame was specially carved out of camphor wood, and the painting is now part of the Smithsonian National Museum of Asian Art.

To counter the negative press about the Empress Dowager Cixi—no doubt influenced by her participation in the Boxer Rebellion—Katharine Carl (1865–1938) published a memoir about her time in the imperial court. In it, Carl expressed her love for the empress, "by far the most fascinating personality it had ever been my good fortune to study at such close range." The portrait Carl delivered was not the only one she worked on with the empress. "Before I finished the first one she told me she wanted 'many,' and suggested my passing the rest of my life out in Peking. I painted four. Who will do the others?"

Celebrated Chinese American artist Hung Liu (1948–2021) created a work focused on the empress dowager, *The Ocean is the Dragon's World*. The title refers to a saying, "Heaven is the crane's home." Liu stated in an interview that "The emperor is always considered the son of heaven, and he has the dragon: it represents young, male, imperial power." The empress dowager's self-presentation in photographs and paintings emphasized the primacy of the phoenix, "representing imperial female power," depicted as a peacock, a symbol of power with its tail of 100 eyes. Liu attached a birdcage to the front of the canvas: "This symbol might express her position in a patriarchal, feudal society: still in the cage, no matter how powerful a woman she was."

—Theodore S. Gonzalves

The Ocean is the Dragon's World, *a painting of the Empress Dowager Cixi by Hung Liu, 1995.*

Lunar New Year Stamp

Georgia-based Chinese American activist Jean Chen, of the Organization for Chinese Americans, opened a history text and saw only white male laborers in the photograph marking the joining of the transcontinental railroad at Promontory, Utah, in 1869. Where was the Asian American labor that made the event possible? Chen and the OCA pressed for the creation of a US commemorative stamp. What started as a chapter-level idea soon became a national campaign, with the organization pressing members of Congress and securing the support of the then postmaster general. During the extensive meetings, the idea emerged to highlight the celebration of the lunar new year. The US Postal Services' Citizens' Stamp Advisory Committee agreed and recommended to the postmaster general to commission a Honolulu-born graphic designer of Chinese heritage, Clarence Lee (1935–2015), to create a stamp for the upcoming lunar new year.

On December 30, 1992, the USPS released the stamp designed by Lee. It was a hit. The American Bank Note Company printed 105 million of the stamps. Post offices couldn't keep enough of the stamps in stock at the initial release. Orders came in from overseas as well. USPS contracted with Lee to create a series for all twelve Chinese zodiac symbols.

The son of a butcher, young Clarence Lee brought home wrapping paper from his father's shop and drew on the large sheets at home. After graduation from college in the continental United States, he worked in Connecticut and New York before returning home to Hawai'i in 1966 when he established a design firm in his own name. Hawai'i locals have seen the work of Lee's design firm for years in the form of logos attached to banks, airlines, shopping malls, tourist and convention sites like the Polynesian Cultural Center, and at the popular eatery chain, Zippy's.

Lee would also design Hawai'i pavilions featured at two world's fairs—in Osaka in 1970 and Brisbane in 1988. He's been the recipient of numerous awards and was recognized as a living treasure in Hawai'i for his lifetime achievement in the arts.

After Lee's lunar new year stamp series was completed in 2004, the USPS commissioned a second series featuring the work of Hong Kong-born, New York City-based artist Kam Mak and art director Ethel Kessler. The second series, spanning 2008 to 2019, incorporated elements of Lee's original design. A third series launched in 2020.

Lunar new year celebrations are not only based in Chinese culture. They are also marked by billions throughout the globe, including various groups in the United States. For Lao Americans, the lunar new year festival is Boun Pi Mai or Pi Mai Lao (new year festival or Lao new year), occasioned by parades, dancing, singing, feasting, and honoring family and ancestors. Vietnamese communities in the United States celebrate Têt Nguyen Dan, which scholar C. N. Lee describes as "the first morning of the first day of the new period." These are important ritual holidays. As he puts it, they're "almost like New Year's Day, Fourth of July, Thanksgiving, and Christmas all rolled into one. It's a holiday that is based on history but has also evolved into a modern celebration that incorporates new elements to produce new traditions."

—Theodore S. Gonzalves

This rabbit commemorative stamp was the seventh design in the Lunar New Year series, which began with the rooster in 1992. Stamp designed and illustrated by Clarence Lee (1935–2015).

Stitching Histories

Violence in the aftermath of the Vietnam War provided motivation for many people to leave Southeast Asia. One of the ethnic groups from that region, the Hmong people, had been recruited by the United States to be guerrilla fighters during the war. Their involvement would become known as the "Secret War." To escape retribution for their actions in the war, when the US withdrew from Vietnam, many Hmong fled to Thai refugee camps.

Hmong immigrant My Yia Vang (b. 1955) created this story cloth to share her people's war experiences in Laos. Vang came to the United States in 1980 and settled in Wisconsin. Vang used her needlework to help support her family and preserve the history of her community's journey.

When asked what was included in the story cloth and why she decided to create one, Vang explained these were "pictures talking about Hmong life and why they left their homeland. Someday they will tell it to their grandchildren. The paj ntaub (flower cloth) was made by my hand only."

The embroidered story in the center square shows why the Hmong left their homeland in Laos. At the top left is a peaceful village; to the right, the army and planes are shown bombing the village; along the bottom of the square are scenes depicting the refugees on the road, camping out, crossing the Mekong River, and at the refugee camps.

Paj ntaub are patterned textiles with intricate designs crafted by the Hmong. There are different varieties of paj ntaub; this one is a story cloth, a style that began to take root in Thai refugee camps as a means of making extra income. After the Hmong arrived in the United States as political refugees in the 1970s and '80s, the paj ntaub continued to serve as both reminder of their past and source of revenue.

Between 2000 and 2019, the Hmong population in the United States increased from 186,000 to 327,000, with the largest communities based in Minneapolis-St. Paul, Minnesota; Fresno, California; Sacramento, California; and Milwaukee, Wisconsin.

—Cedric Yeh

Hmong refugee My Yia Vang's story cloth, made between 1989 and 1992.

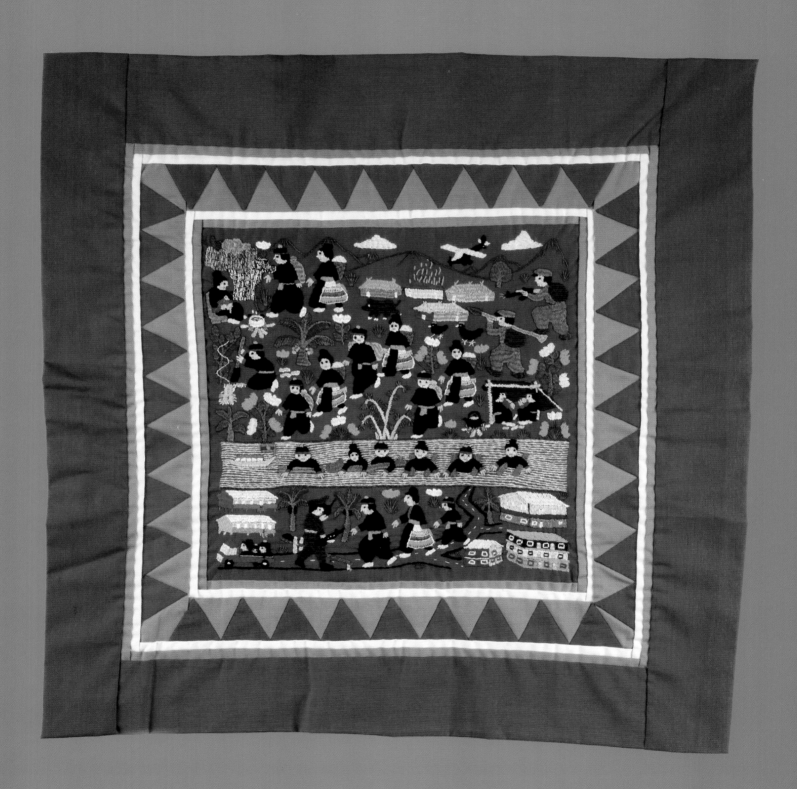

Shimomura Crossing the Delaware *by Roger Shimomura, 2010.*

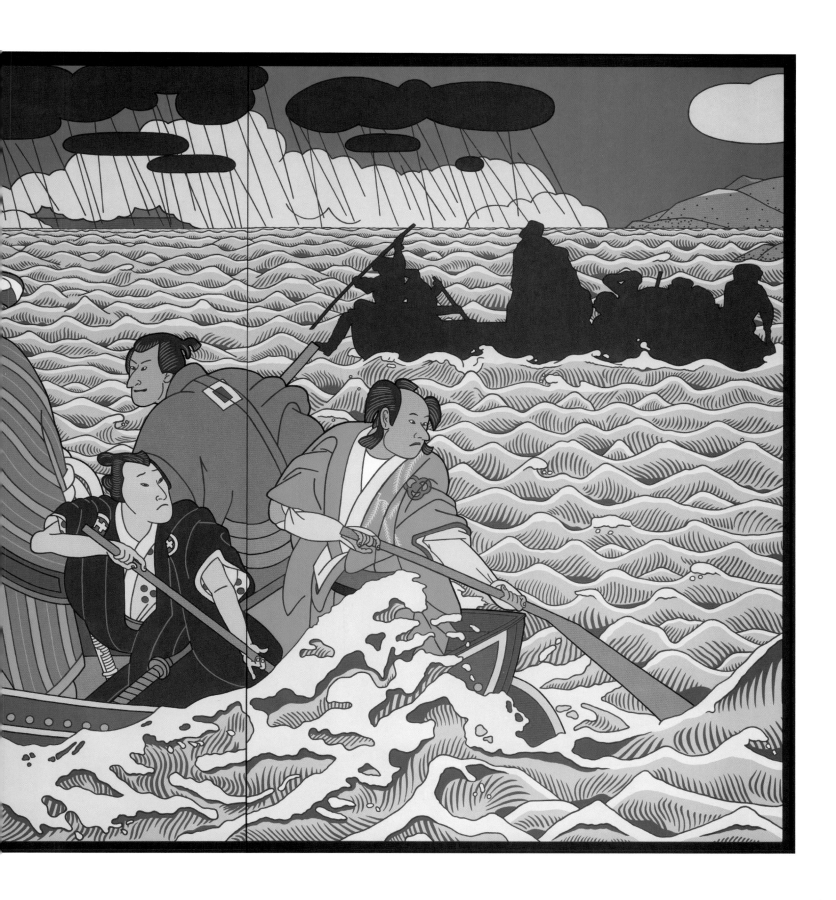

Roger Shimomura Crossing the Delaware

Imagine a scene taking place in Lawrence, Kansas, during the 1970s:

 White Male Kansas Farmer: "Excuse me sir, I was overhearing you speak the language, and I was wondering how you came to speak it so well? Where are you from?"

Roger Shimomura: "I'm from Seattle."

Farmer: "That's not what I mean. Where are your parents from?

Shimomura: "Well, my father was born in Seattle, my mother was born in Idaho."

This scene has played out in a million different ways. It doesn't matter if we're talking about the 1970s or the 1870s. We could be in Honolulu, Hartford, Huntsville, or Hialeah. Persons of Asian descent in the Americas have been bit players in the "Where are you from?" scenario with everyone from the genuinely curious, to the ones eager to let you know how much they love "authentic" Asian cuisine, to the confused racist.

One typical Asian American response involves explaining how your—Insert Your Ancestor Here—came to the United States in—Insert Time Period Immediately Following a US War on Asian Soil—and wait to see the listener make the connection.

An American artist of Japanese descent, Roger Shimomura (b. 1931) has had a distinguished career as a visual artist, teacher, and performance artist. From the ages of three to five, he and his family were imprisoned in a concentration camp in Minidoka, Idaho, one of ten that held 120,000 persons of Japanese descent during World War II. His interdisciplinary work has been informed by personal stories of tragedy and persistence in camp life. His sister died while very young. His grandmother, a respected midwife, left behind a diary that inspired his own work.

Shimomura graduated with a degree in graphic design from the University of Washington in 1961. He served in the military, worked professionally on commercial projects, and earned a master's degree from Syracuse University in 1969. From 1969 to 2004 Shimomura served as professor of art at the University of Kansas at Lawrence. While he was subjected to treatment there that made him feel "intensely foreign," the artist and educator developed a critically acclaimed body of work.

Shimomura plays with our commitments to cultural icons. Whether in the figure of Superman, Pikachu, or Hello Kitty, the artist has found creative ways to insert versions of his face and person into well-known and beloved characters. As if to make the familiar foreign to the rest of us, Shimomura drives home the point with his masterful *Shimomura Crossing the Delaware*, less an homage to Emanuel Leutze's 1851 original painting, and more of a counterfactual experiment: "The main question here in the end is how does this painting affect the way we see patriotism and what's important about patriotism, or how blind is patriotism? That question, that issue, comes to the forefront in just about all the work that I do."

—Theodore S. Gonzalves

Roger Shimomura, 1989.

"A Whole Foods in Hawai'i"

"Our ancestors were themselves libraries," said Chamoru poet and scholar Craig Santos Perez (b. 1980) in a 2018 speech to inaugurate the launch of a Critical Pacific Islands Studies Library Guide at his alma mater, the University of California, Berkeley. His point was twofold: that Pacific Islander knowledges have historically been preserved and shared orally, rather than in the writing systems of European, Asian, and American colonizers; and that Western libraries have never historically made space for, or considered legitimate, the oral traditions of Oceania.

We are amidst a broad-scale rethinking of not only our contemporary libraries, but also our museums, arts spaces, literatures, and scholarship—a rethinking of their colonial inheritances and infrastructures, as well as the central place of Indigenous knowledge and imagination in critiquing and reimagining them. Perez stands at the forefront of this transformation; he is among the most celebrated contemporary poets in the world. His work in eco-poetry and eco-justice, in particular, has been translated into Chinese, Japanese, German, Spanish, and French and taught across the Americas, Europe, Asia, and the Pacific.

His poem "A Whole Foods in Hawai'i" invokes poet ancestors as it playfully laments the march of gentrification atop occupation. It was published in the July/August 2017 special issue of *Poetry Magazine*, the magazine's first ever devoted to Asian American poets. Produced in partnership with the Smithsonian Asian Pacific American Center (APAC), it was guest edited by APAC curator Lawrence-Minh Bùi Davis, along with poet Tarfia Faizullah, and scholar and poet Timothy Yu. Perez's inclusion in the issue is a nod to both his Filipino ancestry and key role in what he has called "reading across the APA acronym," the ongoing stewardship of cross-community Asian American and Pacific Islander arts coalition-building. Perez also guest edited *Poetry Magazine*'s first folio devoted to Pacific Islander poets, published a year earlier in July/August 2016.

—Lawrence-Minh Bùi Davis

"A Whole Foods in Hawai'i," a poem by Craig Santos Perez, 2017.

A Whole Foods in Hawai'i

Craig Santos Perez

I dreamed of you tonight, Wayne Kaumualii Westlake, as I walked down on the sidewalk under plumeria trees with a vog headache looking at the Māhealani moon.

In my need fo' grindz, and hungry fo' modernity, I stumbled into the gentrified lights of Whole Foods, dreaming of your manifestos!

What pineapples and what papayas! Busloads of tourists shopping at night! Bulk aisle full of hippies! Millennials in the kale! Settlers in the Kona coffee! And you, Richard Hamasaki, what were you doing kissing the ripe mangos?

I saw you, Wayne Kaumualii Westlake, broomless, ghostly janitor, sampling the poke in the seafood section and eyeing the smoked fish.

I heard you ask questions of each: Who butchered the mahimahi? What price opah belly? Are you my 'aumakua?

I wandered in and out of the canned goods aisle following you, and followed in my imagination by Sir Spamalot.

In our bourgeois fancy we strolled through the cooked foods section tasting hand-churned cheese, possessing every imported delicacy, and whispering to the cashier, "Go fuck yourself."

Where are we going, Wayne Kaumualii Westlake? The doors of perception close in an hour. Which way does your pakalōlō point tonight?

(I touch your book and dream of our huaka'i in Whole Foods and feel dādā.)

Will we sail all night through Honolulu streets? The coconut trees no have nuts, tarps up for the homeless, we'll both be lonely.

Will we cruise witnessing the ruined empire of America, past pink mopeds in driveways, home to our overpriced apartments?

Ah, dear uncle, Buddhahead, ghostly poetry teacher, what Hawai'i did you have when TheBus quit turning its wheels and you arrived in Waikīkī and stood watching the canoes disappear on the murky waters of the Ala Wai?

Tiffany Chung, reconstructing an exodus history

Tiffany Chung (b. 1969) searches for what she calls "hidden histories"—stories from the past that have been actively suppressed or lost to memory and time. She uses her art to uncover these stories, making paintings, performances, videos, and maps to picture the ways that periods of upheaval and trauma have shaped our understanding of the world.

These are deeply personal concerns for Chung, stemming from her own experiences during the Vietnam War and its aftermath. Her father, a pilot in the South Vietnamese army, was captured in battle and spent fourteen years in North Vietnamese prison camps. After he was released, the family immigrated to the United States as part of the post-1975 exodus from their home country. Chung witnessed war, fled her country as a refugee, and re-formed her life as an American, first in Los Angeles, and then in Houston, where she lives today. She understands her own "complex relationship to war and power" to be at the root of her curiosity about the connections between geopolitics and displacement.

She made *reconstructing an exodus history* after learning that the full scale and scope of the South Vietnamese diaspora after the war had never been documented. Although there have been attempts to account for the hundreds of thousands of people who escaped Vietnam by boat (commonly known as "boat people" in the 1970s–1990s), the larger resettlement has yet to be understood. Chung is the first person—artist or historian—to track the people who left by airplane in any meaningful way. To map out their trajectories, Chung brought together interviews with migrants, first-hand archival research, and records of commercial carriers' routes and capacities.

She transformed her research into art, creating a twelve-foot-long map of the world, its somber navy-blue ground festooned with spindly scarlet trails of thread. Working with assistants skilled in the traditional art of Vietnamese embroidery, Chung hand-drew and sewed the trajectories of refugees who, like her, fled the country decades ago. The lines of stitches represent the forced migration of the South Vietnamese by boat and plane in Asia, as well as through the United Nations' Orderly Departure Program, to locations all over the world. In one comprehensive summary, it shows how Vietnam's people and culture fanned out across the globe after the war. The delicately and laboriously

embroidered escape routes stretch across oceans of fabric, evoking the tenuous journeys of the real-life migrants.

Chung's map memorializes the experiences of the South Vietnamese people, but it is also a plea to widen our lens of perception more broadly. Foregrounding the stories of people who have been left out of official accounts, Chung asks whose stories get remembered and how those stories become understood as history. *Reconstructing an exodus history* opens our eyes to a forgotten past, showing us how today's world has been formed in its wake.

—Sarah Newman

reconstructing an exodus history: boat trajectories from Vietnam and flight routes from refugee camps and of ODP cases *by Tiffany Chung, 2020.*

Grief Garden

After her mother passed away in 2016, poet Khaty Xiong (b. 1989) visited gardens to sit with grief and commune with her mother's spirit. Xiong would later write, "In those early grieving days, I was after death itself, because that was where my mother now lived." What counts, her searching asked, as acceptable grieving? How, when, where, and for how long are we allowed—do we allow ourselves—to dwell in profound loss, and how do loss and grief inexorably refigure our memories and minds?

These questions animated Xiong's poem "On Visiting the Franklin Park Conservatory & Botanical Gardens," published in the July/August 2017 special issue of *Poetry Magazine*. Xiong would perform the poem at the Library of Congress as part of the 2017 Asian American Literature Festival, cohosted by APAC, the Library of Congress, and the Poetry Foundation.

The poem would go on to be adapted into the immersive poetry installation *Grief Garden*, composed of paper plants modeled after those from the gardens of Xiong's mourning: castor bean, pokeweed, pennywort, iresine, aloe. Visitors were invited to enter the paper garden, read the poem, inscribe plants with messages to lost loved ones, read others' messages, and take what might be called time out of the world for grief and loss. The installation opened in the Poetry Foundation gallery in June 2018; it was later restaged at the Asian/Pacific/American Institute at New York University in spring 2022. An extension of "On Visiting the Franklin Park Conservatory & Botanical Gardens," *Grief Garden* is a multisensory unfolding of its energies, an offering for a fuller, more human engagement with grief and grieving.

—Lawrence-Minh Bùi Davis

"On Visiting the Franklin Park Conservatory & Botanical Gardens," a poem by Khaty Xiong, 2017.

On Visiting the Franklin Park Conservatory & Botanical Gardens

Khaty Xiong

I have come to collect the various species of America:
 ruby-spotted, tigers, kites & pipevines — an armory
of wings & two-week bodies. The room swells openly
 & I ascend to the top —

 I am separate from the boy
 who swats persistently.

Tucked in the corner of a window, a white morpho,
 the only kind to perch long enough for me to satisfy
my collecting — its lunar afterglow still hanging
 as I pulse & pace to get a closer look.

I am separate from the boy who climbs a nearby tower
 & shouts for his father.

Perhaps I am half of this — a set of dots for eyes,
 spine for spine, my insides half my father's —
half my mother's. Kuv tus ntsuj plig unlike the fate
 of quick bodies, sovereign cavities, mother
whose torso fell early in harvest — a bed of muscle
 to hold her from splitting in two —

 & do we hear it?

As in a fever the boy runs back & does not see
 the white morpho the way I must see it:
my personal moon stone-ripe in this foreign corner,
 mother as fauna forever — inhuman & gazing.

Then my body a chariot pulled by a pair of orange helicons
 sweeping towards the main water feature (complete with koi).

This place in which I dream the new body — whole & abiding —

 I am reaching for the boy now as warden to both the living
& the afterliving — the privilege in every gesture — like mother's
 first gifts: name & citizenship, poetry always in departure,
the song about the moon falling over, fast in flames —

Stephanie Syjuco—*Nationalities* and *Reverse View KKK*

Stephanie Syjuco (b. 1974) is a story reteller, directly engaging with the real-world impacts of representation. In *Cargo Cults*, for example, she used herself as model to critically reenact the racial tropes of ethnographic photography, and in *Block Out the Sun* she used her own hand to block out the faces of unwillingly photographed Filipino subjects. Syjuco described these interventions as "talking back to photographs."

In 2019, Syjuco was awarded a Smithsonian Artist Research Fellowship to research the visual legacy of the 1904 St. Louis World's Fair. When the material she came to study turned out to be relatively meagre, she turned to other archives. Being responsive to her environment made Syjuco attentive to its potential as subject. The resulting series, *Latent Images*, considers the role of such collections in shaping American identity and history.

Syjuco made two visits to the National Museum of American History, the last shortly before the COVID-19 lockdowns, and she worked on the series during the social unrest of 2020. In it, the processes of archival work are enacted through the later manipulation of its material in her studio. In *Nationalities*, Syjuco makes visible her engagement through the exposure of a photograph by Alexander Alland (1902–89), shown in the box where she found it, with those already viewed stacked face down beside it and those yet to be viewed upright beneath it. In *Reverse View: KKK*, Syjuco's engagement is made visible through her blockage. Having discovered records of Ku Klux Klan activities in the everyday documents of an Ohio

Reverse View: KKK by Stephanie Syjuco, 2021.

township, her positioning of that material offers a counternarrative to white supremacy.

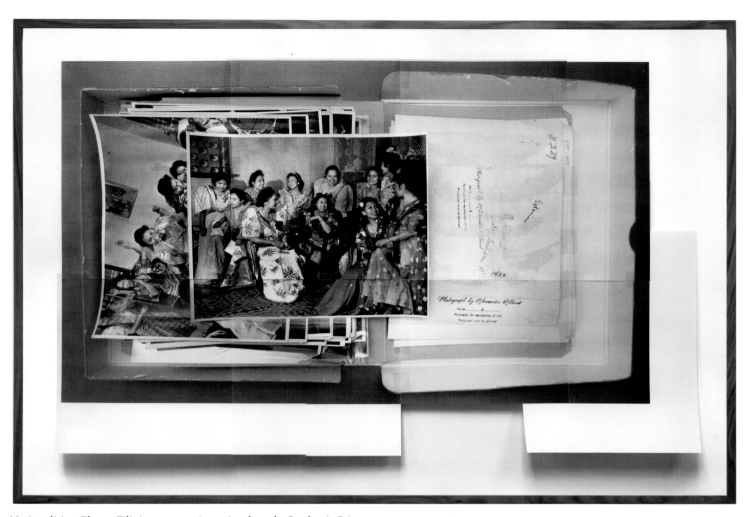

Nationalities: Eleven Filipino women in native dress *by Stephanie Syjuco, 2021.*

Latent Images addresses the fragmentary nature of archives as repositories of things whose meanings are not fixed except by use. Her archival sources provided different topics for the series, from images and identity in *Nationalities* to American history more broadly in *Reverse View: KKK*. The source for *Nationalities* was Alland's now largely forgotten *American Counterpoint* photographs from the 1940s. Himself an immigrant to the United States, the project was his celebration of the melting pot. Recognizing the complicity of photographer and subjects in its staging, Syjuco let Alland's image speak without retort. Her use restored *American Counterpoints* to national memory, visualizing and affirming in relation to her own project its subjects' identities as American.

The source for *Reverse View: KKK* was an archive of American business ephemera. Wedged between the subjects "Ladies Clothes" and "Kitchen Appliances" she found

a folder containing pamphlets, correspondence, and photographs of Ku Klux Klan activities. Insidious in its ordinariness, Syjuco approached this material as she had Alland's, looking at each object and flipping those already viewed face down in a stack. By exposing their backsides, *Reverse View: KKK* acknowledges that racism is deeply embedded in the fabric of American history, as it is in the archive. Her use, refusing to perpetuate its violence, proposes that the future need not be defined by the inequities of the past.

If the quirks of archival practice are capable of shaping history, intervention into those practices can rewrite history, potentially reframing the future. By remaking images Syjuco reimagines history, and as makers and caretakers of our own images she invites us to do likewise.

—John P. Jacob

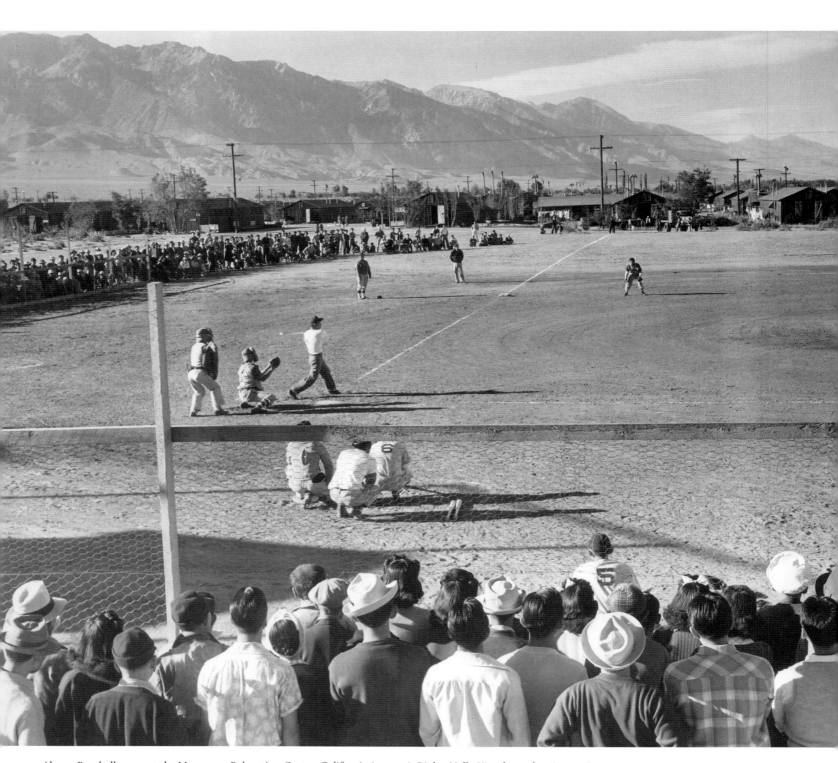

Above: Baseball game at the Manzanar Relocation Center, California (pg. 220). Right: Hello Kitty bento box (pg. 222).

CHAPTER ELEVEN

Joy

This section is inspired by stories of play, activities that are their own reward. Play offers endless possibilities. There is delight and even danger in the chance that play affords. We can be freed—even if only momentarily—of someone else's scripts, ambitions, and fetishes. These stories feature the athleticism of dancers, skaters, and surfers. We find here also the playfulness found in toys, comedy, sports, and comic books. These objects look to moments where we can all welcome surprise and wonder in what could happen or who we could become.

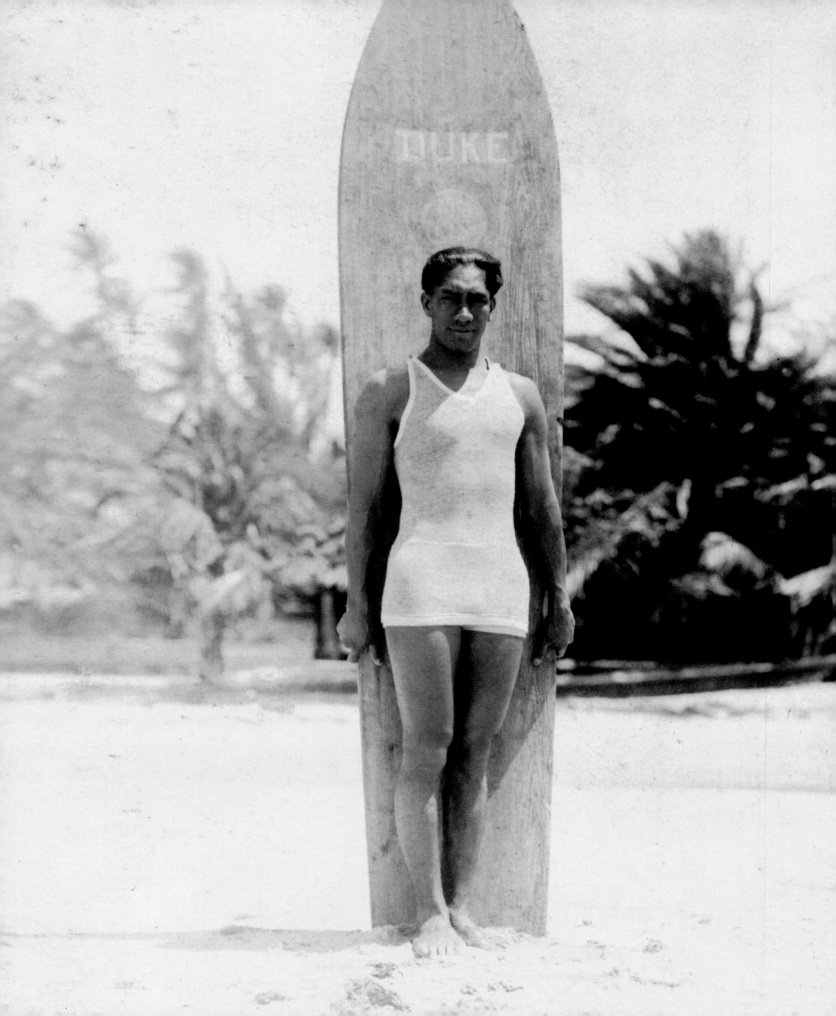

Duke Kahanamoku's Surfboard

Born to a prominent family with direct ties to Hawaiian royalty, Duke Paoa Kahinu Moke Hulikohola Kahanamoku (1890–1968) advanced the world's knowledge about surfing, a Pacific Islander practice dating back at least 1,500 years.

In his early twenties, Kahanamoku's powerful swimming earned him an Olympic gold medal at the 1912 games in Stockholm for the 100-meter freestyle. Along with his two other Olympics appearances in 1920 and 1924, Kahanamoku would win a total of five medals—three gold and two silver.

With his international visits, especially to Australia and the United States, he became a cultural ambassador for surfing, helping to popularize it throughout the world. During a period of legalized segregation, he encountered racist treatment during his trip to the American South, which he met with his characteristic dignity and grace. Kahanamoku's presence couldn't be contained by America's race codes. His celebrity continued to grow, as offers came to appear in more than a dozen films.

A year before he won his first gold medal, Kahanamoku penned an essay titled "Riding the Surfboard" in the inaugural issue of *Mid-Pacific Magazine*. He used powerful imagery to ask the reader: "How would you like to stand like a god before the crest of a monster billow, always rushing to the bottom of a hill and never reaching its base, and to come rushing in for half a mile at express speed, in graceful attitude, of course, until you reach the beach and step easily from the wave to the strand?"

Kahanamoku went into detail about the kinds of wood used in the making of Hawaiian surfboards—wiliwili, ulu, or koa—and the rituals involved in preparing a trunk for carving. Pohaku puna (coral) and oahi (stone) would be used for shaping the boards, while ti plant roots would be used for staining them. He shared his knowledge as he shaped boards for others around the world.

The solid redwood surfboard in the Smithsonian's collection has seen some incredible history. It was personally shaped by Kahanamoku at Corona del Mar for aerospace engineer Gerard (Jerry) Vultee in 1928. That's the same year that Vultee would use the board in the Pacific Coast Surf Riding Championship, a milestone in the sport's history.

According to Paul Burnett, coauthor of *Surfing Newport Beach: The Glory Days of Corona del Mar*, this board is connected to a fantastic story. The dramatic event took place on June 14, 1925. The forty-foot fishing yacht, *Thelma*, capsized off the coast of Newport Beach, California. Kahanamoku and six others, including Vultee, jumped into action. While five persons drowned, twelve were rescued. Kahanamoku's friends pulled four to safety while he was personally responsible for saving the lives of eight people over the course of three trips. A local police captain told the *Los Angeles Times*, "Duke's performance was the most superhuman rescue act and the finest display of surfboard riding that has ever been seen in the world." When asked how Kahanamoku accomplished the feat, Duke said: "I do not know. It was done. That is the main thing. By a few tricks, perhaps." This board was used in what has come to be known as the Great Rescue of 1925.

—Theodore S. Gonzalves

Left: Duke Kahanamoku, ca. 1915. Right: A redwood surfboard shaped by champion surfer and swimmer Duke Kahanamoku on the beach of Corona del Mar, California, 1928.

Yo-Yo Demonstrators

Not all products sell themselves. Some require a nudge from a professional about a gadget's unique qualities. *Maybe it folds into itself. Maybe it'll cut your prep time in half. Maybe it's cool.* In their stylish suits, fedoras, and slicked-back hairdos, these yo-yo demonstrators epitomized cool during the toy's heyday from the 1920s to the 1960s. And they also added another element that was implicit in marketing to generations of kids—associations with danger and exoticism, qualities that were amplified stereotypes of Philippine life. As often repeated in advertisements, the yo-yo was a Filipino weapon! At Woolworths five-and-dime stores across the country, the window displays guided buyers to the store's "Philippine Hut." The yo-yo was touted as the "Philippine National Sport" in Neisner's Rochester storefront, which featured a backdrop of palm trees and an illustration of a young woman in a crop top and grass skirt, adorned with a lei, and smiling to potential buyers.

The Pinoy demonstrators might have had fun with all this messaging. Perhaps it made the stories of a brutal US-Philippine war seem distant. And, by extension, perhaps they and their weapon-toys would be seen as harmless. The yo-yo demonstrators likely welcomed the idea of playing with toys for a living—a way to steer clear of the growing anti-Filipino sentiment in the country. Things were not all that much better five years later when Congress passed the Filipino Repatriation Act, which encouraged Filipinos in the United States, except for those in Hawai'i, to take a one-way ticket back to the Philippines—paid for by the US government. Out of the 45,000 Filipinos in the United States at the time, only 2,200 took up the offer for self-deportation.

American colonial officials in the Philippines wrote about the yo-yo as early as 1916. Alva Brane's article in *Scientific American*, titled "Filipino Toys: How Our Young Island Wards Amuse Themselves," provides a survey of the kinds of toys that the author recommended for America's new colonial subjects: those that would help to create good work habits rather than the ones used in games of chance. The article describes an array of toys with names that range from the odd to the fanciful to the menacing—for example, the buzz saw, the aerial whirligig, the beetle merry-go-round or the diabolo. Brane noted the commercial possibility of these toys, but honed in on a patent that had been secured in the United States for the yo-yo, which had been "extensively manufactured" in the Philippines.

In the United States the history of the yo-yo can be traced to two Filipino entrepreneurs: Pedro Flores (1899–1964) and Joseph T. Radovan (1909–89). Scholar and filmmaker Cynthia Liu documented their unique journeys as friends and then later as rivals. Flores arrived from the Philippines in 1915; Radovan in 1931. By that latter date, Flores had established the Flores Yo-Yo company at his Southern California base. After selling the company to Donald Duncan Sr., Flores and Radovan worked as demonstrators before both left the company to start up their own brands.

Radovan's Royal Tops sold their own yo-yos for years, eventually catching a lawsuit from Duncan who insisted that the former's use of the term was in violation of their trademark. The seventh circuit of the US Court of Appeals decided in Radovan's favor in 1965. The yo-yo, it was decided, was a generic term that had been in use in the Philippines well before its introduction in the United States.

—Theodore S. Gonzalves

Above: Yo-yo from the Duncan Yo-Yo Company. Top right: Seven Filipino entrepreneurs demonstrate the yo-yo. Bottom right: Image possibly of Pedro Flores.

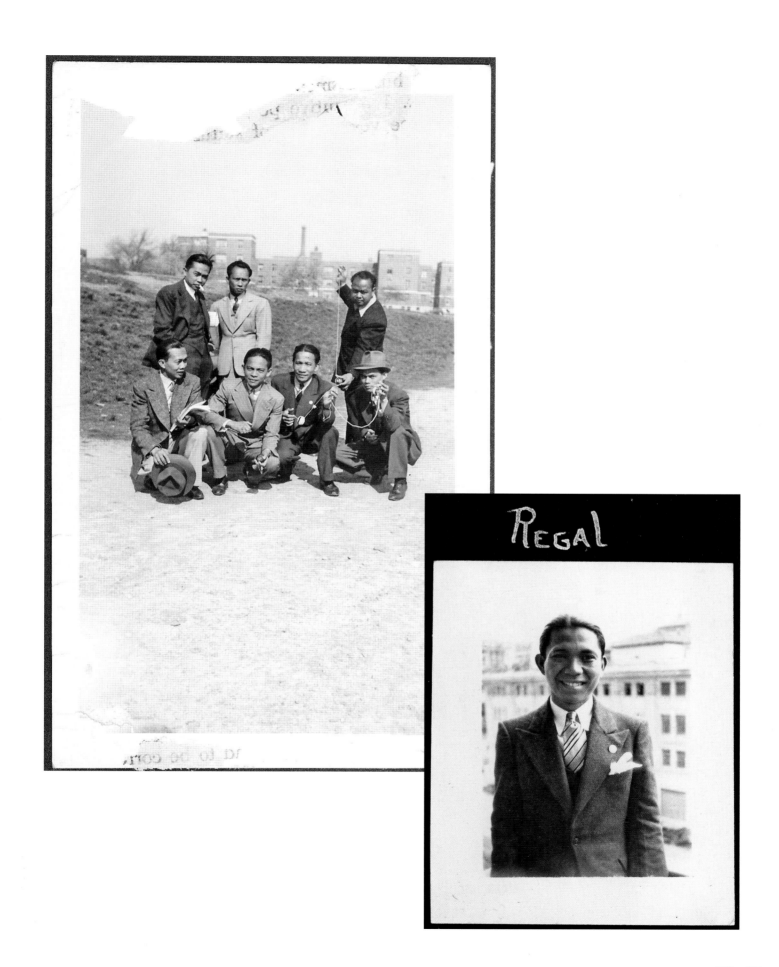

Regal

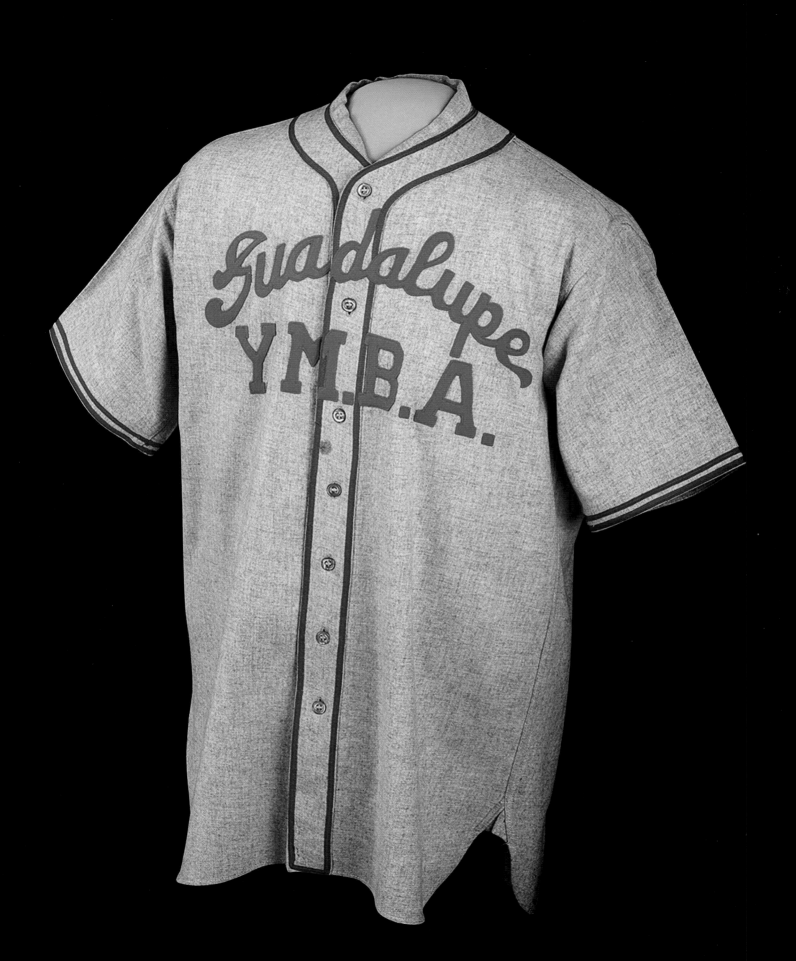

A Baseball Story

Embroidered with "Guadalupe Y.M.B.A.," this uniform was worn by Tetsuo Furukawa while he was incarcerated at the Gila River War Relocation Center, located on the Gila River Indian Reservation, over the objections of the Pima and Maricopa. He was fourteen years old when the family was ordered to evacuate their homes with only what they could carry. Originally from Guadalupe, California—nine miles west of Santa Maria in California's Santa Barbara County—Furukawa arrived at their destination, opened his suitcase, and was pleased to find a baseball glove right on top. "Good old mama," he recalled. "It was one of the most wonderful things that ever happened to me."

The uniform was given to Furukawa by an older baseball player who left camp to find employment. The uniform came from Guadalupe, California, and was used for a team sponsored by the local Buddhist church, which was affiliated with the Young Men's Buddhist Association (YMBA).

Heart Mountain organizers presold seats for the series between the two camp teams, covering travel costs for the Gila River team. The remaining amount was raised by Gila River boosters, their Issei parents, other fans, and the players themselves. Players took various jobs at the camp farms, motor pool, and camouflage net factory, and picked cotton on corporate farms twenty miles away from camp. These were high school kids, mostly sixteen- and seventeen-year-olds.

Furukawa remembers how in 1944 the Gila team boarded a bus in Phoenix, Arizona and headed north, approximately 1,200 miles, to take on the team at the Heart Mountain, Wyoming camp. "Imagine our joy in breathing the fresh air of freedom after being incarcerated for two and a half years on an Indian reservation," he said. Along the way, Furukawa noted how whites accosted them. Still, their coach was able to defuse tempers and keep the team safe on track to their destination.

The teams met for a series of thirteen games spanning fifteen days. The Gila River team won nine of those games. For Furukawa, this was a special trip. The chance to play, travel, and be feted by the Heart Mountain camp community with banquets and dances. "What priceless memories many of us who were a part of this experience have been left with to savor, so that when future generations ask, 'How was it done?' we have this baseball story to tell, as part of our historical legacy. . . . For us kids, baseball saved our lives."

—Theodore S. Gonzalves

Tetsuo Furakawa's Guadalupe Y.M.B.A. baseball uniform, ca. 1944.

Hello Kitty's Soft Power

"Hello Kitty is not a cat. She's a cartoon character. She is a little girl. She is a friend. But she is not a cat. She's never depicted on all fours. She walks and sits like a two-legged creature. She does have a pet cat of her own, however, and it's called Charmmy Kitty." This is how Sanrio, the Japanese design and product company that created Hello Kitty and eighty other characters, corrected anthropologist Christine R. Yano, who wrote the exhibition text for a 2014 Hello Kitty exhibition at the Japanese American National Museum in Los Angeles, California. The clarification sparked much confusion and shock on social media among Hello Kitty's fans. Hello Kitty, or Kitty White as she is named, was created in 1974. When she arrived in the United States in the mid-1970s, Yano told the *Los Angeles Times*, Hello Kitty "was a commodity in mainly Asian enclaves: Chinatowns, Japantowns, etc. . . . In talking to Japanese Americans who grew up in the 1970s, they say, 'That figure means so much to us because she was ours.'"

Hello Kitty and her many friends, such as Keroppi, a frog that lives in a big house on "Donut Pond," or Gudetama, a lazy egg, can be found on stickers, stationary, coin purses, apparel, Christmas decorations, lunchbox sets such as this pink bento box, and much more. Many early characters in the Sanrio universe had similar features—or a noticeable lack of certain features—such as big eyes, no mouths, expressionless faces, and large heads. These characteristics are typical of the kawaii (a simple translation of the Japanese word for "cute," the word can also mean "adorable" or "loveable") aesthetic of Hello Kitty and other Japanese pop culture characters from anime series, manga, video games, and more.

While Hello Kitty's economic and cultural "soft power" has only grown since the 1970s, Asian American literature scholar Sharon Tran observes that Hello Kitty's cuteness tends to promote racial and cultural stereoptypes of Asian and Asian American women, while scholars and activists like Angela Choi, Denise Uyehara note that the character contributes to the stereotype of Asian females as docile. In her book, *Pink Globalization: Hello Kitty's Trek Across the Pacific*, Christine R. Yano shows that critics struggle with Hello Kitty's appeal and limitations.

The audience's relationship to the character may continue to change. Hello Kitty and her roster of friends have expanded and changed over the years, becoming more expressive in appearance and behavior. Their faces now have mouths, and character designs sometimes allow for a seemingly angry look in their eyes. In 2016, Sanrio introduced a new character, Aggretsuko, a female red panda whose name means "fury" or "rage." She's an office worker "whose life at work is usually frustrating. . . . She lets out all of that anger by singing death metal at the local karaoke club." As the Sanrio universe and family of characters grows year after year, it may be safe to say that now, there is someone for everyone, whether it's the classic Hello Kitty, a raging red panda, a lazy egg, or 2022's addition, Cogimyun, a character made of flour dough who goes on walks with her pet, Ebi, a fried shrimp tempura.

—Andrea Kim Neighbors

Left: Two stacked Hello Kitty bento boxes with removable handle and lids. Right: Hello Kitty balloon during the 83rd annual Macy's Thanksgiving Day Parade in 2009.

Skill and Challenge

Judi Oyama (b. 1960) has been skateboarding since she was thirteen years old. She has reflected on how different her childhood was from her parents' experiences. When they were young, she recalls, her parents were imprisoned in a concentration camp in Poston, Arizona.

In the pages of *Skater Girl*, Patty Segovia and Rebecca Heller describe Oyama as a "premiere slalom and downhill skater in the 1970s." There's been many a race where Oyama has been the only woman skater in the competition. She's certainly been one of the pioneering women in the sport. And while writers, photographers, and fans gave a lot of attention to the boys, Oyama continues to command respect.

Nevada City's N-Men race saw her race a slalom at thirty-five miles per hour. On her blog, Oyama has a ton of knowledge to impart to the up-and-comers: "It is a great skill to know how to slow down on a hill and how to generate speed."

In 2017, Aptos High School inducted her to their Sports Hall of Fame. Here's an excerpt from her remarks at the celebration dinner:

A few years ago at the World Championships in Texas, they had two start ramps—a regular four foot and a nine foot that they called the BAR which stood for "Big Ass Ramp." I went up to the top via a ladder; it was shaky, creaky and I looked down and said hell no and climbed back down. But when we started racing and there were two younger women one from Russia and [the other from] Latvia, both the fastest in their countries. I knew I had to get back up on the ramp. My teammate who is ten years younger and no kids was in first place, I wanted second. I climbed up the ramp that was tilted at a forward angle so when you dropped in you couldn't see part of the ramp just the pavement. I just looked ahead and went for it and took two seconds off my time and that got me second place. *The ramp, not the race, was my accomplishment.* One of the ladies came up to me after the race and said "you are crazy." I'm not sure if I'm crazy, but I know I will always challenge myself.

In 2018, Oyama was inducted into the Skateboarding Hall of Fame.

—Theodore S. Gonzalves

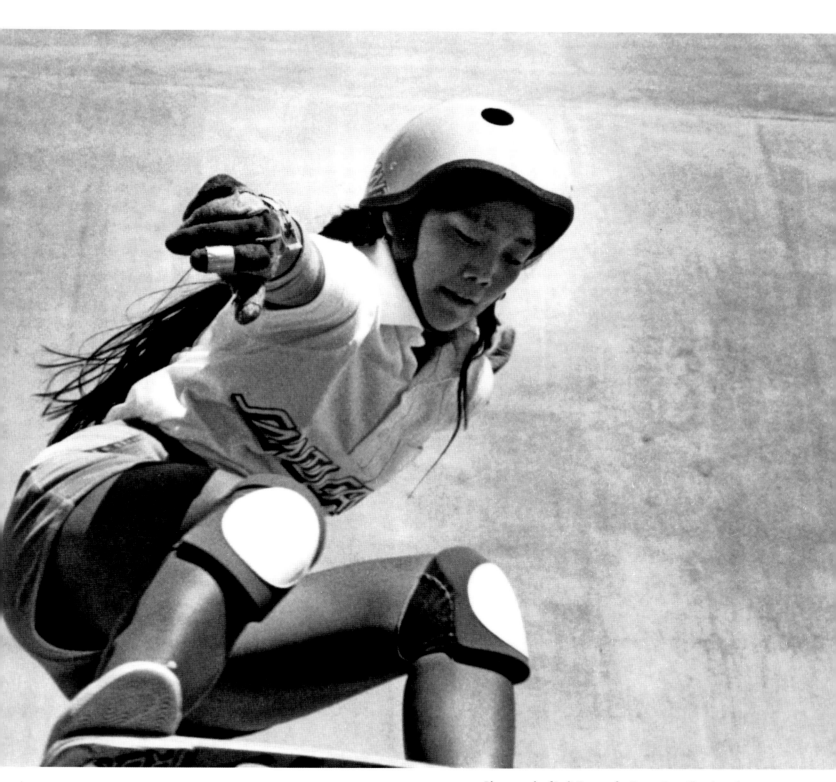

Photograph of Judi Oyama for Santa Cruz Skateboards, ca. 1970s.

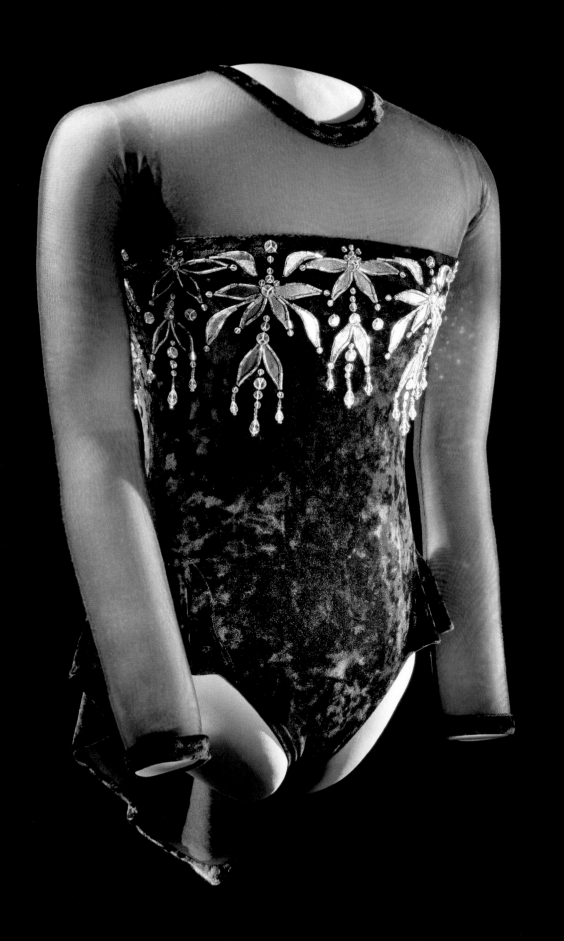

Freedom of Choice

Raised in Fremont, California, Kristi Yamaguchi (b. 1971) began ice skating at the age of six as physical therapy to correct her clubbed feet. Her love of skating grew, and she began competing in junior high. Yamaguchi began winning in pairs skating with her partner Rudy Galindo, before switching to focus on her singles skating. She proceeded to win at the 1991 and 1992 World Championships and earned a gold medal in figure skating at the 1992 Olympics in Albertville, France—becoming the first Asian American woman to do so.

After her Olympic gold medal win, Yamaguchi went on to skate as a member in the "Stars on Ice" tour from 1992 to 2002. This black dress, designed by Lauren Sheehan, is one of many that she wore while on tour. Sheehan also designed several of Yamaguchi's costumes for competition, including Yamaguchi's long program dress for the 1992 Olympics.

The dress featured here is made of crushed velvet fabric with sheer long sleeves. There is no skirt at the front, and the bodice is accented with rhinestones and Swarovski crystals. Sheehan recalls that Yamaguchi was excited at the opportunity to use velvet as the dress's fabric. Previously, velvet was too heavy and the material held in too much heat to be included in any of Yamaguchi's competitive skate outfits. When discussing the design of a costume, some of the biggest factors that Yamaguchi and Sheehan considered were the stretch, mobility, and durability of the fabric. The durability of the costume was especially important on tour because of the repetitive use of the costume to perform.

Sheehan recalled that Yamaguchi seldom wore black while competing because of hesitance from the team; they were afraid it would make her look old. According to Sheehan, Yamaguchi had more freedom to choose what she wanted to wear during her professional career than when she was competing, and was excited to wear black. Speaking about her decision to skate professionally in an interview with Shondaland, Yamaguchi expressed her excitement to skate to contemporary music and the chance to express and challenge herself in diverse ways with different music. This costume is indicative of this change and freedom.

Yamaguchi maintained her technical skills and skated at the same level of difficulty as she would for a competition during her professional career. She recalls how, unexpectedly, her professional career was harder than competition, not due to the pressure, but rather due to Yamaguchi's desire to keep up with the integrity and professionalism of her fellow skaters on tour. As Yamaguchi transitioned to skating professionally following her Olympic win, she was thrust into the public spotlight. According to Scott Hamilton, when Yamaguchi joined "Stars on Ice," the tour jumped from thirty cities to sixty cities almost overnight due to her ability to draw in crowds. The support of the Asian American community continued even after Yamaguchi stopped competing. Her impact after becoming the first Asian American woman to win an Olympic gold in figure skating continues to inspire young Asian American skaters today.

—Thanh Lieu

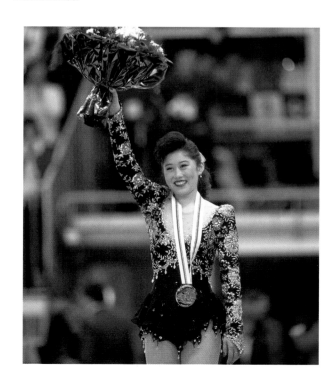

Left: Costume worn by American figure skater Kristi Yamaguchi as a member of the Stars on Ice *tour, with whom she performed from 1992–2002. Right: Kristi Yamaguchi celebrates after receiving a gold medal during the Winter Olympics in 1992.*

Representation in Dance

Born in Manila, Philippines, in 1978, Stella Abrera is the youngest of five siblings. Her father was a civil engineer and, due to his work, her family moved all over the globe, returning to the United States shortly after her birth. Abrera began dancing at the age of five and recalls spending some of her youth in Pasadena, California, while visiting her grandparents in Manila every summer. Her mother had a background in music and was supportive of Abrera's passion for dance, sometimes even playing music for her ballet classes. While both her parents were supportive of her dancing and allowed her to attend numerous international ballet competitions, only when Abrera became a professional dancer with the American Ballet Theatre (ABT) did they realize it was a viable career.

In 1996, at the age of seventeen, Abrera joined ABT as an apprentice after a successful audition. She would go on to rise in the ranks at ABT, earning the role of principal in 2015—the first Filipina American ballerina in the company to do so. However, Abrera's journey to becoming principal was not conventional, nor was it easy. Abrera was promoted to soloist in 2001, but a serious sciatic nerve injury in 2008 took Abrera out of dancing for two years. Abrera recalls the difficulty of recovery and having to relearn the way she danced at the age of thirty.

Fortunately, Abrera was able to return as a soloist, and she saw her recovery as a miracle. She recalled in an interview that the announcement of her promotion to principal was "magic," where all the struggles and triumphs she faced in the years leading up to that point were a "gift." Abrera remained with ABT until her retirement in 2020.

The ballet shoes shown here were worn by Abrera in an October 2017 production of *Daphnis et Chloé*. The shoes would have been worn for rehearsals for this show and likely for only one performance, perhaps two. They have been "pancaked" to match Abrera's skin tone. Dancers often coat their pointe shoes with makeup, known as pancaking, when they are not wearing tights, in order for the shoes to match their skin color. The process varies for each dancer, but it usually involves applying a thin layer to the shoe to cover up the shine, which can take up to ten to fifteen minutes when done with care.

Abrera's shoes are reflective of ABT's effort to promote diversity in the company. Speaking about the significance of her role as principal to young Asian American women, Abrera mentions how much representation matters. People of different skin colors are actively being encouraged to be part of ballet, and companies continue to evolve to attract diverse performers and audiences.

—Thanh Lieu

Ballet shoes worn during a 2017 performance by Stella Abrera.

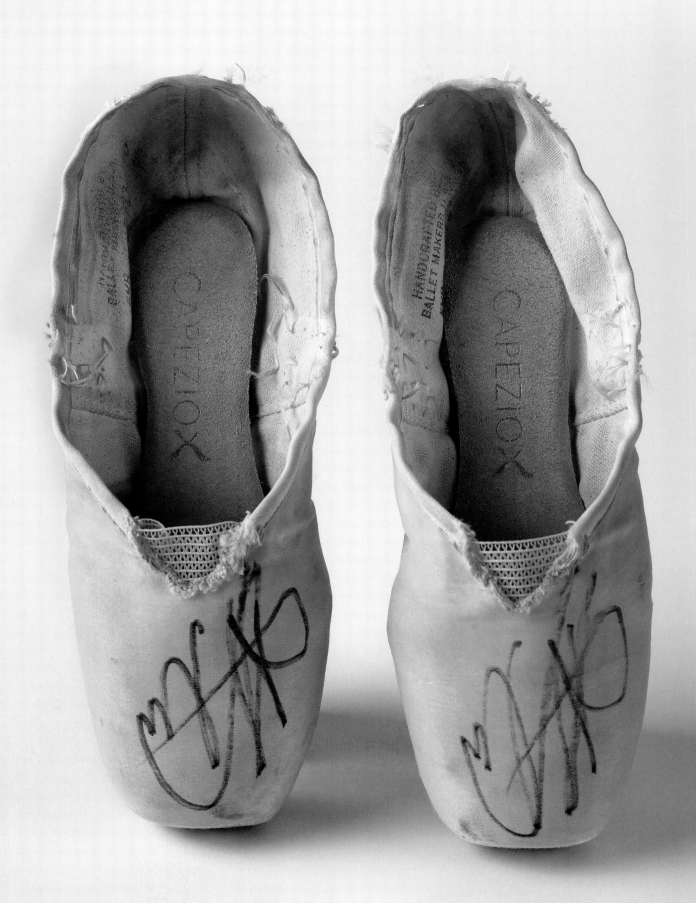

Fierce and Confident Humor

"Convincing an audience that a person who looks like me could be funny, and proving to them that I belonged onstage, was a steep uphill battle," Ali Wong (b. 1982) wrote in her memoir, *Dear Girls*. "Larry David looks like he's supposed to be funny. Richard Pryor, Dave Chappelle, Louie Anderson . . . all look funny. There's precedent for someone who looks like them to be telling jokes."

When Wong told her parents that Margaret Cho, another Asian American stand-up comic from San Francisco who had gone to high school with Wong's eldest sister, was a success, her parents saw the Korean American as an exception to the reality that Asian American women comedians were a rarity.

Born and raised in San Francisco, Wong majored in Asian American Studies at UCLA (which she has referred to as "Asian Wakanda") where she performed with the student theater company, Lapu, the Coyote that Cares, founded in 1995 by Randall Park, Derek Mateo, and David Lee. After graduation, Wong moved to New York City to work as a stand-up comedian.

Her 2016 special, *Baby Cobra*, featured her performance style: sharp observation mixed with raunchy and unapologetic detail. While seven months pregnant, Wong donned a form-fitting inexpensive outfit that inspired imitation among fans at Halloween parties and on social media.

Where did Wong get the confidence to take the stage in such a fierce way? Her parents have been a clear influence. Her father instilled in the young Wong an "unusual amount of Asian pride," from Asian home furnishings to exposure to Wong Kar Wai's films. Instead of following the tired "tiger mom" trope celebrated in media, Wong says that her mother "made me cheap, tough, and salty, like a steak from Sizzler."

Left: Comedian Ali Wong's form-fitting dress. Soon after the release of her 2016 stand-up concert video, Baby Cobra, *fans copied the look for special events. Right: Ali Wong in her 2016 stand-up special,* Baby Cobra.

Beyond home and campus settings, Wong found inspiration in Hawai'i during a two month trip when she was an undergrad. There she met the legendary Native Hawaiian scholar and activist, Haunani-Kay Trask: "The way she used humor and spoke with such strength, all while in her sarong and long hair flowing down to her elbows, really inspired me and influenced how I perform. I loved how she didn't try to repress her beauty or femininity in order to appear more authoritative. In fact, she channeled it into this goddess-queen energy that made her come off as a captivating maternal figure fighting for her beliefs and her people. I had never been so moved by a single speaker."

—Theodore S. Gonzalves

The Hardheaded Route

Let's say you're a young art student who is interested in researching the cultural traditions of your ancestors. Your teacher gives you the bad news: "There is no Filipino art history." What are your options? Maybe, with the teacher's help, you can learn about the better documented and more generously funded areas of Asian art history that focus on Japan, China, or Indonesia. But if you're Carlos Villa (1936–2013), the son of Pedro Villa and Prisca Gorospe, born in San Francisco's Tenderloin district, you take the hardheaded route. You spend decades proving your teacher wrong, and in the winding course of a career that spans decades and continents, you become a revered teacher and acclaimed artist in your own right.

Villa's art education prepared him to address the challenges that faced Filipino American artists of that period. His formal studies began at the California School of Fine Arts in the 1950s in the unconventional Beat Era that creatively combined multiple disciplines. He then moved to New York City for most of the 1960s, where his cousin, Leo Valledor, had ventured a few years earlier to become a member of the original Park Place Gallery Group. In New York, Villa explored abstraction and minimalism, but he kept an eye on the tumult of the decade and also studied non-Western art and cultural traditions.

By 1969, Villa had returned to San Francisco, which had become a vital hub for "third worldist" artmaking, community-organizing, and institution-building. Having had a chance to study ethnographic collections in San Francisco's fine arts museums, he curated a multidisciplinary exhibit titled *Other Sources: An American Essay*, in the same year the nation underwent a self-congratulatory series of bicentennial celebrations. Villa's show embraced traditions and practices from non-Western cultures; he also incorporated and experimented with non-traditional elements such as feathers, bone, blood, and shells in his own painting, sculpture, and performance.

Throughout the 1990s, Villa visited the Philippines. He explored and incorporated aspects of Indigenous culture into his art. Villa also conducted detailed interviews with artists who had been neglected during the postwar abstract expressionist period that had placed a premium on the stories of white male artists. His one-on-one interviews with several women and artists of color attempted to re-historicize the work of that time and place.

Drawing from his experience as student, art gallery artist, and teacher for over forty years, Villa's work expressed the fact that Filipino history and culture was already a vibrant source for contemporary artists. They had only to explore its many facets. As he wrote, "it could come out in many forms, it could come out in poetic terms. And I think that the artist—the artist/cultural worker (whoever they may be, whatever their color, whatever community they come from)—can talk about the idea of artists as conduits to their communities and from their communities. As opposed to just being the documenters—or the specialists. They become members of the community."

—Theodore S. Gonzalves

Artist and educator Carlos Villa, 1980. The photographer Mimi Jacobs (1911–99) was known in the San Francisco Bay Area for her portraits of prominent local figures, many of whom were artists.

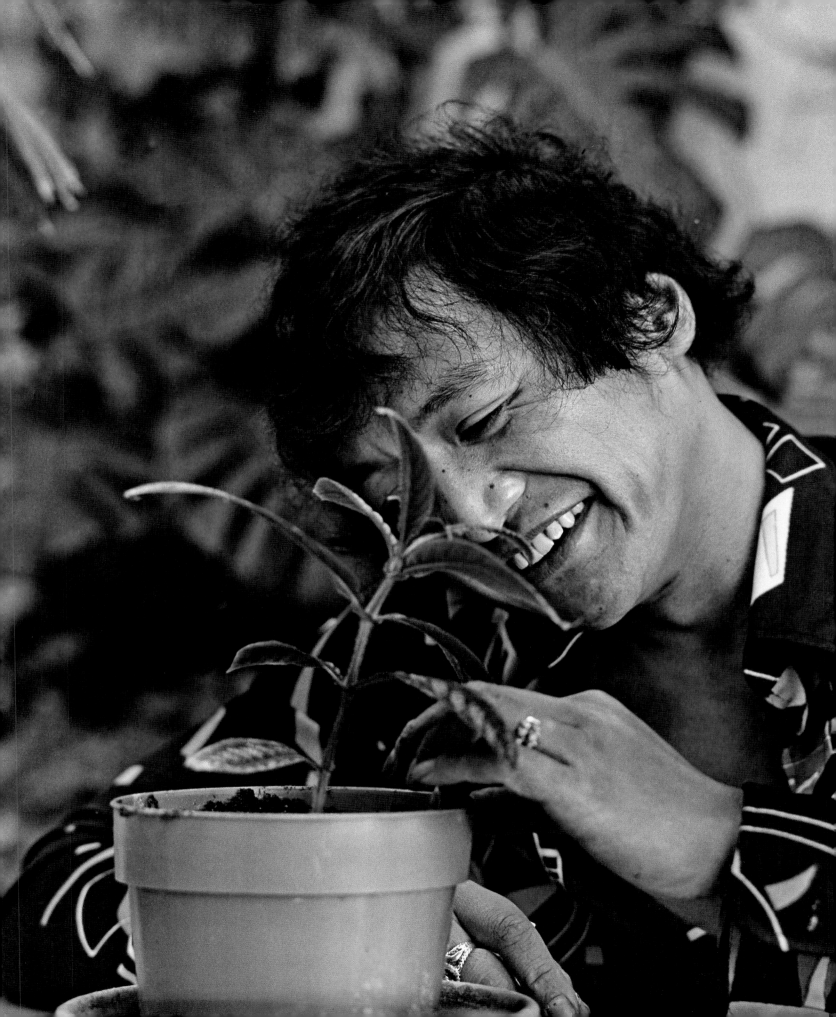

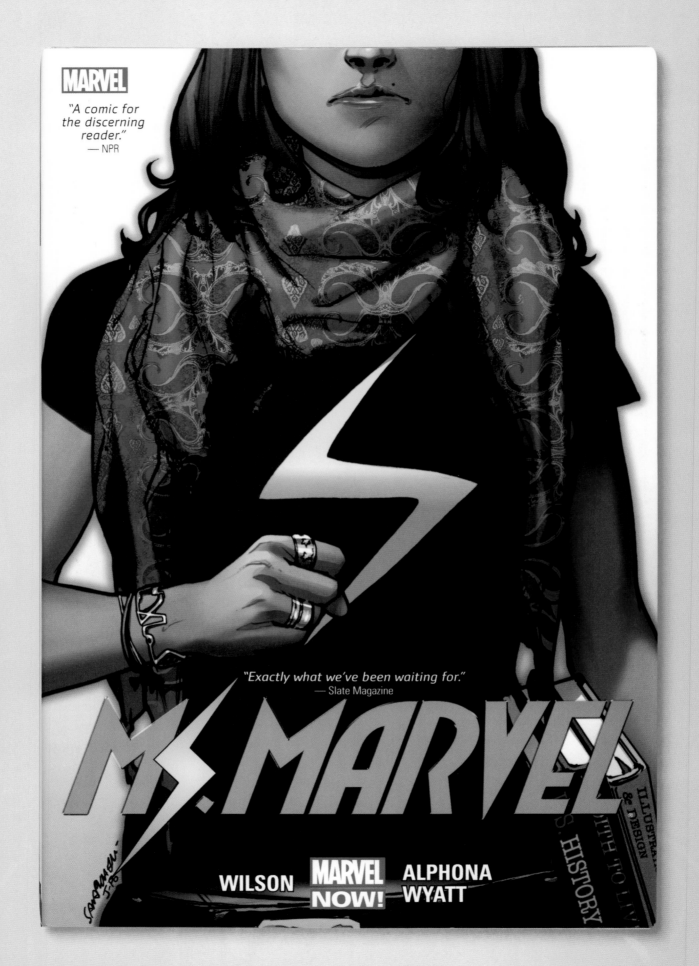

Ms. Marvel— Kamala Khan

In comics, origins are some of the most fun stories to learn about, and this is especially true of characters we've known for a while and have grown up with. When a storyteller winds the tale back to its humble beginnings, we have a chance to make sense out of our own beginnings as well. Sure, some readers may want to figure out how the hero went from rags to riches in the fastest way possible, but the origin story isn't just about the payout at the end. It's also a chance to learn how our heroes navigated a world they may not quite have understood at the time, or how they made choices from a handful of confusing options. As the Swedish author Sven Lindqvist observed, it's not knowledge that we lack, it's "the courage to understand what we know and to draw conclusions."

As a sixteen-year-old child of immigrants living in Jersey City, Kamala Khan seems pretty "normal." Her arrival in 2014 as the newest incarnation of Ms. Marvel seemed to follow the template of other comic book heroes-to-be: a teen outsider trying to make sense of their quirky homelife. Her parents are Muslim immigrants from Pakistan. She has a conservative older brother and a diverse group of friends at school. She's inspired by superheroes like Captain Marvel, Iron Man, and Captain America. And when those iconic heroes visit her in a dreamy sequence involving mist and speaking in Urdu (unusual for them), Khan emerges as something different.

Kamala Khan's transformation mirrors the changes that all teens face. The body changes in awkward ways and hers is even more pronounced—she can "embiggen" parts of herself at will. And yet, as a person of color she can also transform herself in ways many cannot: She can physically become a white woman like Carol Danvers/Captain Marvel whom she admires.

Cover of the comic Ms. Marvel, *vol. 1, 2014. Editor Sama Amanat and writer G. Willow Wilson broke new ground with the creation of the Kamala Khan character—a Pakistani American girl from New Jersey—in the 2014 version of* Ms. Marvel.

No doubt, one of the reasons for the successful launch of a complex character like Khan is the anchoring of her story in truth. Cocreator Sana Amanat (b. 1982), the book's editor and executive for production and development at Marvel, is the daughter of Pakistani immigrants based in Jersey City. The book's writer, G. Willow Wilson (b. 1982), has also worked on some of the legendary stories in mainstream comics—namely, Batman, Superman, Wonder Woman, and the X-Men. As Wilson said in an interview: "The only way we could have gotten this close to recognizable authentic experiences is because both the writer and the editor are Muslim women. I think if it had been anything else, there would have been pressure to conform to a certain narrative."

In an interview with *Bustle*, Amanat pointed to her own experiences as a Muslim and woman of color: "Growing up Muslim and brown in America has at least steeled me up for a lot of this. From a very young age, I'm used to people saying terrible things about Muslims. I've seen some really terrible things done to Muslims in my community. I still see terrible things done to Muslims and I understand that there is an injustice happening every single day."

The diversity of the book's production team is also reflected in the audience. Female comic book readers now represent half of the audience who are looking for relatable and inspiring stories. Superhero stories are just as likely to come from Houston, Little Rock, and Bremerton in addition to Khan's Jersey City backdrop.

Amanat sees the potential of Khan's story connecting with a new generation of comic book fans: "They have this incredible potential within themselves, and they have to find it. It doesn't matter what it looks like, it doesn't matter what it feels like. Their responsibility is to find whatever that weird power is."

—Theodore S. Gonzalves

TIMELINE OF ASIAN AMERICAN HISTORY

50,000 BCE

Coming from what is now continental Asia and Southeast Asia, Oceania's ancestors began migrations throughout the Pacific. Approximately 5,000 years ago, subsequent seafaring waves of explorers sailed to and settled what is now known as Melanesia, Micronesia, and Polynesia.

1492

Financed by Spain, Christopher Columbus arrives in the Americas while trying to reach Asia in search of gold.

1494

The Treaty of Tordesillas divides the "New World" between Spain and Portugal, with a line drawn from Greenland south through what is now Brazil. It claimed that possession of the entire world west of that line would be open to Spanish conquest, and all east of it to Portuguese conquest.

1498

Portuguese colonizer Vasco de Gamma anchors off the Indian subcontinent's Malabar Coast.

1521

Portuguese commander Ferdinand Magellan arrives in what is now Guam and the Philippines.

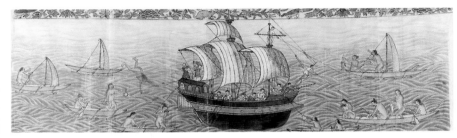

Reception of the Manila Galleon by the Chamorro, ca. 1590.

1565

The Manila galleon trade links Asia, the Americas, and Europe in a global commercial route that circulates goods and labor for 250 years.

1670

Two Chamorros, Matå'pang and Hurao, lead a war of resistance against the Spanish Jesuit missionary Diego Luis de San Vitores in the Mariana Islands.

1761

India becomes a colony of Great Britain.

Captain James Hook, painting by Nathaniel Dance-Holland, 1775.

1778

British captain James Cook arrives in Waimea, Kauai, the Kingdom of Hawai'i.

1784

Ships from the United States begin trading in both India and China.

1790

The US Congress, for the first time, formalizes the term "American" in the Naturalization Act—defined as a "free white person . . . of good character."

1833

With the British government's abolition of slavery throughout its empire, the practice of importing workers from South Asia and China to the Americas intensifies.

1835

American business leaders establish the first sugar plantation in Hawai'i.

1838

The first South Asian indentured laborers arrive in British Guiana.

1840

The basis of Justice Roger Brook Taney's landmark opinion in the Dred Scott case is articulated in an earlier case involving a "Malay" sailor from the Philippines—recognized as "the first federal decision to articulate a broad theoretical basis for White supremacy."

1844

United States and China sign first treaty.

1848

Gold discovered in Sutter's Mill, California. By 1852, around 25,000 Chinese had migrated to California.

1849

Britain annexes the Punjab region of India.

1850

The California state legislature passes the Foreign Miners' Tax, April 13, targeting Mexican and Chinese miners, required "non-natives"—except for native Californian Indians—to pay monthly fees of $20.

1853

US Naval commodore Matthew Perry arrives in Tokyo Bay to open Japan's trading ports.

1854

California's Supreme Court ruled in *People v. George W. Hall* that no Chinese person could testify against a white person in a California court. The United States and Japan sign a treaty for the first time.

Grove Farm plantation, ca. 1854.

1865

Central Pacific Railroad Co. recruits Chinese workers for the first transcontinental railroad.

1867

Two thousand Chinese railroad workers strike for a week.

1869

Workers complete the first transcontinental railroad.

1871

Anti-Chinese violence erupts in Los Angeles. Japan and Hawai'i sign a friendship treaty.

1875

On March 3, Congress passes "An Act Supplementary to the Acts in Relation to Immigration" (known as the Page Law), which bars the entry of Chinese, Japanese, and "Mongolian" prostituted women, felons, and contract laborers.

1877

Anti-Chinese violence erupts in Chico, California. The Workingmen's Party of California, organized in San Francisco, argues that Chinese workers were taking jobs from white competitors.

1878

The Ninth Circuit Court of California rules in the In re Ah Yup case that Chinese persons are ineligible for naturalized American citizenship.

1881

Hawai'i's King Kalakaua visits Japan during his world tour. Sit Moon becomes the pastor of the First Chinese Church of Christ Hawai'i.

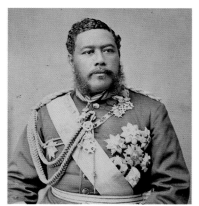

King David Kalakaua, ca. 1882.

TIMELINE OF ASIAN AMERICAN HISTORY

1882

Congress passes "An Act to Execute Certain Treaty Stipulations Relating to Chinese," known as the Chinese Exclusion Act, on May 6, halting the immigration of Chinese laborers for ten years. The Treaty Between the United States and Corea: Peace, Amity, Commerce, and Navigation, signed on May 22, attempts to counter Japan's influence in the region. Leaders in San Francisco's Chinatown form the Chinese Consolidated Benevolent Association.

1884

US missionary and diplomat Horace Allen arrives in Korea, promoting immigration to Hawai'i.

1885

Joseph and Mary Tape sue to reverse a San Francisco school's segregation policy denying their daughter admission based on her race. While they won the case, local administrators create a segregated school for "Orientals," where daughter Mamie is enrolled.

1885

The first group of Japanese contract laborers arrives in Hawai'i.

1887

Hawai'i's King Kalakaua is forced to sign what is known as the "Bayonet Constitution," shifting the balance of power from the Hawaiian monarchy to American and European foreigners.

1893

A small committee of American business leaders overthrows the sovereign Kingdom of Hawai'i, forcing Queen Lili'uokalani to abdicate the throne.

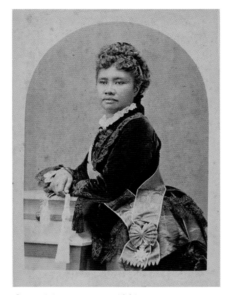

Queen Lili'uokalani, ca. 1891.

1896

Revolutionary leaders in the Philippines launch a revolution against Spain.

1898

The US Supreme Court's landmark decision in *United States v. Wong Kim Ark* formally establishes birthright citizenship. On June 12, Filipino revolutionary forces General Emilio Aguinaldo issues an "Act of the Proclamation of Independence of the Filipino People," which goes unrecognized by the United States and Spain. In July, the United States formally annexes Hawai'i. On December 10, the United States and Spain sign a peace treaty transferring control of the Philippines to the US.

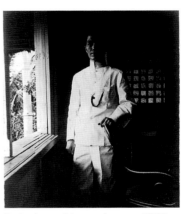

Emilio Aguinaldo in uniform, ca. 1898.

1899

The US-Philippine war begins when two infantrymen from the 1st Nebraska Volunteer Infantry deployed to the Philippines shoot and kill two Filipino soldiers. The Berlin Treaty divides Samoa into two colonies, Western Samoa for Germany and American Samoa (Eastern) for the United States.

1900

Congress passes the Hawaiian Organic Act, which establishes the Territory of Hawai'i and makes all US laws applicable to the archipelago.

1903

Korean workers arrive in the Territory of Hawai'i. In Oxnard, California, Japanese and Mexican agricultural workers form the Japanese-Mexican Labor Association and go on strike in February to reform labor conditions. One hundred Filipino students known as pensionados begin their studies in United States universities for training in a variety of disciplines with the goal of assuming leadership roles in the colony.

1906

A major earthquake and fire in San Francisco destroys public birth records, providing opportunities for persons in China to create illegal immigration documentation for entry to the United States as "paper sons" of relatives already in the country.

1907

President Theodore Roosevelt's Executive Order of March 14, better known as the Gentlemen's Agreement between the United States and Japan, sets out to calm tensions over anti-Japanese policies in the United States and Japan's interest in continued immigration of its citizens. The United States government begins the training of nurses in its Philippine and Guamanian colonies. Five hundred white workers riot against the presence of South Asian migrants working in the lumber mills of Bellingham, Washington.

1908

South Asians are driven out from Live Oak, California.

1909

In San Francisco, Korean immigrant independence activists form the Korean National Association to counter Japanese occupation of Korea. On the Hawaiian island of Oahu, seven thousand Japanese plantation workers launch a four-month strike for higher wages and better conditions.

1910

US officials open the Angel Island immigration station in San Francisco Bay, used to enforce Asian exclusion laws. Chinese who are detained and quarantined there carve two hundred poems into the facility's walls.

Poetry carved into a wall at Angel Island.

1911

Activist Pablo Manlapit forms the Filipino Higher Wages Association in Hawai'i.

1912

Sikh farmers Jawala Singh and Wasakha Singh, members of the Pacific Coast Khalsa Diwan Society, establish the first gurdwara in the United States in Stockton, California—a Sikh house of worship that serves as an important hub for social and political life for several decades.

1913

The State of California's Alien Land Law, known as the Webb Act, paves the way for fifteen states to pass similar legislation to prevent immigrants from owning land.

1917

Congress passes the Immigration Act of 1917, also known as the Barred Zone Act, aiming to restrict the immigration of South Asians to the United States.

1919

Korean leaders protest Japanese occupation of Korea during the March 1st Movement, prompting political activity among Koreans in the United States to mobilize for independence.

1922

Congress passes the Cable Act, stripping American women of their citizenship if they marry "aliens ineligible for naturalization," discriminating against Asian persons by deterring miscegenation.

1923

The Supreme Court denies the naturalization claim of a South Asian American veteran and scholar, arguing in *United States v. Bhagat Singh Thind* that the petitioner does not fit the "common" definition of a "white person."

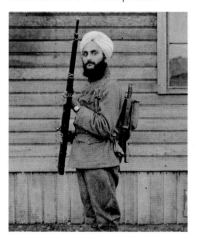

Bhagat Singh Thind in his US army uniform, 1918.

TIMELINE OF ASIAN AMERICAN HISTORY

1924

Congress' National Origins Act—also known as the Immigration Act of 1924, the Johnson–Reed Act, or the Asian Exclusion Act—prevents Japanese persons from immigrating to the United States.

1927

The Supreme Court's decision in *Gong Lum v. Rice* extends the segregation principle of "separate but equal" to Chinese American schoolchildren.

1930

A seven-hundred-strong crowd of mostly white male workers in Watsonville, California, riot against Filipino agricultural workers, blaming them for lowering wages and accusing them of consorting with white women. During the four days of violence, a twenty-two-year-old Filipino by the name of Fermin Tobera is killed, prompting a national day of humiliation in the Philippines.

1934

After several attempts to limit immigration of Filipinos to the United States, Congress passes the Tydings-McDuffie Act, which sets a timetable for Philippine independence while drastically reducing immigration from the colony.

Women participating in the National Dollar Stores strike, 1938.

1938

One hundred and fifty Chinese women garment-workers go on strike for fifteen weeks against the National Dollar Stores garment factory in San Francisco.

1941

United States declares war on Japan following attacks on US military bases in Pearl Harbor and Manila.

1942

President Franklin D. Roosevelt's Executive Order 9066 authorizes the Secretary of War to place certain areas under military authority to remove people of Japanese descent from their homes, including families, and send them to live in concentration camps. Approximately 120,000 are incarcerated.

1943

Congress repeals the Chinese Exclusion Acts, allowing for the naturalization of Chinese immigrants. In two decisions pertaining to Kiyoshi (Gordon) Hirabayashi and Minoru Yasui, the Supreme Court upholds the constitutionality of state-mandated curfews for Japanese persons. Writing for the majority in *Korematsu v. United States*, Justice Hugo Black denies that the exclusion of 120,000 persons of Japanese descent has anything to do with race, deferring to the judgment of military leaders fearing invasion.

Japanese family being relocated from San Francisco. Photograph by Dorothea Lange, April 6, 1942.

1945

With the passage of Congress' War Brides Act, thousands of foreign women who married US servicemen were admitted for naturalization after World War II. The United States and the Soviet Union divide Korea at the 38th Parallel.

1946

In attempting to cut costs, Congress passes the Rescission Act of 1946, stripping Filipino veterans who fought alongside US forces during World War II of their benefits. The Luce-Cellar Act allows for Indians from South Asia to naturalize as American citizens. The United States conducts sixty-seven nuclear weapons tests on Bikini and Enewetak Atolls in the Marshall Islands between 1946 and 1958.

1948

To counter post-war communist states, the US government establishes the Exchange Visitor Program to train foreign students and workers in the United States before their return home. The program has a major impact on nurse training and Philippine migration.

1950

The Korean War begins.

1954

The end of the first Indochina War marks the exit of France and the escalation of the United States' presence as a supporter of the South Vietnamese government.

1955

Twenty-nine Asian and African nations meet at the Bandung Conference, engaging in dialogues on self-determination and nuclear proliferation.

1959

The territories of Alaska and Hawai'i are admitted to the union as states.

1962

Western Samoa gains its independence from New Zealand, changing its name to Samoa in 1997.

1965

The Agricultural Workers Organizing Committee, led by Filipino American activist Larry Itliong, initiates strikes in Coachella and Delano, California, prompting the National Farm Workers Association, led by Dolores Huerta and Cesar Chavez, to join the effort in the boycotting of grapes and the eventual creation of the United Farm Workers. Congress passes the Immigration and Nationality Act, which reshapes the nation's demographics for decades to come.

1966

Asian American students join the 3,000-person boycott of racially segregated Seattle public schools; community organizers establish an alternative Freedom School in the city's Central District.

1967

The Supreme Court's *Loving v. Virginia* decision strikes down the nation's existing anti-miscegenation laws.

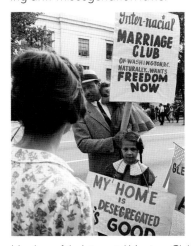

Members of the Interracial Marriage Club protesting bans on interracial unions and advocating for desegregated homes, ca. 1963.

1968

Leaders of San Francisco State College's Third World Liberation Front organize a strike and create the first college of ethnic studies. United States troops murder as many as 500 unarmed Vietnamese civilians in the My Lai Massacre of Sơn Mỹ, Vietnam.

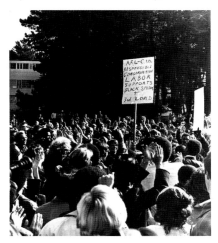

Crowd during the San Francisco State College strike, ca. 1968.

1969

University of California at Berkeley students call for the creation of an ethnic studies program. In New York City, the Asian Americans for Action, also known as Triple A, organize to oppose the Vietnam War and support local educational reform.

1971

The New Zealand-based Polynesian Panthers, inspired by the American Black Panther Party, connect the plight of Maori to structural inequalities throughout the Pacific region.

TIMELINE OF ASIAN AMERICAN HISTORY

1974

In *Lau v. Nichols*, the Supreme Court holds that Chinese-speaking students cannot be denied access to educational programs due to their inability to speak English, paving the way for bilingual education opportunities.

1975

North Vietnamese forces capture Saigon, the capital of South Vietnam. Congress passes the Indochina Migration and Refugee Assistance Act, facilitating the migration of 130,000 refugees from Vietnam, Kampuchea, and Laos to the United States.

1976

The crew of the Hōkūleʻa, a Hawaiian voyaging canoe using traditional wayfinding techniques to sail, arrives in Tahiti.

1977

The San Francisco Sheriff's Office evicts elderly Chinese American and Filipino American residents of the International Hotel after a decade of struggle over affordable housing.

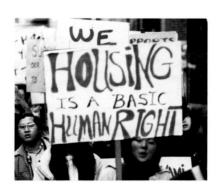

Crowd protesting outside of the I-Hotel, ca. 1977.

1979

President Jimmy Carter issues Proclamation 4650, which designates a week (later extended to the entire month of May) to celebrate the presence of Asian Pacific Americans.

1982

Blaming "Japs" for the economic downturn in Detroit's automobile sales, Ronald Ebens and Michael Nitz murder Chinese American draftsman Vincent Chin. Lily Chin, Vincent's mother, leads a social movement to seek justice for her son's murder. In New York City, 20,000 Asian American garment factory workers go on strike to demand contracts.

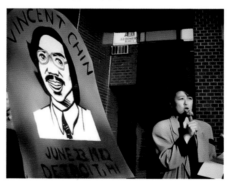

Helen Zia speaks at New York City Chinatown event for the tenth anniversary of Vincent Chin's death, ca. 1992.

1983

Korean American Chol Soo Lee is set free after being wrongly convicted for murder, helped by investigative reporting from K. W. Lee on racial bias in California's criminal justice system.

1984

Researchers Aiko Yoshinaga-Herzig and Jack Herzig in the US District Court case *Korematsu v. United States* prove that the government withheld exculpatory evidence that would have benefited Korematsu's WWII-era claim.

1988

The Civil Liberties Act of 1988 consists of an apology from the United States government for "the evacuation, relocation, and internment of citizens and permanent resident aliens of Japanese ancestry during World War II," and restitution in the form of $20,000 to each internee alive at the Act's signing, affecting some 80,000 persons.

1989

The Supreme Court rules against Filipino American cannery workers' claims of employment discrimination in *Wards Cove Packing Company, Inc., et al. v. Atonio et al.* case.

1992

Korean American businesses sustain damage during Los Angeles' 1992 uprising. While local police defend wealthy neighborhoods, longstanding structural inequalities and events impact working class Black and Korean residents—including the killing of African American teen Latasha Harlins by Korean American business owner Soon Ja Du.

1999

The United States government charges Taiwanese American scientist Wen Ho Lee with spying for China. With nearly all the government's charges against Lee eventually dropped, President Bill Clinton apologizes, Lee settles a civil lawsuit, and federal judge James A. Parker criticizes the government's handling of the case. White supremacist Buford O. Furrow, Jr. wounds five persons in the North Valley Jewish Community Center in Granada Hills and later kills Filipino American letter carrier Joseph Ileto in Chatworth, California.

2001

Al-Qaeda carries out simultaneous suicide attacks in the United States on September 11. The United States government engages in a "War on Terror," directed at targets in the Middle East with broad impacts for Muslim people across the globe. Four days later, Frank Roque kills Sikh business owner Balbir Singh Sodhi in Mesa, Arizona.

2002

Repatriation of approximately 1,500 Cambodian persons convicted of crimes in the United States results in family separations.

2010

The US Census reports that Asian Americans are the fastest growing racial group in the United States population.

2012

Wade Michael Page kills six and wounds four persons at the Sikh temple in Oak Creek, Wisconsin.

2014

Protests of the building of the Thirty Meter Telescope on the Island of Hawai'i receives media coverage, with protestors calling to halt construction at the Native Hawaiian sacred site.

2020

President Donald Trump and several other public officials link the novel coronavirus to the Chinese government and Chinese persons, resulting in an upswell of anti-Asian violence. Advocacy group Stop AAPI Hate documents 11,500 acts of violence. Kamala Harris is the first person of South Asian descent to be elected as Vice President of the United States.

Vice President of the United States Kamala Harris.

2021

Robert Allan Long kills six Korean women in the Atlanta area, and later receives a life sentence without parole. Illinois becomes the first state to require the teaching of Asian American history in public schools.

Adapted from Franklin Odo's *The Columbia Documentary History of the Asian American Experience,* Sucheng Chan's *Asian Americans: An Interpretive History,* ChangeLab's *A Different Asian American Timeline,* and the University of Hawai'i at Mānoa's Teaching Oceania Series.

Zach Schroeder teaches Asian American history in his Chicago classroom.

Acknowledgments

Working on this book has been an honor and a lot of fun. The following individuals have made the journey worth it.

Thanh Lieu's contribution to this effort has been immeasurable. Richard Kurin provided wise counsel and valued encouragement.

This book embodies the Institution's vision of One Smithsonian. Special thanks to the staff of the fourteen museums, centers, and archives who participated in this project. I am grateful to work with Anthea Hartig, Yao-Fen You, Noriko Sanefuji, Healoha Johnston, Mitch Toda, Kay Peterson, Benjamin Filene, Melanie Blanchard, John Troutman, and Eliza White.

The staff at Smithsonian Books, including Carolyn Gleason and Matt Litts, championed the project from the start. Special thanks go to Julie Huggins for her patience and attention to detail.

Every page of this book is infused with the Pinay Power of Jean Vengua's deft editing and Christina Newhard's brilliant design.

I am fortunate to have the support of the Gonzalves and Castro families. Diego, Rosalí, Julián, Sophia, and Eyla kept me in good spirits and offered excellent feedback. Rudy Gonzalves is the best brother any sibling could have. Charita Libao Castro inspires me every day. *Remember that night I had to call you? We were rappin' 'till the sun came up.*

Contributors

Joshua A. Bell is curator of globalization at the National Museum of Natural History, where he is the steward of the Oceanic collections, and those of the National Anthropological Archives and Human Studies Film Archive. He also codirects the Mother Tongue Film Festival and runs the Summer Institute in Museum Anthropology (SIMA). Currently, he is curating the exhibit *Cellphone: Unseen Connections*, which explores the global ecological, material, and cultural story of our mobile technology.

Kālewa Correa is the curator of Hawai'i and the Pacific at the Smithsonian Asian Pacific American Center. He leads the Our Stories Initiative, which teaches a mixed-media approach to present traditional storytelling. The initiative works with Pacific Islander youth and elders to present, preserve, and perpetuate Pacific Island stories. Correa's research focus at the Smithsonian Institution is on Native Hawaiian and Pacific Islander canoes, fabrics, and

post-contact political structures. He is a graduate of the University of Hawai'i at Mānoa and holds advanced degrees in Information Science and Education Technology.

Chelsea R. Cozad is a recent graduate of Miami University of Ohio where she earned her BA in history with a focus on sharing the experiences of American women. As a Because of Her Story intern for the Smithsonian's American Women's History Museum, Cozad authored biographies of women honored by the US Mint's American Women Quarters Program.

Lawrence-Minh Bùi Davis is a curator at the Smithsonian Asian Pacific American Center. He oversees the Smithsonian Literature + Museum Initiative, devoted to rethinking collective responsibility for what we write and read, and why, and serves as lead organizer of the Asian American Literature Festival and the pop-up Center for Refugee Poetics. He is currently ranked as the ninth best ice cream maker in human history.

Theodore S. Gonzalves is curator of Asian Pacific American History at the Smithsonian's National Museum of American History. A Fulbright Scholar and past president of the Association for Asian American Studies with more than thirty years of teaching experience in the United States, Spain, and the Philippines, he has released several publications including *Stage Presence: Conversations with Filipino American Performing Artists*, *The Day the Dancers Stayed: Performing in the Filipino American Diaspora*, *Carlos Villa and the Integrity of Spaces*, *Filipinos in Hawai'i* (with Roderick N. Labrador), and *Gossip, Sex, and the End of the World: Collected Works of Tongue in a Mood* (coedited with A. Samson Manalo).

Saisha Grayson is curator of time-based media at the Smithsonian American Art Museum, where she spearheads research, exhibitions, and acquisitions related to this aspect of the museum's collection, which includes the Nam June Paik Archives. Her recent projects include the pop-up exhibition *Pride@SAAM*, the group exhibition *Musical Thinking: New Video Art and Sonic Strategies*, a focus show with Carrie Mae Weems, and collaboratively reimagining SAAM's modern and contemporary galleries.

Diana Jocelyn Greenwold is the Lunder Curator of American Art at the National Museum of Asian Art, where she oversees the institution's marquee collection of late-nineteenth and early twentieth-century American fine and decorative arts. Her recent projects include exhibitions on Gilded Age painting and American studio craft. Greenwold received her BA from Yale University and her PhD from the University of California, Berkeley.

Jon Grinspan is curator of political history at the Smithsonian's National Museum of American History, focusing on the deep history of American democracy and how it speaks to contemporary politics. Grinspan is the award-winning author of *The Age of Acrimony: How Americans Fought to Fix Their Democracy*, and *The Virgin Vote: How Young Americans Made Democracy Social, Politics Personal, and Voting Popular in the 19th Century*. His writing frequently appears in the *New York Times* and elsewhere. Grinspan's work also takes him to political events, from conventions to protests to riots, collecting materials to help teach future generations about twenty-first century American democracy.

Melissa Ho is curator of twentieth-century art at the Smithsonian American Art Museum, where she is responsible for research, acquisitions, and exhibitions related to the museum's collections focusing on art since 1945. She also leads the museum's Asian American art collecting initiative. Ho's exhibitions include *Artists Respond: American Art and the Vietnam War, 1965–1975* and *Composing Color: The Paintings of Alma Thomas*.

Nafisa Isa is a program manager at the Smithsonian Asian Pacific American Center. She is an educator and designer with a passion for engaged learning, social innovation, and collective liberation. Nafisa was the lead planner for Smithsonian APA's groundbreaking Culture Lab exhibitions and is the founder of the Muslim Writers Salon at the Asian American Literature Festival. Her latest publication, "Communities Over Collections: Three Principles for Partnership" can be found in *Change is Required: Preparing for the Post-Pandemic Museum*, published by Rowman & Littlefield. Nafisa holds a BA in history from Davidson College and an MA in Learning, Design, and Technology from Georgetown University.

John P. Jacob is the McEvoy Family Curator for Photography at the Smithsonian American Art Museum. Jacob was curator of *Harlem Heroes: Photographs by Carl Van Vechten* (2016), and in 2018 he organized the exhibitions *Diane Arbus: A Box of Ten Photographs* and *Trevor Paglen: Sites Unseen*. In 2021, he organized *Dawoud Bey and William H. Johnson* and *Welcome Home: A Portrait of East Baltimore, 1975–1980*. Jacob earned a BA from the College of the Atlantic in 1981, and MA in art history from Indiana University in 1994.

Sojin Kim is a curator at the Smithsonian Center for Folklife and Cultural Heritage. Her work spans festival programs, exhibitions, workshops, as well as research and documentation projects, primarily engaging communities in Washington, DC; Southern California; and Asian Americans in multiple regions. She holds a PhD in Folklore and Mythology from UCLA.

Thanh Lieu is a museum technician at the National Museum of American History. She manages the museum's collection of objects related to Asian Pacific American history. Additionally, she assists with APA curatorial projects.

Adriel Luis is a community organizer, artist, writer, and curator who believes that collective liberation can happen in poetic ways. He is the curator of digital and emerging practice at the Smithsonian Asian Pacific American Center, where he advocates for equitable practices in museums and institutions. His life's work is focused on the mutual thriving of artistic integrity and social vigilance.

Andrea Kim Neighbors serves as the head of education for the Smithsonian Asian Pacific American Center. She collaborates with K12 educators and Asian American and Pacific Islander content specialists, and community members on developing APAC's National Education Program. She also serves as a lecturer in the Museum Studies department at George Washington University and as a board member for the Museum Education Roundtable.

Sarah Newman is the James Dicke Curator of Contemporary Art and deputy head curator at the Smithsonian American Art Museum. At SAAM, she is currently leading a major reinstallation of the museum's contemporary permanent collection, and has organized the exhibitions *Tiffany Chung: Vietnam, Past Is Prologue*; *Do Ho Suh: Almost Home*; and *Kara Walker: Harper's Pictorial History of the Civil War* (Annotated). In the past several years, she has worked with artists including Theaster Gates, Spencer Finch, Ellen Harvey, and Chris Martin.

Sam Vong is a curator at the National Museum of American History, where he is building the museum's collections related to Asian Americans and Pacific Islanders. His projects include working with agricultural laborers and refugee communities to tell their stories, as well as curating exhibitions on Chinese building the Transcontinental Railroad, and the topic of girlhood. He earned his BA from University of California at Berkeley and PhD from Yale University.

Grace Yasumura is an assistant curator at the Smithsonian American Art Museum. Among her current research projects is *The Shape of Power: Stories of Race and American Sculpture*, an exhibition that examines the intertwined histories of race and sculpture in the United States.

Cedric Yeh is the curator for the National September 11 collection at the National Museum of American History. In a twenty-seven-year career at the Smithsonian, he has curated exhibitions on AAPI history and culture, directed the New York City Latino Covid 19 Collecting Initiatives, and escorted R2-D2 on a tour of Germany. He earned his BA from Brandeis University and MA from George Washington University.

Claudia E. Zapata (they/them) earned their BA and MA from the University of Texas at Austin and a PhD in art history from Southern Methodist University. From 2018–22, Claudia was the curatorial assistant of Latinx art at the Smithsonian American Art Museum for the *¡Printing the Revolution! The Rise and Impact of Chicano Graphics, 1965* exhibition. Currently, Zapata is a Chancellor's Postdoctoral Fellow at UCLA.

Recommended Reading

Amerasia Journal. Los Angeles: Taylor & Francis, University of California at Los Angeles.

Camacho, Keith L., ed. *Reppin': Pacific Islander Youth and Native Justice*. Seattle: University of Washington Press, 2021.

Choy, Catherine Ceniza. *Asian American Histories of the United States*. Boston: Beacon Press, 2022.

Contemporary Pacific: A Journal of Island Affairs. Honolulu: University of Hawai'i Press.

Fujikane, Candace, and Jonathan Y. Okamura, eds. *Asian Settler Colonialism: From Local Governance to the Habits of Everyday Life in Hawai'i*. Honolulu: University of Hawai'i Press, 2008.

Hirahara, Naomi. *We Are Here: 30 Inspiring Asian Americans and Pacific Islanders Who Have Shaped the United States*. New York: Running Press Kids, 2022.

Johnson, Mark, Gordon H. Chang, and Paul Karlstrom, eds. *Asian American Art: A History, 1850-1970*. Redwood City: Stanford University Press, 2008.

Journal of Asian American Studies. Baltimore: Johns Hopkins University Press.

Kim, Elaine H., Margo Machida, and Sharon Mizota, eds. *Fresh Talk/Daring Gazes: Conversations on Asian American Art*. Berkeley: University of California Press, 2005.

Kina, Laura, and Jan Christian Bernabe, eds. *Queering Contemporary Asian American Art*. Seattle: University of Washington Press, 2017.

Lee, Erika. *The Making of Asian America: A History*. New York: Simon & Schuster, 2015.

Lee, Shelley Sang-Hee. *A New History of Asian America*. Milton Park, Abingdon-on-Thames, Oxfordshire: Routledge, 2013.

Odo, Franklin, ed. *The Columbia Documentary History of the Asian American Experience*. New York: Columbia University Press, 2002.

Okihiro, Gary Y. *The Columbia Guide to Asian American History*. New York: Columbia University Press, 2001.

Parikh, Crystal, and Daniel Y. Kim, eds. *The Cambridge Companion to Asian American Literature*. New York: Cambridge University Press, 2015.

Schlund-Vials, Cathy J., K. Scott Wong, and Linda Trinh Võ, eds. *Keywords for Asian American Studies*. New York: New York University Press, 2015.

Teaching Oceania [7 volumes]. Honolulu: Center for Pacific Islands Studies, University of Hawai'i at Mānoa, 2019-2022.

Zhao, Xiaojian, and Edward J. W. Park, eds. *Asian Americans: An Encyclopedia of Social, Cultural, Economic, and Political History* [3 volumes]. Santa Barbara, CA, Denver, CO, Oxford, England: Greenwood, 2013.

Zia, Helen. *Asian American Dreams: The Emergence of an American People*. New York: Farrar, Straus, and Giroux, 2001.

Bibliography

INTRODUCTION

Chin, Charlie, Iijima, Chris, and Miyamoto, Nobuko JoAnne. *A Grain of Sand: Music for the Struggle by Asians in America.* Paredon Records, 1973, LP.

San Juan, Jr, Epifanio, ed. *If You Want to Know What We Are: A Carlos Bulosan Reader.* Minneapolis: West End Press, 1983.

Hau'ofa, Epeli. *We are the Ocean: Selected Works.* Honolulu: University of Hawai'i Press, 2008.

Robles, Al. *Looking for Ifugao Mountain,* Fifth World Tales. San Francisco: Children's Book Press, 1977.

NAVIGATION

Boundless Space

Genz, Joseph H., "Resolving Ambivalence in Marshallese Navigation: Relearning, Reinterpreting and Reviving the 'Stick Chart' Wave Models." *Structure and Dynamics,* 9.1 (2016).

Hau'ofa, Epeli. "Our Sea of Islands*." The Contemporary Pacific* 6, no. 1 (Spring 1994): 147–161.

Kein, Armij Aelon, and Spenneman, Dirk H. R., "Traditional and Nineteenth Century Communication Patterns in the Marshall Islands." *Micronesian: Journal of the Humanities and Social Sciences,* no. 4.1 (June 2005).

Family History in a Lacquered Trunk

Chan, Sucheng. *Asian Americans: An Interpretive History.* Immigrant Heritage of America Series. Woodbridge, CT: Twayne Publishers, 1991.

Luo, Michael. "Chinatown Journal; Store Founded in 1891 Succumbs to Effects of 9/11." *New York Times.* October 26, 2003.

Mead, Virginia Lee. "Mr. Lee B. Lok at his store, Quong Yuen Shing & Co. Photoprint." National Museum of American History.

Searching for the Heart of the Nation

Bulosan, Carlos. *America Is in the Heart: A Personal History,* Brace and Company. New York: Harcout, 1943.

Tenazas, Lucille. *peregriNasyon,* 1994, poster, 61.0 x 45.7 cm (24 x 18 in.), Cooper Hewitt Smithsonian Design Museum.

Millado, Chris B. *peregriNasyon: Is America in the Heart?* Play. Teatro ng Tanan, 1994.

This Way to Chinatown

"Chinatown's Gateway Arch," *Public Art and Architecture from Around the World,* May 11, 2012.

Gonzales, Richard. "Rebuilding Chinatown After the 1906 Quake." *NPR Morning Edition,* April 12, 2006.

Lee, Clayton. "Gateway to Chinatown - an award-winning design," *Architecture West,* vol. 73, issue 10 (October 1967).

Yung, Judy. *San Francisco's Chinatown: A Revised Edition.* Images of America Series. Charleston: Arcadia Publishing, 2016.

All One Family

Gray, Paul. "Ellison Onizuka 1946-1986." *TIME,* February 10, 1986.

"Hero hailed space travel as 'fantastic'." *Hawaii Tribune-Herald,* February 9, 1986.

Connecting Communities

Vilayphonh, Catzie and Ashley Khakeo. "Philly Map" in *Verge: Studies Global Asias* 6, no. 4 (Spring 2020).

INTERSECTIONS

A Lesson in Stillness

Brooks, Gwendolyn. "my dreams, my works, must wait till after hell" from *Selected Poems.* New York: Harper and Row, 1963.

Grayson, Saisha. "Identity and Visibility: How a recent acquisition addresses themes of race and LGBTQ+ identity." *Smithsonian,* June 30, 2020.

Leigh, Simone and Chitra Ganesh, dir. *My Dreams, My Works Must Wait Till After Hell,* 2011.

A Dancer's Stance

Burgess, Dana Tai Soon. *Slant,* September 5, 2022.

Hwang, Cindy (CYJO). *KYOPO.* https://www.cyjostudio.com/kyopo

Kaufman, Sarah. "Retired Burgess Hasn't Lost A Step." *Washington Post,* October 27, 2008.

A Journeyed Costume

Irving, David. "Introduction." *Colonial Counterpoint: Music in Early Modern Manila,* CURRENTS IN LATIN AMER & IBERIAN MUSIC. New York: Oxford Academic, 2010.

Light as Salvation

Noguchi, Isamu. "I Become a Nisei," typescript, 1942. The Noguchi Museum Archives, MS_WRI_005_001.

Lyford, Amy. *Isamu Noguchi's Modernism: Negotiating Race, Labor, and Nation, 1930–1950.* Berkeley: University of California Press, 2013.

Fighting for the Nation

Public Law, 111-244 [para. 2]. An act to grant the congressional gold medal, collectively, to the 100th Infantry Battalion and the 442nd Regimental Combat Team, United States Army, in recognition of their dedicated service during World War II.

Public Law, 114–265 [para. 4]. Filipino Veterans of World War II Congressional Gold Medal Act of 2015.

Public Law 115–337, [para 6]. Chinese-American World War II Veteran Congressional Gold Medal Act.

An Ordinary Guy Remaking American Music

Bataan, Joe. "Young, Gifted, and Brown." *Singin' Some Soul.* Fania Records. Originally released in 1969, LP.

Bataan, Joe. "Unwed Mother." *Singin' Some Soul.* Fania Records. Originally released in 1969, LP.

Bataan, Joe. "Mestizo." *Mestizo.* Salsoul Records. Originally released in 1980, LP.

Bataan, Joe. "If I Were a King," *Saint Latin's Day Massacre*. Fania Records. Originally released in 1971.

Ambassador of Hawaiian Culture

Kaʻai, Ernest K. *The Ukulele: A Hawaiian Guitar and How to Play It*. Honolulu: Wall, Nichols Co. 1906.

King, John and Tranquada, Jim. "A New History of the Origins and Development of the ʻUkulele, 1838-1915," *The Hawaiian Journal of History 37*, (2003): 1–32.

Shadows and Light

Chen, Fan-Pen Li. *Chinese Shadow Theatre, History, Popular Religion, and Women Warriors*. Montréal: McGill-Queens University Press, 2007.

Tumbocon, Mauro F. "The Puppetmaster is No Clown, but a Real Swell Guy!" *Kayumanggi* 1.4, (1999): 27.

LABOR

Hawaiian Cowboys

Bergin, Billy. "Dr. Billy Bergin – Paniolo Cowboy." Interview. *National Cowboy & Western Heritage Museum*, https://www.youtube.com/watch?v=Z3hB4x9-j0.

Freitas, Gordon. "Cheyenne Waiomina." *Local Folk*. Blue Tarpolin Music. 1997.

Sproat, Clyde "Kindy." *Paniolo O Hawaiʻi: Cowboys of the Far West*. Directed by Edgy Lee. FilmWorks, Ltd., 1998.

Young, Neil. "Are There Anymore Real Cowboys?" Old Wars, Geffen Records, 1985, LP.

Native Pattera vs. Nurse-Midwife

DeLisle, Christine Taitano. *Placental Politics: Chamoru Women, White Womanhood, and Indignity under US Colonialism in Guam*. Chapel Hill: University of North Carolina Press, 2022.

Hattori, Anne Perez. "'The Cry of the Little People of Guam': American Colonialism, Medical Philanthropy, and the Susana Hospital for Chamorro Women, 1898-1941," *Health and History* 8, no.1, (2006): 4–26.

Leary, Richard. General Order No. 11. January 19, 1900.

McKinley, William. *The Benevolent Assimilation Proclamation*. December 21, 1898.

Traditions for Survival

Proschan, Frank. "Tradition and Survival: Kmhmu Highlanders in America." *1986 Festival of American Folklife*. Smithsonian Institution and National Park Service, 7–90.

A Worker's Proper Topper

Chan, Sucheng. *This Bittersweet Soil: The Chinese in California Agriculture, 1860-1910*. Berkeley: University of California Press, 1986.

DuFault, David V. "The Chinese in Mining Campus of California, 1848-1870." *The Historical Society of Southern California Quarterly* 41.2, (June 1959): 155-170.

Wok

Becker, Joseph. "The Coming Man—A Chinese Camp Scene on the Line of the Central Pacific Railroad," *Frank Leslie's Illustrated Newspaper*, 1870.

Chang, Gordon H. and Fishkin, Shelley Fisher, eds. *Chinese and the Iron Road: Building the Transcontinental Railroad*. Stanford: Stanford University Press, 2019.

Chen, Yong and Suey, Chop. *USA: The Story of Chinese Food in America*. New York: Columbia University Press, 2014.

Heffer, Sarah Christine, and 莎拉·贺弗那, "Exploring Health-Care Practices of Chinese Railroad Workers in North America," *Historical Archaeology* 49.1 (2015): 134–147.

Knox, Thomas W. "The Coming Man," *Frank Leslie's Illustrated Newspaper*, June 4, 1870, 189–190.

Spier, Robert F. G. "Food Habits of Nineteenth-Century California Chinese," *California Historical Society Quarterly* 37.1 (March 1958): 79–84.

Sunseri, Charlotte K. "Food Politics of Alliance in a California Frontier Chinatown," *International Journal of Historical Archaeology* 19.2 (June 2015): 416–431.

Tongyue, Cui. *Hua Ying Chu Shu Da Quan* (Chinese-English Comprehensive Cookbook). San Francisco: Fa Ming Gong Si, 1910.

Across the Street from Portland's Chinatown

Brookes, Will. "A Fragment of China." *The Californian VI*, no. 31 (July 1882): 6–14.

"Portland's Chinatown," *West Shore Magazine*. October 1886, p. 10, col. 2.

Filipina/os in California's Asparagus Fields

Mabalon, Dawn Bohulano. *Little Manila Is In the Heart: The Making of the Filipina/o American Community in Stockton, California*. Durham: Duke University Press, 2013.

Rony, Dorothy B. Fujita. *American Workers, Colonial Power: Philippine Seattle and the Transpacific West, 1919–1941*. Berkeley: University of California Press, 2003.

Tending to Details

Hendry, Erica R. "The precise stitchwork of May Asaka Ishimoto, a second generation Japanese American who survived two years in an internment camp." *Smithsonian*, February 12, 2010.

Kastor, Elizabeth. "Remembrance Of Sorrows Past: The Smithsonian's Hard Look at WWII," *Washington Post*, October 1, 1987.

After-Dinner Tradition

Berglund, Barbara. *Making San Francisco American: Cultural Frontiers in the Urban West, 1846–1906*. Lawrence: University of Kansas Press, 2007.

Lee, Jennifer. "Solving a Riddle Wrapped Inside a Mystery Inside a Cookie." *New York Times*, January 16, 2008.

Lee, Jennifer. *The Fortune Cookie Chronicles: Adventures in the World of Chinese Food*. New York: Hachette Book Group, 2008.

Ono, Gary T. "Japanese American Fortune Cookie: A Taste of Fame or Fortune—Part 1," *Discover Nikkei*, October 31, 2007.

Ono, Gary T. "Japanese American Fortune Cookie: A Taste of Fame or Fortune—Part 2," *Discover Nikkei*, November 1, 2007.

Weaving a Life

Sekimachi, Kay. "The Weaver's Weaver: Explorations in Multiple Layers and Three-Dimensional Fiber Art," an oral history conducted in 1993 by Harriet Nathan. Regional Oral History Office, The Bancroft Library, University of California, Berkeley, 1996.

INNOVATION

Anna May Wong

Chan, Anthony B. *Perpetually Cool: The Many Lives of Anna May Wong*. Lanham, Maryland: The Scarecrow Press, 2007.

Groundbreaking Cinematographer

Chin, Frank. "James Wong Howe: The Chinaman Eye," in *Moving the Image: Independent Asian Pacific American Media Arts*, edited by Russell Leong, 167–95. Los Angeles: UCLA Asian American Studies Center, 1991.

Acupuncture Kit

Montgomery, Paul. "Acupuncture Patients Fear Ban." *New York Times,* September 5, 1971.

Reston, James. "Now, About My Operation in Peking." *New York Times,* 1971.

Scripting Unity through Literacy

"A Devanagari Linotype: Indian Engineer's Invention." *Times of India*, August 2, 1933.

Gandhi, Mahatma. February 19, 1922, in *Gandhi and Non-Violent Resistance: The Non-Cooperation Movement of India*, compiled by Blanche Watson. Madras: Ganesh & Co., 1923.

"India Society Plans Cultural Center Here." *The New York Times*, February 17, 1929, A5.

Oak, V. V. "Foreign Propaganda." *Hindustan Review: India's Journal of Sociology, Politics, and Literature* 48, (1924): 397–400.

Finding Solutions

Wang, An, and Eugene Linden. *Lessons: An Autobiography*. Reading, Massachusetts: Addison-Wesley Publishing Company, 1986.

BELONGING

Finding Purpose

Correspondence between Nishimoto, Ujihara, and Henderson from the following collections: Smithsonian Institution Archives, Record Unit 305, United States National Museum, "USNM Accession Records: 1945 Acc. No. 168531"

"New Large Meteorite Found," *Rocks and Minerals* Vol 20, No. 3 (March 1945): 110–111.

"Large Siderite Found in the Drum Mts., Millard Co., Utah," *Popular Astronomy* Vol 53 (1945): 87.

"Meteorite Found Near Topaz, Specimen Sent to Washington." *Topaz Times*. October 11, 1944.

"Meteorite Found by Residents is 9th Largest in US." *Topaz Times*. December 23, 1944.

Beckwith, Frank. "Topaz Internees Find Valuable Meteorite." *Salt Lake Tribune*, July 29, 1945.

Science News Letter. "Meteor from Outer Space," Vol. 54, No. 17 (October 23, 1948): 262.

Fabric of Connections

Azeez, Minnath and Iran Tavera. "6 types of Hanbok that can be worn today." *Korea.net*.

Hyesoon, Kim. "Shades of History." *KOREA* webzine. https://www.kocis.go.kr/eng/webzine/202003/sub01.html

Korean Cultural Centre. "History of the Hanbok." https://kccuk.org.uk/en/about-korea/history-hanbok/

Yam, Kimmy. "Congresswoman wears hanbok at swearing-in ceremony, honors Korean immigrant mom." *NBC*. January 4, 2021.

Hawaiian Flag Quilt

Hammond, Joyce D. "Hawaiian Flag Quilts: Multivalent Symbols of a Hawaiian Quilt Tradition," *The Hawaiian Journal of History* 27 (1993): 1–26.

Haley, James L. *Captive Paradise: A History of Hawai'i*. New York: St. Martin's Press, 2014.

1st Filipino Infantry Insignia

"1st Filipino Infantry," *Camp Roberts Trainer*, vol. 2, no. 3, August 6, 1942.

Friend, Theodore. *Between Two Empires: The Ordeal of the Philippines, 1929-1946*. New Haven: Yale University Press, 1965.

"History of the U.S. Army's 1st Filipino Regiment and 2d Filipino Battalion (Separate)." US Army Center of Military History.

Kramer, Paul A. *The Blood of Government: Race, Empire, the United States, & the Philippines.* Chapel Hill: The University of North Carolina Press, 2006.

Zarina's Poetic Legacy

Cotter, H. "Zarina Hashmi, Artist of a World in Search of Home, Dies at 82." *New York Times*, May 5, 2020.

Life | Zarina Hashmi. (n.d.). Zarina. https://www.zarina.work/life

Layered Translations of *The Star-Spangled Banner*

Christine Sun Kim, "I Performed at the Super Bowl. You Might Have Missed Me." *The New York Times,* February 3, 2020.

TRAGEDY

Reverse Ethnography

Fusco, Coco, and Guillermo Gómez-Peña. *Two Undiscovered Amerindians*. 1992.

Margolis, Carolyn and Viola Herman, ed. *Magnificent Voyagers: The U.S. Exploring Expedition, 1838-1842.* Washington, DC.: Smithsonian Institution, 1985.

United States National Museum, *A Descriptive Account of the Building Recently Erected for the Departments of Natural History,* Bulletin 80 (1913).

Chinese Argument

"A Contentious Piece of Greenpoint's Porcelain Past." Booklynbased.com, March 6, 2014. https://brooklynbased.com/2014/03/06/a-contentious-piece-of-greenpoints-porcelain-past/.

Burke, Doreen Bolger, ed. et al. *In Pursuit of Beauty: Americans and the Aesthetic Movement*. New York: Metropolitan Museum of Art, 1986.

Lilienfeld, Bonnie. "My Ten Favorite Ceramic Objects from the National Museum of American History," *Chipstone*, 2014.

Padwee, Michael. "Nineteenth Century Brooklyn Potteries." Academia.edu, 2013.

St. Louis World's Fair Pamphlets

Afable, Patricia O. "Journey from Bontoc to the Western Fairs, 1904-1905: The 'Nikimalika' and their Interpreters." *Philippine Studies* 52.4 (2004): 445–73.

Jenks, Albert. *The Bontoc Igorot*. Manila: Bureau of Public Printing, 1905.

Wicentowski, Danny. "The World's Fair and the Lost Dead of St. Louis' Human Zoo." *River Front Times*, September 8, 2021.

Moro Brass Helmets

Hollister, N. "A Review of the Philippine Land Mammals in the United States National Museum - No. 2028. December 31, 1913," in *Proceedings of the United States National Museum*, Vol. 46, 299-341. Washington, DC: Government Printing Office, 1913.

Krieger, Herbert W. *The Collection of Primitive Weapons and Armor of the Philippine Islands in the United States National Museum*, Washington, DC: Government Printing Office, 1926.

Moorfield, Storey. *The Moro Massacre*. Anti-Imperialist League, 1906.

Mirikitani: Grand Master Artist

Hattendorf, Linda, dir. *The Cats of Mirikitani*. Documentary film. 2006.

Wakida, Patricia. "Jimmy Mirikitani." Densho Encyclopedia, last modified March 2015.

Balbir Singh Sodhi

Sodhi, Rana Singh. "The man who murdered my brother post-9/11 just died. This is why I mourn him." *AZCentral*, June 7, 2022.

Sidhu, Dawinder S., and Gohil, Neha Singh. *Civil Rights in Wartime: The Post-9/11 Sikh Experience*. London: Ashgate, 2009.

RESISTANCE AND SOLIDARITY

Filipino Homemade Rifle

Beveridge, Alfred J. "Our Philippine Policy," *Congressional Record*. Senate, January 9, 1900: 704–711.

Francia, Luis. *A History of the Philippines: from Indios Bravos to Filipinos*. New York: Overlook Press, 2010.

Kramer, Paul A. *The Blood of Government: Race, Empire, the United States, and the Philippines*. Chapel Hill: The University of North Carolina Press, 2006.

United, Victory

Muñoz, Carlos. *Youth, Identity, Power: The Chicano Movement* (revised and expanded edition). London: Verso, 2007.

Bowl of Rice Party Banner

"China Refugees Total 60,000,000." *Victoria Daily Times*. June 8, 1938, 3.

Yu, Renqiu. *To Save China, To Save Ourselves: The Chinese Hand Laundry Alliance of New York*. Philadelphia: Temple University Press, 1992.

Drafted While Incarcerated

Kuromiya, Yosh. Densho Digital Archive, August 15–16, 1993.

Fred Korematsu

Brief of Amicus Curiae Fred Korematsu in Support of Petitioners, Supreme Court of the United States, Nos. 03-334, 03-343. 2003.

Chandler, Anupam and Madhavi Sunder. *Fred Korematsu: All American Hero*. Durham: Carolina Academic Press, 2011.

Herzig-Yoshinaga, Aiko. Densho Digital Repository, https://ddr.densho.org/narrators/18/.

Irons, Peter, ed. *Justice Delayed: The Record of the Japanese American Internment Cases*. Middletown: Wesleyan University Press, 1989.

Korematsu v. United States, 323 U.S. 214. 1944.

Organizing in the Fields

"Coachella Valley: Filipinos' 1965 strike set stage for farm labor cause." *The Press Enterprise*, September 3, 2005.

Guillermo, Emil. "Larry Itliong Day Celebrated in Honor of Filipino-American Labor Leader." NBC News, October 23, 2015.

Kushner, Sam. *Long Road to Delano*. International Publishers, 1975.

Yuri Kochiyama

Arthur Tobier, ed. *Fishmerchant's Daughter: Yuri Kochiyama, an oral history, vol. 1 and 2*. New York: Community Documentation Workshop, 1981.

Rallying Against Racism

"San Francisco Chinese anti-epidemic anti-discrimination parade / Fight the Virus, Not the People." Sing Tao TV, March 4, 2020. https://www.youtube.com/watch?v=6j9P1zVtr2Q.

Tang, Julie. Email to Theodore S. Gonzalves. May 5, 2022.

DC Funk Parade

"Antibalas' 'Fu Chronicles' Is A Martial Arts-Inspired Testament To Afrobeat," *NPR*, February 8, 2020.

Muhammad, Abdur-Rahim. *Dragonz Rising: Reclaiming My Time After Wandering Through the Valley*. 2018.

COMMUNITY

Uncovering Native Hawaiian Histories

Malo, Davida. *Mo'olelo Hawai'i* (*Hawaiian Antiquities*). Honolulu: Hawaiian Gazette Company, 1908.

Malo, Davida [attributed]. *Ka mooolelo Hawaii* (*The Hawaiian History. Written by certain students of the college, and edited by a teacher of the school*). 1838.

Picture Bride Kimono

Fujisaka, Kyoko Kakehashi. "Japanese immigrant women in Los Angeles, 1912–1942: A transnational perspective." PhD diss., University of Wisconsin-Madison, 2005.

National Museum of American History. *Photograph of Shizue Sato Nagao*, 1917. Ink on paper.

Dancing with Tradition

Flores, Judy. "The Re-creation of Chamorro Dance as Observed Through the Festival of Pacific Arts." *Pacific Arts* 25 (December 2002): 47–63.

A Star in Her Own Right

"Nobel laureate's wife Lalitha Chandrasekhar dies at 102." *The Hindu*. September 6, 2013.

Guide to the Lalitha Chandrasekhar Papers 1920-2013. (n.d.).

Unified Melodies of Language, Culture, and Faith

Various Artists, Music from Western Samoa: From Conch Shell to Disco. 1982, LP. Recorded by Ad and Lucia Linkels.

Fatausi Brass Band. *Velo Mau Disco*, in *Various Artists, Music from Western Samoa: From Conch Shell to Disco*. 1982, LP.

Youth Group from Saleufi, Apia, "Lau Lupe," in *Various Artists, Music from Western Samoa,* 1982, LP.

Campaign Pins

"The Candidates: 5th Congressional District of Virginia Republican Committee, Convention 2020," Madison County Republican Committee, 2020.

Songs About Our Life

Caravan. *Songs for Life.* Smithsonian Folkways. 1978, LP.

Liner notes for *Thailand: Songs for Life.* Caravan. 1978. Paredon Records P-1042. LP. https://www.chicagomanualofstyle.org/qanda/data/faq/topics/Documentation/faq0146.html

Lockard, Craig A. "Popular Musics and Politics in Modern Southeast Asia: A Comparative Analysis," *Asian Music* 27.2 (Spring-Summer 1996): 149–199.

Padoongpat, Mark. *Flavors of Empire Food and the Making of Thai America.* Berkeley: University of California Press, 2017.

Revelation in Portraiture

Akhtar, A., & S. Sikander. "The Incantatory Power of Ayad Akhtar and Shahzia Sikander." *The Nation,* September 15, 2020.

Timeline—*Shahzia Sikander.* (n.d.). https://www.shahziasikander.com/timeline

Ruby Ibarra

Ibarra, Ruby. Interviewed by Theodore S. Gonzalves, June 29, 2019.

Ibarra, Ruby. "US" in *Circa91.* 2017. Beatrock Music, CD.

Magalona, Francis. "'Mga Kababayan' (My Countrymen)" on *Yo!* 1990. OctoArts EMI, LP.

Naomi Osaka Masks and Racquet

Osaka, Naomi. "I Never Would've Imagined Writing This Two Years Ago." *Esquire Magazine,* July 1, 2020.

Ramsay, George. "These were the Black victims Naomi Osaka honored on face masks at the US Open," CNN, September 14, 2020.

SERVICE

From Orphan to Statesman

Chol, An Jong. "No Distinction between Sacred and Secular: Horace H. Underwood and Korean-American Relations, 1934–1948." *Seoul Journal of Korean Studies* 23, no. 2 (December 2010): 225–246.

Oh, Bonnie B. C. "Kim Kyu-sik and the Coalition Effort" in *Korea Under the American Military Government, 1945-1948,* ed. Bonnie Kim. Westport, CT: Greenwood Publishing Group, Inc., 2002. 103:122

Oppenheim, Robert. *An Asian Frontier: American Anthropology and Korea, 1882-1945.* Lincoln: University of Nebraska, 2016.

Roanoke College News. "Remembering alumnus Kim Kyusik, leader of Korean independence movement, 100 years later." February 28, 2019.

Ryang, K. S. "Kim kyu-sik as a common man and a political leader," *Korean Observer* 13:1 (1982): 36–54.

Alice Kono's Uniform

Fecteau, Katherine. "Alice Tetsuko Kono: Wise, well-traveled, WAC." National Museum of American History blog, August 4, 2017.

Moore, Brenda L. *Serving Our Country: Japanese American Women in the Military during the World War II.* New Brunswick, NJ: Rutgers University Press, 2003.

Medal of Honor

Mauldin, Bill. *Back Home.* New York: Bantam Books, 1948.

"Joe M. Nishimoto." Congressional Medal of Honor Society, https://www.cmohs.org/recipients/joe-m-nishimoto

Dalip Singh Saund

"[California] Senate Concurrent Resolution No. 104—Relative to the 100-year anniversary of the Sikh American community." Resolution Chapter 122, September 10, 2012.

Dalip Singh Saund. *Congressman from India.* New York: E. P. Dutton and Company, 1960.

Saund, Dalip Singh, *My Mother India.* Stockton, California: The Pacific Coast Khalsa Diwan Society, Inc. (Sikh Temple), 1930.

Reelect Patsy Mink

Campaign to Re-elect Patsy Mink to the US House of Representatives. "Re-Elect Patsy Mink" leaflet, 1966.

Wu, Judy Tzu-Chun, and Gwendolyn Mink. *Fierce and Fearless: Patsy Takemoto Mink, First Woman of Color in Congress.* City: Press, date.

Godfather of Asian American Journalism

Walters, Dan. "Legislature protects its secrecy." *Sacramento Bee.* March 21, 2008.

Lee, K. W. Acceptance Speech, John Anson Ford Award, for print media, Los Angeles County Human Relations Commission in recognition of his coverage while at the *Korea Times English Edition* of the 1992 Los Angeles riots—"for promoting racial harmony... through journalism and community involvement." Reprinted in Stewart Kwoh and Russell C. Leong, editors, *Untold Civil Rights Stories: Asian Americans Speak Out for Justice* (Los Angeles: Asian Pacific American Legal Center and UCLA Asian American Studies Center, 2009): 71-73.

A Record First

Iijima, Chris Kando, Nobuko JoAnne Miyamoto, and William "Charlie" Chin, *A Grain of Sand: Music for the Struggle by Asians in America.* 1973. Paredon Records, LP.

Iijima, Chris. "Pontifications on the Distinction between Grains of Sand and Yellow Pearls," in *Asian Americans: The Movement and the Moment.* Steve Louie and Glenn Omatsu, eds. Los Angles: UCLA Asian American Studies Center Press, 2006.

Kim, Sojin. "A Grain of Sand: Music for the Struggle by Asians in America." *Smithsonian Folkways Magazine.* 2011.

Nash, Phil Tajitsu. "Remembering Chris Iijima," *CommonDreams.* January 7, 2006.

Following the Voice

Tringali, Stephen, dir. *Corridor Four,* Culver City, CA: Ratajack Productions, 2017.

Finland, Glen. "The Guardians." *Washington Post,* September 11, 2005.

MEMORY

Leaving a Mark

Kim, Kristine. *Henry Sugimoto: Painting an American Experience.* Berkeley: Heyday Books, 2000.

"Madeleine Sugimoto." *Tessaku: Oral histories and testimonies from the Japanese American incarceration.* November 15, 2016.

The Ocean is the Dragon's World

Carl, Katharine A. *With the Empress Dowager of China.* New York: The Century Co., 1907.

Lunar New Year Stamp

Le, C. N. "Tet, a Celebration of Rebirth," *Asian-Nation: The Landscape of Asian America,* 2001.

Kakesako, Gregg K. "Clarence Lee, designer of New Years stamps, dies." *[Honolulu] Star-Advertiser,* January 30, 2015.

Roger Shimomura, *Crossing the Delaware*

Beale, John. "Roger Shimomura interview," Asian American Art Oral History Project, DePaul University, April 25, 2013.

Goodyear, Anne Collins. "Roger Shimomura: An American Artist." *American Art* 27.1 (Spring 2013): 70–93.

"A Whole Foods in Hawaiʻi"

Perez, Craig Santos. "A Whole Foods in Hawaiʻi," *Poetry Magazine* (July/August 2017).

Perez, Craig Santos. Speech for launch of *Critical Pacific Islands Studies Library Guide.* University of California, Berkeley. 2018.

Grief Garden

Xiong, Khaty. "On Visiting the Franklin Park Conservatory & Botanical Gardens." *Poetry Magazine* (July/August 2017).

Xiong, *Grief Garden*, 2018. Art installation, Poetry Foundation Gallery, Asian/Pacific/American Institute at New York University, restaged 2022.

JOY

Duke Kahanamoku's Surfboard

Burnett, Claudine E., and Paul Burnett. *Surfing Newport Beach: The Glory Days of Corona del Mar.* Charleston and London: History Press Library Editions, 2013.

Kahanamoku, Paoa Kahinu Moke Hulikohola. "Riding the Surfboard," *Mid-Pacific Magazine,* 1.1 (1911): 3–10.

"Five are drowned when waves capsize yacht," *Los Angeles Times,* June 15, 1925.

Yo-Yo Demonstrators

Donald F. Duncan, Inc. v. Royal Tops Manufacturing Company, Inc., and Randy Brown, 343 F.2d 655 (7th Cir. 1965).

Hirahara, Naomi. *Distinguished Asian American Business Leaders.* Westport, CT: Greenwood Press, 2003.

"The Original Yo-Yo." *Filipino Forum,* January 15, 1930.

A Baseball Story

Furukawa, Tetsuo. "When Gila Fought Heart Mountain." *Discover Nikkei,* February 26, 2010.

McNulty, Sean. "Guadalupe resident Tetsu Furukawa remembers baseball and internment during World War II." *Santa Maria Sun* 16.27, September 9, 2015.

Hello Kitty's Soft Power

Miranda, Caroline. "Hello Kitty is not a cat, plus more reveals before her L.A. tour." *Los Angeles Times,* August 26, 2014.

Tran, Sharon. "Hello Kitty Love/Hate: On Asian Cuteness, Disability, and Affect." UCLA Center for the Study of Women, February 3, 2016.

Yano, Christine. Hello Kitty exhibition text. Japanese American National Museum, 2014.

Yano. *Pink Globalization: Hello Kitty's Trek Across the Pacific.* Durham: Duke University Press, 2013.

Skill and Challenge

Oyama, Judi. "Remarks at induction to Aptos High School Sports Hall of Fame," 2017.

Segovia, Patty, and Rebecca Heller. *Skater Girl: A Girl's Guide to Skateboarding.* Ulysses Press, 2006.

Oyama, Judi. Skateboard Sports Hall of Fame Speech Judi Oyama Class of 2017. https://judioyama.blogspot.com/2017/04/skateboard-sports-hall-of-fame-speech.html.

Freedom of Choice

Chung, Nicole. "Kristi Yamaguchi, Unlaced." *Shondaland,* February 12, 2021. https://www.shondaland.com/inspire/a14436692/kristi-yamaguchi-interview/

Samuels, Robert. "Kristi Yamaguchi Won Gold 30 Years Ago. American Figure Skating Would Never Look the Same." *Washington Post,* February 15, 2022.

The Skating Lesson, director. *Kristi Yamaguchi: TSL's Interview with the Olympic Champion.* YouTube, 26 Jan. 2016. Video, 51:45, https://www.youtube.com/watch?v=eea3v7Kml5Y&t=56s

Lieu, Thanh, and Sheehan, Lauren. "Kristi Yamaguchi's Skate Dress." Interview. October 15, 2021.

Representation in Dance

Abrera, Stella. Interviewed by Theodore Gonzalves. October 29, 2021.

Fierce and Confident Humor

Wong, Ali. *Dear Girls.* New York: Penguin Random House, 2020.

The Hardheaded Route

'Exterminate all the brutes': One Man's Odyssey Into the Heart of Darkness and the Origins of European Genocide. New York: The New Press, 1996.

Ms. Marvel—Kamala Khan

Norris, Maria. "Comics and Human Rights: An Interview with G. Willow Wilson." London School of Economics and Political Science Human Rights blog, February 3, 2015,

Stahler, Kelsea. "Learn Sana Amanat's Name Now—The Future Of Marvel Might Just Be In Her Hands." *Bustle,* July 24, 2018.

Image Credits

3: Images courtesy of Erika Lee. 5: Narrative of the United States Exploring Expedition. 7: Images courtesy Valerie Soe. 9: Photograph by Bob Hsiang. 10: National Museum of American History (NMAH). 2018.0068.0007 11: NMAH. 1992.0620.01. 12: National Anthropological Archives. NAA INV.05058500. 13: Smithsonian Institution Archives. MAH-13036. 14: Department of Anthropology, National Museum of Natural History. E160416-0. 15: National Anthropological Archives. NAA INV.04884200. 16: NMAH. 2007.0193.01. 18: NMAH Archives Center. 1994.3135. 19: NMAH, Gift of James Edgar Mead and Virginia Lee Mead. 1992.0620.01. 20: *PeregriNasyon: Is America in the Heart?* 1994. Designed by Lucille Tenazas. Offset lithograph on paper 24 x 18 in. (61.0 x 45.7 cm). Cooper Hewitt, Smithsonian Design Museum, Gift of Lucille Tenazas, 1995-171-2. 23t: NMAH. 2018.0068.0007. 23b: Photo by Paul Rovere/Getty Images. 24: National Air and Space Museum. A19970599000. 25t: Image courtesy of NASA. 25b: Image courtesy of NASA. 26: Center for Refugee Poetics. Map published in *Verge*. 28: *Joe Bataan*. 1965. Unidentified Artist. Gelatin silver print. National Portrait Gallery, Gift of Joe Bataan. NPG.2012.80. 29: NMAH. 2001.0130.01. 30–31: *My Dreams, My Works Must Wait Till After Hell*. Girl, Simone Leigh, Chitra Ganesh. 2011. Single-channel digital video, color, sound; 07:14 minutes. Smithsonian American Art Museum, Museum purchase through the Samuel and Blanche Koffler Acquisition Fund, 2019.33.1, © Girl (Simone Leigh and Chitra Ganesh); Courtesy of the artists and Luhring Augustine, New York. 33: *Dana Tai Soon Burgess*. CYJO (Cindy Hwang), born 1974. December 16, 2007 (printed April 1, 2014). Digital pigment print. National Portrait Gallery, through the generosity of Ms. Gie Kim and Mr. Rich Chang. © 2007 CYJO. 34: NMAH. 2001.0130.01. 35: Photo by H. Armstrong Roberts/ClassicStock/Getty Images. 36: Archives of American Art. (DSI-AAA)5018. 37: © 2023 The Isamu Noguchi Foundation and Garden Museum, New York / Artists Rights Society (ARS), New York. Hirshhorn Museum and Sculpture Garden. 66.3867. 34 1/2 x 24 3/4 x 7 7/8 in. (87.5 x 62.8 x 20 cm). Gift of Joseph H. Hirshhorn, 1966. 38–39: NMAH. 2011.0263.01 (Japanese American). 2017.0288.01 (Filipino American). 2021.0018.01 (Chinese American). 40: *Joe Bataan*. 1965. Unidentified Artist. Gelatin silver print. National Portrait Gallery. Gift of Joe Bataan. 43: NMAH. 1981.0530.05. 44–45: Department of Anthropology, National Museum of Natural History. E168224-0. Photo by James Di Loreto and Brittany M. Hance. 46: MANAN VATSYAYANA/AFP via Getty Images. 47: AMAN ROCHMAN/AFP via Getty Images. 48: Bob Stocksdale and Kay Sekimachi papers, circa 1900-2015. Archives of American Art. (DSI-AAA)22514. 49: NMAH. CL.280280.13. 50t: NMAH. 2012.0205.05. 50b: NMAH. 2012.0205.01. 53: National Anthropological Archives. NAA INV.05051300 OPPS NEG.80-9501. 54: NMAH. 1985.0562.0. 55: Photo by Frank Proschan. 1986 Festival of American Folklife book. 57: NMAH. CL.280280.13. 58–59: NMAH. CL.64.1005. 60–61: *The Chinese Merchants.* Childe Hassam. Freer Gallery of Art, Gift of Charles Lang Freer. F1910.22a-b. 62: NMAH. 2001.0066.01. 63: Image courtesy of the National Archives and Records Administration. 64tr: NMAH. 2011.0041.32. 64tl: NMAH. 2011.0041.01. 64b: NMAH. 2012.0009.01. 67t: NMAH. 2010.0091.03. 67b: Manny Crisostomo/Sacramento Bee/Tribune News Service via Getty Images. 68: Bob Stocksdale and Kay Sekimachi papers, circa 1900-2015.

Archives of American Art. (DSI-AAA)22514. 69: *Leaf Vessel*. Kay Sekimachi. 2012. Smithsonian American Art Museum. Gift of Fleur S. Bresler. 70: NMAH. 1997.0268.02. 71: NMAH. 1996.0292.29a. 72: Nam June Paik. *Electronic Superhighway: Continental U.S., Alaska, Hawaii.* 1995. Fifty-one channel video installation (including one closed-circuit television feed), custom electronics, neon lighting, steel and wood; color, sound. Smithsonian American Art Museum, Gift of the artist. 2002.23. © Nam June Paik Estate. 73: NMAH. 1980.0096.01. 74: *Anna May Wong*. Carl Van Vechten. 1932. Gelatin silver print. National Portrait Gallery. © Carl Van Vechten Trust. 75: National Portrait Gallery. NPG.2015.134. 76: Everett Collection. 77: *James Wong Howe*. George Hurrell. 1942. Gelatin silver print. National Portrait Gallery. © George Hurrell, Jr. 78t: *Forlorn Spot*. Yayoi Kusama. 1953. Watercolor, pastel, ink on paper. 8 $\frac{3}{4}$ × 11 $\frac{5}{8}$ in. (22.2 × 29.5 cm)/ Smithsonian American Art Museum, Gift of Mr. and Mrs. John A. Benton and The Joseph and Robert Cornell Memorial Foundation. 2019.32.4. 78bl: *Fire*. Yayoi Kusama. ca. 1954. Watercolor, pastel, ink, tempera on paper. 10 $\frac{3}{4}$ in. × 8 in. (27.3 × 20.3 cm). Smithsonian American Art Museum, Gift of Mr. and Mrs. John A. Benton and The Joseph and Robert Cornell Memorial Foundation. 2019.32.3. 78bm: *Autumn*. Yayoi Kusama. 1953. Watercolor, pastel, ink on paper, overall: 11 $\frac{3}{4}$ × 8 $\frac{7}{8}$ in. (29.8 × 22.5 cm). Smithsonian American Art Museum, Gift of Mr. and Mrs. John A. Benton and The Joseph and Robert Cornell Memorial Foundation. 2019.32.1. 78br: *Deep Grief*. Yayoi Kusama. 1954. Watercolor, ink on paper. 9 $\frac{7}{8}$ in. × 7 in. (25.1 × 17.8 cm). Smithsonian American Art Museum, Gift of Mr. and Mrs. John A. Benton and The Joseph and Robert Cornell Memorial Foundation. 2019.32.2. 80: Library of Congress Prints and Photographs Division. 81: NMAH. 1989.0196.082. 83: NMAH Archives Center. NMAH-AC0666-0000059. 84: NMAH. 1980.0096.01. 87: *Electronic Superhighway: Continental U.S., Alaska, Hawaii.* Nam June Paik. 1995. Fifty-one channel video installation (including one closed-circuit television feed), custom electronics, neon lighting, steel and wood; color, sound. Smithsonian American Art Museum, Gift of the artist. 2002.23. © Nam June Paik Estate. 88: *Fervor* © Shirin Neshat. Courtesy of the artist. 89: NMAH. 2003.0259.01A. 90: National Museum of Natural History. 2022-01040. 93: NMAH. 1979.1263.01867. 94: NMAH. 2003.0259.01A. 97: NMAH. TE.T18486, 93. 98: NMAH. AF.70303M. 99: Image courtesy of the US Army. 101: *House of Many Rooms*. Zarina. 1993. Etchings on paper. Smithsonian American Art Museum, museum purchase through the Patricia Tobacco Forrester Endowment. 2014.42A-D. © 1993, Zarina. 102: *The Star-Spangled Banner (Third Verse)*. Christine Sun Kim. 2020. Charcoal on paper. Smithsonian American Art Museum, museum purchase and purchase through the Asian Pacific American Initiatives Pool, administered by the Smithsonian Asian Pacific American Center and through the Julia D. Strong Endowment. 2021.31.1. © 2020, Christine Sun Kim. Courtesy of the artist and François Ghebaly, Los Angeles. 105: *Fervor* © Shirin Neshat. Courtesy of the artist. 106: NMAH. 2008.0162.01. 107: NMAH. CE.75.122. 109: Smithsonian Institution Archives. Image # SIA2009-1805. 110: NMAH. CE.75.122. 113: Warshaw Collection, NMAH Archives Center. NMAH-AC0060-0001972-01. 114: NMNH, EL3477-0. 117: *Hiroshima*. Jimmy Tsutomu Mirikitani. 2001. Mixed media on paper. Smithsonian American Art Museum, museum

purchase made possible by the Ford Motor Company. 2008.32.3. 118: NMAH. 2008.0162.01. 119: NMAH. 2011.0255. 120: NMAH. 2013.3060.03. 122: NMAH. Image by Lucy Xie. 123: NMAH. 2019.0166.1. 124: NMAH. AF.NM367. 127: *No More Hiroshima/Nagasakis: Medical Aid for the Hibakushas.* Nancy Hom. 1982. Screenprint on paper. Smithsonian American Art Museum, Gift of Gilberto Cárdenas and Dolores García. 2019.51.53. 128: *Viet Nam / Aztlan.* Malaquias Montoya. 1973. Offset lithograph on paper. Smithsonian American Art Museum, Museum purchase through the Frank K. Ribelin Endowment. 2015.29.3. © 1973, Malaquias Montoya. 131: NMAH. 2017.0216.01, 77.5 cm x 53 cm x 1 cm; 30 1/2 in x 20 7/8 in x 13/32 in. 132: NMAH. 2008.0105.02. 134: Bettmann via Getty Images. 135: *Fred T. Korematsu.* Unidentified Artist. c. 1940. Hand-colored gelatin silver print. National Portrait Gallery, gift of the Fred T. Korematsu Family. 136: NMAH. 2019.0166.1. 139: *Yuri Kochiyama.* Corky Lee. 1980 (printed 2016). Gelatin silver print. National Portrait Gallery. © Corky Lee. 140: *Disneyland, California*, from the series *East Meets West.* Tseng Kwong Chi. 1979, printed 2013. Gelatin silver print. Smithsonian American Art Museum, Museum purchase through the Luisita L. and Franz H. Denghausen Endowment and the Asian Pacific American Initiatives Pool, administered by the Smithsonian Asian Pacific American Center. 2021.14.3. © Muna Tseng Dance Projects, Inc. 142–143: NMAH. Image by Lucy Xie. 144: Community Documentation Photographs, Anacostia Community Museum Archives. ACMA.CDC.1. 146: Center for Folklife and Cultural Heritage. 147: NMAH. 1988.0520.053. 148: Smithsonian Cullman Library Rare Books, DU625 .M252 1838. 149: Attributed to Alfred Thomas Agate. Smithsonian Institution Libraries. 151: NMAH. 2005.0249.01. 152: National Anthropological Archives. INV.05053500 155: Smithsonian Institution Archives, Accession 90-105, Science Service Records. Image No. SIA2008-0425. 156: Courtesy of Smithsonian Folkways Recordings. FW04270. 159: Abrams pin: NMAAHC, 2021.6.5, 2 1/8 × 2 1/8 × 5/16 in. (5.4 × 5.4 × 0.8 cm). Courtesy of Stacey Y. Abrams. Bush-Cheney poster: NMAH. 2002.0312.085, 11 in x 17 in; 27.94 cm x 43.18 cm. Dinkins pin: NMAAHC, 2013.68.135, 1 9/16 × 1 9/16 × 5/16 in. (4 × 4 × 0.8 cm). Gift of T. Rasul Murray. Jackson pin: NMAH. 1988.0520.053, 2 1/2 in; 6.35 cm. Collection of the Smithsonian National Museum of African American History and Culture, Gift of T. Rasul Murray. 160: Courtesy of Smithsonian Folkways Recordings. PAR01042. 161: Photo by AFP via Getty Images. 163: *Portrait of the Artist.* Shahzia Sikander. 2016. Etching. National Portrait Gallery, acquisition made possible through Federal support from the Asian Pacific American Initiatives Pool, administered by the Smithsonian Asian Pacific American Center. © Shahzia Sikander. 164: NMAH. 2022.0073. 165: NMAH. 2022.0073. 166: Photo by Matthew Stockman/Getty Images. 167: NMAH. 2021.0085.01. Gift of Naomi Osaka. 168: Smithsonian Folkways. 169: NMAH. 2016.0219.01. 170: National Anthropological Archives. OPPS NEG 72-8368, NAA INV.04762200. 172: NMAH. 2016.0219. 173: NMAH. 2016.0219.01. 174: NMAH. 2016.0154.01. 177: National Portrait Gallery. NPG.2017.25. © AP Images. 178: NMAH. 1977.0857.04. 181: NMAH. 182: Courtesy of Smithsonian Folkways Recordings. PAR01020. 184: NMAH. 2002.0272.02. 185: NMAH. 2002.0204.01. 186: NMAH. 2021.0056.01a. 187: AP Photo/Andrew Harnik. 188: *Nationalities: Eleven Filipino women in native dress* (from the American Counterpoint project, Alexander Alland, Sr., Photoprints, circa 1940, National Museum of American History, Archives Center, NMAH. AC.0204). Museum purchase through the Catherine Walden Myer Fund, in partnership with the Smithsonian Asian Pacific American Center, 2022.24.1. 189: E76180-1. 191: National Museum of Natural History. Department of Anthropology. Catalog number E76180-1. 192:

NMAH. 1984.1118.02. 195: *Strong Woman and Child.* Yasuo Kuniyoshi. 1925. Oil on canvas. Smithsonian American Art Museum, Gift of the Sara Roby Foundation. 1986.6.50. 196: *The Ocean is the Dragon's World.* Hung Liu. 1995. Oil on canvas. Painted wood panel, metal support rod, and metal bird cage with wood and ceramic appendages. Smithsonian American Art Museum, Museum purchase in part through the Lichtenberg Family Foundation. 1996.34A-D. 198: NPM, 2000.2021.29. © United States Postal Service. 201: NMAH. 1997.0010.2. 202–203: *Shimomura Crossing the Delaware.* Roger Shimomura. 2010. Acrylic on canvas (3 canvas panels). National Portrait Gallery, acquired through the generosity of Raymond L. Ocampo Jr., Sandra Oleksy Ocampo, and Robert P. Ocampo. NPG.2012.71. © 2010, Roger Shimomura 204: Archives of American Art. Roger Shimomura papers, 1959-2014. (DSI-AAA)13776. 208–209: *reconstructing an exodus history: boat trajectories from Vietnam and flight routes from refugee camps and of ODP cases.* Tiffany Chung. 2020. Embroidery on fabric. Smithsonian American Art Museum, Museum purchase through the Luisita L. and Franz H. Denghausen Endowment and through the American Women's History Initiative. 2021.37. 212: *Reverse View: KKK (from Warshaw Collection of Business Americana Subject Categories: Ku-Klux-Klan, circa 1950s, National Museum of American History, Archives Center, NMAH.AC.0060.S01.01.KKK).* Stephanie Syjuco. Smithsonian American Art Museum, Museum purchase through the Catherine Walden Myer Fund, in partnership with the Smithsonian Asian Pacific American Center. 2022.24.2. 213: *Nationalities: Eleven Filipino women in native dress (from the American Counterpoint project, Alexander Alland, Sr., Photoprints, circa 1940, National Museum of American History, Archives Center, NMAH.AC.0204).* Stephanie Syjuco. Smithsonian American Art Museum, Museum purchase through the Catherine Walden Myer Fund, in partnership with the Smithsonian Asian Pacific American Center. 2022.24.1. 214: Library of Congress Prints and Photographs Division. 215: NMAH. 2012.0151.01. 216: National Portrait Gallery. NPG.2007.195. 217: NMAH. 2015.0190.01. 218: Duncan Family Yo-yo Collection, Archives Center, NMAH. 219*l:* Duncan Family Yo-yo Collection, Archives Center, NMAH. 219*r:* Duncan Family Yo-yo Collection, Archives Center, NMAH. 220*t:* NMAH. 2015.0034.02. 220*b:* Library of Congress Prints and Photographs Division. 222: NMAH. 2012.0151.01. 223: Photo by Joe Kohen/WireImage. Getty Images. 225: NMAH. 2013.0128.02. 226: NMAH. 2003.0165.01. 227: Photo by Eileen Langsley/Popperfoto via Getty Images/Getty Images. 229: NMAH. 2018.0115.02. 230: NMAH. 2021.0082. Gift of Ali Wong. 231: Alex Crick / ©Netflix / Courtesy: Everett Collection. 233: Archives of American Art. 5034. 234: NMAH. 2018.3072.04. 236*t:* Boxer codex [manuscript], ca. 1590. Indiana University Digital Library. 236*b:* National Maritime Museum, Greenwich, London, Greenwich Hospital Collection. 237*t:* Image courtesy of Grove Farm. 237*b:* California -- The Chinese Agitation in San Francisco -- A Meeting of the. National Portrait Gallery. NPG.80.317. 238*m:* National Portrait Gallery, Smithsonian Institution; gift of the Bernice Pauahi Bishop Museum. NPG.80.320. 238*m:* Library of Congress Prints and Photographs Division. 239*r:* Library of Congress Prints and Photographs Division. 239: Image courtesy of the South Asian American Digital Archive. 240*l:* Labor Archives and Research Center, San Francisco State University. 240*r:* National Archives and Records Administration. 241*b:* National Archives and Records Administration. 241: Image courtesy T erry Schmitt. 242*l:* Image courtesy I-Hotel-SF.org. 242*m:* Estate of Corky Lee. 243*t:* Library of Congress Prints and Photographs Division. 243*b:* Photograph by Susie An. Image courtesy of WBEZ.

Index